FUTURIST ART
AND THEORY

Oxford University Press, Ely House, London W.1

GLASGOW NEW YORK TORONTO MELBOURNE WELLINGTON
CAPE TOWN SALISBURY IBADAN NAIROBI LUSAKA ADDIS ABABA
BOMBAY CALCUTTA MADRAS KARACHI LAHORE DACCA
KUALA LUMPUR HONG KONG TOKYO

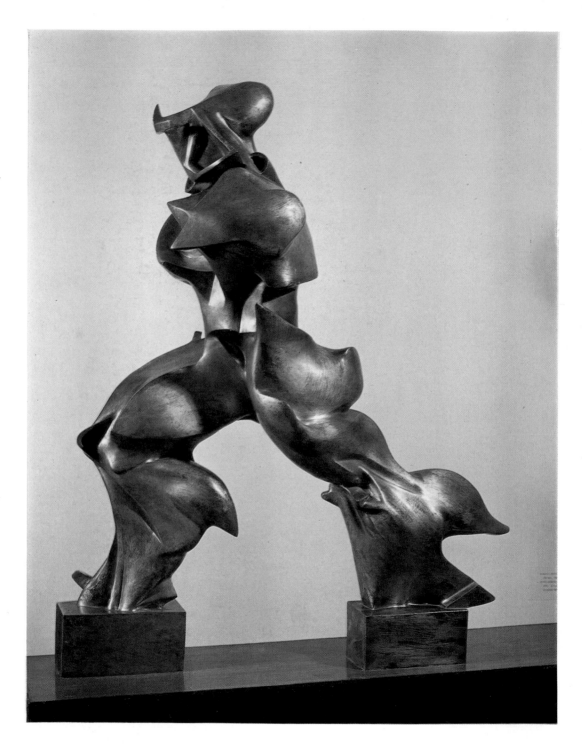

Umberto Boccioni. *Forme uniche della continuità nello spazio.* (1913). Bronze, 43½″ high

FUTURIST ART AND THEORY
1909-1915

by
MARIANNE W. MARTIN

CLARENDON PRESS · OXFORD
1968

© *Oxford University Press 1968*

Printed in Great Britain by
W. S. Cowell Ltd, at the Butter Market, Ipswich

to
R. M. M.
with gratitude

Non sunt ergo novitates penitus respuendae, sed sicut vetusta, cum apparuerint onerosa, sunt omnimode abolenda, ita novitates, cum utiles, fructuosae, necessariae, expedientes secundum rectum iudicium videbuntur, sunt animosius amplectendae.

WILLIAM OF OCCAM

ACKNOWLEDGEMENTS

In the preparation of this study I had the good fortune of being able to draw upon the valuable recollections of several Futurists and their families and friends. I am therefore deeply indebted to the great patience, courtesy and generosity of the Signorine Luce and Elica Balla and their late father, Giacomo Balla, of Rome; to the late sister of Boccioni, Signora Raffaella Boccioni-Callegari of Verona; to the late Carlo Carrà and to Signora Carrà of Milan; to Russolo's widow, the late Signora Maria Zanovello Russolo of Cerro di Laveno; to the late Ardengo Soffici of Poggio a Caiano; to the late Gino Severini and to Madame Severini of Paris. Donna Benedetta Marinetti of Rome provided significant insights into her late husband's work and ideas and permitted me to examine rare documents in her possession. The late Vico Baer, close friend and supporter of Boccioni, and Frau Grete Löwenstein of Ascona, pupil and admirer of Balla, took exceptional trouble in supplying me with very important information. Signora Elva Bonzagni Poggi, Bonzagni's sister, of Milan, the late Anton Giulio Bragaglia, photographer, scenographer, author, the late Enrico Prampolini, painter and Futurist, and Dr Giuseppe Sprovieri, formerly director of the Galleria Futurista, all of Rome, gave freely of their time and knowledge.

In the course of research I was assisted by numerous individuals and institutions in this country and abroad whose goodwill I warmly acknowledge. The authors of the fundamental *Archivi del Futurismo*, Dottoresse Laura Drudi Gambillo and Teresa Fiori, as well as Professor Carlo Giulio Argan of the University of Rome, helped me faithfully with word and deed while in Rome. The Museum of Modern Art in New York, whose splendid exhibition of *Twentieth Century Italian Art* of 1949 first introduced me to Futurism, has been a virtually inexhaustible source of information, materials and encouragement, and my gratitude extends to most of its departments. I am especially indebted to Mr Alfred H. Barr, Jr., Director of the Museum Collections, and Mr James T. Soby for their unfailingly sympathetic interest and many kindnesses. Mr Bernard Karpel, Librarian, Miss Dorothy C. Miller, Curator, and Miss Sara Mazo, Associate Curator, Department of the Museum Collections, were unsparing in their advice and made the unparalleled resources of the Museum available to me. Miss Pearl L. Moeller, Supervisor of Rights and Reproductions, and Mr Richard Tooke helped enormously in the procurement of photographs.

I should like to thank the many collectors who have kindly opened their homes to me: Mrs Harry Lewis Winston and her late husband of Birmingham, Michigan, have

graciously permitted me to study their admirable Futurist collection, and have spared no trouble in their efforts to assist me; and the following have been especially helpful – Mr and Mrs Herbert M. Rothschild of Ossining, Mr and Mrs Joseph Slifka, Miss Barbara Jane Slifka, Mr Sidney Janis, and Mr Richard Zeisler (New York); Mr Eric Estorick (London); Dr and Mrs Emilio Jesi, Dr and Mrs Riccardo Jucker, Dr Gianni Mattioli, and Dr Rodolfo Ruberl (Milan).

The staffs of the following Libraries have helped me very much, indeed have made this study possible: New York Public Library, Columbia University and its Casa Italiana, Frick Reference, Bryn Mawr College, the Free Library of Philadelphia, the University of Pennsylvania, the Victoria and Albert Museum in London, the University of Rome, and the Biblioteca Nazionale in Florence.

Among the many others of whose kindness I was the beneficiare are: Avv. Carlo E. Accetti, Milan; Dr Clelia Alberici, Conservatore, Castello Sforzesco, Milan; Mr Ronald Alley, Keeper, Tate Gallery, London; Dr Umbro Apollonio, Curator of Historical Archives of Contemporary Art, Venice Biennale; Dr Paolo Arrigoni, Director, Galleria d'Arte Moderna, Milan; Dr Reyner Banham, London; Miss Christa Baumgarth, Kunsthistorisches Institut, Florence; Prof. Dott. Gian Guido Belloni, Direttore Reggente, Civiche Raccolte d'Arte, Milan; Mr Hans Bolliger, Gutekunst & Klipstein, Berne; Professor L.-C. Breuning, Columbia University; Dott. Palma Bucarelli, La Soprintendente, Galleria Nazionale d'Arte Moderna, Rome; Mr David Burliuk, Hampton Bays, New York; Mr Ettore Colla, Rome; Madame Sonia Terk Delaunay, Paris; Madame Théo van Doesburg, Paris; Professor Bernard Dorival, Paris; Mr Piero Dorazio, Rome; Mr F. Ertl, Bonn; Signora Gina Severini Franchina, Rome; Miss Rose Fried, New York; Signora Gonnelli, Florence; Dr H. L. C. Jaffé, Adj. Director of the Municipal Museums, Amsterdam; Madame Gabrielle Kueny, Curator, Musée de Peinture et de Sculpture, Grenoble; Professor Kenneth Lindsay, Harpur College, Endicott, New York; the late Frau Gabriele Münter, Murnau; Dr Domenico Petrosino, Curator, Galleria d'Arte Moderna, Milan; Professor Olga Ragusa, Columbia University; Dr Georg Schmidt, Basle; Dr Louise A. Svendsen, Curator of Education, Guggenheim Museum, New York; Mrs Carol K. Uht, Curator, New York; Signorina Tullia Vallecchi, Florence; Dr Hans Maria Wingler, Frankfurt. In addition: Avv. Paride Accetti, Milan; Mr Jack E. Berizzi, New York; Mr Robert M. Connolly, Casa Italiana, New York; Mr Karl A. Dimler, Bryn Mawr College; Dr Dario Durbé, Curator, Galleria Nazionale d'Arte Moderna, Rome; Madame Cécile Goldscheider, Conservateur du Musée Rodin, Paris; Mr George F. Goodyear, Buffalo; Miss Peggy Guggenheim, Venice; Mr Philip Johnson, New York; Mr and Mrs Samuel R. Kurzman, New

York; Mr Lino di Marzo, Archivio Fotografico del Castello Sforzesco, Milan; Mr Samuel H. Maslon, Minneapolis; Mrs Margarete Schultz, New York; Mr S. J. Zacks, Toronto.

Very special thanks go to Professors James Fowle, Rhode Island School of Design, Providence, and to Charles Mitchell, Chairman of the Department of Art History at Bryn Mawr College, who in 1961–2 supervised the writing of this study in its original form as a doctoral dissertation. My appreciation for their valuable counsel and enthusiasm is not easily expressed.

To the American Association of University Women, whose fellowship permitted me to study abroad, and to the American Council of Learned Societies, whose summer grant helped make possible additional research and the purchase of photographs, I am particularly indebted.

My most sincere thanks go to Miss Lucy Lippard for her skilled editorial assistance and devotion. The staff of the Clarendon Press has been particularly helpful in the long drawn out course of the publication of this book.

New York MARIANNE W. MARTIN

CONTENTS

LIST OF TEXT ILLUSTRATIONS

LIST OF ILLUSTRATIONS

at end

The sizes are given in inches, height precedes width. Dates in parenthesis do not appear on the works of art. The titles, so far as possible, are the ones used at the first public showings or are taken from other contemporary records. Alternatives are given in the footnotes to the text.

INTRODUCTION

The artistic movement hopefully called Futurism was born of an ardent demand for the cultural rejuvenation which Italians had impatiently awaited since the mid-nineteenth century, when the nation fought for political independence and unification. But the significance of Futurism far transcends its national boundaries, and the movement's contribution to subsequent artistic developments in Europe and America is now widely recognized. As a result, there exists an urgent need for reliable information about the aims and achievements of Futurism. The following art historical and critical study attempts to satisfy this need.

It may seem odd that Futurism, which emerged nearly sixty years ago, is only now receiving a thorough examination. Although this neglect was partly due to the domination of the School of Paris, the chief reason for it was the Italian political situation between the two World Wars and, above all, the evolution of the movement itself. Its founder, in 1909, was the poet F. T. Marinetti, who formed a lasting friendship with Mussolini in 1914. Futurism has been much tainted by this association with the Fascist leader, and the fact that its most original phase had virtually ended by 1915 has not prevented numerous Italian and non-Italian writers from giving biased accounts of the movement in terms of later events and regarding it primarily as a political manifestation. Aside from this sympathy with Fascism, the very nature of Futurism permitted and even invited such misinterpretation.

Marinetti's movement was the best organized and most vociferous of a series of efforts to expose and overcome the spiritual and cultural stagnation of the increasingly prosperous Italian nation. Artists in Italy were anxious to regain a dignified and, if possible, a meaningful position in their country. In addition, their ideas and action were undoubtedly affected by the widespread political and social ferment of the early years of the century. The impatient Futurists found the tactics of radical politics well suited to their purposes. They glorified war and encouraged belligerence, but this was above all an aspect of their desire for a courageous and active creative life. Although politics as such played only a minor part in the Futurist programme before the First World War, the urgency and aggressiveness of Marinetti's movement were, at least superficially, prophetic of Fascism. Nevertheless, it would be a severe distortion of facts to force Futurist art and theory into the political straitjacket of Fascism on the basis of a limited concurrence of attitudes. The goal of the Futurists, as Giovanni Papini once put it, was 'the renewal of the spirit through a new art and a new vision

of the world'. By opening Italy's windows to the world they hoped to participate once again in the mainstream of European culture. One of the fundamental differences between Fascism and Futurism lies in the ratio of nationalism to internationalism. The original Futurists were chiefly concerned with the international mosaic of ideas; Fascism, on the other hand, grew increasingly insular.

The broad scope of Futurism has provided a further obstacle to an objective critical assessment. Unlike Cubism, Fauvism or Impressionism it was not limited to one artistic discipline, but quickly and deliberately branched out from its originally literary orientation to all major creative fields. Each of these attracted its own exponents who, in time, formulated an appropriate theory. All of these theories, and their artistic fulfilment, evolved from the basic Futurist aesthetic outlined in Marinetti's First Manifesto of 1909. In addition, each individual Futurist was swayed by the common ideal of a 'total art' that was to result from the interaction of the various art forms and correspondence of the diverse kinds of perception. Among the novel and provocative means and forms discovered were 'Free-word Poetry', 'Free-word Painting', the 'Art of Noises', 'Total Theatre', memory montages, kinetic, multi-material and noise-making assemblages. Succeeding generations of artists, particularly those of the nineteen-fifties and sixties, have accepted and fruitfully expanded these innovations. While the Futurists themselves greatly benefited from such creative interdependence, none was able to express himself with equal force in more than one area. The relationships between the various areas must be taken into account, but in the end it is only through consideration of each of its expressions as a separate phenomenon that a true understanding of Futurism in its entirety will be achieved.

The present volume deals only with the plastic arts during the first and main phase of the movement (so-called *il primo futurismo*), which reveals a self-contained process of evolution and disintegration from about 1909 to 1915, and is concluded by the death of Boccioni in 1916. This phase falls roughly into two stages. The first consists of the initial efforts to establish an appropriate artistic language for the Futurist aesthetic: it extends from the Futurist Foundation Manifesto in 1909 to approximately the end of 1911, when the Futurist artists were ready to show their work in Paris. The second stage, that of mature Futurism, embraces the formal and physical expansion of the movement and, finally, its climax. Futurist art and ideas were promulgated beyond the borders of Italy on a large scale. Significant exchanges with other movements took place, especially with those in France. Cubism, of course, had the most profound and far-reaching effect on Futurist art, but the dialogue between them has been generally misunderstood. Earlier critics, writing on the Italian movement from the French standpoint, often held that Futurist painting and sculpture were merely

offsprings of Cubism. Since then, less partisan interpretations have suggested that mature Futurism adapted some of the Cubist formal vocabulary to its own specifically Futurist ends. Such a concept, while essentially correct, still disregards the major portion of this problematic relationship. It does not explain the Futurists' gradual estrangement from some of their own key precepts which began in mid-1913 at the point of their most masterful and original exploitation of Cubist means. In fact, the encounter with Cubism, which so quickly and brilliantly 'modernized' early Futurist works, also seems to have heralded the end of the Italian movement. The two aesthetics were fundamentally opposed, thus necessitating a choice between the *l'art pour l'art* classicism of Cubism and the expressionist dynamism of Futurism. While such a necessity was disregarded at first, it soon made itself felt in the contradictory tensions which threatened the artists' work. Personal conflicts, jealousies and physical exhaustion contributed further to the decline of *il primo futurismo*, and its end was hastened by the advent of the First World War.

Only the five artist members of the *gruppo dirigente* in the visual arts are studied in detail: Boccioni, Carrà, Russolo, Severini, and Balla. The versatile Soffici, who was a writer as well as a painter, and the architect Sant'Elia have been added because they played significant roles in the heroic period. It was Soffici who was chiefly responsible for calling the Futurists' attention to Paris and to Cubism; hence his share in determining the course of the movement is greater than has usually been acknowledged. Sant'Elia, although joining the group officially only in mid-1914, daringly applied Futurist principles to architecture. His designs and statements have become celebrated Futurist documents in spite of the still heated debate about their commitment to the movement. Depero, Prampolini, Rosai, Sironi, Dudreville, Funi, Giannattasio, Lega, and many others, who adhered to the movement or were strongly influenced by it just before or during the war, are not included, for they contributed nothing essentially new to the first Futurism. Most of these men were some ten years younger than the five original artist members, and their connection with the movement was, with a few notable exceptions, only a temporary stage in their development; those who remained belong in a discussion of *il secondo futurismo*.

Very little accurate information is available about this second Futurism, which was organized after the First World War. Its artistic history has been almost completely obscured by its far from clear association with Fascism. The zealous Marinetti was still its head, but the majority of its adherents were of a new generation, and while based on the original aesthetic principles of the movement, it was also attuned to current international and national trends. The main accomplishment of the second span of Futurism appears to have been its dogged adherence to the *avant-garde* spirit

in opposition to the pompous traditionalism of Mussolini's sycophants. Nevertheless, the cultural provincialism officially supported by the regime was so effective that at the end of his life the disillusioned Marinetti could remark that now only he and a few others were aware of the existence of Picasso. Open-minded research on *il secondo futurismo* would throw much needed light on the state of the arts in Italy between the two wars. The dramatic artistic resurgence immediately after the fall of Mussolini was certainly due in part to the spadework of both the first and second Futurisms.

PAINTING AND SCULPTURE IN ITALY
DURING THE LATER NINETEENTH CENTURY

Iᴛᴀʟʏ's contribution to the major artistic reorientation of the nineteenth century was slight compared to that of France, on which it generally depended. But the spirit as well as the work of a few artists demonstrated that a new aesthetic was being evolved in Italy too, and that beginnings were being made, however fitful and tentative.

The Italian Romantic Movement

It has been argued that Italy did not take part in the original development of Romanticism and that Futurism should therefore be regarded as a belated and final paroxysm of this movement.[1] Definition of Romanticism is the basis for this controversy, and for the purpose of this study it will be maintained that Italy did take part in the Romantic movement early in the nineteenth century. By direct contact with Germany and France, the writings of the Schlegel brothers, Schiller, Madame de Staël, Stendhal and others, Italy was drawn into the new current of thought, and in literature at least produced such famous Romantic documents as Giovanni Berchet's *Lettera semiseria di Crisostomo* (1816) – a veritable manifesto of Romanticism, defending artistic liberty of form and subject – and Alessandro Manzoni's *I promessi sposi* (completed in 1823). Here contemporary political and artistic aspirations are reflected by the undercurrent of national struggle in the medieval theme. Italian Romanticism's distinguishing feature was the almost complete subordination of artistic energy to the struggle for national unity. Thus the *risorgimento* itself, as a creative expression of the country's most progressive intellectual and artistic minds, can be considered the major monument of the Italian Romantic movement.

The plastic arts were much slower than literature in responding to the liberating call of Romanticism. This delay may be partly explained by the fact that literature – unlike painting and sculpture – played an important role in the *risorgimento*, and by the temporary absence of a talent capable of giving the plastic arts a new lease of

[1] For example: Gina Martegiani, *Il Romanticismo italiano non esiste* (Firenze, 1908); Francesco Flora, *Dal Romanticismo al futurismo* (Piacenza, 1921); Lamberto Vitali, *Lettere dei macchiaioli* (Torino, 1953), 20–21.

life. At the turn of the eighteenth century Italian art was dominated by foreign artists and the neo–classic style – then at its height – fostered a sterile academicism. Although Italy produced such outstanding craftsmen as Canova, Appiani, Camuccini and L. Sabatelli, whose work on occasion approached the level of masterpieces, on the whole their conceptions were too imitative to be effectively explored by followers. A number of artists – Benvenuti, Bezzuoli and others – adopted the new Romantic subjects (the Napoleonic wars, medieval history), but technically they remained completely conventional.

Naples: School of Posillipo

With the aid of some imported ideas, real innovations were made in the modest genre of landscape painting by the Naples school of Posillipo. The founder of this group was a Dutch painter, Antonio Sminck van Pitloo (1790–1837), who studied in Paris, settled in Naples about 1815, and held the chair of landscape painting at the Academy from 1824 to his death. There he defied the academic curriculum by having his students paint out of doors in the nearby town of Posillipo. Pitloo's fresh little scenes of Naples and the surrounding countryside are filled with air, and their natural compositions and tender sentiment are in marked contrast to the arid constructions of the classically-oriented landscapists. His talented pupil Giacinto Gigante (1806–76) was the outstanding representative of the 'school'. Endowed with a penetrating eye and the soul of a poet, he captured the essence of the local scene in his spontaneous paintings and sketches, whose rich colour makes him heir to the great seventeenth-century Neapolitan tradition.

The Second Half of the Century: The Florentine Macchiaioli

The most systematic and fruitful attempts at a more thorough artistic renewal were made during the second half of the century, especially by a group of Florentine Realists called the *macchiaioli*.[1] The name, derived from the word *macchia* (sketch, spot, forest) was originally used derogatorily in the sense of patches of colour by a critic reviewing their 1862 exhibition.[2] It was immediately adopted by a member of the group, Telemaco Signorini (1835–1901), who became one of their most impassioned spokesmen. About a dozen artists – all born between 1820 and 1838 – belonged to the original *macchiaioli*. Their youthful imaginations had been fired by the insurgent spirit of the 1848 revolutions and some were veterans of the Garibaldine exploits

[1] They were not all born Florentines.

[2] The name was used in 1861 as well. For a summary statement on the origin of the name see Emilio Lavagnino, *L'Arte moderna dai neoclassici ai contemporanei* (Torino, 1956), II, 813 ff.

of 1848 and 1849. All of them had participated to a greater or lesser degree in the Italian independence campaigns of 1859, 1860 and 1866.

Their revolutionary fervour extended to art as well. After having emancipated themselves from academic teaching, they heatedly debated aims and theories at the Caffè Michelangiolo on via Larga where, after 1850, artists from all over Italy congregated, as well as foreign visitors of whom Degas was the most famous. The ensuing exchange of ideas was highly important to the development of Macchiaiolism.

The *macchiaioli* movement lasted roughly from 1855 to 1875, although its most vital period was that of about 1863 to 1870. Many of its artists continued to work along similar lines for the rest of their lives and feeble technical imitations were still in evidence in the early twentieth century. Macchiaiolism began primarily with efforts to recapture solid pictorial construction: 'the *macchia*', wrote Signorini, 'was nothing more than an excessively resolute chiaroscuro method. [It was] the result of the artists' . . . need to free themselves from the chief defect of the old school, which sacrificed the solidity and relief of their bodies to an excessive transparency.'[1] Rembrandt, Velasquez, Tintoretto, and Ribera, as well as photography, were cited by them as sanctions for their experiments. The group's scope was greatly broadened in the early 1860's through direct and indirect contact with contemporary French painting – Corot, Courbet, the Barbizon artists – as well as with the writings of Proudhon, Champfleury, and others, which helped them to sharpen their Realist aesthetic. In Signorini's ardent words of 1863 the *macchiaioli*'s mature goal was a 'modern art . . . [which would be] a page of our times, a reflection of our sentiments and of our customs; . . . only by analysing and studying our century can we obtain a distinct character suitable to the era of *risorgimento*; . . . only by moulding a present for ourselves shall we be worthy of the past which we have.'[2] Nevertheless, artists of the past – the masters of the *trecento* and *quattrocento* – served also as models. Their attitude toward these men was, however, radically opposed to the imitatively religious approach of the Purists (the Italian Nazarenes), with whom a number of the *macchiaioli* had studied. 'In Lippi, in Benozzo, in Carpaccio and in a thousand others,' explained Signorini, 'modern art found that which it intends to conquer for itself today: that is, the sincerity of sentiment and love for the whole of nature with which the art of the *quattrocento* childishly caressed every form.'[3]

In the mid-1860's the *macchiaioli*'s paintings assumed the characteristics generally associated with the movement. They recorded their fleeting perceptions of the

[1] Enrico Somaré, *Signorini* (Milano, 1926), 221.
[2] Ibid., 227.
[3] Quoted in E. Somaré, *Storia dei pittori italiani dell' ottocento* (Milano, 1928), I, 23.

Tuscan landscape and its people in flat areas of predominantly light colours in which all detail is suppressed. Their small canvases or panels are illumined and unified by a crystalline Mediterranean light accentuating the architectural severity and clarity of their compositions. Adriano Cecioni (1836–86), another *macchiaiolo* artist-critic, left a telling account of the technical principles of this mature phase and of the artists' struggle to fulfil them. Writing in 1884 he tried, however, to equate French Impressionism with the Florentine movement, which is unjustified, as can be seen from his statements below. 'All the *macchiaioli* . . . agreed,' he said, 'that their art did not consist of the investigation of form but of a way of rendering the impressions received from reality by using patches of colour [and] light and dark; for instance, a single patch of colour for the face, another for the hair, a third . . . for the neckerchief . . . The figures scarcely ever exceeded the dimension of fifteen centimetres, this being the dimension assumed by the object (*il vero*) when viewed at a certain distance – the distance at which the parts of the scene that gave us the impression are seen as masses and not in details. Hence the figure viewed against a white wall . . . or against a sunlit surface was considered as a dark patch on a light patch . . . It would be impossible to give an idea of the attempts made, especially to render the effects of the sun. We exhausted all the powers of the palette . . . we even turned to artifice, but without success. It was a continuous doing and undoing, testing, trying and trying again, and all this in order to prove the accuracy of one value as compared to another, both with regard to *colour* and *chiaroscuro*.'[1]

Giovanni Fattori (1825–1908) and Silvestro Lega (1826–95)

Fattori and Lega are generally regarded as the two most distinguished *macchiaioli*. They stand out among the relatively few significant Italian artists of the nineteenth century. Fattori painted many canvases of *risorgimento* subjects, which won the public acclaim denied to his landscapes and other scenes. But it is in the less ambitious subjects such as the *Rotonda del Palmieri*[2] of 1866 (Pl. 1), which are geared to 'catching nature unawares' (Cecioni's words), that Fattori's creative powers are especially apparent. In *Rotonda del Palmieri* the artist translates his spontaneous experience into a deliberate composition of small planes of contrasting or modulated colours and values. He reveals his great sensitivity to their structural and expressive potential in the almost dramatic build-up of the various greys, beiges and creams to the glistening blue sky, which is topped by the softer hues of the roof. Fattori vividly suggests the windswept clarity of a summer's day as it is experienced by well-bred ladies from the city.

[1] Adriano Cecioni, *Scritti e ricordi* (Firenze, 1905), 302–3.
[2] *La Rotonda dei bagni Palmieri.*

A similar refinement and urbanity is found in Lega's work. But this painter had a very different temperament and artistic training. Before his attachment to Macchiaiolism about 1860 he had studied with the famous Purist Mussini (1813–88) and had executed church decorations. In 1859, after joining his friends on their trips to the countryside to paint *en plein air*, he discovered 'a new life in art . . . [and soon] began to work as I felt, as I wished and as I could'.[1] Lega now turned to everyday subjects, but his earlier *macchiaioli* scenes, such as the serene *La Visità* (The Visit) of 1868 (Pl. 2), indicate as much if not more concern with the gracious if circumscribed life of the Tuscan middle class than with the technical problem of the *macchia*, or patch. Yet the artist evokes the mood and manners of this segment of society through purely painterly means. A simple design harmonizes the precisely defined and uncomplicated shapes of muted colours with the lovingly detailed landscape which brings the International Style to mind. This cultivated naiveté is made lyrical and mysterious by the silvery grey winter light which envelops the scene. In the seventies Lega's *macchie* become somewhat bolder and more strongly hued like those of his fellow artists, but the delicacy and intimacy of his vision lends his work something of the poetic magic of Vuillard's future paintings.

Macchiaioli Apologists

Like Futurism, Macchiaiolism was a vocal and polemical movement. Two of its members, Signorini and Cecioni, were as adept with their pens as with their brushes and wrote penetrating criticism of the state of the arts in Italy, as well as more technical essays on the movement's theoretical principles. Cecioni was a radical thinker and his writings display an intransigence worthy of Courbet, whom he venerated.[2] His stand against the art of the past is prophetic of the Futurists' attitude. ('The Macchiaioli painter,' he wrote, 'must have neither affections for nor sympathies with the past . . . The divorce between the modern and the old must be absolute, the disregard of history must be complete and absolute.'[3])

The most informed and loyal defender of the *macchiaioli* was the Florentine writer and theorist Diego Martelli (1833–96). In 1867 he founded the short-lived *Gazettino delle arti del disegno*, which became the mouthpiece of the movement and carried frequent contributions by Signorini.[4] Martelli holds the further distinction of having

[1] L. Vitali, *Lettere dei macchiaioli*, Lega to Diego Martelli (2 May 1870), 127.
[2] Ibid., Cecioni to Signorini (24 July 1870), 144–5.
[3] Quoted in Carlo Carrà, *Il Rinnovamento delle arti in Italia* (Milano, 1945), 30.
[4] In 1873 Martelli was one of the founders of the *Giornale artistico*, which also contained much *macchiaioli* polemic and in which many of Cecioni's essays were printed.

been – in 1879 – the first Italian to lecture in public on French Impressionism.[1] He lived for several years in Paris, where he knew Corot, Courbet, Millet, Manet and Daumier, and formed lasting friendships with Degas and Pissarro. Although his efforts to bring together the Impressionists and the *macchiaioli* were for the most part unsuccessful, he did persuade Pissarro to exhibit two pictures at the Florentine Società Promotrice di Belle Arti in 1879.[2]

In general, the *macchiaioli* remained unaffected by the French Impressionists' discoveries. In some ways this is rather surprising, for their development – grounded partly in Courbet's Realism – ran parallel to Manet's and the early work of the Impressionists.[3] Chauvinism may well have been responsible for their inability to continue to benefit from the example of their French colleagues, and the strained diplomatic relations with France at that time put them even more on the defensive. Because of their failure to extend the boundaries of their original vision, the *macchiaioli*'s art did not become more profound, and their followers were incapable of escaping from its ultimately circular path. Nevertheless, directly and indirectly the movement's aims and spirit influenced artists all over Italy. On the other hand, the Italian public remained almost completely oblivious of Macchiaiolism for the rest of the nineteenth century. Even today its achievements and its place in the history of art are not fully understood.

Rome: Giovanni Costa (1826–1903)

What little genuine artistic life existed in Rome during the last quarter of the century was fostered by Giovanni (Nino) Costa as artist, critic and organizing force. He was born and educated in the capital, but his artistic development was guided by English and French landscape painters whom he met at Ariccia in the Roman Campagna, at Anzio and in Rome in the early 1850's.[4] One of his first major works, *Donne che portano la legna a Porto d'Anzio* (Women Carrying Wood at Porto d'Anzio)[5] (Pl. 3), painted about 1852 and based on outdoor studies, is remarkably vigorous and

[1] Published in 1880 and reprinted in Antonio Boschetto, *Scritti d'arte di Diego Martelli* (Firenze, 1952). Martelli's point of view was influenced by Duranty, whose *La Nouvelle peinture* had appeared in 1876.

[2] L. Vitali, *Lettere dei macchiaioli*, 42 note 5, 66 note 7. The two Pissarros are now in the Florence Galleria d'Arte Moderna.

[3] This is not true of Signorini nor of Federico Zandomeneghi (1841–1917) who settled in Paris in 1874 and exhibited with the Impressionists in 1879. Revealing attitudes towards Manet and the Impressionists are found in two 1874 letters, *Lettere dei macchiaioli*, 283, 287.

[4] Olivia Rossetti Agresti, *Giovanni Costa* (London, 1907), 50 ff., and L. Vitali, *Lettere dei macchiaioli*, Costa to Martelli (26 February 1871), 253–6.

[5] *Donne che imbarcano legna ad Anzio.*

advanced for its time and place, though still influenced by Romantic landscape. Apparently, it was shown at the Paris Salon of 1863 and won praise from Troyon and Corot, whose work Costa in turn admired.[1]

After doing his patriotic duty in the campaign of 1859 – he had also been very active in the revolutionary events of 1848–49 – Costa went to Florence, where he was quickly drawn into the *macchiaioli* ferment. As his ideas were more advanced than theirs at the time, he profoundly affected the Florentines' evolution, a fact duly acknowledged by Fattori, Cecioni, Martelli and Signorini.[2] In 1870 he returned to Rome and began to devote himself tirelessly to organization and polemics on behalf of a series of artists' groups, with the hope of counteracting the commercialism and opportunism of tourist-filled Rome and their degrading effects on art. 'The object of our association', read Costa's 1879 manifesto for the new Circolo degli Artisti Italiani, 'is to . . . form and proclaim an artistic standard, to give life, character, dignity to Italian art'. The Scuola Etrusca, established four years later, allowed Costa to translate his aims into a practical teaching programme which, in spite of his stress on colour and nature, revealed his classical tendencies as well as the influence of the Pre-Raphaelites. He recommended to his students that 'A picture should not be painted from nature . . . Sentiment before everything. . . The Etruscan School consists in seeing the direction of the lines and in drawing them with strength'.

In 1885 Costa founded In Arte Libertas, which reached a still broader public with its international exhibitions (preceding the Venice Biennale by ten years). It also attempted to fight the corruption of critics by announcing in its statutes that the society 'will pay nothing to the press for criticisms'. Among those represented in the annual exhibitions of In Arte Libertas were Rossetti, Burne-Jones, Watts, Leighton, Lenbach, Boecklin, Corot, Daubigny and Puvis de Chavannes. The society naturally encouraged Italian artists above all, showing some of the *macchiaioli*, Segantini, and others still struggling for recognition. Their work was even sent to England, where Costa was well connected. In 1900 the association merged with the older and more reactionary Roman Società Promotrice degli Amatori e Cultori di Belle Arti, and subsequently brought a larger, if more academic, cross-section of foreign and Italian art to the attention of the Romans.[3]

Costa's own painting, although quite influential in Italy at the end of the century,

[1] O. R. Agresti, *Giovanni Costa*, 98 ff. Agresti states that Costa showed at the 1862 Salon, but actually he did not exhibit until 1863 when he is listed in the catalogue with two paintings.

[2] See L. Vitali, *Lettere dei macchiaioli*, Fattori to Uzielli (17 February 1904), 93 and note 2; Telemaco Signorini, *Caricaturisti e Caricaturati al Caffè Michelangiolo* (Firenze, 1952; reprint of original 1895 edition), 126; A. Cecioni, *Opere e scritti* (Milano, 1932), 180; O. R. Agresti, *Giovanni Costa*, 86 ff.

[3] O. R. Agresti, *Giovanni Costa*, ch. x, especially 199, 201, 211, 213, 221.

lost some of its freshness and yielded to a more decorative, linear manner indicated even in his earlier work and stressed in his teaching. In this respect it was attuned to the spirit of the swelling current of the international Art Nouveau style, then beginning to gain adherents in Italy.

Milan: The Scapigliatura

When Florentine Macchiaiolism was showing signs of exhaustion in the 1870s, Milan began to take an increasingly lively part in Italian artistic life. It had been active throughout the century and with the insurgent journal *Il Conciliatore* was the cradle of Italian literary Romanticism. In addition, it had the cultural advantage of proximity to France and Germany as well as a comparative lack of weighty artistic tradition.

Earlier in the century a highly original Lombard painter, Giovanni Carnovali, called il Piccio (1804–73) had rejected cold neo-classicism and evolved a shimmering palette and atmospheric style by studying light and colour and the art of Correggio, Titian and Rembrandt. He shared Delacroix's Romantic intensity and preoccupation with technical innovation, but he lacked the French artist's majestic breadth of conception. Il Piccio's vision was intimate, personal and occasionally sentimental. He settled in Milan in 1836 and his work set a liberating precedent for subsequent artistic developments in that city.

In the 1860s a broader search for new aesthetic principles was initiated by several young writers, musicians and artists who, after having called their movement *avvenirismo*, chose the name *la scapigliatura* (dishevelledness, untidiness) from the title of a novel by their colleague Carlo Righetti published in 1862.[1] Although the Milanese group had only a superficial knowledge of Baudelaire's writings, they modelled themselves and their ideas on his *poète maudit*. The recent description of the literary *scapigliati* as 'vacillating rebels . . . revolting against tradition in their bohemian ways and habits more than in their poetry, which is a . . . mixture of residues of the past and aspirations to novelty'[2] could generally be extended to the artist members. In contrast to the *macchiaioli* whose programme was primarily formal and who were thorough Realists, the *scapigliati* artists were Romantic idealists at heart and closely bound to their literary milieu. As the century progressed they became increasingly eager to put the notion of the interchangeability of the arts (Baudelaire's *correspondances*) into practice. Even the two most gifted painters, Tranquillo Cremona (1837–78) and Daniele Ranzoni (1843–89) were not always able to overcome the limitations of their environment. But in their search for greater spiritual expressiveness

[1] Severino Pagani, *La Pittura lombarda della scapigliatura* (Milano, 1955), 73–74.
[2] Olga Ragusa, *Mallarmé in Italy; Literary Influence and Critical Response* (New York, 1957), 101.

they developed an airy, loosely brushed, quasi-Impressionist manner of painting in which the 'vibrations' of the atmosphere were subtly attuned to the subject's mood (Pls. 4, 5). Cremona and Ranzoni undoubtedly derived their vaporous technique from the example of il Piccio as well as from the Piedmontese Antonio Fontanesi (1818–82) who was much inspired by Corot.[1]

The *scapigliatura* spirit made itself felt in Milan until the end of the century, although its literary contingent – at its height around 1870 – had by then long passed its prime.[2] The plastic arts, which had come into their own more slowly, received a second impetus in the later eighties with the introduction of new ideas from France and Holland leading to the formation of the group known as the Divisionists. In the last decade their disciplined technique gradually replaced the vague and dreamy manner of the *scapigliatura* painters.[3]

The Italian Divisionists: The Grubicy Brothers

The credit for introducing and sustaining Divisionism in Milan (and by extension Italy) goes to two brothers – Vittore and Alberto Grubicy de Dragon. Alberto was a successful business man who, following his brother's initiative, became interested in and later ran the art gallery started by Vittore which specialized in the work of the Italian Divisionists and other Lombard artists. Vittore (1851–1920) was the apostle and propagandizer of Divisionism and an artist. He only began to paint at the age of thirty-three while visiting his friend, the artist Anton Mauve, in Holland.[4] The exact circumstances of his introduction to Divisionism are not known, but as he was extremely well read and widely travelled (he visited France almost annually during the seventies and eighties), the paintings and theories of the Impressionists and Neo-Impressionists were undoubtedly familiar to him. Apparently he was much influenced by Rood's

[1] Although Cremona and Ranzoni were friends and influenced each other, their temperaments and lives were very different. Cremona – sensual, ardent, and facile – achieved considerable renown during his life, while Ranzoni, a more penetrating artist, appreciated by only a few, died insane.

[2] Scholarly opinion differs somewhat on the dates for the *scapigliatura*. Although the 1860's are usually cited as the best period of the literary wing, Severino Pagani, op. cit., 70, suggests with some justice that the *scapigliatura* spirit prevailed in all the arts of Lombardy during the last forty years of the century.

[3] The Milanese Famiglia Artistica, founded in 1873 by the painter Vespasiano Bignami (1841–1929), was of great importance in the activities of the *scapigliati*. It constituted a meeting place for the group comparable to the Florentine *macchiaioli's* Caffè Michelangiolo, sponsoring exhibitions, lectures and briefly, an art school. The association is still active at present.

[4] See letter from Grubicy quoted in S. Pagani, *La Pittura lombarda della scapigliatura*, 372–5, recalling his beginnings as an artist.

treatise on colour.[1] After 1886 he actively promoted the cause of Divisionism in Italy and published articles on it in *Cronaca d'arte*, *La Riforma* and other journals; he also helped to present Italian Divisionist art to both national and foreign audiences.

Italian Divisionism incorporated a heterogeneous assortment of ideas, most of which were generally current in Europe in the last two decades of the century. Technically it emphasized the Neo-Impressionists' preference for 'pure' colour and optical blending. This method, inspired by science, was combined with some of the mysticism of German *Naturlyrismus* and the Pre-Raphaelites, the literary and synaesthetic tendencies of the *scapigliati* and the symbolism of Art Nouveau. Grubicy's own work is a good example of this mixture. His peaceful landscapes, painted in an orthodox, delicately hued 'pointillism', seem permeated by an almost supernatural light. He worshipped light, regarding it as a 'sublime subject, the aspiration of man and of all of nature'. So anxious was he to appeal to the spirit, and not to the eyes alone, that he conceived of his pictures as 'pantheist poems' which would be comparable to 'unseen music'.[2]

Giovanni Segantini (1858–99)

The most talented of the Grubicys' artist protégés was Giovanni Segantini, whom Vittore 'discovered' through a painting of a church interior – *The Choir of Sant' Antonio* – which was exhibited in 1879.[3] In it V. Grubicy perceived an intuitive ability to depict light effects by means of juxtaposed colour, and through the following decade he guided Segantini's development by suggestion and example. He urged him to study nature, to lighten his colours, and supplied him with reproductions and originals of Millet, Mauve and others. Between 1882 and 1886 Segantini went through a Millet phase, drawing the peasants of the Brianza where he lived at the

[1] Nino Barbantini, *Gaetano Previati* (Roma-Milano, 1939), 63. Grubicy seemed unwilling to grant any connection between French and Italian Divisionism. In his preface to the 1896 Milan Triennale exhibition he claimed that the Italian movement developed independently and termed Ranzoni a proto-pointillist. During the nineteenth century a number of treatises on colour were published in Italy, in which some of the premises of Divisionism were touched upon. It is doubtful, however, that Italian Divisionism would have developed on its own without the French precedent. For earlier Italian colour theories see Gaetano Previati, *I Principii scientifici del divisionismo* (2ª edizione, Torino, 1929), 119–22.

[2] See for example his *Inverno in montagna, poema panteista in 8 quadri* of 1894–1911. (Information from a set of photographs with the artist's handwritten annotations at the Frick Art Reference Library, New York.)

[3] L. Villari, *Giovanni Segantini* (London, 1909), 25. The painting is presently in the collection of Paolo Stramezzi, S. Bartolomeo, Crema; illustrated in Luciano Budigna, *Giovanni Segantini* (Milano, 1962), Pl. XII.

time. In 1886 he moved to Savognino, a little village high in the Grisons alps. There he realized that his previous methods of rendering light and colour were inadequate for the lucid atmosphere at this high altitude, which greatly intensified and transformed natural appearances. As a result, Segantini began to experiment more fully with the Divisionist technique and evolved the personal method which he later described: 'As soon as I have decided upon the lines which correspond to my intention, I proceed to lay on the colours . . . and I begin to cover the canvas with narrow, precise and rich [ly coloured] strokes leaving always a space between one stroke and the next. This interstice I fill with complementary colours. . . The purer are the colours which we put on the canvas, the more easily shall we be able to lead our painting to the light, the air and the truth.'[1] Segantini's long, parallel brush strokes of thick and sparkling pigment give his paintings of the late eighties and nineties a startling freshness of colour and textural solidity very similar to the mature work of Van Gogh, with whom he has much in common.[2] Segantini lacked Van Gogh's background and was much more isolated from the stimulus of the Parisian art world (in spite of Grubicy's efforts), but their sensibilities were similar, although expressed within different frames of reference. Both adapted certain elements of Impressionism to their subjective visions; both achieved solidly constructed compositions by emphasizing pattern and flat surfaces; lastly, and most significantly, both were able to convey visually their deep pantheistic reverence for nature. Segantini's meadows and cows, and above all his skies and silent, majestic mountains (Pl. 6), communicate a transcendental poetry, much as Van Gogh's sunflowers and cypresses are omniscient witnesses of eternal mysteries. Segantini once remarked: 'Others have painted the Alps as a background, but I paint them for their own sake.'[3]

Radical Italian artists in the nineteenth century customarily wrote on art and kindred subjects, and Segantini conformed, although he acquired most of his limited education in adult years. His opinions reflect the issues with which the Italian vanguard was concerned during the nineties, issues which were mostly still centred on the problem of tradition. He declared that the artist's education should not be pursued in the academies, but 'in the fields, in the streets, in the theatres and the cafés'. He shared the socialists' hopes for a radiant, new world and gave the artist a leading role

[1] Undated letter of the mid-90's reprinted in Budigna, *Giovanni Segantini*, 102. The similarity of his technique to that recommended by Ruskin in his *Elements of Drawing* was already noted by L. Villari, *Giovanni Segantini*, 74–75. It is quite possible that either Grubicy or Segantini, or both, knew Ruskin's text in the original or through Rood's reference or through H. E. Cross' recent translation.

[2] Segantini probably did not know of Van Gogh.

[3] L. Villari, *Segantini*, 94.

in its creation. 'The old ideals have fallen or are about to fall,' he wrote in 1894, 'new ideas have emerged or are about to emerge. Hence the looking backward [and] the contemplation of outmoded ideals are no longer justified. The thought of the artist must no longer turn to the past, but must forge forward towards the future which he preconceives.'[1]

Gaetano Previati (1852–1920)

Previati was also brought to the Divisionist camp by Vittore Grubicy about 1888, and Alberto saved him from starving ten years later.[2] Of those in the Grubicys' circle, he unquestionably had the most thorough intellectual grasp of the physical and physiological phenomena of Divisionism, which he considered not just a new method of painting, but the one 'most suitable to express the thoughts and sentiments of modern men'.[3] He maintained that a knowledge of its underlying elementary scientific principles was as imperative to every modern artist as the scientific study of anatomy and perspective.[4] Rather like Alberti, Previati saw himself entering a new artistic epoch, and like his illustrious predecessor he felt called upon to write a learned treatise on painting as a guide for future artists. The first two volumes – *La Tecnica della pittura* and *I Principii scientifici del divisionismo* – appeared in 1905 and 1906. The third – *Della Pittura; tecnica e arte* – was not published until 1913.[5] Volume one is an artist's handbook with the same intentions as Cennino Cennini's. It grew out of Previati's concern over the decline of painting during the nineteenth century and the artists' ignorance of the sheer mechanics of their craft. The second volume, as its title suggests, is devoted to a review of the scientific explanation of light and colour perception. The final volume was apparently intended as a reply to attacks on Divisionism – an effort which still seemed necessary to Previati as late as 1913.[6]

To anyone familiar with the rational and scientific tone of his writings, Previati's

[1] 'Cosí penso e sento la pittura', reprinted in *Catalogo delle esposizioni riunite* (Milano, 1894). This quotation was proudly cited in A. Soffici's polemical *Il Caso Medardo Rosso* (Firenze, 1909), 54.

[2] A. Grubicy had contracts with both Segantini and Previati which assured them of a livelihood. Segantini, who was quite renowned in Germany, Austria and Switzerland at the end of his life, needed this support less than Previati.

[3] Reported by Carlo Dalmazzo Carrà, *La Mia vita* (Milano, 1945), 81.

[4] Gaetano Previati, *I Principii scientifici del divisionismo*, 238–9; see also the preface to his *La Tecnica della pittura* (3ª edizione, Torino, 1930).

[5] At the end of the nineteenth century Previati translated J. G. Vibert's *La Science de la peinture* (Milano, n.d.) into Italian. He later regarded this artist 'troppo soggettivo nell'apprezzamento delle tendenze dell'arte moderna, troppo preoccupato della diffusione di determinati ingredienti pittorici'. *La Tecnica della pittura*, 18.

[6] He was then a sick and defeated old man who felt the need to justify his life's work more sharply.

impassioned, mystical paintings come as something of a surprise. Actually, they are quite characteristic of the heterogenous framework of Italian Divisionism. Previati was a very original colourist and an excellent painter whose work reveals his great artistic integrity. His technique resembled that of Segantini, but Previati thought primarily in terms of expressive design in keeping with the anti-realistic spirit of the turn of the century (Pls. 7, 8).[1] His deformations, evocative illumination and colour deeply affected the young Milanese Futurists and provoked Boccioni to acclaim 'Previati the greatest artist which Italy has had from Tiepolo until today . . . the only great Italian artist of this period who has thought of art as representation in which visual reality serves merely as a point of departure.'[2]

During their lifetimes Previati and Segantini received scarcely any recognition in their own country apart from that accorded them by the Grubicy circle, Costa in Rome and a few others.[3] Denunciation of Italy's indifference to these two men became one of the battle cries of the Futurists, who added one more neglected artist to the list – the sculptor Medardo Rosso.

Sculpture: Medardo Rosso (1858–1928)

The history of sculpture in nineteenth-century Italy was less eventful than that of painting, though it followed roughly the same course. Only at the beginning and at the end of the century did men of international reputation arise – the Neo-classicist Antonio Canova and the 'Impressionist' Medardo Rosso. In the interim one finds reflections of the various painting movements. Romantic rebellion against the Academy and inclination to naturalism were exemplified by Lorenzo Bartolini (1777–1850). In 1839 he shocked his colleagues at the Florentine Academy by bringing a hunchback to his class as a model and by maintaining vehemently that 'all nature is beautiful'. In practice his reform turned out to be much less startling. Essentially he only substituted the naturalistic classicism of the *quattrocento* for the more archaeological classicism of Canova and his followers, and even this slight innovation deteriorated into a sterile academicism in the hands of his students. Nor did the initially vigorous *macchiaioli* produce any radical changes in sculptural tradition. Adriano Cecioni was a sculptor as well as a painter, but he was at his boldest defending his fellow *macchiaioli* with a pen in hand. His sculptures, especially the more ambitious

[1] In some of his late works influenced by Symbolism, Segantini worked along similar lines.

[2] Umberto Boccioni, *Opera completa* (Foligno, 1927), 276.

[3] The Divisionists attracted a number of followers in the years around the turn of the century. Among the most important were Giuseppe Pellizza (1868–1907) and Angelo Morbelli (1853–1919) who combined this technique with socialist subject matter.

large pieces, have little of the spontaneity and unconventionality implicit in Macchi-aiolism. But his smaller work, such as his perceptive portrait of his friend, the poet Giosuè Carducci, or the lively *Bambino col gallo* (Child with Cock) of 1868 (Pl. 9), reveals a freshness of approach and execution. In Northern Italy the influential Ticinese sculptor Vincenzo Vela (1822–91) evolved toward the end of his life a humanitarian realism combined with slight technical experimentation which suggests limited awareness of the painterly style of the *scapigliatura* artists and possibly of Rodin's freer surface modelling.[1] Giuseppe Grandi (1843–94), the only sculptor member of the original *scapigliatura*, carried this approach to sculpture much further in his bozzetto-like statuettes (Pl. 10) and even in his large, official monuments in Milan. A contemporary critic described one of these as having been 'chiselled with a brush, in fact, with the brush of Tiepolo'.[2]

It was Medardo Rosso who truly understood and explored the sculptural possi-bilities of Impressionism. Born in Turin, he was taken as a child to Milan where he grew up in the *scapigliatura* milieu, drawing inspiration from the example of Cremona, Ranzoni and of course Grandi. From the beginning, however, he strengthened their artistic conceptions with forcefully objective observation. Even in his first youthful pieces the purely sculptural content derived from acute experience dominated over the sentimental and literary one. *Bacio sotto il lampione* (Kiss under the Lamp-post)[3] of 1882 (Pl. 11) is a good example. With remarkable economy Rosso conveys the impulsiveness of the action and the psychological differences between the two lovers. The uncanny spatial relationships of the two leaning figures to each other and to the straight lamp-post and the sporadic play of light on the broken surfaces are the principal means which evoke the mood of this fleeting nocturnal encounter. This 'environment', to use the studio language of the 1960s, was originally even more firmly controlled and unified by the inclusion of a miniature light.[4] *Bacio sotto il lampione* was an early reply to Baudelaire's indictment of sculpture as being at the mercy of fortuitous external conditions (illumination, spectator's movements, etc.), which apparently very much affected Rosso's development as a sculptor. The

[1] See *Vittime del lavoro, c.* 1882, at the Galleria d'Arte Moderna in Rome, which was inspired by an accident at the St Gotthard tunnel and related to Meunier's sculptural depictions of human toil.

[2] Quoted in Margaret Scolari Barr, *Medardo Rosso* (New York, 1963), 11.

[3] Ibid, 67, note 15. See Barr, *passim*, for discussion of Rosso's knowledge of Impressionism.

[4] Rosso used a 'real' object in another contemporary piece, *Il Scaccino* (The Sacristan) (Barr, *Medardo Rosso*, 22), who leans over a miniature holy water basin. The sculptor undoubtedly introduced these objects to create atmosphere and perhaps to point up the difference between the artist's and ordinary vision. The Futurists' (and Synthetic Cubism's) introduction of 'non-artistic' elements such as hair, glass, railings, etc., is a development of Rosso's idea. (See Pl. 141 and Chapter XIII.)

succeeding relief-like ensembles are still bolder responses to Baudelaire and, more significantly, to the Impressionist conception of the visual interdependence of objects and their resultant loss of representational tangibility. The destroyed *Impressione d'omnibus* (Impression in an Omnibus) (Pl. 12), executed in 1883–4[1] even before his first visit to Paris, dealt quite fully with the sculptural problems raised by the Impressionist aesthetic. Obviously related to Daumier's many studies of railway or bus passengers, it differs from them and his own earlier work in that its anecdotal connotations are only incidental. The subject actually is the anonymity, diversity and momentary visual unity of five chance neighbours on a bus bench and the spontaneous impression received by the artist who faced them. Their craggy mass outlined against the light calls for a frontal vantage point for the spectator. His interest is held above all by the rich surface activity which creates complex tensions between the sculptural volumes that also describe human forms.[2]

To reduce the effect of the tactile identity of objects still further Rosso began to experiment at about this time with the unusual medium of wax over plaster, which he seems to have discovered quite accidentally.[3] The masterful *Conversazione in giardino* (Conversation in the Garden) (Pl. 13)[4] of 1893 shows how the transparency and special kind of luminosity of this medium enhance the suggestion of material insubstantiality. At the same time the fluidity of its waxy gloss strengthens the abstract homogeneity of the total mass which wittily emerges now in the attentive and monumental form of a man – a self portrait – now as succinctly characterized women, a hedge or a bench. The depiction of the organic oneness of man and his ambience, which had become Rosso's central artistic principle, was even more dramatically illustrated in *Uomo che legge il giornale* (Man Reading Newspaper)[5] of 1894 (Pl. 14). Again a profile view, but of a single walking figure, Rosso now showed it as if seen from high above, hence leaning away from the viewer. This leisurely reader is rooted in and pursued by the aura of shadow and street which especially at first sight is representationally indistinguishable from the human form.[6]

Rosso also modelled a number of individual heads and portraits. In these he strove to depict the relationship of man to his surroundings solely from the facial reflection

[1] M. S. Barr, *Medardo Rosso*, 25 and 67, note 37.

[2] The surviving photographs are very poor and raise questions about the shape of the leftmost passenger. See Barr, *Medardo Rosso*, 25.

[3] M. S. Barr, *Medardo Rosso*, 20–21.

[4] Ibid., 71, notes 96, 97.

[5] Ibid., 73, note 108.

[6] The suggestion of unity between object and cast shadow was inspired by an actual experience during his student days in Milan. See Barr, *Medardo Rosso*, 43.

of transitory emotional states. The flexible, expressive features of Yvette Guilbert (Pl. 15) inspired one of his best portrayals of this kind and perhaps one of the best portraits of her altogether. Rosso shows the magnetic singer deeply absorbed in her art and straining forward to communicate with her audience, to whose pulse she seems extremely sensitive. This give and take and the split-second changes of indefinable moods resulting from it the artist conveys strikingly. He contrasts the subtly blurred modelling (with its elusive *sgrafito*-like marks) to the simple bulk of the head which the tense neck supports architectonically.

To the present-day critic it may seem that Rosso was unable to exploit fully the great originality of his approach, and in spite of climactic achievements, his *oeuvre* gives the impression of having fallen short of his intentions. No doubt the frustrations of his lonely, unappreciated struggle were partly responsible.[1] Yet this lack of fulfilment may have its source in his more general historical and artistic circumstances. Rosso came to Impressionism at a time when it had nearly exhausted its vitality. By translating it into another medium and broadening its principles with ideas current at the end of the century, he was able to give form to his fresh insights. Nevertheless, he was handicapped by a nineteenth-century point of view and vocabulary. It was not until the twentieth century that the great potential of his artistic ideas was realized. The unencumbered Futurists liberated Rosso's conceptions from this baggage of the past and worked out their own solutions to Rosso's fervent wish to 'transmit . . . the emotion and the unification of light, space and air'.[2]

The Artistic Situation in Italy at the Turn of the Century

Although there were various brave efforts to strike out in new directions during the latter half of the nineteenth century, they did not gather sufficient momentum to bring about an effective and widespread renewal of the arts. This failure was not due to lack of talent or vision but to the prevailing apathy of Italian taste which kept the general public in ignorance of the aims and achievements of the best creative minds. At the turn of the century the pompous sculptures of Leonardo Bistolfi (1859–1932), the D'Annunzian rhetoric of Aristide Sartorio's (1860–1932) *machines*, the technical extravaganzas of Antonio Mancini (1852–1930) and the virtuoso but superficial portraiture of the erstwhile *macchiaiolo* Giovanni Boldini (1845–1932) enjoyed public esteem. But the vanguard of Italian artists was forced to endure extreme privation and

[1] Rosso virtually stopped working after 1897, completing his last piece in 1906–7. This slackening off used to be blamed on an accident in Vienna in 1904, but Mrs Barr believes that that was not the reason. See *Medardo Rosso*, 53–59.

[2] Quoted in C. Carrà, *La Mia vita*, 287. For additional discussion of Rosso see pp. 56–57.

humiliation or to leave Italy and seek a livelihood elsewhere. To all outward appearances the arts in Italy seemed no better off than fifty or a hundred years before.

However, the tide had begun to turn. The Venice Biennale, founded in 1895, put an official end to Italy's isolation from the mainstreams of European art. There the public as well as the artists could discover, among much that was meretricious, samples of the work of a few leaders of modern European art.[1] In addition, there was the growing influence of such widely read foreign journals as *The Studio*, the *Jugend*, *Simplicissimus* and *Pan*, which disseminated the Art Nouveau style and informed their readers of issues under discussion in the international forum of art. With the 1902 Turin Exhibition of Modern Decorative Art, Art Nouveau was displayed in all its glory and set down roots in Italian soil as the *stile liberty* or *stile floreale*. At the same time the spirit behind this international movement – the search for a new language of formal expression – was generally accepted, for good and ill; for ill in that Italy produced only a few truly first-rate artists in this idiom and, instead, used it to justify many public and private monstrosities; for good in that these very excesses incited vociferous reaction which cleared the air and raised some very important issues.

Towards the end of the 1890s two new Italian cultural journals appeared – *Emporium* in Turin and *Marzocco* in Florence. Both aimed at acquainting the educated public with new trends in the arts. Vittorio Pica (1864–1930), the industrious, self-effacing editor of *Emporium*, emphasized the plastic arts more than the Orvieto brothers did in *Marzocco*, which concentrated mainly on literature. In the pages of *Emporium*, Pica conducted a systematic campaign to introduce the French Impressionists, Post-Impressionists and Symbolists to Italy, as well as to call living Italian artists and writers to the attention of his readers.[2] Pica is also remembered as the author of several of the luxurious official commemorative volumes of the Venice Biennale, of the Turin Exhibition of 1902, and of the Roman World's Fair of 1911, among others. Into these bewildering pictorial surveys, which found their way into the homes of the culturally ambitious middle classes, he timidly and tactfully inserted suggestions as to what was vital and representative of recent artistic revolutions, although generally remaining faithful to the *fin de siècle* aesthetic conventions.

[1] Artists like Zandomeneghi, accustomed to neglect, viewed the Biennale with some misgivings. He predicted that the outcome of the Biennale would be 'that the famous artists would remain famous and those who are not . . . will try everything to become famous . . . ap[ing] the famous ones of the world'. L. Vitali, *Lettere dei macchiaioli*, Zandomeneghi to Martelli (7 August 1895), 308.

[2] A group of these articles were subsequently reprinted in his *Gli Impressionisti francesi* (Bergamo, 1908). Pica is also remembered for having introduced Mallarmé to the Italian public during the 1880s.

Finally, the increasingly frequent journeys to France and other European countries made by Italian artists, writers and intellectuals had a significant long-range effect. Their sympathetic observation, occasional assistance at the birth of artistic and literary movements, and personal friendship with the leaders, helped more than is generally realized to prepare the way for an effective modern movement in Italy.

II

NEW DIRECTIONS: THE FLORENTINE MOVEMENT

THE genteel tone of *Emporium* and *Marzocco*, which attempted to calm rather than to arouse indignation, did not satisfy the impatient younger generation. In the opinion of these angry young men Italy's somnolent cultural life needed a violent jolt to set it on the right course. A casual changeover to a new ethic or aesthetic would not do. Total rejuvenation was needed. Numerous reformative efforts grew out of this state of ferment: in some respects Futurism marked their culmination. But the influential Florentine movement, as it is sometimes called, was its most immediate and vital precursor. Its development from about 1903 onwards reflected the rapid shift of cultural interests in those formative years.

After the short-lived flurry of cultural and political activity which had accompanied Florence's glory as capital of the Italian Kingdom from 1864 to 1870, it had reverted to a quiet, day-dreaming city – an ivory tower standing proudly aloof from the events of the modern world. Cultural life was stultified by the learned institutes and academies; these served as shrines for the large foreign population which, like the Florentine citizenry, had taken refuge in the city's noble past. Small wonder that many intelligent young Florentines felt intensely isolated and began to voice their discontent in several more or less ephemeral publications.

Leonardo and its successor *La Voce* were the most important of these. Both were sponsored by Giuseppe Prezzolini (b. 1882) and Giovanni Papini (1881–1956), who had barely come of age when they brought out the first issue of *Leonardo* in January 1903. Like Croce in his almost contemporary *La Critica*, they dedicated their journal to the reassertion of idealist philosophy in an attempt to break the hold of positivism and materialism on Italian arts and letters. Here the similarity to Croce's journal ends. Where *La Critica* was staid, historical and professorial in tone, *Leonardo* was mercurial and polemical, though no less scholarly. Through its existence of nearly four years, *Leonardo* faithfully devoted itself to the cultivation of freedom and the creative spirit proclaimed in its first issue: 'A group of young men . . . joined together in Florence . . . in LIFE are pagans and individualists . . . In THOUGHT are personalists and idealists.'[1] Nevertheless, *Leonardo* underwent several ideological metamorphoses which reveal the intellectual growth of its editors, who were eager to explore new

[1] *Leonardo*, I no. I (4 Gennaio 1903), I.

worlds of thought and action. Its first, brief phase, directly derived from *Marzocco*, was replete with mysticism and D'Annunzian aestheticism. With its second series, beginning in November 1903, *Leonardo* became Italy's authoritative pragmatist organ, in which the editors and other distinguished contributors – among them F. C. S. Schiller, Vailati and Calderoni – argued with precision and originality. This phase ended in disillusionment for Papini and Prezzolini, who finally devoted more and more space to examinations of various forms of mysticism as a demonstration of their intellectual detachment.

Art and Nationalism

Artistically the *Leonardo* group was less venturesome. After the end of its first series in May 1903, *Leonardo* became a journal of ideas, only occasionally carrying discussions of art and literature. The artist-collaborators of the first series were headed by Adolfo De Carolis (1874–1928) and Giovanni Costetti (1878–1949), both of whom made reputations as illustrators of D'Annunzio. They belonged at that time to the Italian fringe of the late Pre-Raphaelite style, which had been rejuvenated by the advent of *stile liberty*. Their elaborate illustrations and decorations fill the first ten issues of *Leonardo*, which was printed on fine hand-rolled paper in keeping with its original aesthetic tendencies. Costetti's acceptance of *stile liberty* as an advanced trend[1] and De Carolis' attack on it were typical of the *Leonardo* group's general artistic ambivalence. De Carolis described the sinuous Art Nouveau line as 'the product of a mad manner and bad German taste . . . [and demanded that Italians] must be steadfast in supporting the law of beauty against the barbarians'.[2] He recommended a re-examination of Mediterranean sources of art.

The insidious traditionalism and parochialism inherent in De Carolis' point of view had already checked Florence's artistic development in the nineteenth century, and was now reappearing with the growing nationalist sentiment. Modern Italian nationalism was influenced by the ideas of Barrès and Maurras, and soon found its own spokesman in Enrico Corradini, who began to publish *Il Regno* in Florence in November 1903. At first both Papini and Prezzolini sympathized with the undertaking and the former was *Il Regno*'s editor in chief for a time. Both contributed to it important articles in which they attempted to outline and refine the nationalist ideology.[3] But neither ever succumbed to the narrow-minded, backward-looking idealism which characterized the nationalist movement, especially after 1910.[4]

[1] Perseo (Giovanni Costetti), 'Delle esalatazioni', *Leonardo*, 1 no. 5 (22 Febbraio 1903), 7.
[2] Adolfo De Carolis, 'L'Arte nova', *Leonardo*, 1 no. 1 (4 Gennaio 1903), 6.
[3] They later reprinted many of their articles in *Vecchio e nuovo nazionalismo* (Milano, 1914).
[4] See their facetious note in *Leonardo*, II (Marzo, 1904), 32.

The remaining series of *Leonardo* dispensed with the criticism of both De Carolis and Costetti, although occasionally featuring their illustrations. Both artists were welcomed in the pages of *Hermes*, which was founded in 1904 by G. A. Borgese in opposition to *Leonardo*. Under the banner of *Hermes* Borgese had united a group of aesthetes who professed to be 'D'Annunzio's successors and overcomers (*superatori*)'. They set themselves the difficult task of combining their nascent patriotism with a reverence for tradition and a belief in art for art's sake. Their artistic creed was clearly stated in the *Prefazione* of *Hermes*: 'We are not aesthetes if aesthetes are those who can contemplate and judge life solely in accordance with sensible beauty . . .; if aesthetes are instead those who in considering a work of art separate it from its content and its morality – which is very difficult indeed – then we endeavour to be such.'[1] Croce was evidently their guide; in fact the same issue of *Hermes* extolled his *Estetica* as 'the most complete and rigorous theory that we know on the expressiveness of form and on the intuitive character of art'.[2]

Croce's name was anathema at that time to the *Leonardo* group, especially to Papini.[3] But he too sought to formulate an aesthetic and in 1904 wrote an article on the Belgian painter Charles Doudelet (1861–?), a friend and illustrator of Maeterlinck, who had settled in Florence. Papini's interpretation of Doudelet's work strangely foreshadows the spirit of *pittura metafisica* or of Surrealism. Art is seen as a materialization of dreams, 'a more than real reality . . . a super-reality . . . [Doudelet removes] all that which is accessory, transitory, contingent and particular; and intensifies to exaggeration that which is profound and substantial. This is not offered by photography nor caricature of reality, but . . . by the metaphysics of reality.'[4] Papini's ideas were based upon Symbolist literature and related critical and philosophical studies; but the Leonardists apparently were discovering Symbolist painting at the same time. An article on Gauguin – which for some reason was not published – was announced in the same issue.[5] It would have been the first one on this artist in Italy.

Ardengo Soffici (1879–1964) made his appearance among the new collaborators of *Leonardo* in 1907. This young Florentine, whose interests and talents were almost

[1] *Hermes*, I (Gennaio, 1904), 2. See also Aurelia Bobbio, *Le riviste fiorentine del principio del secolo (1903–1916)* (Firenze, 1936), 120 ff.

[2] *Hermes*, I (Gennaio, 1904), 60.

[3] Papini remained a serious opponent of Croce throughout his life. This was not the result of personal incompatibility, but rather an indication of Papini's philosophical honesty and humility which made it impossible for him to accept uncritically the premises for Croce's idealism.

[4] Gian Falco (Papini), 'Un donatore di sogni', *Leonardo*, II (Giugno 1904), 25. Doudelet contributed illustrations and a cover design to the magazine.

[5] Seven years later, *La Voce*, III no. 8 (23 Febbraio 1911), 116 ff., published an essay on Gauguin by the same author.

equally divided between painting and literature, had grown up with several of the Leonardists, but in 1900 had left for Paris, where he remained with only a few interruptions until 1907. He was responsible for making *Leonardo* known to the Parisian literary and artistic vanguard with whom he began to associate soon after his arrival, and in 1908 he began to introduce recent French developments to Italy. However, his sole *Leonardo* essay, 'Pittori e scultori sacri',[1] was nothing but a re-arrangement of the ideas current among the various Florentine groups in the preceding decade. He postulated a kind of religion of art, with the artist as high priest and seer, a vision to which Soffici remained faithful throughout his life, and one which was shared by Marinetti.

The End of Leonardo

In August 1907 Papini and Prezzolini decided to discontinue *Leonardo*. Their intellectual odyssey had left them in a state of spiritual and physical exhaustion and they felt the need to 'reconsider the problems of Italian culture . . . to re-examine all our opinions, . . . in short to begin another round of our intellectual life'.[2]

Although the *Leonardo* experience had not provided its editors with the answers which they sought so avidly, the roads which they had travelled had opened up new or forgotten vistas to them – and what is more important – to the Italian public. William James, one of their first English-speaking supporters, spoke admiringly of the Leonardists and held them up as examples worthy of emulation.[3] These self-styled 'villains of philosophy' and 'intellectual boors'[4] had disrupted the smooth and stagnant surface of Italian culture and called attention to important issues that had to be faced immediately.

La Voce

After a fifteen-month pause, during which Papini and Prezzolini travelled independently and followed their individual intellectual inclinations, they joined forces once again in a new publishing venture – *La Voce*. In the meantime, both had flirted briefly with the Modernists[5] and Prezzolini had moved toward Croce's idealist camp.

[1] Stefan Cloud (Soffici), *Leonardo*, v (Aprile–Giugno 1907), 183–200. Soffici contributed illustrations to the magazine.

[2] 'La fine', *Leonardo*, v (Agosto 1907), 262–3.

[3] William James, 'Giovanni Papini and the Pragmatist Movement in Italy', *The Journal of Philosophy*, III (1906), 338.

[4] *Leonardo*, II (Marzo 1904), 32.

[5] The Modernist movement, led by Don Romolo Murri and undoubtedly following French and English precedents, attempted to modernize Catholicism. Its aim was the establishment of a Christian democracy which, in keeping with the spirit of the times, would stress the social justice of the here and now.

Prezzolini now held the editorial reins.[1] The first issue of *La Voce* appeared on 20 December 1908, and from the start it was obviously quite a different undertaking from *Leonardo*. Its tone was even more urgent and the journal's programme was, in a sense, a practical response to the ultimatum Prezzolini and Papini had delivered in their book, *La Coltura italiana*, two years before. In it the alternatives had been starkly and melodramatically phrased: 'It is an *aut-aut* which the soul of the nation must decide upon; a *to be or not to be*, an *Entweder-Oder*, an *ainigma* in the words of Hamlet, Kirkegaard, the Sphinxes. Either gather the courage to create the third great Italy – not the Italy of the popes nor of the emperors, but the Italy of the thinkers, the Italy which has not existed so far – or only leave behind a wake of mediocrity which will instantly vanish in a gust of wind.'[2]

In the first number of *La Voce* Papini resolved this choice into a workable course that Italy could follow without losing any self respect. This qualification was especially precious to many of the Voceans. Papini declared that it was now 'Not only a matter of bringing Italy back into contact with European culture but also of restoring the historical awareness of its own culture which is part of European culture as well. I content myself with little: Nationalists no, but Italians yes.'[3]

La Voce's scope was thus more explicitly Italian, with emphasis chiefly on ethical and practical matters. Its forceful and frequently hard-hitting tone was directed to the widest possible Italian audience. Prezzolini was anxious to avoid the shortcomings of *Leonardo* and the many other crusading publications which, because of their narrow range, had appealed to only a limited number of people, or had defeated their often noble purposes with the idiosyncrasies and unbending individualism of their staffs. With unfailing zeal and intelligence Prezzolini assembled an amazingly varied roster of contributors who treated political, social, religious and artistic questions competently and from widely differing standpoints. Most notable among these was Croce, whom Prezzolini admired profoundly by now and dubbed 'the poet of philosophy . . . a model of discipline, order, moral seriousness [who has] convictions

[1] Papini's spirit had dominated in *Leonardo*. *La Voce*, on the other hand, was the realization of a vision described in Prezzolini's *Leonardo* article of August 1906 (200 ff.). He tells of a young man who is possessed by a mysterious voice which enjoins him to embark upon a mission of moral purification and elevation of himself and others. The small woodcut by Prezzolini in *Leonardo*, III (Febbraio, 1905), 7, seems also to have some connection with *La Voce*. It shows a man listening to a gramophone and smoking a long (possibly opium) pipe. The idea of the 'mysterious voice' may have started as an ironic allusion to the R.C.A. Victor label 'His Master's Voice'.

[2] (Firenze, 1906), 172.

[3] 'L'Italia risponde', *La Voce*, I no. 1 (20 Dicembre 1908), 2.

which are put into practice and [are] therefore [a model] of instruction.'[1] During its best years, up to 1912, *La Voce* was truly a bazaar of ideas. Prezzolini was working toward 'an integral education of man',[2] and if he has been referred to – somewhat maliciously – as the 'impresario of Italian culture',[3] this description is apt in its most objective and generous sense.

The Arts

In spite of the practical bias of *La Voce*, from the beginning the arts played an important though not dominant role. In the very first number Angelo Cecconi, also a *Leonardo* veteran, attacked the burning issue of traditionalism in art in his spirited essay 'Innovation and Junk': 'To respect the past is fine; to preserve it in proportion to its worth and importance is also fine. But beyond these limits [this cult] is foolish superstition. . . Old age and rubbish must not have an everlasting domain. We must make room for the young ones.'[4] Unfortunately, his subsequent articles did not follow up this promising introduction with further courageous recommendations.

Ardengo Soffici was the real star of *La Voce* in artistic matters. Prezzolini had invited him to collaborate on the strength of an article on Cézanne, published in 1908.[5] By this time Soffici was thoroughly familiar with the French literary and artistic *avant-garde* and the condition of the Italian arts seemed by contrast even more appalling.[6] One of the effects of this awareness was his celebrated series of discussions on Impressionism and Medardo Rosso, in which he displayed his critical acumen, and charted a new course for Italian artists.

Soffici's typically Tuscan brand of dry, biting irony made him an effective polemicist. His review of the 1909 Venice Biennale is a masterpiece of its kind. Almost nothing escaped his vigorous attack. He began with the method of selection, which he found inferior to that of the Paris Salon d'Automne and Salon des Indépendants. Passing to the Italian Pavilion, he was revolted by Galileo Chini's (b. 1873)

[1] Quoted in Carlo Martini, *'La Voce'; storia e bibliografia* (Pisa, 1956), 58.

[2] G. Prezzolini, 'Come faremo La Voce', *La Voce*, IV no. 45 (7 Novembre 1912), 925. The diversity of the journal's contents is suggested by this selection from the contributors. Idealists – Croce, Gentile, Lombardo-Radice; Modernists – Murri, Boine, Casati; the political economist Einaudi, the Socialist Salvemini, the Irredentist poet Slataper; music criticism by Pizzetti, Bastianelli; art criticism by Longhi, Soffici, and so on.

[3] Peter M. Riccio, *On the Threshold of Fascism* (New York, 1929), 195.

[4] *La Voce*, I no. 1 (20 Dicembre 1908), 2.

[5] A. Soffici, *Ricordi di vita artistica e letteraria* (Firenze, 1942), 36. See below, pp. 55–57.

[6] Soffici had collaborated on *La Plume, La Revue Blanche, L'Europe Artiste, L'Assiette de Beurre* and had made the acquaintance of men like Apollinaire, Rémy de Gourmont, Moréas, Jacob, Picasso, Braque, Modigliani.

decorations, which reminded him of the 'trash found on placards and calendar covers'; their inscriptions were termed 'verbiage of indannunziated chiropodists'. Then one by one, he pulled the idols of popular taste from their pedestals, going from Sartorio's 'saraband of nude bodies' in 'epileptic poses' to Franz von Stuck's 'junk, at best good enough to adorn the increasingly boring pages of the eternal Jugend'. Soffici's distaste for Art Nouveau was aesthetic rather than racial, and stemmed from his awareness that the exponents of this style were being shown at the expense of the Impressionists and other challenging artists. Finally, he was shocked by the poor examples selected for the memorial exhibitions of Fattori and Signorini. Recalling the force of the *macchiaioli* movement, he lamented that the Signorini paintings shown were scarcely worthy of this 'paladin of a famous school, this overthrower of aesthetics, this proponent and defender of revolutionary ideas'.[1]

Most of Soffici's writings focused upon the arts and aesthetics of France. This is also true of essays by the Frenchman Henri Des Pruraux, another art critic and former member of *Leonardo* who lived in Florence and participated in the *La Voce* venture. In 1911–12 his articles were devoted to French art beginning with Post-Impressionism. Intrinsically of little merit, for Des Pruraux was much less daring than Soffici, their virtue lies chiefly in his concern with this subject, which was insufficiently known in Italy.

These efforts to bring about an artistic *rapprochement* between France and Italy extended to literature as well, and *La Voce* carried articles on such authors as Jammes, Péguy, and Claudel. To a certain extent this choice of subjects reflected Italy's political aspirations. At that time the country was straining more than ever under the yoke of alliance with Austria and eagerly looking to France and the *Entente* for more congenial associates.

Dissension within La Voce: Foundation of Lacerba and Merger with Futurism

In 1952, more than forty years after the birth of his journal, Prezzolini still found it something of a miracle that *La Voce*, with all its contradictions and lack of discipline, could have lasted as long as it did.[2] The combination of his own youthful vacillations with those of his motley and equally immature crew often made the going at *La Voce*

[1] 'L'Esposizione di Venezia (1909)' *La Voce*, I nos. 46–8 (28 Ottobre, 4, 11 Novembre 1909), 191–2, 195–6, 199–200, reprinted in A. Soffici, *Scoperte e massacri, scritti sull'arte* (Firenze, 1919), 265–99. On page 273 Soffici alludes to the official invitation of Picasso (without mentioning his name) to the Biennale and the scandalous withdrawal of his work by exhibition officials a few days after the opening 'because his painting did not conform to the taste of what a genial work should be'.

[2] Reported in C. Martini, '*La Voce*'; *storia e bibliografia*, 57.

headquarters very difficult. In addition, it seems that almost from the beginning Papini and Soffici, who were becoming increasingly close friends, were not in complete accord with Prezzolini's plans for the journal. Allowed their own way, they would have given first place to the arts and, as early as 1910, there was talk of founding a purely artistic review.[1] Out of respect for Prezzolini they continued to collaborate with him. But as time passed, Soffici has recalled, he and Papini inclined daily 'more towards poetry and art while Prezzolini and his review became increasingly preoccupied with practical questions of culture, sociology, and politics'.[2] The resultant influx of an entirely new group of associates with whom Papini and Soffici had nothing in common brought the difference of opinion to a head, and at the end of 1912, Papini and Soffici finally seceded from *La Voce*. With the Futurist poet Aldo Palazzeschi and the writer Italo Tavolato they founded a new periodical, *Lacerba*, which appeared on 1 January 1913. Here the arts were to be completely at home: 'The birth of *Lacerba* was an act of liberation', said Papini and Soffici in 1914. 'Some of us had felt too restrained for too long in *La Voce*. . . Art was always tolerated there but without enthusiasm, and no theory which did not have idealist colour and stamp was admitted.'[3]

The publication of *Lacerba* marked the union of the most adventurous spirits of the Florentine movement and the Milanese Futurists. Since 1909 the latter had been waging a battle for cultural revival as vigorous as that of the *La Voce* group. Although the Florentines had watched the activities of the Futurists (and vice versa) with curiosity and some sympathy, they remained publicly hostile to their efforts for a variety of reasons. But by the end of 1912 Futurism had achieved international renown and the dissatisfied Soffici and Papini realized that they were in closer harmony with the rebellious Milanese than with Prezzolini's *La Voce*. It did not take much persuasion from Marinetti and other members of his movement to make the apostate Florentines climb on to the Futurist bandwagon.[4] Papini subsequently rationalized this move by claiming, with some justice, that he had been a Futurist *avant la lettre*.[5]

Prezzolini, still dedicated to his cause, carried on alone at *La Voce* after this schism, and the journal continued to appear regularly up to 1914. At that point some

[1] Ibid., 85 ff.

[2] A. Soffici, *Ricordi di vita artistica e letteraria*, 40.

[3] G. Papini and A. Soffici, ' "Lacerba", il Futurismo e "Lacerba" ', *Lacerba*, II no. 24 (1 Dicembre 1914), 323.

[4] See below, pp. 122–3, 131 ff.

[5] G. Papini, 'Perchè son futurista', *Lacerba*, I no. 23 (1 Dicembre 1913), 267–8, reprinted as 'Affetuosa accettazione' in his *Il mio futurismo* (Firenze, 1914), 45–48.

fundamental policy changes prolonged its life until 1916. In its final phase, under the directorship of Giuseppe De Robertis and renamed *La Voce Letteraria*, it helped to clear the way for the literary and artistic trends in Italy after the First World War.

In general, Prezzolini's *La Voce* showed signs of having lost its *raison d'être* in 1913–14. Although it still printed many valuable articles and continued to find new and promising contributors, some of its best essays were inspired by the controversies which the Futurist invasion of Florence had provoked. Thus in retrospect it appears that one of *La Voce*'s most useful services was that it paved the way for *Lacerba*, and all that this implied.

The concentration of such strong cultural forces in Florence before the First World War was as admirable as it was unexpected. This thought consoled Papini, who in 1913 remarked that 'When a city like this one, which deliberately suffocates all vigorous life with its provincial narrow-mindedness and its *passéiste* bigotry, succeeds in a few years in producing that group of young writers who have made Florence with its *Leonardo*, *Regno*, *La Voce*, and *Lacerba* the spiritual centre of Italy, then this suggests that it has not gone to hell completely.'[1] But it is doubtful – and Papini, were he still alive, might perhaps agree – whether the tremendously invigorating and far-reaching Florentine movement could have been brought to its climax without coalition with Marinetti's Futurism. In spite of the integrity and international breadth of interests of the Florentine insurgents, they remained at heart irrevocably tied to their Florence, their Tuscany.[2] In itself this local pride is by no means condemnable. But as the main object had been to end the provincialism which divided and weakened Italy, a far more detached and iconoclastic leadership was needed. This was found in Filippo Tommaso Marinetti and his movement, Futurism.

[1] 'Contro Firenze passatista', *Lacerba*, I no. 24 (15 Dicembre 1913), 285, reprinted in *Il mio futurismo*, 56.

[2] Pride in Tuscany and in the great Tuscan tradition is frequently expressed in the writings of Papini and Soffici. See for example, Papini's 'Le due tradizioni letterarie', *La Voce*, IV no. 1 (4 Gennaio 1912), 727–8, or Soffici's *Lemmonio Boreo* (Firenze, 1911).

F. T. MARINETTI: LIFE AND WORK BEFORE THE LAUNCHING OF FUTURISM

First Literary Efforts

ILIPPO Tommaso Marinetti was born on 22 December, 1876[1] in Alexandria, Egypt, the son of a wealthy and influential lawyer of Piedmontese origin and of a Milanese mother. If his autobiographical notes can be trusted,[2] he displayed at an early age some of the qualities which were to make him the controversial public figure of his Futurist days. As a student of the strict Jesuit College of Saint François Xavier in Alexandria, he was expelled for smuggling Zola's forbidden novels into the classroom. In revenge he published a journal, *Le Papyrus*, devoted to anti-Jesuit invective and romantic poetry. Although typically adolescent, these pranks anticipate his Futurist eagerness to shock and to ridicule existing rules and standards.

Because this kind of behaviour made it impossible for him to obtain in Egyptian schools the classical education his father had in mind, Marinetti was sent to Paris. He arrived there alone at the age of seventeen and three years later received his *bachelier ès lettres* from the Sorbonne. Although Marinetti had already shown some literary promise in his Alexandrian days, his father was opposed to a career in letters, so he studied law, first at Pavia, then at Genoa, where he became a Doctor of Jurisprudence in 1899. But his poetic calling asserted itself and Paris became his spiritual home. From Pavia, Genoa and later Milan, he practically commuted to Paris in order to keep in touch with his writer friends there and to remain abreast of cultural events.[3]

Not long after Marinetti first arrived in Paris in 1893 he apparently contacted at least the periphery of the literary *avant-garde*, which at that time was the still triumphant, though disintegrating Symbolist movement. A great many foreign-born poets who found the French idiom more compatible than their own were participants, and Symbolism's principles were almost as diverse as its supporters. They were united

[1] He often gave both 1878 and 1879 as his birthdate, perhaps to support the claim made in the First Futurist Manifesto of 1909 that 'The oldest amongst us is thirty'.

[2] These autobiographical notes are found in several of Marinetti's books. Facts given here are taken from *Marinetti e il futurismo* (Milano, 1929), 20 and *passim*.

[3] Marinetti's energy and capacity for continuous travel have become almost legendary and played a large part in the dissemination of Futurism in Europe. See Emilio Settimelli, *Marinetti l'uomo e l'artista* (Milano, 1921), *passim*.

only in their renewed affirmation of artistic freedom and differed from their Realist-Naturalist predecessors in their search for new sources of aesthetic experience and expression. Marinetti was obviously deeply impressed by their experiments,[1] but his own development was more directly affected by the increasingly vociferous reaction against the Symbolist state of mind – its excessive introspection, its divorce from tangible reality, and its melancholy and preciosity. Of the welter of 'isms' that sprang up after 1895 *naturisme* was one of the earliest and most consistent and had far reaching consequences.[2] Its manifesto, by Saint-Georges de Bouhélier, appeared in *Le Figaro* on 10 January, 1897. It declared that the *naturistes* were opposed to 'pretentious techniques . . . sensualisms of art . . . artificial mysteriousness . . . We will sing of the high holidays of man. To give splendour to this scene, we shall call up the plants, the stars, and the wind. A literature will be born which will glorify the mariners, the labourers . . . and the shepherds.'[3] Apollinaire recalled in 1908 that *naturisme* 'impressed the spirits of the young men of my generation . . . [who] aided by the civic exaltation, . . . discovered themselves the sons of Naturalism and chose Émile Zola as their master'.[4] Walt Whitman's unrestrained song of life understandably provided spiritual nourishment for the *naturistes* as well. Of the older Symbolist generation they praised only the Belgian poet, Émile Verhaeren, one of the very few to rejuvenate his art in the nineties and find a new faith in scientific progress. Some ten years later he cried exultantly: 'Futur vous m'exaltez comme autrefois mon Dieu.'[5] By 1911 he had earned Marinetti's praise as 'ce grand poète futuriste et de génie'.[6]

Marinetti's own poetry was written almost exclusively in French before 1911–12.

[1] In 1902 he replied to an *enquête* entitled 'Quel est votre poète?': 'J'aime entre tous, le poète Stéphane Mallarmé parce que . . . il rêva de créer une symphonie poétique aussi definitive et magique que celle executée par Richard Wagner, en musique. 'L'Après midi d'un Faune' et 'Hérodiade', témoignages éblouissants de cet effort héroique, sont les poèmes les plus grands et les plus purs du XIX siècle, de par leur puissance evocatrice, leur prodigieuse harmonie et leur innombrables sorcelleries verbales.' *Ermitage* 13e année no. 2 (Février, 1902), 121–2. See also O. Ragusa, *Mallarmé in Italy*, *passim*. According to F. Ruchon, *Jules Laforgue* (Genève, 1924), 260, Marinetti also published translations of Laforgue. I have not been able to verify this.

[2] See Florian-Parmentier, *L'Histoire de la littérature française de 1885 à nos* jours (2e édition, Paris, 1915?), *passim*, and Marcel Raymond, *De Baudelaire au surréalisme* (Paris, 1952), 65 ff.

[3] Quoted in Guy Michaud, *Message poétique du symbolisme* (Paris, 1947), 518. See also Maurice Le Blond, *Essai sur le naturisme* (Paris, 1896), 72 ff.

[4] P.-N. Roinard, Victor-Emile Michelet, Guillaume Apollinaire, *La Poésie symboliste. Trois entretiens sur les temps héroiques* (Paris, 1908?), 136.

[5] 'La Prière', *Les Rythmes souveraines* (6e édition, Paris, 1913). Faith in the future is expressed in much of Verhaeren's poetry; *Les Villes tentaculaires*, published in 1895, end with 'Vers le futur'.

[6] F. T. Marinetti, *Le Futurisme* (5e édition, Paris, 1911), 228.

An outgrowth of the *naturiste* revolt, it began to attract attention in Paris in 1898,[1] although his first important poem, a long epic entitled *La Conquête des étoiles*, was not published until 1902. This was an allegory modelled on the mythological giganto-machy, except that here the violent contest is waged between the sea, the winds and the stars which are animated by an all-embracing pantheism.[2] The poem is written in free verse and dedicated to Marinetti's 'cher maître',[3] Gustave Kahn, a close friend and collaborator who later became a supporter of Futurism.

La Conquête des étoiles reveals many of Marinetti's consistent literary virtues and vices. It shows his capacity for understanding advanced literary trends (*vers libre*),[4] as well as his youthful enthusiasm, audacity and ambition. How many foreign poets dare to make their début in Paris, and with a single poem of more than four thousand verses? One can only be impressed by the grandeur of his poetic design – which re-calls Romantic poets like Hugo – and also by the barbaric ferocity of his language, the richness of his rhythms and the plasticity of his images. On the other hand, at times one is overwhelmed by his volubility, and the rhetorical tone of certain passages detracts from the poem's effectiveness. Yet the fact that *La Conquête des étoiles* was written by a young man of twenty-six makes its laudatory reception by the French and Italian press seem less astonishing.

Two years later Léon Vannier, who published the Symbolists, brought out a volume of Marinetti's slightly shorter poems entitled *Destruction*, which continued *La Conquête*'s theme of diluvial destruction and showed a similar *élan*. But the poetic distance of the earlier poem was replaced by a highly subjective, almost expressionist tone, suggestive of great spiritual inquietude. The violence of his mood is reflected in the choice of modern images of speed and electricity and the series entitled 'Le Démon de la vitesse' presents a 'kind of railway journey of the modern soul . . . [which] end[s] . . . in the grinding shock of a collision'.[5]

[1] His poem 'Les Vieux marins' was published in *Anthologie revue*, 1 no. 12 (20 Septembre 1898), 1–2; reprinted as 'Les Barques mourantes' in *La Ville charnelle* (Paris, 1908), 121 ff. Sarah Bernhardt recited it at *Les samedies populaires de poésie ancienne et moderne*, organized by Gustave Kahn and Catulle Mendès, who awarded it a first prize. The date for this award is given variously as 1898, 1899.

[2] (Paris, 1909), 23–24, 153–54, *passim*.

[3] Handwritten inscription by Marinetti in the New York Public Library copy.

[4] See below, p. 33.

[5] Horace B. Samuel, *Modernities* (London, 1914), 226. A number of passages from another poem in *Destruction*, 'Dans les cafés de nuit', suggest a mixture of images from Van Gogh, Anglada, and Toulouse-Lautrec and foreshadow the 'screaming' electric lights of the Futurist Painters' Technical Manifesto of 1910. For example: 'Et voilà que soudain sur nos pâleurs/les lampes électriques brandissent leurs coeurs blancs/qu'elles serraient entre leurs doigts de fer,/jusqu'à les faire crier expu-mant de laits bleus', 146–7.

Two prose publications contemporary with *Destruction* revealed other aspects of Marinetti's personality and interests. The first, *La Momie sanglante*,[1] was an Egyptian love fantasy in which the influence of his oriental childhood is apparent. His own fascination with the sensuousness and languor of North Africa was combined with a predilection for the exotic then generally fashionable. The second book, *D'Annunzio intime*,[2] consisted of a group of articles (most of them reprinted from *Gil Blas*) which disclosed Marinetti's attitude toward his illustrious compatriot. Like most of his generation he had admired and learned much from D'Annunzio. But like Papini, Prezzolini, Borgese and others, he was much concerned about the spell which the legend of D'Annunzio's life and his word-magic had cast over the Italian public. In 1908, when Marinetti had moved still further away from the older poet's ideas, he sharpened his attack in an enlarged edition of *D'Annunzio intime*.[3]

Actually, in the course of Marinetti's career, he emulated and exaggerated some of D'Annunzio's tricks for attracting publicity. Both wanted to revive the arts in Italy, but D'Annunzio was an egotist who wanted all the glory of leadership and success for himself. Marinetti on the other hand, product of another time, rebelled against the romantic cult of the individual and concentrated his talents, charm and money on the success of an entire artistic movement – Futurism.[4]

Marinetti's Début as Cultural Entrepreneur: Poesia

By 1905 Marinetti was a well-known literary figure in France and Italy and a friend of the famous and would-be famous in both countries. In February 1905 the first issue of his *Poesia* appeared in Milan.[5] Sub-titled *Rassegna Internationale*, it gradually paved the way for the emergence of Futurism. An intimate of *La Plume* and *La Revue Blanche*, in 1897 he and Edouard Sansot-Orland had collaborated on the short-lived *Anthologie-Revue* which was published both in Milan and Paris. It presented samples of new French and Italian literature, often reprinted from other publications. In the following year it was absorbed by the third reincarnation of Kahn's initially Symbolist organ *La Vogue*, of which Marinetti was a contributor and later an

[1] (Milano, 1904?).

[2] (Milano, 1903?).

[3] Renamed *Les Dieux s'en vont, D'Annunzio reste* (Paris, 1908). Marinetti had dedicated one of the poems in *Destruction* to D'Annunzio. He also published a French translation of his 'Le città terribili' from *Laus vitae* in *Vers et prose*, v (Mars–Mai, 1906), 80–83.

[4] Although the poet Gian Pietro Lucini called Futurism 'Dannunzianesimo esasperato', it is possible to detect the influence of Futurism on D'Annunzio. See Alberto Viviani, *Il Poeta Marinetti e il futurismo* (Torino-Milano, 1940), *passim*.

[5] Marinetti had originally two collaborators on *Poesia*, the poet and playwright Sem Benelli and Vitaliano Ponti. They withdrew late in 1907.

editor. When *La Vogue* expired in 1901, Marinetti threw his energy into a crusade of recitation throughout Italy – mainly propagating modern French poetry. This pause gave him ample opportunity to observe Italian literary life, with its widespread ignorance of and hostility to the important contributions that had been and were being made in France and its dearth of outlets for young Italian poets.

Poesia had its headquarters in Milan at Marinetti's luxurious home on the via Senato. Famed for its exquisite oriental atmosphere, it became the meeting place of the Milanese *avant-garde*, a spiritual oasis amid the aggressive materialism of the huge metropolis.[1] The magazine's motto, 'Ma qui la morta poesia risurga',[2] expressed the regenerative aims of its founder, reiterated by a fantastic Klingeresque cover – used on all issues – by Alberto Martini (1876–1954) (Pl. I) showing a woman on a mountain-top killing a monster.[3] The large oblong format and expensive raw-edged paper gave the magazine an air of sophisticated cosmopolitanism and respectability. In these respects *Poesia* resembled both the first *Leonardo* and the Viennese Art Nouveau journal *Ver Sacrum*. Unlike either of these it did not at the outset stand for any specific point of view and it was limited to literature. Living up to its goals and seeking international scope *Poesia* printed unpublished poetry and some prose by a wide variety of European and even some American authors. Almost every issue contained a medallion to an 'admired master' accompanied usually by a dithyramb by Marinetti. These 'masters' belonged mostly to the French Symbolist descendants of Verlaine and Mallarmé[4] – Kahn, de Régnier, Vielé-Griffin, Fort, Jammes, Verhaeren, Mauclair – but Holz, Dehmel, Yeats, Swinburne, Carducci, Pascoli, and Negri were also included. Hundreds of poets were given a hearing, some still young and then relatively unknown: Lucini, Buzzi, Govoni, Palazzeschi, Cavacchioli among the Italians, Jarry and L'Abbaye group – Arcos, Duhamel, Mercereau, Périn, Romains, Royère, Vildrac, Varlet[5] – among the French. This achievement was unique in Italy,

[1] Paolo Buzzi, 'Souvenirs sur le futurisme', *Cahiers d'art*, xxv (1950), 18.

[2] Dante, *Purgatorio*, i, 7.

[3] The poet Jules Bois explained Martini's symbolical cover design as representing 'l'hydre de vulgarité et d'ignorance traversé par les flèches d'une Walkyrie debout sur un Parnasse qui serait un Mont-Salvat'. *Poesia*, iv no. 5 (Giugno 1908), 2.

[4] O. Ragusa, *Mallarmé in Italy*, 111.

[5] *Poesia*, ii nos. 9–12 (Ottobre – Gennaio, 1906–7), 24 ff., is dedicated to 'I poeti dell'Abbaye, cenacolo d'artisti all'avanguardia dell'arte di Francia'. Although the charter members of L'Abbaye included only Arcos, Barzun, Duhamel, Mercereau, Vildrac, the painter Gleizes and the printer Linard, Périn, Romains, Royère, Varlet were loosely associated with this 'centre where the problems of creating an art suited to the life of the new age were of paramount interest'. Marinetti was a frequent visitor at L'Abbaye and a close friend of Arcos and Mercereau. The group's collective artistic efforts may well have inspired his own movement. See Daniel Robbins, 'From Symbolism to Cubism: The Abbaye of Créteil', *The Art Journal*, xxiii no. 2 (Winter 1963–64), 111–16.

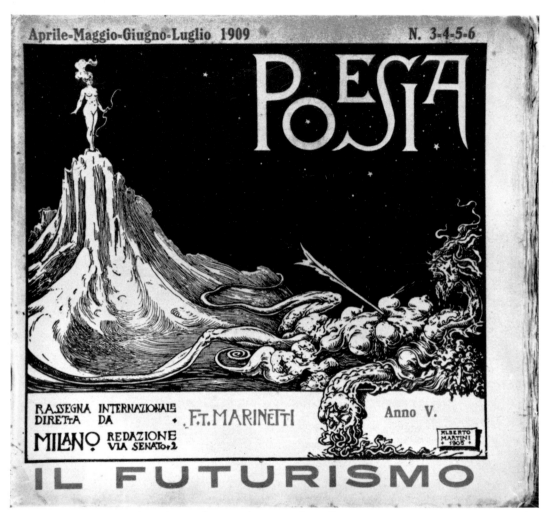

1. *Poesia*, V nos. 3–6 (Aprile–Luglio 1909). Cover by Alberto Martini, designed in 1905. This issue is the first one to bear the red subtitle 'Il Futurismo'

where there was no magazine at that time devoted solely to poetry. *Poesia* became known and respected there and abroad, and was a first proof of Marinetti's talent 'as a cultural middleman and literary propagandist.'[1]

Marinetti's zeal to assist and stimulate young artists and to educate the public found further expression in a series of contests, *enquêtes* and campaigns launched in the pages of *Poesia*. In August 1905, for example, he began a spirited argument in favour of the foundation of an Italian Academy.[2] This was to be modelled on the Académie Française, but was to include both men and women active in all the arts (though with a literary preponderance), and representing 'all tastes, tendencies and schools.' Members were to be chosen in a national election. What a utopian dream! These plans never progressed beyond the stage of discussion in *Poesia*. Marinetti's suggestions foreshadow his later political ideal of '*Artecrazia*', which was to be a state run by artists, that 'great proletariat of the inspired ones', as well as his acceptance of membership in Mussolini's resurrected Accademia Italiana in 1929.[3]

Much more important, in view of later developments, was the *Enquête internationale sur le vers libre*, begun in the October 1905 issue of *Poesia*. This type of survey had become popular in France since Huret's famous *Enquête sur l'évolution littéraire* of 1891, and the periodical literature of the time abounded in *enquêtes* on a great variety of subjects. Like Huret, Marinetti later published in book form the replies – mostly from the 'masters' of *Poesia*.[4] In 1905 free verse was no longer a novelty, but to Marinetti it still symbolized modernism in poetry and hence emancipation from convention just as it had some sixteen years before to its chief apologist, Gustave Kahn.[5] Marinetti's advocacy of free verse forms the basis of the subsequent Futurist literary reform, but in a broader sense its principles also came to stand for artistic liberty and formal innovation – the flesh and blood of the entire Futurist programme.[6]

Marinetti's own writings are sprinkled liberally throughout the pages of *Poesia*.[7]

[1] O. Ragusa, *Mallarmé in Italy*, 111.

[2] *Poesia*, 1 no. 8 (Settembre 1905), 3. The idea originated with Marinetti's friend, the writer U. Notari.

[3] 'Al di là del comunismo' (c. 1919), reprinted in *Futurismo e Fascismo* (Foligno, 1924), 218; excerpts in Maria Drudi Gambillo and Teresa Fiori, *Archivi del Futurismo* (Roma, 1958), I, 38 ff. (Hereafter this book will be referred to as *Archivi*.) Marinetti's critics have always interpreted his acceptance of membership as an act of opportunism. This was probably not the whole story. Marinetti above all hoped to obtain official status for his movement, increasingly unpopular during the Fascist period.

[4] (Milano, 1909).

[5] See for example Kenneth Cornell, *The Symbolist Movement* (New Haven, 1951), for a discussion of *vers libre*.

[6] See Proclamation 1 of the Technical Manifesto of Futurist Painting, and the Technical Manifesto of Futurist Sculpture, reprinted in *Archivi*, I, 67, 70.

[7] *Poesia*, IV no. 6 (Luglio 1908), 5, carries a medallion to him with a dedicatory poem by Emile Bernard.

One of his best and most important poems to appear there was 'A l'automobile' of 1905, which begins:

> Dieu véhément d'une race d'acier,
> Automobile ivre d'espace
>
> Je lâche enfin tes brides métalliques et tu t'élances,
> avec ivresse, dans l'Infini libérateur! . . .[1]

Three years later Marinetti rebaptized this poem 'A Mon Pégase'.[2] Both new title and content clearly indicate the direction of Marinetti's development. In 'Le Démon de la vitesse' (of 1904) his muse had received fresh incentive from feats of modern technology. Here he began to free her from the soul-searching and decadent luxuriance of his earlier imagery. 'A Mon Pégase' recounted the triumphs of the new Pegasus – a cross between an automobile and an aeroplane – whose force and speed conquer space and time, enabling Marinetti to escape finally from 'la terre immonde'.[3] Here were all the incipient elements of Futurism – intoxication with speed and space, veneration of the motor car, horror of confinement. But they were still on trial until he commenced the First Futurist Manifesto.

Marinetti's First Play: Le Roi Bombance[4]

In Le Roi Bombance Marinetti's youthful Weltanschauung was first fully expounded and his hatred of the existing world much elaborated. Published in 1905, it was not produced until April 1909 in Lugné-Poë's Théâtre de l'Oeuvre, where, as its author had hoped, it provoked a pandemonium equal to the battle of Hernani. In this 'tragédie satirique' consisting of a parable of the digestive system Marinetti savagely denounced the moral corruption of society and the hypocrisy of so-called religious and democratic practices. He portrayed man's folly and selfishness in the face of disaster with the detachment found in Ensor's pictorial treatment of a similar theme.[5] The general philosophy of the play is positive, however, and the story's hero, the poet L'Idiot, strikes a hopeful note. Although he is ridiculed and tortured by the

[1] *Poesia*, I no. 7 (Agosto 1905), 11.

[2] Published in *La Ville charnelle* (8ᵉ édition, Paris, 1908), 167–72. Reprinted as 'A l'automobile de course' in *I Poeti futuristi* (Milano, 1912), 324 ff.

[3] *La Ville charnelle*, 172. See also his prose poem 'Le Circuit de la Jungle' (*Poesia*, III nos. 9–12 (Ottobre–Gennaio, 1907–8), 22 ff., reprinted as 'La Mort tient le volant', *La Ville charnelle*, 221 ff.) in which a Negro driver in a 'Jaguar métallique' dares to race 'Plus vite que le vent . . . Plus vite que la foudre . . . [and] enjamba le torpilleur funèbre de la Mort.'

[4] (Paris, 1905).

[5] Marinetti may well have seen the Ensor exhibition sponsored by *La Plume* in 1898.

populace, he remains its unacknowledged leader. He alone recognizes the unattain-
ability and ceaseless challenge of liberty, which he defines as 'un azur toujours plus
large et plus abreuvant!' The poet is finally driven to suicide, but his return, and that
of all other inhabitants of the world, are assured by Sainte Pourriture. She represents
the life force, the eternal process of creation, destruction and regeneration, and causes
her handmaiden to conclude that 'Le devenir, voilà la seule religion!... Quand vous
regrettez quelque chose... c'est déjà un germe de mort que vous portez en vous!...'[1]

Never at a loss when it came to selecting appropriate godfathers for his work,
Marinetti dedicated this play to the writer Paul Adam – the anarchists' friend. When
Adam reviewed it for *Poesia* in 1907[2] he commented that Marinetti was 'on the way
to the most astounding creation' and this prediction turned out to be truer than any-
one realized at the time. The Futurist ideology was outlined in *Le Roi Bombance*. All
that was still lacking was a specific cause for the artist-leader to espouse.

The First Futurist Manifesto

The unwitting truth of Adam's prophecy was first demonstrated on 20 February
1909 when *Le Figaro* – that venerable battle-ground of artistic allegiances in Paris –
printed on its front page a long manifesto signed by Marinetti. In it he proclaimed
the birth of a new literary movement, *Le Futurisme*.[3]

The First Manifesto is a prose poem, again describing a voyage. It falls into three
parts, each apparently symbolic of a different stage of artistic activity in Italy: the
pseudo-scientific, D'Annunzio-dominated present from which the artist escapes at
dawn in an automobile; the immediate future which starts with a specific Futurist
programme; and the hazier, more distant future of ten years hence, when a new
generation of artists will repeat the ruthless emancipatory process of the present
Futurists.

With this manifesto Marinetti reached a climax in his life and literary career. Its

[1] *Le Roi Bombance*, 252, 263.

[2] III nos. 9–12 (Ottobre–Gennaio, 1907–8), 3. This issue prints also Jarry's letter praising *Le Roi
Bombance*.

[3] Notices of the new movement appeared in the Italian press as early as 4 February 1909 (see Christa
Baumgarth, *Geschichte des Futurismus* (Hamburg, 1966), 31–2). Although only Marinetti signed the
manifesto, it was apparently edited and approved by some of his literary friends, notably P. Buzzi,
E. Cavacchioli, C. Govoni and D. Cinti, later secretary of the movement. Other early adherents to
Futurism were L. Altomare, F. De Maria, L. Folgore, A. Mazza and A. Palazzeschi. Much to Mari-
netti's chagrin, G. P. Lucini, another contributor to *Poesia*, vehemently refused to have anything to do
with Futurism. This was brought out in Marinetti's preface to Lucini's *Revolverate* (Poesia, Milano 1909),
10, and in Lucini's 'Come ho sorpassato il Futurismo', *La Voce*, V no. 15 (10 Aprile 1913), 1049 ff., in
which he published his 1909 correspondence with Marinetti regarding his doubts about the movement.

E

publication marked the beginning of his most influential years as cultural catalyst and Maecenas to much of the most promising talent in Italy at the time. As a piece of writing it was undoubtedly his most mature work to date, suggesting that the manifesto form suited him ideally. It demanded a marriage of literary facility with polemic sharpness; his verbal and emotional excesses were held in check and his urge to self expression was channelled into the service of a greater cause. Over the years Marinetti perfected the 'art of making manifestos'.[1] Even Apollinaire conceded in 1916 that the Italian excelled at this form of writing,[2] and he and many others later maintained that Marinetti's manifestos of 1909–15 were his finest literary performances. Certainly his ability to present highly technical details and shocking points of view in an appealing manner without the loss of precision was a rare gift.

Marinetti's Cultural Tactics

In retrospect, Marinetti's choice of time and place for the emergence of Futurism seems a brilliant piece of strategy. By February 1909 he had consolidated his reputation in France and Italy. Apollinaire included Marinetti and *Poesia* in his important survey of recent poetic activity given at the 1908 Salon des Indépendants.[3] In Italy Marinetti had acquired a large and devoted circle of friends and followers, many of whom were active contributors to his review. Some of them, especially the younger ones, readily accepted the aims of the Futurist movement as outlined in the First Manifesto. Thanks to his skilful handling of publicity, the manifesto rapidly reached an enormous audience. Its large red letters could be seen posted on kiosks in Italy, copies were distributed at street corners, and major newspapers all over the world carried reprints, translations and discussions of it.[4]

The Italian public had been made sufficiently aware of the need for new spiritual values and Marinetti and Prezzolini realized almost simultaneously that the time had come to take its education firmly in hand. *La Voce*'s programme, which preceded Marinetti's Futurism by about two months, was forceful but austere from the outset. Above all, it failed to give the arts an integral place. Futurism, on the other hand, had a youthful buoyancy reminiscent of the *Leonardo* group. It swaggered forth with a broad yet apparently practical agenda couched in catchy phrases, in which everything

[1] *Archivi*, I, Marinetti to Severini (15 September to 1 October 1913), 294.

[2] Guillaume Apollinaire, *Anecdotiques* (Paris, 1926), 219.

[3] P.-N. Roinard, V. E. Michelet, G. Apollinaire, *La Poésie symboliste*, 171.

[4] *Poesia* became the vehicle of Futurism, its green Art Nouveau cover and format contrasting strikingly with the simple red font of the words 'IL FUTURISMO' which were added to the covers of the last two – and final – 1909 issues. Of special interest is the April–June 1909 number which reprints letters and opinions about Futurism.

was made contingent on the arts. Marinetti was trying to appeal not only to the young and adventurous, but to all those who were out of sympathy with D'Annunzio's esotericism and were casting about for new ideas and leaders.

Still more strategically knowing was Marinetti's bold decision to announce his movement in Paris, where cultural ferment was at a high pitch. By throwing Italy's hat into the French arena, he forcibly reminded the world's artistic capital that new life was stirring elsewhere and that Italy might eventually be a force to be reckoned with. To the Italians, Futurism's seemingly official birth in Paris greatly added to its snob-appeal and acceptability.

Marinetti was far-sighted, courageous and arrogant; he was also wealthy, cosmopolitan, and an Italian patriot who was untainted by local loyalties. Only such a man could have dared to attempt a *coup* of this nature. Marinetti genuinely loved and understood French culture. This enabled him to discern the course it was taking, and provoked him to aid Italian artists in the hope that they would reach the goals first.

THE FIRST MANIFESTO
AND THE FUTURIST AESTHETIC

MARINETTI'S manifesto established the general terms for the theory and practice of the entire Futurist movement. The consequent succession of written statements and related works of art was almost unprecedented in post-Renaissance cultural history. But the evolution of Futurist art was not determined by an arbitrary set of axioms. Just as the First Manifesto had gradually taken shape over a ten-year period as the result of Marinetti's own development in a changing world, so the artists who joined the movement brought with them a backlog of work and ideas. In one way or another, these predisposed them to accept Marinetti's aesthetic principles.

Analysis of the First Manifesto: Traditional Aspects

The bomb-shell effect of the First Futurist Manifesto has become a commonplace in discussions of modern art. But analysis of this document reveals that beneath the censure and insults a surprisingly large part of its content can be reduced to a few well-worn notions. Some had already served as rallying cries for artistic revolutions in France in the second half of the nineteenth century, and had roused echoes in Italy and the rest of Europe. In brief, its message was a general appeal to youth made up of the following major precepts: (1) to seek inspiration in contemporary life; (2) to be emancipated from the crushing weight of tradition, which to Marinetti was synonymous with existing academies, museums, libraries and all similar institutions. Implicit in his repudiation of tradition was (3), contempt for prevalent values of society and its corresponding conceptions of art.

This faith in young people (those under forty) as the only ones capable of carrying the creative burden of society goes back at least as far as the Romantic movement; in Italy it had been expressed politically by Mazzini's famous youth squadron, the *Giovane Italia* of the *risorgimento*. At the turn of the twentieth century the young of most nations were becoming increasingly aware that the hopes of the world had been tacitly placed in their hands. To meet this challenge the creative ones frequently banded together in loose associations whose spirit was a blend of the boisterous, adolescent extremism of a German *Burschenschaft* and the ardent utopianism of an

early trade union. Examples abound: the French *naturistes*, L'Abbaye de Créteil, the various *Sezession* movements in Germany and Austria, *Die Brücke*, *Der Blaue Reiter*, and the Florentine groups, to cite a few. Collective security became a shield against a hostile world.[1]

Under scrutiny, Marinetti's new 'modern' subject matter is disclosed as merely a more insistent and up-to-date restatement of Baudelaire's appeal to the artist to concern himself with 'l'héroisme de la vie moderne'.[2] Marinetti readily acknowledged his debt to those numerous artists who had been influenced by these words since they were voiced, and this debt is evident in his manifesto: 'We shall sing of the large crowds agitated by work, pleasure and rebellion; we shall sing of . . . the greedy stations devouring smoking serpents; the factories suspended from the clouds by their strings of smoke; of bridges leaping like gymnasts over the diabolical cutlery of sunbathed rivers; . . . of broad-chested locomotives pawing at the rails like huge steel horses bridled with steel tubes; and of the gliding flight of aeroplanes whose propellers sound like the flapping of flags and the applause of an enthusiastic crowd.'[3] Precedents for Marinetti's blasphemous order to 'démolir les musées, les bibliothèques'[4] also can be found in the Realist-Naturalist camp. Fifty years before the First Futurist Manifesto Edmond Duranty had published a similarly virulent statement advocating the burning of the Louvre.[5] Like Marinetti he wished to free the artist from the burden of the past. Even the gentle Pissarro is said to have repeatedly suggested the same action.[6] These are all basically reiterations of the desire to clear the road for artistic 'progress' or growth which had also activated the *macchiaioli*, the Italian Divisionists, and many others including Fénéon and Apollinaire.

Marinetti's disdain for the status quo – or anything generally accepted as the product of so-called reason and wisdom – can only partly be explained by the ostracized nineteenth-century artist's urge to *épater le bourgeois*. It was also symptomatic of the

[1] Maurice Le Blond's *Essai sur le Naturisme* begins with the exclamation 'Le droit à la jeunesse!' The *Brücke* manifesto of 1906 reads: 'Mit dem Glauben an Entwicklung an eine neue Generation der Schaffenden wie der Geniessenden, rufen wir alle Jugend zusammen und als Jugend, die die Zukunft trägt, wollen wir uns Arm und Lebensfreiheit verschaffen gegenüber den wohlangesessenen älteren Kräften'. Quoted in Peter Selz, *German Expressionist Painting* (Berkeley and Los Angeles, 1957), 95.

[2] Voiced in 1845 and 1846. Charles Baudelaire, *Curiosités esthétiques* (Paris, 1889), 75, 193–98. For an Italian formulation of the notion of cultural modernity see the writings of the Lombard lawyer and economist Giandomenico Romagnosi (1761–1835), and his theory of 'helikiasticism'.

[3] Unless otherwise indicated, all references are made to the French version of the manifesto published in *Le Figaro*.

[4] In the 1909 Italian version of the manifesto the destruction is extended to 'le accademie d'ogni specie'.

[5] Edmond Duranty, 'Notes sur l'art', *Réalisme*, no. 1 (1856), 2.

[6] John Rewald, *History of Impressionism* (New York, 1946), 26.

strong anti-positivist sentiment already discernible in Symbolist circles during the 1880's, to which fuel was provided later by the influential writings of Nietzsche, Bergson and Croce. Marinetti's parody of the rescue of his automobile by 'gouty naturalists', which ends the first part of the manifesto, was evidently intended as an attack upon the pseudo-scientific, sterile bombast of the ubiquitous and officially venerated positivists. The attack was founded on the belief that creativity does not spring from the rational intellect. Marinetti clearly expresses this in his exhortation: 'Let us leave Wisdom behind like a horrible mine . . . Let us throw ourselves to be devoured by the Unknown, not because we are desperate, but simply to enrich the bottomless reservoirs of the Absurd!' This again recalls Baudelaire, who wished to descend 'Au fond de l'Inconnu pour trouver du nouveau',[1] as well as Laforgue's similarly intentioned paraphrase of the Marseillaise, 'Aux armes citoyens, il n'y a plus de raison'.[2] Since then both Bergson and Croce in their own ways had elevated intuition to first place in the creative process. Marinetti himself had previously stressed the artist's natural irrationality by naming l'Idiot as the poet-hero of *Le Roi Bombance*. In *Tuons le clair de lune*, Marinetti's second and less influential Futurist proclamation of the spring of 1909, which continues the escape from the past begun in the First Manifesto, the insane carry out the grand Futurist conquest of the towns of 'Podagra' and 'Paralysie'. These 'frères bienaimés' are ideally suited to 'rajeunir et farder la face ridée de la terre'.[3] If the First Manifesto had done no more than reiterate these older incitements to rebellion it would still have shaken the foundations of tradition-secured Italian culture. But Futurism stood for more than that.

Novel Aspects: Futurist Dynamism

Marinetti originally wavered between Dynamism and Futurism as names for his incipient movement.[4] Although Dynamism would have been equally apt, describing, if more prosaically, the spirit and philosophy of his vision, he chose the more

[1] 'Le voyage', *Les Fleurs du mal* (Paris, 1892), 351. This quotation was used as epigraph by the Futurist poet Libero Altomare in the poem 'Apocalisse', *Poesia*, v nos. 1–2 (Febbraio-Marzo, 1909), 41.

[2] Quoted in François Ruchon, *Jules Laforgue*, 57.

[3] Reprinted in *Poesia*, v nos. 7–9 (Agosto-Ottobre, 1909), 4.

[4] *Guerra sola igiene del mondo* (Milano, 1915), 5, where he dates the manifesto 11 October 1908. Cavacchioli stated in June 1911 that *elettricismo* was also considered as a possible name. This information and the suggestion that Marinetti may have taken the word from Gabriel Alomar's *El Futurismo*, reviewed in *Mercure de France*, LXXVI (1er Décembre 1908), 559 ff., are found in Pär Bergman, '*Modernolatria*' et '*Simultaneità*' (Uppsala, 1962), 52–3. Bergman's valuable book unfortunately came to my attention only after the manuscript had gone to press. Carrà stated in a 1956 conversation with me that Marinetti's friend Umberto Notari suggested the name Futurism. The antonym *passatismo* was apparently invented by E. A. Butti; see Lucini, 'Come ho sorpassato il Futurismo', *La Voce*, v no. 15 (10 Aprile 1913), 1050.

picturesque term. The concept of dynamism did not originate with Futurism either, but in time it was so exhaustively embraced and exploited that it became synonymous with the movement. This concept rejected the idealist notion of a static, changeless reality – a rejection derived from the metaphysics of Nietzsche and Bergson and from positivist and pragmatist epistemology. Such a dynamic philosophy was latent in Marinetti's earlier writings, notably *Le Roi Bombance*, but in the First Manifesto it was asserted explicitly in the cry, 'Let us go . . . my friends! At last Mythology and the Ideal have been outdone.' Whereas in the play the artist was represented as an outsider, though half reluctantly, in the manifesto Marinetti proposed a reconciliation of art and life by enjoining the artist to 'shake the gates of life in order to test the bolts and the hinges!' The artist was to abandon the life of passive contemplation and take his place in the figurative centre of the world's ceaseless activity, which he was to direct and follow simultaneously: 'We shall sing of the man at the steering wheel whose ideal stem [*tige idéale*] transfixes the Earth, racing over the circuit of her orbit.' Thus movement, i.e., activity or change, was equated with reality and life and was hence to be the essence of art. The manifesto gives many examples of the various kinds of movement, ranging from rapid locomotion made possible by the new automobile and the aeroplane to speed extolled as the only absolute universal. It passes from approbation of any vital human activity to glorification of specific forms of bodily and intellectual exertion and agitation: conflict, violence, misogyny, anarchism, and ultimately war are welcomed as expressions of universal dynamism. In fact the entire manifesto – its fierce language, abrupt tone, change of images, deliberate exaggeration and insults – is permeated with this sense of vitality. It was undoubtedly the all-embracing dynamism, more than the specific recommendation, which had the most unsettling effect on the reader of 1909.

Fauvism and a Machine Aesthetic

The manifesto's dynamism is related to the spirit of the French Fauves. Although this name – literally wild beasts – had been given to the group of painters whose explosively coloured canvases caused great excitement at the Paris Salons of 1905–6, a similar attitude had previously manifested itself during the decade of reaction against the Symbolists' nebulosities. It found its most typically Fauve expression in the writings of Alfred Jarry. Generally speaking, the Fauve spirit can be defined as an inversion of Verlaine's Symbolist axiom to 'pas la nuance, rien que la couleur', as Christopher Gray has suggested.[1] Some of Marinetti's earlier pieces had shown a

[1] Christopher Gray, *Cubist Aesthetic Theories* (Baltimore, 1953), 26.

similar approach, and the First Futurist Manifesto not only sounds Fauve but even specifically alludes to that controversial group. Marinetti uses the image of young lions for himself and his friends who escape from the past in automobiles and whom he exhorts to 'assister à la naissance du Centaure' – the traditional Greek symbol for animal desires and barbarism. And in their hectic drive through narrow streets animal instinct was to be the only guide: 'Here and there wretched lamps in windows taught us to scorn our mathematical eyes. – The scent . . . alone is enough for wild beasts!' A month or so later in his *Tuons le clair de la lune*, these Italian Fauves replaced the pale green moonlight – illumination of Symbolist and D'Annunzian visions – with three hundred glaring electric 'moons'.[1]

But the French Fauves' attempt to establish a full-blooded art was still based on the past and represented only one side of the new aesthetic attitude which was being affirmed in the first decade of the century. More important for the immediate future was the *avant-garde*'s awareness of the machine, both as an unlimited and as yet untapped source of artistic inspiration and as a figurehead for the anti-traditional dynamism of the new century. In 1909 perhaps no one better understood these possibilities than Marinetti.

Such visionaries as Zola, Whitman, Verhaeren and the younger writers Wells, Jarry, and others had perceived the aesthetic potentialities of the machine long before Marinetti, who had followed their leads in 'Le Démon de la vitesse' and 'A l'automobile'.[2] But most of these men, and especially Jarry, had seen the machine as a dual symbol – 'a thing of beauty and a curse'. On the other hand, by 1906 Henry Adams had made a declaration of faith in the machine as a modern symbol and modern force to be reckoned with. To him the Dynamo represented infinity and 'ultimate energy', and was the 'most expressive' icon for the new century.[3] It is doubtful whether Marinetti, or anyone in France at that time, was familiar with Adams' ideas. Yet Italy too had produced a prophet of the machine aesthetic in Mario Morasso (1871–?). Now almost entirely forgotten, this critic, writer, journalist and philosopher of sorts enlivened the increasingly reactionary pages of *Marzocco* between 1902 and 1905 with such provocatively entitled essays as 'The Aesthetics of Speed', 'The Heroes of the Machine', and 'The Great Flight'. The machine's poetry and symbolic importance for the twentieth century occupied him as much as it did Henry Adams, and he

[1] *Poesia*, v nos. 7–9 (Agosto-Ottobre, 1909), 6. See also Marinetti's later article, 'Nous renions nos maîtres les Symbolistes, derniers amants de la lune', *Le Futurisme* (Paris, 1911), 82 ff.

[2] See N. Pevsner, *Pioneers of Modern Design* (New York, 1949), 11–12.

[3] *The Education of Henry Adams. An Autobiography* (Boston and New York, 1918), 380. It was first published privately in 1906.

expounded it in books as well as in articles.[1] Morasso was more practical than the American and much concerned with the image of the machine in the visual arts. He held that the modern artist must 'know and love . . . [machines] and grasp their energies and great destinies' in order to render their spirit and beauty, which should evolve from their function: 'A racing car will be called beautiful when it appears as light and nimble as possible, . . . [and] the more it approaches the ideal form of a knife cutting through the air.'[2]

Although Marinetti never mentioned Morasso in his writings, he certainly must have been stimulated if not directly influenced by his ideas. Marinetti's truculent cry in 1909: 'A racing car . . . is more beautiful than the Victory of Samothrace' was a climactic statement of the insistent role of the machine in modern art. Elevated in the First Manifesto to the Pegasus and saviour of the artist, the machine was to be instrumental in the new if temporary truce between art and science.

Apollinaire, whom Marinetti had known since his early days in Paris, later also celebrated the creative vitality of the machine age, which he baptized l'esprit nouveau in 1918.[3] Although his poetic interests ranged far and wide, he, like many other artists and intellectuals, benefited from Marinetti's forceful pronouncements which summarized the attitudes of many of the young and rebellious.

The Artist as Agitator

One further important idea conveyed by the manifesto was the way in which the artist was to take his envisaged position as guide to this ever-changing promised land. Marinetti has recorded that in 1908, having laboured several years for *Poesia*, he realized that 'articles, poems and polemics were no longer adequate. It was necessary to change methods completely, to go out into the streets, to launch assaults from theatres and to introduce the fisticuff into the artistic battle.'[4] The artist had to become an agitator to gain a hearing. Marinetti obviously had political agitation in mind when he adopted its time-honoured weapon – the manifesto. Although in use as an artistic propaganda tool in anti-academic uprisings even before the French Revolution, in the course of the nineteenth century the manifesto had lost some of its

[1] *Marzocco*, VII no. 37 (14 Settembre 1902), 1–2; VIII no. 8 (22 Febbraio 1903), 3; VIII no. 15 (12 Aprile 1903), 1; VIII no. 48 (29 Novembre 1903), 3. See also *L'Imperialismo artistico* (Torino, 1903), especially the chapter 'Il Monumento e le sue arti'; *La Nuova arma: la macchina* (Torino, 1905).

[2] *Marzocco*, x no. 26 (25 Giugno 1905), 2; VII no. 37 (14 Settembre 1902), 2. Morasso contributed once to *Poesia*, 'L'Artigliere meccanico', II nos. 6–8 (Luglio-Settembre 1906), 24–5, as well as to numerous other journals such as *Il Regno* and *L'Illustrazione Italiana*.

[3] G. Apollinaire, 'L'Esprit nouveau et les poètes', *Mercure de France*, CXXX (1 Décembre 1918), 385 ff.

[4] *Guerra sola igiene del mondo*, 5.

militancy.[1] But in the Futurist proclamation Marinetti took up again the challenging tone of its political ancestors. It is traditionally divided into the accusation, numbered articles of proposed reform, and finally the prophecy of new horizons visible only to the artist who 'stands on the crest of the world ... cast[ing his] challenge to the stars!'

Extension to the Other Arts: Painting

Although the First Manifesto was intended to apply to all creative endeavour – indeed to all of human existence – and although it made only a few specific references to literature, its origins and immediate relevance were predominantly literary.[2] Marinetti seems to have thought it advisable, therefore, to support and advertise the adherence of non-literary men to the movement by publishing more specific programmes announcing the extension of Futurism to other arts. Thus after a year's feverish solo activity,[3] the first such statement – the Manifesto of the Futurist Painters – was read by Boccioni on 8 March 1910, from the stage of the Teatro Chiarella in Turin. Its original version, dated 11 February 1910, seems to have been signed by five Milanese painters – Boccioni, Carrà, Russolo, Bonzagni and Romani – of whom only the last-named had been an active member of the *Poesia* circle.[4] A more prosaic, less symbolic, but equally belligerent, reiteration of the main arguments of the First Manifesto, this one added a few references to the figurative arts which will be discussed in the next chapter. It contained most of the relatively traditional ingredients of its predecessor: Stress on contemporary subjects,

[1] See N. Pevsner, *Academies of Art Past and Present* (Cambridge, 1940), 198 ff., and *passim*. Eleven years earlier, Hermann Bahr, the apologist of the Viennese *Sezession*, had come to a similar conclusion when – with keen insight into mass psychology – he recommended that the artist 'must know how to make oneself hated. The Viennese respects only those people whom he despises. The Viennese painters will have to show whether they know how to be agitators. This is the meaning of our Secession.' Quoted in Selz, *German Expressionist Painting*, 149.

[2] In *La Vogue*, II no. 7 (15 Juillet 1899), 25 ff. Marinetti reviewed the Venice Biennale. This appears to have been his only early venture into the plastic arts. He evidently found himself in unfamiliar territory and his taste was strongly influenced by his Symbolist associates.

[3] In the course of the year Marinetti's poetry readings were turned into Futurist demonstrations, the precursors of the Dada *soirées*. See Pl. II which originally appeared in the *Pasquino* of Turin and may refer to the 15 January 1909 performance of Marinetti's play *La Donna è mobile* at the Turin Teatro Alfieri. According to *Poesia*, V nos. 3–6 (Aprile–Luglio, 1909), 9, the play was fiercely hissed and Marinetti thanked the audience from the stage for this reception. He stated later that he read the Foundation Manifesto on this occasion. See C. Baumgarth, *op. cit.*, 36 ff., for discussion of other early Futurist *soirées*.

[4] See below, pp. 71–72.

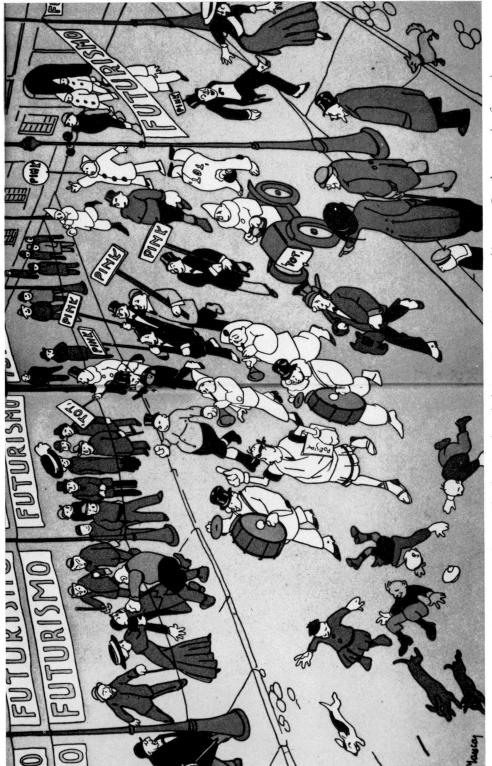

11. Manca. *Après une grande assemblée futuriste.* (1909). (From *Poesia*, V nos. 7–9 (Agosto–Ottobre 1909), after 46)

repudiation of the past, dismissal of accepted standards and the call to youth; it even begins 'Agli artisti giovani d'Italia'.[1]

The earnest tone and basic principles of these young artists recall the aims of the *macchiaioli*, who at the time were finally being discovered by the Italian public. The Florentines would have agreed with the Futurists that 'Only that art which finds its components in its surroundings is vital. Just as our ancestors received substance for their art from the religious atmosphere which imposed itself upon their spirits, so we should draw inspiration from the tangible miracles of contemporary life.'[2]

There are pointed digs at the so-called mentors of culture – the critics and their ilk – who, according to the Futurist painters, had reduced 'Italian art to the ignominy of real prostitution', by their failure to recognize Segantini, Previati, and Rosso. The critics' opinions, couched in such vague and elastic words as 'harmony' and 'good taste' were derided as capable of destroying even the work of Rembrandt and Goya. The artist-signatories took pride in being dubbed lunatics by these taste-makers. But although they approved of irrationality, they did not look to it as a source of artistic inspiration, as had been recommended by the First Manifesto. The artists' proclamation was rather intended to encourage indifference to the lack of public comprehension and support.

Dynamism, especially speed – its most characteristic Futurist form – was not treated as an independent artistic value.[3] Instead, vitality and change were postulated in terms of scientific progress or, in the arts, originality. Originality was demanded at all costs, 'even if reckless, even if extremely violent'; for if the artist portrayed daily life which was 'incessantly and tumultuously transformed by victorious science', he would cast off the shackles of the past. He would become free, and aware of the 'magnificent radiance of the future'.

It follows that the chief distinction between the two Futurist manifestos lies not so much in the greater practicality of the second, but in their different philosophical backgrounds. The painters emerge as latter-day descendants of the nineteenth-century positivists and their Realist-Naturalist exponents in art, whereas Marinetti's manifesto had incorporated some of the current *avant-garde* ideological mixtures derived from Bergson, Nietzsche and others.

[1] Unless otherwise indicated, this and the following quotations are taken from the original Futurist manifestos. These appeared originally as broadsides. All except the *Manifesto dei drammaturghi* were reprinted in *I Manifesti del futurismo* (Florence, 1914); the painting manifestos are contained in *Archivi*, I.

[2] From conversation with the late Vico Baer, a close friend and supporter of Boccioni, it appears that the Futurists and Boccioni especially admired the *macchiaioli*. Boccioni helped Mr Baer to assemble a collection of *macchiaioli* paintings.

[3] It is mentioned only incidentally in the enumeration of new subjects.

Only five weeks later, on the canonical 11th day of April 1910, the artists made news again, this time with a *Manifesto tecnico* of Futurist painting.[1] This document may have been conceived in reply to queries and attacks urging the painters to be more specific in their commitments to the figurative arts. The second paragraph declares somewhat defensively: '[Previously] we were concerned . . . with the relation between ourselves and society. Today, instead, with this second manifesto, we resolutely shake off all relative considerations and aspire towards the loftiest expressions of the absolutes of painting.' Only a week earlier an exhibition which included the work of the Futurists had closed at the Milanese Famiglia Artistica. Compared with their proclamation, the painters' work had seemed so mild and unrevolutionary that there was some question as to whether any distinguishing factor existed between Futurist and non-Futurist art. The painters' answer was given in the third paragraph in typically grandiose rhetorical style: 'Our longing for truth can no longer be satisfied by traditional Form and Colour!' There follows a searching and inventive exposition of Futurist dynamism. The careful and consistent formulation of this central Futurist principle added much-needed substance to the outline of dynamism set forth in the First Manifesto. Thus the Technical Manifesto of Painting, despite its pictorial orientation, is the chief theoretical statement of early Futurism as a whole. It was improved upon only in 1912 with Marinetti's Technical Manifesto of Futurist Literature and Boccioni's Technical Manifesto of Futurist Sculpture, and both of these are in a sense further elaborations of the painters' technical statement.

The technical manifesto differed profoundly from the painters' first broadside. Its style, which rivalled that of Marinetti's First Manifesto, united directness and technical accuracy with what in retrospect might be called quasi-Cubist fragmentation of images and meanings. This poses the apparently insoluble problem of the manifesto's authorship. What part did Marinetti play? It is almost certain that he pulled this manifesto, like most of the others, into its final shape. But the highly technical knowledge displayed makes it improbable that he did much more than that. Boccioni is occasionally mentioned as the author, but it seems more likely that the Milanese artists formulated it together, with Boccioni setting it down on paper. Within the short span of less than two months the painters had broadened their ideological horizons to such an extent that they were able to combine Marinetti's complex, modern view of the world with remnants of their previous positivism. They

[1] The dates given at the bottom of the manifestos – except the Futurist Foundation Manifesto – do not necessarily mean the date of publication. Usually the date printed preceded the manifesto's actual appearance, but it is difficult to verify the length of this gap. The Technical Manifesto is mentioned on 19 April 1910 in *Il Secolo*, Milan.

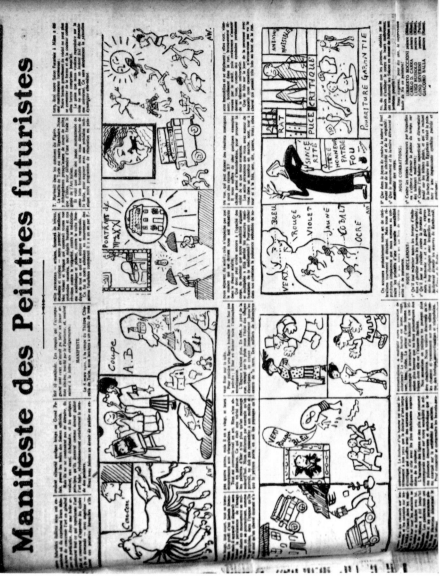

III. French version of the Technical Manifesto of Futurist Painting with caricatures by André Warnod. (From *Comœdia*, IV no. 961 (18 Mai 1910), 3)

apparently preferred this manifesto to their earlier one, which was rarely cited after 1910 and not translated into French. The *Manifesto tecnico* was translated in full as *Le Manifeste des peintres Futuristes* and appeared in the Paris *Comoedia* on 18 May 1910, with caricatures by André Warnod. (Pl. III).[1]

Drama and Music

Futurism was extended to still other creative fields in the next three manifestos. Although none of them deals with the plastic arts, their programmes throw additional light upon the development of Futurist ideas in the formative stage of the movement. Moreover, many of the cardinal points brought up are relevant to all the arts. This solidarity is partly due to Marinetti's domination and partly to the close-knit quality of the group. The intellectual give and take shared by all the participants is a particularly interesting phenomenon also to be found in contemporary and later European vanguard movements such as the various Russian groups, Dada, and de Stijl.

First to be published was the *Manifesto dei drammaturghi* (Dramatists' Manifesto) which was signed by Marinetti alone, as self-appointed spokesman of the dramatic as well as the literary wing. It is dated 11 October 1910.[2] Resuming the forceful, direct tone of the painters' first manifesto, it states simply and clearly the Futurist prescriptions for revitalization of the theatre. But a large portion of this manifesto is devoted to bolstering the dramatist's morale and preparing him to swim against the tide of public opinion. It seems that while the audience is to be hated ('We futurists teach authors above all contempt for the public'), it must also be educated if new values are to be given a hearing. As in the painters' first manifesto, originality was the prime requisite, but to ease its reception, Marinetti suggested that some sort of explanation was needed. Although the nature of the explanations is not specified, he probably had in mind the kind of commentary he offered with his readings of contemporary poetry, or in Futurist *soirées* and manifestos.

As might be expected, Marinetti proposed that Futurist drama should deal with 'some part of the great Futurist dream . . . excited by the speeds on the earth, the sea, and in the sky and dominated by steam and electricity, . . . [and that the] sensation of the power of the Machine' be introduced into the theatre. Futurist 'modernolatria' was to form the dramatic core.

[1] Benedetta (Benedetta Marinetti), 'Le Futurisme', *Cahiers d'art*, xxv (1950), 11 and Gino Severini *Tutta la vita di un pittore* (Milano, 1946), 118, mistakenly date this publication in 1911.

[2] This manifesto is rarely listed among the Futurist statements, although it forms a chapter in Marinetti's *Le Futurisme*, 107 ff. The more unconventional manifesto, *Il Teatro di varietà* of 1913 supplanted it. See below, p. 136.

The last programmatic manifestos in the first phase deal with music. On 11 January 1911, Francesco Balilla Pratella[1] issued the *Manifesto dei musicisti futuristi*, succeeded by *La Musica futurista, manifesto tecnico* on 29 March 1911.[2] The first, general statement again follows the painters' first manifesto in repeating the stock Futurist principles as they applied to the Italian music of the time. Emulating Richard Wagner's notion of the *Gesamtkunstwerk*, Pratella exhorted the composer to write his own libretto – in free verse, as Marinetti had recommended to the dramatists – and with as much care as his music. Still greater emphasis was laid upon the education of the public. Pratella contended that one of the goals of the Futurist musician is 'to provoke in the public an ever increasing hostility against the exhumations of old works which prohibit the appearance of new masters'. Three months later, in the technical manifesto, he declared that the present insurgent young musicians, 'the experts of tomorrow, will be the guides and objective collaborators of the students to come'. This image is very different from that of the solitary phalanx of explorers at the antipodes of the earth, tremblingly conscious of their brief creative span and influence, of whom Marinetti sang only two years before in the First Futurist Manifesto.

Pratella's technical manifesto – in many ways comparable to that of the painters – expounded the aims of Futurist music in much greater detail. Like the painters, Pratella showed himself aware of the various more or less advanced trends in his field. Discarding the traditional values of consonance and dissonance, he advocated the tonal, modal, and rhythmic changes with which a number of European composers were experimenting.[3] But for the composer the modern world was not cited as a pivotal point. The reason is obvious enough, since music is not, broadly speaking, a 'representational art'. As if to make up for this omission, the final sentence of the manifesto – as a kind of afterthought – established that the musician must '*Add* [italics mine] the power of the machine and the victorious reign of electricity to the great central motifs of the musical poem'. In 1913 this phrase, perhaps imposed

[1] Francesco Balilla Pratella was born in 1880 at Lugo in the Romagna and trained at the Liceo Musicale at Pesaro. His masters were Cicognani and Mascagni. Both his early operas, *Lilia*, performed in 1905, and *La Sina d'Vargöun*, performed in 1909, had texts written by him as well. It is not known how and when he met Marinetti. B. Pratella, *Appunti biografici e bibliografici* (Ravenna, 1931), *passim* and *Grove's Dictionary of Music and Musicians* (London, 1954), VI, 913–14.

[2] Although the first manifesto bears the date of 11 January 1911, it is dated 11 October 1910 in Pratella, *Musica futurista per orchestra; riduzione per pianoforte* (Bologna, 1913?). The date for the second manifesto is given variously 11 or 29 March 1911.

[3] See Nicolas Slonimsky, *Music Since 1900* (New York, 1949), 90–1, *passim*. Ives had begun to experiment with polyrhythmy in 1904, Schönberg's second *Klavierstück*, the beginning of atonal music, was composed in 1909, etc. Such ideas were in the air.

or added by Marinetti, became the central thesis of Russolo's daring conception of the Art of Noises.

Looking back at the Futurist proclamations made before 1912, we can discern a few significant changes in attitude in three years of existence. To a certain extent these resulted from internal conditions, such as the adaptation of the Futurist doctrine to other arts and the intervention of new personalities. A more general development is expressed in the shift from the symbolically evocative, sometimes elliptical assertions of the First Manifesto to the explicit didacticism of the later ones, especially those dealing with technique. In the course of three years the Futurists had realized that they must support their roles of visionaries and leaders with the more practical ones of teachers and guides. The technical manifesto became a kind of handbook symptomatic of the change. Many rebelled against this role and Boccioni remarked pointedly in 1912 that 'it is practically impossible to express the essential values of paintings in words'.[1] At the same time he and his companions were awed by that 'new monster: the PUBLIC'. Subsequently he justified his activities as a master Futurist apologist and theorist by asserting that 'Only the painter who thinks well can see well'.[2] By 1912 the Futurists had bowed to the fact that an artist cannot exist without an audience.

[1] Bernheim-Jeune et Cie, *Les Peintres futuristes italiens* (Paris, 1912), 10. Reprinted *Archivi*, I, 107.
[2] Umberto Boccioni, *Estetica e arte futuriste* (Milano, 1946), 39; see also 137. Unless otherwise noted, this edition of Boccioni's *Pittura scultura futuriste (Dinamismo plastico)* (Milano, 1914) will be used.

V

FUTURIST PAINTING THEORY AND ITS SOURCES

MARINETTI had made only one specific reference to the plastic arts in the First Manifesto, apart from his notorious elevation of the automobile over the Victory of Samothrace in the aesthetic hierarchy. After comparing museums to cemeteries, he warned the artist of the overpowering effect past works of art could have on fragile creative sensibilities and bid them stay away from museums. But one wistful concession mitigated the tone of total iconoclasm: 'Let us make one visit a year [to the museums] just as one goes to see one's dead once a year . . . Let us even place flowers at the foot of *La Gioconda* once a year.'

In their first manifesto of February 1910, the painters adopted Marinetti's therapeutic statements as part of their general dependence on his First Manifesto, adding little that was new and specifically relevant to painting. They advocated a more honest and aggressive approach to art, denouncing the easy success won by catering to popular taste. The artist was to 'Sweep the ideal camp of art free of all previously exploited motifs and subjects'. But apart from general directions to express the changing modern world, the artist was still left in the dark as to the kind of art the Futurist painters really had in mind. The single clue was given in their second point: 'Profoundly to despise all forms of imitation.' This warning evidently applied not only to art of the past, but to imitation of various current forms of drawing-room realism and earnest social realism as well. Not until the appearance of the technical manifesto two months later were the characteristics of Futurist painting finally itemized and the means of their realization discussed. The fundamental premise is stated metaphorically at the beginning of the manifesto, and repeated more simply, with a slightly different emphasis, at its conclusion: 'For us the gesture will no longer be an *arrested moment* of the universal dynamism: it will clearly be the *dynamic sensation* itself made eternal . . . the universal dynamism must be rendered as dynamic sensation.'[1] These sentences establish the two interlocking directions which Futurist painting and, in a broad sense, all Futurust art was to take. It was (1) to concern itself

[1] Unless indicated, this and the following quotations are from the Italian version of the painters' manifestos published as broadsheets. The French version of the Technical Manifesto, the *Manifeste des peintres futuristes*, omits the words 'made eternal'.

with the emotional expression of the vital impulse as revealed through 'gesture';[1] (2) to present the temporal extension of this perception. In other words, Futurist dynamism was to be rendered in terms both of psychic and physical phenomena.

The Futurist painters were undoubtedly aware that they had established difficult requirements, and having blithely tossed academic rules and methods to the winds, they looked to science both for example and inspiration. 'Today's science, [which] discards its past [achievements], responds to the material necessities of our time; similarly, art, disowning its past, must meet the intellectual needs of our time.' They drew especially upon the much discussed psychophysics and psychophysiology of visual perception for analogues which could be explored in representations of their new dynamic image of the world. For instance, the phenomenon of after-sensation of seen movement[2] largely accounts for their chief proposition that: 'Everything moves, everything runs, everything changes rapidly. A figure is never motionless before our eyes, but continuously appears and disappears. Because of the persistence of the image upon the retina, moving objects are multiplied, deformed, succeed each other like vibrations within the space through which they run. Therefore a race horse does not have four legs; it has twenty and their movements are triangular.' Irradiation and the various types of geometrical optical illusions[3] could produce effects such as those described below. While these recall certain ideas suggested by the canvases of Van Gogh or Munch they anticipated the more daring ones of the German Expressionists: 'Space no longer exists: a rain-drenched street illuminated by electric lights will form an abyss down to the centre of the earth. The sun is thousands of miles away from us, yet does not the house in front of us appear to be set into the solar disk?' Because the perception of light and movement thus destroys the apparent autonomy and inviolability of objects in space, and hence conventional concepts of space,

[1] Marinetti may well have suggested the metaphor of the 'gesture' to the painters, because the idea of gesture as spontaneous expression of spiritual life was central to literary Symbolism. See A. G. Lehmann, *The Symbolist Aesthetic in France* (Oxford, 1950), *passim*; Henri Bergson, *Laughter* (New York, 1911), 143. G. P. Lucini's *Il Verso libero* (Milano, 1908) may also have given the artists some leads; unfortunately, this book was not available to me when this was written. See Baumgarth, *Geschichte des Futurismus, passim*.

[2] The preoccupation with this phenomenon was probably stimulated by the contemporary development of the moving picture, which is based on this sensory illusion. For a technical discussion and the history of its scientific explanation see Edwin G. Boring, *Sensation and Perception in the History of Experimental Psychology* (New York, London, 1942), 588 ff.

[3] Leonardo had already noted that whites tend to be larger than blacks, but the phenomenon of irradiation was more fully studied in the nineteenth century. The problem of geometrical optical illusions which affect the visual perception of space was a particularly popular subject of study during the 1890s, and this led to the new theory of space perception of the Gestalt school. E. G. Boring, 238–52.

F

the artist's attention was to be called to startling spectacles like the following: 'The sixteen people around you in a moving tram are one, ten, four, three; they stand still and move; they come and go, they leap into the street, are swallowed up by a zone of sunlight and then come back and sit down . . . And sometimes we see on the cheek of the person to whom we are talking a horse which passes by in the distance. Our bodies penetrate the benches on which we sit and the benches penetrate our bodies, just as the passing tram penetrates the houses which in their turn hurl themselves upon the tram and merge with it.'[1] That the Futurist painters concerned themselves with such phenomena is suggested by Boccioni's and Carrà's accounts of specific experiences which reportedly formed the basis for some of the manifesto's propositions.[2]

The artists' search for a new experience and interpretation of the universe was accompanied by a desire to provide fresh angles for perception of their work. Like Marinetti, they believed themselves to be situated at the heart of the world and recommended a corresponding position for the spectator 'in the centre of the picture'. In this projected transposition of the artist (and the spectator) into the creative core of life, they were reflecting the Futurist desire to regain a leading position in society. In the purely artistic sense, the painters were trying to break down the traditional psychological distance between the aesthetic object and the spectator. Their principle was that of empathy, which at the time had theoretical spokesmen in France, Germany and Italy.[3] It is based on the hypothesis of an unconscious physical response to, and consequent psychological identification with, the object contemplated.

Such unorthodox modes of seeing and representation obviously demanded an untrammelled consciousness. The Futurists considered themselves 'the Primitives of a new and completely transformed sensibility', and called for a similar spiritual purity in the spectator: 'To conceive and understand the novel beauties of a modern painting, the soul must again become chaste; the eye must free itself from the veil with which atavism and culture have covered it and look to nature and not the museum . . . as the unique control.'

[1] The disparity between the retinal images of the two eyes may partly account for the apparent transparency and interpenetration of objects described in the passage quoted. Again Leonardo seems to have noted this, for he speaks of the apparent binocular transparency of the opaque object. E. G. Boring, 282–4, 307–8.

[2] Boccioni, *Estetica*, 98–99; Carrà, *La Mia vita*, 73–74. See also Severini 'La Peinture d'avant-garde', published 1917, reprinted *Archivi*, I, 213–14.

[3] Croce analysed Lipps' psychology and aesthetic in his own *Aesthetic* (London, 1909), 347–8. Marinetti no doubt heard of Charles Henry's researches through his friend Gustave Kahn, who had attempted to apply some of Henry's theories in his poetry. J. Rewald, *Post-Impressionism* (2nd edition, New York, 1962), 184, note 28.

This brings up the attitude of the Futurist painters towards 'artistic truth', 'nature', and 'reality'. Although their views were not yet clearly formulated they subscribed to an aesthetic relativism in keeping with their philosophy of dynamism: 'Everything in art is convention, and the truths of yesterday are today, for us, pure lies.' The artist was the subjective transmitter of an ever-changing truth which was, however, subject to the laws of nature. They prescribed 'sincerity and virginity in the interpretation of nature'; but they did not mean to say that the artist should paint what was commonly accepted as visual reality. Instead he was told to draw upon an internal, conceptual image of reality and was reminded 'that the portrait in order to be a work of art neither must nor can resemble the sitter, and that the painter carries within himself all the landscapes which he wishes to create'.

Some of the actual technical problems of executing Futurist dynamism were also taken up in the manifesto, as promised in the title. The expectations aroused by the painters' grandiloquent claim in the first paragraphs, that traditional form and colour would no longer suffice, are later somewhat deflated by the recommendation of *complementarismo congenito*, a form of Divisionism, as the basic technique. Today it is not entirely clear as to how 'innate complementarism' was understood in the early days of the movement.[1] The manifesto explained that 'we conceive of divisionism not as a technical *process* which can be methodically learned and applied. To the modern painter divisionism must mean *innate complementarism* which we deem essential and inevitable.' From this vague definition, and from their comparison of *complementarismo congenito* to free verse,[2] it appears that what the artists had in mind was more than a specific technique, but a general rejection of academic formulae which inhibited spontaneous perception and the free flow of emotional expression. Thus the innate optical and physiological reactions implicit in Divisionism were regarded as mere points of departure. The Futurists evidently wished to explore other instinctive perceptive processes in their creations and may well have hoped to draw upon the findings of the then fashionable parapsychology. Hence *complementarismo congenito* may partly have been conceived as an occult spiritual experience bringing the artist in closer touch with the universal forces. Their own statements support such an approach: 'Who can still believe in the opacity of bodies,' they asked, 'when our sharpened and multiplied sensibility allows us to perceive the obscure disclosures of mediumistic phenomena? Why should we continue to create without taking into

[1] In reply to a question, sent to Severini in 1958, about the original meaning of *complementarismo congenito*, he said: 'La phrase: "complementarismo congenito" . . . voulait dire que désormais le divisionisme et complementarisme étaient devenus une habitude, une chose naturelle.'

[2] In the first conclusion of the technical manifesto. *Archivi*, I, 67.

account our perceptive powers [*potenza visiva*] which can give results analogous to those of X rays?'[1]

The more general technical recommendations were less equivocal. The painters dismissed 'the false *avvenirismo* of the secessionists and independents, new academicians of all countries . . . [and] the superficial and elementary archaism based on flat colours which reduces painting to an impotent synthesis, both childish and grotesque . . . [the latter being a reference to the *stile liberty*, and] the patina and varnish of the false old masters'. Above all they wanted to exclude 'the nude in painting', which would rob the academy of its chief stock-in-trade. This principle also made explicit the pantheism of Futurist dynamism. When man was portrayed, he was to be dressed in modern clothes, whose 'musicality of line and fold have for us an emotive and symbolic power equal to that which the nude held for the ancients'. But man was deprived of the monopoly on psychic states with which he had been endowed by the humanist tradition. His passion and anguish were to be of no more interest to the artist than those of any other bundle of molecules, for example 'an electric lamp which suffers, writhes and shrieks with the most heart-rending expressions of colour'.[2] This declaration opened the way to the less romantic conception of animated matter which characterized later Futurist art and theory in particular.

Sources: Soffici's Interpretation of Cézanne, Impressionism and Medardo Rosso

Futurist painting theory as outlined in the technical manifesto was in essence an adaptation of Impressionism leavened by Symbolist and other current ideas. These debts were fully and repeatedly acknowledged, especially by Boccioni in his 1914 *Pittura scultura futuriste*, in which he declared: 'our [technical] manifesto was founded on Impressionism'. But with characteristic shrewdness he minimized Futurism's dependence by asserting that 'today there does not exist in Europe or in the world a trend in painting or sculpture . . . which is not derived from French Impressionism.'[3]

None of the signatories of the painting manifestos could claim an intimate knowledge of French art comparable to Marinetti's in the field of literature.[4] But a key to local interpretations upon which they could have drawn when formulating their

[1] Boccioni, *Estetica*, 190–1, confirms the interest in parapsychology and calls attention to the work of Charles Richet.

[2] In the broadside editions (Italian and French) of this manifesto the word 'colore' is used, as also in Boccioni's *Pittura scultura futuriste* (Milano, 1914), 367. In *Manifesti del futurismo*, 29, 'dolore' appears instead. 'Colore' would seem more in keeping with the Fauve tendencies of the Futurists.

[3] Boccioni, *Estetica*, 97, 98, 53, and *passim*.

[4] Severini, who was living in Paris, probably did not contribute anything to this manifesto.

artistic precepts is supplied by the writings of Ardengo Soffici. One of the first important articles on French art by this painter-critic to be published in his native country was devoted to Cézanne; it appeared in *Vita d'arte* in 1908 and was one of numerous statements to result from the large Cézanne retrospective at the 1907 Salon d'Automne in Paris. Soffici seems to have based himself on Maurice Denis' Symbolist interpretation of Cézanne of that year.[1] He presented the painter as an impassioned seeker of truth and made Cézanne's method sound like an anticipation of the aggressive, expressionist vitalism postulated by the Futurists. Cézanne's art was seen as 'a philosophy in action . . . Because nature appears as a colossal hieroglyph to a spirit starved for the absolute, which only an enraptured soul can decipher, Cézanne wished to assault and violate [nature], exploring her to the blood and bone.'[2]

Soffici's critique of Impressionism – even more suggestive to the groping Futurists – was printed during 1909 in *La Voce*[3] and climaxed in April 1910 by the first French Impressionist exhibition and Medardo Rosso's first one-man show in Italy.[4] Soffici revealed again an essentially Symbolist approach, but he now invoked the radical, unorthodox authority of Jules Laforgue rather than following later and weaker Symbolist critics. Laforgue was singled out as one of the exceptional few who truly understood Impressionism and the movement's bold rejection of absolute and objective standards of beauty. Soffici underlined the poet's interpretation of Impressionism as a revolutionary effort with Laforgue's celebrated declaration of artistic independence, which must have struck a loud chord in the Futurists' anarchic spirits: 'Every

[1] *Vita d'arte*, IV no. 24 (Dicembre, 1909), 505–14, published an article on Denis by Soffici which was written in 1908. Denis, like Cézanne, is made an heir of the Italian artistic tradition.

[2] *Vita d'arte*, I no. 6 (Giugno, 1908), 320–31, reprinted with slight changes in *Scoperte e massacri*, 49. Soffici knew two famous early collectors of Cézanne's works, Egisto Fabbri, an Italian who lived in Paris, and Charles Loeser, an American living in Florence who, according to Gertrude Stein, introduced Leo Stein to the work of this artist in 1903. A Soffici, *Autoritratto d'artista italiano nel quadro del suo tempo. Il Salto vitale* (Firenze, 1954), 531. *Fine di un mondo*, 157; *The Autobiography of Alice B. Toklas* in *Selected Writings of Gertrude Stein* (New York, 1946), 25–26.

[3] Reprinted in *Il Caso Medardo Rosso* (Firenze, 1909) which appeared in July, 1909. Soffici's articles on Impressionism started out as reviews of two books on this subject, Camille Mauclair's *L'Impressionnisme. Son histoire, son esthétique, ses maîtres* (Paris, 1904) and Vittorio Pica's *Gli Impressionisti francesi* (Bergamo, 1908).

[4] These exhibitions were held simultaneously at the Lyceum Club in Florence, opening on 20 April 1910. The sculpture remained on view throughout May, the paintings were taken down on May 15. The exhibition catalogue was not available to me, but *La Voce*, II no. 18 (14 Aprile 1910), 303, and no. 23 (19 Maggio 1910), 317, give a fairly complete picture of what was shown. There were six Cézannes, some of them lent by Loeser. Rosso had shown some of his work in Italy on three earlier occasions: Esposizione di Belle Arti, Rome, 1883; Esposizione Internazionale Artistica, Venice, 1887 and Società degli Amatori e Cultori di Belle Arti, Rome, 1903, no. 559.

man is . . . a keyboard on which the external world plays in a certain manner. My keyboard is perpetually changing and there is not another identical to mine . . . All keyboards are legitimate.'

To Soffici, as to Edmond Duranty before him, the Impressionists were 'the primitives of a new epoch'. He praised especially their transformation of the academic concept of '*disegno* . . . [into] a mystical writing . . . suitable to the transposition and translation of sentiments which objects evoke in the sensibility of the person contemplating them'. This foreshadows the Futurists' empathetic identification with the objective world. Soffici also admired the Impressionists' daring *mise en cadre*, explaining that this resulted from the suggestion of an infinite expansion beyond the frame, the unexpected juxtaposition of objects and, above all, the interdependence of objects and surroundings. By the giving of equal importance to every constituent of the picture, the '*ambiente*'[1] became a dominant expressive element.[2]

This last point was again much stressed in Soffici's provocative discussion of Medardo Rosso – also of 1909 – in which he elaborated upon the sculptor's own ideas. Rosso, as transcribed by Soffici, held 'that sculpture should not be condemned to produce solely beautiful forms isolated in space and enclosed by definite, static, certain lines; forms are thus almost imprisoned in a profile of immobility, shaved off from the whirling centre of universal life, remaining there stiff and still to be examined from all sides by curious spectators'. The sculptor demanded therefore that a piece of sculpture should be conceived not only as a part of the life surrounding it, but that its suggested movements should express the greater cosmic rhythms as well. 'The movements of a figure must not stop with the lines of its contour, . . . but the intensity of the play of values and the protrusions and lines of the work should impel it into space, spreading out to infinity the way an electric wave emitted by a well-constructed machine flies out to rejoin the eternal force of the universe.' It is a short step from such a concept of the union of works of art with the universal flux to Futurist dynamism as illustrated in the images of the technical manifesto, particularly since Rosso maintained that 'nothing is material in space'.

Following in the footsteps of his Impressionist masters, Rosso apparently relied on contemporary expositions of the psychology of visual perception to support his ideas.

[1] See p. 97, n. 1.
[2] *Il Caso Medardo Rosso*, 11, 17, 21, 18–19.
Soffici, in general, was very generous to the Impressionists, considering that he was writing at a time when the tide had completely turned against them in the *avant-garde*. His friend Apollinaire wrote in 1908, 'L'ignorance et la frénésie, voilà bien les caractéristiques de l'impressionnisme. Et, disant ignorance, j'entends un manque absolu de culture dans la plupart des cas.' 'Georges Braque', reprinted in *Chroniques d'art (1902–1918)*, ed. L. C. Breunig (Paris, 1960), 59.

The seriousness with which he explored these leads may have been suggestive to the Milanese artists. For example, Rosso described the inconstancy of visual sensations and suggested that such changeability was indicative of 'the movements of life'.[1] Man was considered as only one integral, but not dominant, part of the total environment and thus subject to its variability of appearance. Rosso in fact made man a dependent element: 'We are mere consequences of the objects which surround us', he once said.[2] Hence the proud, self-sufficient, and technically free-standing isolation of the antique nude did not appeal to him any more than to his Futurist heirs and he hoped for its exclusion from the contemporary sculptural vocabulary.[3]

Soffici's tribute to Rosso and his efforts on the artist's behalf undoubtedly inspired the Futurist painters to follow suit. Rosso was included among those Italian artists whom they defended in their first manifesto. That they knew Soffici's writings is proved by a telegram they sent to him on 19 May 1910, with congratulations on his courageous propaganda for Rosso and the Impressionists. The message shows that they had followed his activities and those of the *La Voce* group for some time.[4]

Divisionism: Previati's Treatise

The Futurist painters did not have to go far afield to learn about the technical principles of Divisionism, since Milan had its own eloquent spokesman in Gaetano Previati, whose two volumes on painting had appeared in 1905 and 1906. Late in 1907 Boccioni noted in his diary that he was reading Previati and felt 'humbled in the presence of so much technical erudition . . [and wondered] how to do it . . . where, when to study all that chemistry and physics?'[5] Previati's books must have held a place in Italian artistic circles comparable to that of Chevreul's *De la loi du contraste*

[1] Soffici, *Il Caso Medardo Rosso*, 56, 57, 95–96.

[2] Ludwig Hevesi, 'Medardo Rosso', *Kunst und Kunsthandwerk*, VIII (1905), 181.

[3] Mino Borghi, *Medardo Rosso* (Milano, 1950), 20.

[4] Soffici, 'Risposta ai futuristi', *La Voce*, II no. 23 (19 Maggio 1910), 324. He reprinted the Futurists' telegram: 'Malgrado note ostilità vostri amici *Voce* contro futurismo noi conoscendo vostra coraggiosa campagna per grande Medardo Rosso e per risveglio arte italiana avendo letto vostro interessantissimo articolo impressionismo sentiamo bisogno esprimervi nostra fraterna ammirazione.' Signed 'Boccioni, Ruspolo (sic), Carrà e poeti Marinetti, Paolo Buzzi'. The article on Impressionism to which the Futurists refer was published in *La Voce*, II no. 22 (12 Maggio 1910), 317–18, reprinted in Soffici, *Scoperte e massacri*, 135–48. The Futurists had twice been ridiculed by *La Voce*; I no. 27 (17 Giugno 1909), 111, and II no. 16 (31 Marzo 1910), 295. Soffici must have known Marinetti from his Parisian days, because they both moved in the same circles. Soffici met Boccioni through Papini in Milan in 1908; *Fine di un mondo* (Firenze, 1955), 42.

[5] Boccioni, unpublished diary, 21 December 1907. It is hard to know which of the two volumes Boccioni was reading, because he identifies his text only as *La Tecnica della pittura*, a title used in both volumes. By 1910 both volumes may have been known to him.

simultané des couleurs in France. Because of the later date, Previati was able to include recent findings in optics and the psychology of visual perception, making his books veritable compendia of opinion on the subject.

Previati's writings contain valuable sources for the ideas incorporated by the Futurist painters into the technical manifesto. The first chapter in *I Principii scientifici del divisionismo* is especially rich in influential passages. There Previati dealt with 'Visione oculare e visione soggetiva', including short discussions of some of the general and individually variable determinants of the appearance of the object, such as binocular vision, geometrical illusions, irradiation, astigmatism, diplopia, and so on. Although he stressed the importance of these researches for the artist, Previati, like the Futurists, insisted that the 'subjective sensations . . . open the doors of art'.[1] But Previati, unlike his French compeer Seurat, did not in his writings examine the psychic effects of the artist's formal uses of colour, line and shape.[2] Yet abundant literature on this subject was available to the Futurists. While Seurat relied in part on Charles Henry's theories of *dynamogénie* in his attempt to enhance the emotional expressiveness of his work, the Futurists must have known of the related concept of empathy possibly through Croce's discussion of Lipps' researches, or through Berenson's notion of tactile values, or even through Bergson's *Essai sur les données immédiates de la conscience*.

From Fauvism to 'Cubism'

The impassioned Futurists were not satisfied by the relative restraint with which their older mentors employed and advocated expressionist principles. They wanted their works of art to be such forceful vehicles of emotions and sensations that the spectator would be completely absorbed by them. In spite of important dissimilarities, Matisse's dream of 'an art . . . like a good armchair' has therefore certain characteristics in common with the highly evocative creations envisaged by the Futurists. The artists' translation of Marinetti's precepts into painterly terminology retains the exaggeratedly Fauve spirit of his First Manifesto and suggests some knowledge of Fauve painting. 'Our pictorial sensations can no longer be whispered. We shall make them sing and shout on our canvases which will blare forth [with] deafening and triumphant fanfares', said the painters, pointing out 'that beneath our skin brown does not

[1] *I Principii scientifici del divisionismo*, 7, 4–6, 27–28, 21–23.

[2] There are some similarities between the technical manifesto and Seurat's theories as he explained them in a letter to Beaubourg, but the Futurists could not have had access to this then unpublished manuscript.

course, but . . . yellow sparkles, red blazes, and . . . green, blue and violet dance voluptuously and caressingly there . . . The pallor of a woman's face who is looking at a jeweller's shop window is more iridescent than all the prisms of the jewels which bewitch her . . . Your eyes accustomed to dimness will be opened to the most radiant visions of light. The shadows which we shall paint will be more luminous than the highlights of our predecessors; and our pictures, compared to those stored in museums, will be as a refulgent day to a gloomy night.'[1] Boccioni later confirmed that their theory presumed a Fauve approach and that their technical manifesto was a 'synthesized Impressionism made more violent, the only possible neo- and post-Impressionism for us who were in a hurry; a kind of theoretical *Matisse* which was hastily to prepare our plastic consciousness [and] our pictorial evolution'.[2]

In their attempt to transpose Futurist dynamism into a workable pictorial theory, the painters not only drew near Fauvism but posited a vision of objects and space which approached the 'Cubist' mode of depicting a state of flux. Some of Picasso's and Braque's tangential followers – Gleizes, Metzinger, Léger, Delaunay, and others – eagerly received the technical manifesto when it appeared in Paris, because its explicit statements bolstered their own still uncertain efforts which derived in part from similar social and philosophical convictions. It is more difficult to say whether Futurist theory had at this time any effect on Picasso and Braque themselves. Their development followed a very isolated course in these early years.[3]

There is no indication that the Milanese painters were familiar with any Cubist work or statement about it before the summer of 1911.[4] But because the Futurists' precepts were part of the general European intellectual climate, Boccioni's claim made in the preface to their Parisian exhibition catalogue seems generally justified: 'Our experiments and our achievements have followed a different route, but one in

[1] Approving mention of Fauve paintings was made by R. Canudo – Marinetti's and Apollinaire's friend – in *Vita d'arte*, I no. 6 (Giugno, 1908), 344. But it appears that the 'Fauvism' of the painters' manifesto owes more to Marinetti's views and to his probable accounts of the Paris Fauve salons than to actual knowledge of the work of Matisse and his friends. See Chapter VI.

[2] Boccioni, *Estetica*, 99.

[3] See my 'Futurism, Unanimism and Apollinaire', to appear. It is important to distinguish between the fundamentally different orientations of the Cubism of Picasso and Braque and that of the group around Gleizes and Metzinger.

[4] Marinetti may have called Apollinaire's 'Les Trois vertus plastiques' to their attention. This essay, which perhaps was an attempt to define Fauvism's rationale and subsequently became the very general introduction to his *Les Peintres cubistes* (Paris, 1913), 5–10, establishes purity, unity, truth as 'plastic virtues'. They are synonymous with anti-traditionalism, the incorporation of the time element into artistic perception, and an ever-changing truth perpetually discovered by the artist with the aid of intuition. The essay first appeared as preface to Le Havre, *IIIᵉ Exposition du 'Cercle de l'art moderne'*, (June, 1908), republished in *Le Feu* (1ᵉʳ Juillet 1908), 39. *Le Feu* was advertised on *Poesia*'s back cover.

some ways parallel to that followed by the Post-Impressionists, Synthetists and Cubists in France, guided by their masters Picasso, Braque, Derain, Metzinger, LeFauconnier, Gleizes, Léger, Lhote, etc.[1] Their work itself further corroborates this statement and helps to explain why the Futurists were able to make such amazingly rapid and imaginative use of the formal vocabulary of Cubism.

[1] Bernheim-Jeune et Cie., *Les Peintres futuristes italiens*, 1; reprinted *Archivi*, I, 104.

VI

THE ARTISTS: THEIR BEGINNINGS

FUTURIST art was the fruit of a brief but intense collaboration. All the signatories of the painters' manifestos – Boccioni, Carrà, Russolo, Severini, Balla[1]– were challenged by Marinetti's spirit and at times financially supported by him. The background and inclination of each painter gave resonance to the general character of their group and the success of this complex partnership of distinct artistic personalities derived from its chief common denominators: the youth, relative obscurity and poverty of the members and their impatience with the inertia of Italian artistic life. In addition, they all met the requirements of the 'complete Futurist', set down by Boccioni in a letter of 1910: 'The fidelity to the movement must be complete and without mental reservations,' he wrote. 'It is essential that faith in *complementarismo congenito* be combined with such intellectual qualities as are necessary for the complete Futurist. We need young men (and there are few) of secure faith and self-denial; [young men] of culture and of action who aspire in their works – as yet uncertain – towards the total perfection which will indicate the radiant path of the ideal.'[2] Accounts differ about the date and origins of the Futurist painters' wing. Although Marinetti's movement was undoubtedly known to the young artists who met at the Famiglia Artistica and the Caffè del Centro, the idea of joining his group seems not to have arisen until after the Milanese Futurist *soirée* of 14 February 1910, at the Teatro Lirico. A few days later, the Futurist poet Libero Altomare introduced his old friend Boccioni to Marinetti, and soon these two men had their 'first, long talk'. Boccioni recalled later that they were in immediate accord 'about the Futurist sensibility to be created in Italy and the urgent need to join the Futurist movement with a very violent painting manifesto'. Carrà and Russolo were quickly infected by Boccioni's ardour and, according to Carrà, the three 'enthusiastically sketched an outline of our appeal. The drawing up of the final version was however a laborious process'.[3]

[1] The first editions of the painters' first manifesto were signed by Boccioni, Carrà, Russolo, Bonzagni and Romani. See pp. 71–72.

[2] *Archivi*, I, Boccioni to Severini (1910), 231.

[3] See Carrà, *La Mia vita*, 129; Boccioni, *Estetica*, 99; Libero Altomare (Remo Mannoni), *Incontri con Marinetti e il futurismo* (Roma, 1954), 22–23.

Marinetti dramatically announced the expansion of his movement by Boccioni's recitation of the painters' first manifesto at the next Futurist *soirée* on 8 March 1910 at the Politeama Chiarella in Turin.

The Milanese Trio: Umberto Boccioni (1882–1916)

The vigorous Boccioni seems to have taken a leading role from the beginning. It is evident from his correspondence and other writings that he was regarded as the group's leader and spokesman by the others as well as by himself, and that he tried to keep them together at all costs in order to assure their collective security and fame. As early as February 1912, no less discerning a critic than Apollinaire selected him as the most talented of the Futurist painters.[1] His versatility, ambition and promise, and his premature death, which left them unfulfilled, have surrounded his name with a romantic aura. He has since become a symbol of Futurism, especially as his demise roughly coincided with that of the first and strongest stage of the movement itself. Boccioni emerges as a dominant figure in twentieth-century Italian and international art even after the more exacting tests of time and recent critical re-examination.

He was born in Reggio Calabria on the tip of the Italian peninsula, the son of an impecunious petty official of the prefecture who, while Boccioni was growing up, held similar posts in Forlì, Genoa, Padua, and finally Catania, where the artist's schooling was completed at the Istituto Tecnico. During his schooldays Boccioni had already shown a great interest in the arts and is said to have written a novel and to have contributed some critical articles to local newspapers.[2] In mid-1900 he seems to have left Sicily for Rome and, following his father's wish, took drawing lessons from a placard maker.[3] Soon thereafter he struck up a friendship with Gino Severini, also a recent arrival in the capital, and together they frequented the studio of the older painter, Giacomo Balla, whom Boccioni had got to know. Balla, who had just returned from a sojourn in Paris, introduced his disciples to the rudiments of Divisionist technique, of which he was one of the few practitioners in Rome. Beyond this instruction, he impressed them with his admirable artistic integrity.

[1] G. Apollinaire, 'Les Peintres futuristes italiens', *L'Intransigeant* (7 Février 1912); reprinted in *Chroniques d'art*, 212.

[2] Giulio Carlo Argan, *Umberto Boccioni* (Roma, 1953), 25.

[3] Opinion seems to differ as to whether or not Boccioni attended the Scuola di nudo of the Accademia di Belle Arti in Rome. In 1906–7 he did attend the Scuola libera del nudo of the Venice Accademia di Belle Arti. See *Archivi*, I, 407; *Primi espositori di Ca' Pesaro 1908–1919. Catalogo a cura di Guido Perocco*. (Venezia, 1958), 63; Raffaele de Grada, *Boccioni. Il mito del moderno* (Milano, 1962), 32.

By 1908 Boccioni had travelled a good deal both in Italy and abroad. He lived in Paris and St Petersburg for a few months in 1906, and in the next two years made brief visits to Munich and twice to Paris.[1] In Italy he apparently moved back and forth between Rome, Padua and Venice, finally settling in Milan with his mother and sister in the autumn of 1907.

It is difficult to gauge the effect of Boccioni's travel on his early development. His art is unquestionably grounded in the Lombard school of painting, as he himself admitted with some regret at the height of his Futurist fame.[2] The revolutionary work of the contemporary and older generation of French artists apparently did not yet suggest satisfactory answers in his quest for a modern art which would 'become a function of life and not stand haughtily apart'. But the large number of paintings, drawings and prints executed from about 1907 to 1910 reflect a restless and vacillating course indicative of Boccioni's groping efforts to clarify his ideas. Nearly simultaneously he experimented with almost opposing approaches to art, but from the beginning his work was directed towards the discovery of a virile artistic order inspired by scientific conquests. An emotional entry into his diary of 1907 articulates this aim fully: 'I must confess that I seek, seek and seek and do not find. Shall I discover [what I seek]? I feel that I wish to paint the new, the fruits of our industrial age. I am nauseated by old walls and old palaces, and by old motifs, by reminiscences! I wish to have the life of today in front of my eyes . . . It seems to me that today art and artists are in conflict with science . . . Our feverish epoch makes that which was produced yesterday obsolete and useless.'[3]

Il Sogno: Paolo e Francesca (The Dream: Paolo and Francesca) and *Allegoria del natale* (Allegory of the Nativity) (Pls. 16, 18), both of 1908, illustrate a laboured exploration of literary symbolism and of Art Nouveau, following a precedent set most

[1] Most biographies indicate that Boccioni went to Paris in 1902. The late Signora Boccioni-Callegari stated in conversation with me in 1961 that her brother made his first trip to Paris in 1906. This is supported by several entries into Boccioni's unpublished diary. On 28 March 1907 he speaks of his visit to Paris in August 1906, on the way to St Petersburg. On 8 October 1907 and on 1 April 1908 he speaks of being in Paris. Severini suggested in a letter of 1958 that Boccioni's trip to Russia was occasioned by a liaison with a Russian woman by whom he apparently had a child. This is alluded to in the diary entry of 5 April 1907.

[2] Soffici alleges that when Boccioni saw his paintings in about 1912 or 1913 he said: 'Tu sei partito da un punto che potrebbe essere il macchiaiolismo toscano, e attraverso le esperienze successive, liberatrici e formatrici, dell'impressionismo, del postimpressionismo, del cubismo, eccetera, sei arrivato logicamente a quello che fai adesso. Ma pensa io, invece. Io son partito dalla scuola lombarda del pittoresco, dei Tallone, dei Conconi, dei Longoni, dei Gola, tutt'al più dei Grubicy; . . . Bisogna ricominciar tutto daccapo' *Autoritratto d'artista italiano nel quadro del suo tempo; Fine di un mondo*, 340.

[3] *Archivi*, I, 227, 225–6.

recently in Italy by Segantini and Previati.[1] However, the ink sketches for these moral allegories (Pls. 17, 19) are bold and spontaneous and reveal his familiarity with Rodin's watercolours in *Il Sogno* and with Vallotton's graphic work in *Allegoria*. Numerous contemporary landscape studies, most of them very small, show a concern with control of space, colour and shape. Here the influence of the sensitive Impressionist Emilio Gola (1851–1923) and of Giacomo Balla is noticeable. Following the example of his former teacher, he superimposed a geometric framework upon his studies from nature. Such transformations are especially apparent in the pencil sketches for these small pictures (Pls. 20, 21) and correspond with another comment in his 1907 diary: 'Today the great heart and . . . mind of humanity moves towards a virility which consists of precision and exactitude and positivism. It is the poetry of straight lines and of calculation – everything becomes rectangular, square, pentagonal, etc. I notice this in all of life's functions.[2] Boccioni's geometrical vision sounds like a two-dimensional paraphrase of Cézanne's famous dictum about reducing everything to forms of solid geometry, but it was probably not known to him.[3] It reflects his early training at the Istituto Tecnico, and his ideas may have been sharpened by recent work of the pioneers of the modern movement in architecture.[4] In spite of this stern discipline, Boccioni retained also his perceptive immediacy in some oil studies of this group. *Treno a vapore* (Steam Train)[5] (Pl. 22) of 1908 is one of his first attempts to suggest movement, and has something of the 'poetry of the moment' that he sought. The speeding train and sailboats skimming to the strong wind which also ruffles the grasses are freshly evoked by subtle divergencies of the long and short diagonals from the overall horizontality of the design.

Somewhere between these formal exercises and the more sentimental works stands a small group of prints on which Boccioni worked intermittently from about 1907 to 1910.[6] One of the earliest is the precise portrait of *Boccioni's Mother Crocheting* (Pl. 23), an etching and drypoint dated 1907, which reveals his expressed admiration for Dürer. In its lucidity it conveys something of Dürer's 'calmness of style'. The

[1] See Previati's *Paolo e Francesca*, illustrated in Pagani, *La Pittura lombarda della scapigliatura*, 401 and 402. *Allegoria del natale* was published in *L'Illustrazione italiana*, XXXV no. 52 (27 Dicembre 1908), 617.

[2] *Archivi*, I, 226–7.

[3] Cézanne's statement was published in October 1907, a month after Boccioni's diary entry.

[4] The work of Wagner, Behrens, Hoffmann, Perret, Loos, Voysey, Mackintosh, and others was discussed in the new art journals including *Emporium* and *Vita d'arte*. Some of it was shown at the 1902 Turin Exhibition.

[5] *Treno che passa.*

[6] Boccioni probably made his first prints about 1906–7 in Venice. Diary entries of the late spring and summer 1907 refer to his print-making.

textural variations and detailed definition of each object show Boccioni's desire to imbue his work with 'that religious observation of details, that marvellous union of reality and ideal, that serene glorification which must penetrate [everything] from a grandiose and gentle arrangement down to the subtle intimacy of the most humble detail.'[1]

By 1909 he had gained greater freedom in his etching technique and was able to achieve a more fluent and succinct expression. He had also shifted from Dürer to Zorn, Manet, and Rembrandt,[2] as his models. *Seated Woman Holding a Fan* (Pl. 24) – a portrait of his sister – is typical of these later prints. The dramatic contrast of light and shadow, the undefined space, and the stark simplicity of the individual forms contain something of the candour and veiled psychological intensity of Manet's characterizations.

Certain oil portraits of this period also indicate Boccioni's efforts to strike a balance between his chosen stylistic extremes. The graphic development from *Boccioni's Mother Crocheting* to *Seated Woman* is paralleled in the oil medium by the progress from *Ritratto dello scultore Brocchi* (Portrait of the Sculptor Brocchi) (*c.* 1907, Pl. 25)[3] – an astute student piece – to the powerful *Figura al sole* (Figure in the Sun), dated 1909 (Pl. 26).[4] The *mise en cadre* of the Brocchi portrait follows Previati's advice to heighten the luminous effect of a picture through the use of an open window which would bring out the contrast between the subdued local colour of the room and the brilliant atmospheric colour beyond it.[5] But Boccioni disregarded the older painter's admonition never to mix the Divisionist and other techniques. In fact, Boccioni took advantage of the contrast between the solid, freely-brushed figure within the room and the pulsating, filmy panorama of the Paduan skyline, which was executed with meticulous pointillist dots. Much of the pictorial animation results from this opposition. It is augmented by the subject's pose and the unusual spatial treatment. The window frame is so large and so nearly the size and shape of the canvas that it becomes the frame for all of the composition except the figure, which is forced forward into an

[1] *Archivi*, I, Diary entries 1 February 1908, 230; 14 March 1907, 226.

[2] *Archivi*, I, 229–30. He calls Rembrandt 'il padre dei moderni luminosi'.

[3] *Archivi*, II (1962), 256, No. 69, erroneously identifies this portrait as that of the sculptor Riccardo Ripamonti (1849–1930). Boccioni portrayed Ripamonti, then an old man, in about 1915, and there seems to be no resemblance between the two likenesses (Argan, *Boccioni*, pl. 75). The Brocchi portrait has been dated 1906, but for stylistic reasons and because Boccioni speaks of his 'painting of Brocchi' in a diary entry of 15 August 1907, it would seem more accurate to date it 1907.

[4] *Effetti di sole* (*Ritratto della madre*).

[5] Previati, *I Principii scientifici del divisionismo*, 154–5, 157. See also 234, 235. French Neo-Impressionists frequently painted counter-light portraits.

apparently inadequate space. This destroys the picture plane and gives an illusion of three-dimensionality and added immediacy, as well as establishing a stronger *rapport* with the spectator. In principle, this painting prepares the way for the Futurists' more intensified attempts to break down the barrier between the aesthetic object and the audience.

Like Cézanne's patient wife, Boccioni's mother was a willing sitter and throughout his life his most important undertakings had their points of departure in portraits of her. In *Figura al sole* (*Signora Boccioni*) the earlier Brocchi portrait's self-consciousness was largely overcome. With the omission of contrasting techniques, pictorial immediacy results from a subtle composition which resembles a compressed high relief and which thus again draws attention to a secondary plane as frame of reference – here a bold geometric pattern of dark and light, instead of a window.[1] At the same time, however, the strong diagonal of the left arm and back acts as a *repoussoir*, uniting the figure with the background and giving the subject the distance and inscrutability of a Michelangelesque sibyl.[2]

The paintings discussed above may seem very far removed from the aims of a young man who professed to want to paint 'the fruits of our industrial age'. Indeed Boccioni did not begin a series of studies of the working life of the city until 1908–9, after he had established himself in Milan, near the Porta Romana, which was then on the industrial outskirts of the thriving metropolis. He was immensely impressed by the vitality of Milan and spoke of it as the only city 'that does honour to Italy, indeed which alone is representative of her'.[3] City life as a subject for painting was nothing new, nor was the humanitarian attitude underlying Boccioni's scenes particularly novel. What was new was his attempt to suggest something like a collective sentiment, an idea which Boccioni had mentioned in his diary and which Jules Romains had incorporated in his concept of 'Unanimism' in 1905. It is possible that Boccioni was familiar with Romains' belief in the superior strength of collective actions and feelings which the poet had expounded in his collection of poems, *La Vie unanime*, published in 1908.[4]

[1] The spatial illusionism used here and in the Brocchi portrait had a distinguished Paduan precedent in the Mantegna frescoes at the Ermetani Chapel.

[2] Of all the great masters of the past, Michelangelo was the one whom Boccioni admired the most (*Archivi*, I, 230). Cf. the *Libyan Sibyl* or some of the *Ignudi* of the Sistine ceiling. The back-view pose was also used by Degas, Seurat, Pissarro, Toulouse-Lautrec, etc.

[3] *Archivi*, I, Boccioni to Severini (Autumn 1907), 228.

[4] *La Vie unanime*, was published by l'Abbaye de Créteil, with which Romains was loosely associated. Paolo Buzzi, one of the chief Futurist poets-to-be, reviewed it for *Poesia*, IV no. 8 (Settembre 1908), 41, calling it 'Arte di un dinamismo sintetico eccelso e d'una squisitezza analitica infinita'.

Two 1909 examples – *Officine a Porta Romana* (Factories at Porta Romana) and *Mattino* (Morning)[1] (Pls. 27, 28) are as formally composed as the slightly earlier rural sketches (Pl. 20), but now Boccioni sought to go beyond mere pictorial veracity and convey a deeper meaning. His method was the exploration of expressive and dynamic resources of light and space similar to those of his portraits. For both scenes he chose a very high viewpoint,[2] creating a long, steep perspective which accentuates the dominant forward and upward movement of all the diverse forms. The tiny figures, cart-horses, tenements, scaffoldings, telegraph poles, are all mysteriously drawn towards or dependent upon the tall smokestacks on the horizon. The weaving patterns of smoke repeat in a fainter and more relaxed form the tense silhouettes of people and objects. This upward rhythm is counterbalanced by brilliant chutes of light bearing down from the sky on to the long road ahead like celestial emanations.[3] The individual's anonymity and insignificance compared with the immense and growing city – the fruit of collective effort – is the major theme of these paintings. Boccioni's scenes also exalt the urban spirit in the way that Marinetti urged, and it is quite possible that some of their force came from Futurism, which had just burst upon the horizon.

While working on his urban scenes, Boccioni seems to have become acquainted with Carrà, whose signature always follows immediately after his own in the painters' manifestos. Although this order was probably determined alphabetically, it also signifies Carrà's position as second in command, a position with which he was less and less satisfied as the years of collaboration passed.

Carlo Dalmazzo Carrà (1881–1966)

In his autobiography Carrà tells how he met Boccioni late in 1908 at the exhibition of Lombard artists held at the Permanente in Milan.[4] He was criticizing Boccioni's entry to his companion so audibly that the artist, standing nearby, overheard the conversation, stepped up and introduced himself. A long argument followed, at the

[1] The late Vico Baer, who donated *Officine a Porta Romana* to the Banca Commerciale, stated in conversation that it should be entitled *Meriggio* and that it and similar scenes were intended as a polyptich. See Balla's *La Giornata dell'operaio*, pl. 36. *Mattino* was shown at the 1909 annual of the Famiglia Artistica. Ill. in catalogue.

[2] The Impressionists, especially Pissarro, frequently used such high viewpoints.

[3] Cf. Romains' 'L'Église' in *La Vie unanime* (2ᵉ édition, Paris, 1926), 58: 'Les jeunes usines! Elles vivent très fort./Elles fument plus haut que ne sonnent les cloches./Elles ne craignent pas de cacher le soleil./Puis qu'elles font du soleil avec leur machines.' Point no. 11 of the First Futurist Manifesto expresses a similar sentiment.

[4] Carrà, *La Mia vita*, 220 ff. The catalogue of this exhibition was not available for verification.

end of which the two men found that in spite of their disagreements they had much in common, and thereafter they saw each other frequently. Their numerous long discussions formed the basis for a large part of Futurist theory and art.

Their personalities and backgrounds were complementary in some ways. Boccioni, a handsome and boundlessly energetic extrovert, was endowed with great personal charm which opened doors to him wherever he went. Carrà was more pedestrian. Severini described him as 'a Socialist deputy, small and stocky, with a deep, hoarse voice, and a discursive logic always animated and a bit rudimentary'.[1] He was reserved and a little shy; he thought and worked slowly but very deliberately. Although his keen intelligence is amply revealed in his later critical and theoretical writings, he lacked the mental suppleness and daring which enabled Boccioni so rapidly to select and comprehend the most promising ideas of others and re-employ them in a startlingly original way. Undoubtedly it was this difference which gradually led to the break in their friendship.

Their artistic training too shows significant contrasts. While Boccioni had received very little proper academic education, Carrà earned a *patente di disegno* from the Brera Academy in 1909.[2] Before entering art school, Carrà, who was born in 1881 in Quargnento in the Piedmont, had been a mural decorator's apprentice in nearby Valenza and then in Milan, where he arrived in 1895. This experience and education, which from the beginning had stressed the importance of the painter's craft, turned Carrà into a very sound technician and gave him much feeling for paint surface and texture. But on the debit side it seems to have impressed upon Carrà an indelible respect for tradition. This was already indicated in his choice of the *Victory of Samothrace* as the motif of a membership card for the Famiglia Artistica, which won a contest in 1908.[3] This choice in turn foretells his 'rediscovery' of Giotto and Uccello in 1915.[4] Carrà was introduced to the Milanese vanguard through his friendship with his teacher, the fairly broad-minded academician Cesare Tallone. Its luminaries were still Segantini, Previati, and other members of the Grubicy circle, and these men had a decisive effect on Carrà's development, as on Boccioni's. He travelled abroad, spending – save for a short stay in London – three-quarters of a year in Paris, where he found employment as a decorator for the World's Fair of 1900. Like Boccioni, his

[1] Gino Severini, *Tutta la vita di un pittore* (Milano, 1946), 123.

[2] The Brera Academy archives show that Carrà was enrolled in 1905–6 and 1906–7, and that he passed his exams in October 1908.

[3] Carrà, *La Mia vita*, III. I was not able to find a copy of this card. Unless otherwise indicated, the facts of Carrà's life are drawn from his book.

[4] *La Voce*, VIII no. 3 (31 Marzo 1916), 162–74, and VIII no. 9 (30 Settembre 1916), 375–84; reprinted in his *Pittura metafisica*, (2ª edizione, Milano, 1945), 153–81.

foreign experiences do not seem to have affected his work, although he tells of being impressed by his visits to the Luxembourg and of his joy at discovering Turner and Constable in London.

At the time of their encounter, Carrà occupied quite an important position among Milanese artists of his generation. Having won the Famiglia Artistica membership card competition, he was asked to join the directorate of the famous but declining association. He earnestly set to work to revive it and to attract young artists by establishing the inexpensive life classes which it had formerly sponsored. More important, he began to include the work of young and untried artists in the current exhibitions, thus providing them with a public forum and resurrecting the 'ardent and polemic . . . tone' of the *scapigliatura* days. Carrà's innovations won the hearty support of his many artist friends, who in 1909 included not only Boccioni, but also Romolo Romani, Aroldo Bonzagni, and Luigi Russolo, who later signed the first painters' manifesto.

Except for a handful of pictures, all of Carrà's pre-Futurist and early Futurist works were either lost or, more often, destroyed by him. Unlike Boccioni, whose life up to 1909 is only sparsely documented but whose large number of works and diary notes provide a record of his aspirations, Carrà's story is told only in his autobiography of 1943 which, amidst some *Dichtung*, gives a fairly reliable, if belated, picture of his early development. His personal destruction of his own youthful efforts, and his practice (begun after 1912) of antedating his pictures,[1] confirm his sense of rivalry with Boccioni.

Among Carrà's definitely pre-Futurist pictures are *Ritratto del padre* (Portrait of Father) (Pl. 29),[2] apparently executed in 1903, and the allegorical cover-design for the catalogue of the annual exhibition of the Famiglia Artistica in 1909 (Pl. 30). The portrait, evidently executed before Carrà had any formal training, is understandably awkward; it reveals, nevertheless, his innate sensitivity to painterly qualities. Six years later he was more technically expert and more aware of the artistic trends popular in Italy at the time. He seems to have been influenced by a conglomerate of Art Nouveau with a native brand of Pre-Raphaelitism and perhaps by Franz von

[1] A practice unfortunately frequent in twentieth-century art. Primacy often came to stand for originality during the early years of the century. Perhaps this stress on primacy was due to the lag in the public's comprehension of the artistic revolution taking place. The claim of having been the first became one of the few ways of establishing *rapport* with the public and in time was mistaken for a criterion of value. The artists – in need of sales – frequently took advantage of this misunderstanding.

[2] The portraits of his aunt and uncle, in the artist's collection, and dated 1901, appear to have been repainted during the 1920s or later. Illustrated in Guglielmo Pacchioni, *Carlo Carrà* (2ª edizione, Milano, 1959).

Stuck and Rodin as well. The results are as uncertain as Boccioni's *Paolo e Francesca*. Carrà too was apparently groping for a style of his own by trying out whatever was available. He speaks of having painted *plein air* landscapes as well as some pictures with sober, humanitarian subject matter. But we have only his statements to verify this, as neither photographs nor the paintings themselves have been found.

Luigi Russolo (1885–1947)

Of the five signatories of the painters' manifestos of 1910, Luigi Russolo had the most short-lived reputation. He had fallen into such oblivion that he was completely omitted from the retrospective exhibition of Futurist art at the 1955–6 Quadriennale in Rome. This was rectified in the 1959 Futurist anniversary exhibition, also in Rome, in which three of his canvases were included. It is true that Russolo 'was more important to the movement through his music of "Intonarumori" than through his painting', as the editor of the catalogue noted, but even his musical contribution has been much neglected. In the introduction to a recent French reprint of his 1913 manifesto, *L'Arte dei rumori* (The Art of Noises), Maurice Lemaître calls him a forgotten master at a time when 'neo-Russolians à la John Cage, Varèse or Schaeffer (*musique concrète*) swell with impudence'.[1] Technically the weakest painter of the group, Russolo may nevertheless have had the most subtle concept of art.

He was born in 1885 at Portogruaro in the province of Venezia. His father was the church organist and director of the local Scuola Filarmonica. The three sons all showed musical ability and were taught piano, violin, and organ by their father. But only the two elder sons fulfilled their parent's desire that they should study at the Milan Conservatory and ultimately became professional musicians. Luigi decided at an early age to turn to painting instead, and after having completed his courses at the gymnasium of Portogruaro, he joined his family, who had moved to Milan.

Although Russolo was never registered as a regular student at the Brera, he seems to have visited there and met Carrà, Bonzagni and Romani.[2] He absorbed some of the rudiments of the art of painting through his friends, but was mainly self-taught, and acquired additional technical knowledge while employed on the restoration of the Leonardo frescoes at S. Maria delle Grazie and at the Castello.[3] His somewhat dilettante interests seem to have included poetry as well, and, according to the Futurist poet Paolo Buzzi, he was a member of Marinetti's *Poesia* circle before 1909.[4] His sensitive, mystical temperament and alert mind were welcomed and appreciated

[1] Luigi Russolo, *L'Art des bruits* (Paris, 1954), 12. Introduction by Maurice Lemaître.
[2] Paolo Buzzi, 'Souvenirs sur le futurisme'. *Cahiers d'art*, xxv (1950), 26.
[3] Maria Zanovello Russolo, Ugo Nebbia, Paolo Buzzi, *Russolo, l'uomo, l'artista* (Milano, 1958), 20.
[4] P. Buzzi, *Cahiers d'art*, xxv (1950), 26.

in this group; he was apparently equally at home with the complexities of Bach or Beethoven and the most abstruse philosophical speculations. Russolo's wide range enabled him to effect a liaison between the literary, musical and fine arts branches of the movement. He probably helped to stimulate a productive exchange of ideas between the various disciplines and the results of this cross-fertilization are to be seen in both the art and theory of Futurism.

So far no painting of Russolo's that can be dated earlier than 1909–10 has come to light. However, he exhibited a group of etchings at the Famiglia Artistica annual in 1909. Among those which can be identified was a head of Nietzsche (Pl. 31).[1] This ponderous profile portrait shows the philosopher imprisoned in the tresses of his *alter ego* – a fierce-looking female representing a muse or the personification of madness. It recalls the luminous, sinuous texture of some of Previati's works, the influential German *fin de siècle* art and Romani's mysterious drawings and prints.

Romolo Romani (1885–1916) and Aroldo Bonzagni (1887–1918): Two Reluctant Futurists

The painters Romolo Romani and Aroldo Bonzagni[2] – the first two deserters from the Futurist group – are barely known today, and if they are mentioned at all it is usually in reference to their brief adhesion to Futurism. Romolo Romani was the only one of *Poesia's* painter collaborators to become a Futurist.[3] His great promise was recognized when he was still very young by Vittore Grubicy, who was one of his teachers and who arranged several exhibitions of his work after 1903. The series of pencil drawings entitled *Sensazioni* and *Simboli* (Pl. 32), the first versions of which were completed before 1906, are remarkable attempts to express spiritual states.[4] Their force stems principally from the linear arrangement – a style which owed much to international Art Nouveau. Redon and Munch may have stimulated Romani's psychoanalytic probings, but he extended his weaving line into a fantastic geometry which brings the perverse spaces of Poe or Piranesi to mind. Romani revelled in the

[1] No. 288; illustrated in catalogue.

[2] Romani was born and died in Brescia, but he was active in Milan. His birth date is variously given as 1884 or 1885. Bonzagni was born at Cento and died in Milan. He studied at the Brera, and he lived in South America for a time between 1910 and 1920.

[3] See his drawing of Marinetti, *Poesia*, IV no. 6 (6 Luglio 1908), which accompanies Emile Bernard's dithyramb to him. Other artist-contributors to *Poesia* were Ugo Valeri (1874–1911), Enrico Sacchetti (1877–?), G. Grandi (dates unknown), Carlo Agazzi (1870–1922).

[4] In the choice of the title *Sensazioni*, if not in subject and technique, Romani followed Grubicy, who called his landscapes *Sensazioni gioiose*, etc. See Giorgio Nicodemi, *Romolo Romani* (Brescia, 1927), preface; and Carrà, *La Mia vita*, 88.

macabre, and it was this quality in his art that seems to have brought him in or about 1906 to the attention of Marinetti, whose youthful tastes were attuned to such esoteric visions. From mid-1906 onwards Romani's drawings occasionally appeared in *Poesia*, but as these were only portrait sketches, his native fantasy was curtailed. Whatever the reasons for Romani's disavowal of Futurism, the fact remains that all three of the other Milanese artists – especially Boccioni – were affected by his powerful linear abstractions.

Bonzagni had a very different artistic temperament. As a student at the Brera Academy, he had joined Carrà's lively group of friends. Carrà remembers him chiefly for the flawlessly elegant clothes he wore in spite of his abject poverty and for his studies of prostitutes and scenes of night life. His early paintings are reminiscent of Anglada (Pl. 33), the later ones of Vallotton's prints and *Simplicissimus* cartoons. Their palatable blend of sentimentality and satire, combined with Bonzagni's technical facility, account for the relative popularity he enjoyed during his lifetime. As with Romani, the events which led to his estrangement from the Futurist movement are still, and will probably remain, a mystery. Boccioni alluded to the break rather defensively in a letter to Severini in the early summer of 1910: 'You see that one (Bonzagni) no longer signs the manifesto because he does not believe in divisionism. . . . This fact is most annoying because it gives the imbeciles the impression that . . . the intelligent ones are abandoning us!!!!'[1] Later he laconically confirmed both desertions in *Pittura scultura futuriste*: 'Two members of the signatory group of the first manifesto refused to sign the technical one and returned to the darkness. Giacomo Balla . . . and Gino Severini . . . gave us their enthusiastic adhesion shortly thereafter.'[2]

Thus the places vacated by Bonzagni and Romani were soon filled by Balla and Severini, both friends of Boccioni from his Roman days, and both unknown to his Milanese colleagues – Carrà and Russolo. But Boccioni, who was as acute as Marinetti when it came to choosing his associates, seems to have known what he was doing (intuitively at least) when he asked Balla and Severini to add their signatures to those of the Milanese trio in the technical manifesto of 1910.[3] Although Balla and Severini were relatively inactive members of the movement during the formative stage of Futurist art, each in his own way contributed decisively to the movement as a whole. Severini, in Paris, was instrumental in bringing Futurism into contact with Cubism,

[1] *Archivi*, I, Boccioni to Severini (after either 8 July or 1 August 1910), 231.

[2] Boccioni, *Estetica*, 99. Apollinaire gives further support to this sequence of adhesions to the Futurist painters' wing in his *Le Petit Bleu* article (9 Fevrier 1912), reprinted in *Chroniques d'art*, 214-15.

[3] Severini, *Tutta la vita*, 21, and 115. Severini confirms here that he had not signed the original editions of the first painters' manifesto, and that he heard of the painters' movement from Boccioni only *after* the appearance of this statement.

while Balla, pursuing his own single-minded course in almost complete isolation in Rome, in the last analysis may prove to have produced the purest Futurist paintings of the group.

Rome: Giacomo Balla (1871–1958)

Balla occupies an exceptional place among the Futurist painters. Not only the oldest by far, he was more widely known, having gained some slight recognition from the Italian conservative press and public. In addition, he was distinguished by having been the first real teacher of Boccioni and Severini. His renunciation of the small share of security which he had achieved to start on a new and nebulous course was certainly courageous, the more so as he was a married man with a family, approaching middle age and nearly mature as an artist. In a rare autobiographical statement, he later recalled how 'Friends . . . took him aside imploring him to return to the right course, predicting a disastrous end. Little by little acquaintances vanished, the same happened to his income, and the public labelled him MAD, BUFFOON. At home his mother begged the Madonna for help, his wife was in despair, his children perplexed! . . . [but] he regarded these obstacles as mere jests and . . . without further ado put all his *passéiste* pictures up for auction, writing on a sign between two black crosses: FOR SALE – THE WORKS OF THE LATE BALLA.'[1] Balla's character and art were equal to such a bold decision.

He was born in Turin in 1871, son of a chemist and amateur photographer who died when Balla was eight, leaving the family in extremely precarious circumstances.[2] To help support his mother, Balla began to work for a lithographer in 1883. Thus his artistic interests were stimulated at an early age, and he started to attend night classes at the Accademia Albertina. In 1893[3] he and his mother moved to Rome to stay with an uncle who was a gamekeeper to the king, and for a short period Balla assisted him in this occupation. Before long he decided to become an artist and started to earn his livelihood by making caricatures, illustrations, and, whenever possible, portraits.

[1] Undated and unpublished statement by Balla kindly sent to me in 1959 by Signorina Luce Balla. The auction referred to apparently did not take place until at least 1912 or 1913 and may even have been contemporary with the solo exhibition of his work in Rome at the Sala d'Arte A. Angelelli, 15 December 1915, called *Esposizione fu Balla e Balla futurista*.

[2] Much of the information about Balla's life was graciously supplied by Signorina Luce Balla during long conversations in 1956 and in letters. Balla's birth date is occasionally given as 1874.

[3] A date of 1895 for his arrival in Rome is given in Torino, Galleria Civica d'Arte Moderna, *Giacomo Balla* (Aprile 1963), 137.

Balla had apparently discovered the work of the Italian Divisionists even before he came to Rome. He venerated Segantini and was influenced by him and by his follower, the younger socialist painter Giuseppe Pellizza (1868–1907), whom Balla later knew in Rome. Following Pellizza's example, he began to paint the epic of the working man. A subtle poetry of design and colour saved many of Pellizza's pictures from the latent sentimentality of such subjects; Balla avoided this pitfall through his unwavering objectivity and his intuitive grasp of the monumental. In this respect he probably benefited from his seven-month stay in Paris in 1900. The only other effect of this visit was an increased enthusiasm for Impressionism.

The chronology of Balla's entire *oeuvre* presents something of a problem because he seems to have dated most of the paintings at a much later period in his life, and usually incorrectly. The only reliable guides to approximate datings are the catalogues and reviews of exhibitions in which he took part. After 1900 he was a regular exhibitor at the Roman salon of the Società degli Amatori e Cultori di Belle Arti.

The nearly monochromatic *Fallimento* (Bankrupt) (Pl. 34),[1] of around 1902, provides an early glimpse of Balla's artistic inclinations. The mood is set by a terse realism in which the cunningly cut and foreshortened space is the most eloquent force. A sense of failure is conveyed by the abruptly close-up depiction of a dead-end – the small area closed off by door and wall and composed almost solely of diversely textured rectangles, whose vanishing point is disquietingly placed beyond the picture frame to the right. An impressive night scene entitled *Lavoro* (Work),[2] probably of the same year (Pl. 35), is still more taut and architectonic in composition as well as more emotionally urgent. The deep, richly glowing colours, reminiscent of Van Gogh, animate the stark, geometric design which effectively suggests various aspects of external order imposed upon existence – construction in the city and the rhythm of working life. *Lavoro* is one of the earliest of a series of night scenes culminating in the transcendental stellar paintings of 1914. Balla's interest in nocturnes may have stemmed from his father's experiments in night photography.[3]

The influence of cinematography rather than still photography is evident in *La Giornata dell'operaio* (The Labourer's Day) (Pl. 36) of about 1904.[4] At first glance it is not clear that this picture was conceived as a kind of diptych in three parts, consisting of one large and two smaller panels, each depicting a different time of day.

[1] Dated 1902. Società degli Amatori e Cultori di Belle Arti, Rome, 1904, no. 1055.

[2] Dated 1902. A painting called *Lavoro* was no. 1057 in the same exhibition.

[3] In 1908 Balla exhibited a night painting, *Orione*, at the Amatori e Cultori. According to his daughter, he later overpainted this canvas. See V. Pica, *Emporium*, XXVII no. 162 (Giugno, 1908), 410.

[4] *Fabbrica*. Dated 1904. The painting called *Principio e fine* at the Amatori e Cultori, 1905, no. 875, may be identical with *La Giornata dell'operaio*.

Colour and shifts of viewpoint are so delicately adjusted from one part to the next that the passage from dawn to midday to evening seems as inevitable as the flow of life. The impression is that of a slow-motion film. Beginning in the upper left panel, Balla depicted dawn in the dusky, remote skeleton of the house, which extends beyond the confines of the picture; at the lower left, the brilliant light of the noon-day rest is shown; this progresses to a final view, at the right, of the still unfinished building, marked by the deepening shadows of approaching night which already engulf the homeward-bound workers. While an allusion is made to the toils and dreams of men, this external symbolism is subordinated to, and completely integrated with, the chief theme, which is time. In this respect *La Giornata* is notable as a distinguished experiment and a direct antecedent of one of the key doctrines of Futurism.

Boccioni remarked frequently during these years on the power of Balla's art, to which his own paintings, particularly the industrial studies, owed a great deal. Nevertheless, he found Balla wanting in some respects. In the autumn of 1907 he complained to Severini that 'Balla absolutely lacks decorative vision – the only thing which can make a great work of art . . . [His] universe does not throb!'[1] This censure is more revealing of Boccioni than of Balla. The former was at that time floundering between a very objective, disciplined manner and a complicated emotional symbolism; in the above passage he seemed to be musing about his own problems. Yet Balla's *Salutando* (Saying Good-bye)[2] (Pl. 37) looks almost like a reply to Boccioni's criticism. It was exhibited in 1910, but may have been painted one or two years before.[3] The angular, unyielding architecture of *Fallimento*, *Lavoro* and *La Giornata* had given way to the vertiginous spiral of a stairway. The decorative and dynamic potential of this Art Nouveau motif was utilized by the choice of a hazardous and uncustomary angle of vision which again recalls photography. The viewpoint visually hastens the rapid descent into the pit of the stairwell, which draws the spectator into its shadowy depths like a vortex. This downward passage is only momentarily arrested by the three women, whose upward gazes form a strategic connection with the world beyond the picture plane. *Salutando* is as important as *La Giornata* in Balla's development because it too contains the seeds of his abstract studies of motion.

A critic reviewing the 1910 exhibition who did not care for *Salutando* thought 'that [here] the means were mistaken for the ends of art'. Like most of Balla's official supporters he preferred the Carrierè-like triptych *Gli Affetti* (Affections) (1910;

[1] *Archivi*, I, Boccioni to Severini (Autumn 1907), 229.
[2] *La Scala – salutando; Gli Addii scala.*
[3] Amatori e Cultori, 1910, no. 194, Pl. VI.

Pl. 38), which was also exhibited. This painting he welcomed as a 'work of sentiment and thought, of poetry'.[1] To the modern critic who admires the forceful and original works like *Salutando*, *Gli Affetti* and others like it are of little interest. They reveal that Balla was uncertain and still undergoing an experimental phase. But his brave acceptance of Boccioni's invitation to join the Futurists implies his awareness of the latent possibilities of his unpopular pictures, and his desire to develop them.

Paris: Gino Severini (1883–1966)

The first sentence of Severini's autobiography sheds much light on his life: 'The cities towards which I feel the deepest affection are Cortona and Paris: in the first I was born physically, in the second intellectually and spiritually.'[2] Unlike Boccioni, Carrà and Balla, who remained loyally bound to Italy and whose first exposure to French artistic life did no more than stimulate them, Severini capitulated to France, patriotically and artistically. France became his home; there he found a family who treated him like a son, and in 1913 he married the daughter of the reigning Parisian *prince des poètes* – Paul Fort.

The circumstances of Severini's early youth and his enterprising temperament, as well as sheer luck, undoubtedly influenced his decision to settle in France. His father was an usher to the magistrate in Cortona, where Gino was born in 1883 and received all his formal education. This stopped abruptly in 1898 when he was expelled from the Scuola Tecnica, and consequently barred from all other Italian schools, because of a juvenile prank. About this time he began to show some artistic promise. As the possibilities for further training seemed limited in the provinces, his mother accompanied him to Rome in about 1899. His first years in the capital were marked by poverty and to survive he was forced to accept a variety of employments. He briefly attended evening art classes at the Villa Medici, but it was the contact with Boccioni and Balla which was decisive for his future career.

Severini's fortunes began to change about 1904, when a small stipend from a Cortona prelate enabled him to devote his time fully to art. In 1905 his entries for the salon of the Società degli Amatori e Cultori di Belle Arti were rejected as were most of Boccioni's, despite the vigorous interjections of Balla, who was a member of the jury and a respected participant. Angered, they got together with a group of young artists who had also been refused and arranged a '*mostra dei rifiutati*' in the Foyer of the

[1] Arduino Colasanti, 'L'Esposizione internazionale d'arte in Roma', *Emporium*, XXXI no. 185 (1910), 384.

[2] Unless otherwise indicated, the facts regarding Severini's life are drawn from *Tutta la vita di un pittore*.

Teatro Nazionale. Severini has written how his and Boccioni's paintings stood out among the generally inferior works and how they were both praised by the press. During this exhibition he attracted the attention of a wealthy Dutch banker who bought two of his pictures and suggested that he go to Florence to make copies of paintings in the Uffizi for him. When he failed to satisfy his Dutch patron with his replica of Filippino Lippi's *Adoration of the Magi*, a French artist's widow, visiting in Florence, came to his rescue by purchasing it for 100 lire. With this money he departed for Paris, where he arrived on a 'grey and rainy Sunday morning in October, 1906'.

In Paris Severini quickly made friends with the many other Italian artists who were also trying to make their way, one of whom was Amedeo Modigliani.[1] A young dentist, who was an amateur of the arts, also attached himself to him and his family repeatedly came to Severini's rescue when his delicate health and finances failed. About 1908 he had the good luck to find a studio behind the offices of the important experimental Théâtre de l'Oeuvre, directed by Lugné-Poë, who produced Marinetti's *Le Roi Bombance* in 1909. Severini apparently did not meet the Futurist leader on that occasion, but before long he had become an intimate of the lively literary and artistic circle of the theatre, which consisted mostly of the older Symbolist poets and the Nabis painters. They nicknamed him the *gosse de l'Oeuvre*.

This was the time when the aerial feats of the Wrights, Blériot, and Chavez were provoking great excitement and capturing the imaginations of many, including Severini.[2] As a result of a friendship with a Peruvian flyer, he decided that he too wanted to try this new art. Introductions from Lugné-Poë enabled him to make the right contacts, but after a month's association with other ' "*chauffeurs*" del cielo', the frail Severini realized that painting, not flying, was his true calling. He ruefully returned to Paris and rented a studio at 5 Impasse Guelma. There his neighbours later included Suzanne Valadon, Utter, Utrillo, Raoul Dufy and, briefly in 1911, Braque.[3]

Only a very few of Severini's pre-Futurist pictures are known. The pastel *La Bohémienne*, dated 1905 (Pl. 39), seems to be characteristic of some of his work before he went to Paris. The influence of the *macchiaioli* and indirectly even that of Manet is suggested by the large, unmodelled planes and the strong contrast of light and dark, but the picture gives also an early intimation of Severini's decorative sense. The

[1] Severini, *Ragionamenti sulle arti figurative* (Milano, 1936), 120-1.

[2] Marinetti was similarly inspired and dedicated his play, *Poupées électriques*, (Paris, 1909), to 'Wilbur Wright qui sut élever nos coeurs migrateurs plus haut que la bouche captivante de la femme'.

[3] *Tutta la vita*, 78 ff. Severini apparently returned to Paris during 1910. He gives the impression that Braque and Dufy moved to the same building in the same year he did; actually, they did not do so until 1911.

animated contours of the woman's figure anticipate to some degree the rhythmic grace of his later dancer studies.

In Paris Severini exhibited both at the staid Societé Nationale des Beaux Arts (1908, 1909) and the Salon des Indépendants (1908–10). *La Bohémienne*, listed in the catalogues of both 1908 salons, may be identical with the earlier pastel. None of the others mentioned can be identified. Two works of 1909 or early 1910, *Printemps à Montmartre*[1] and *Portrait du peintre Utter* (Pls. 40, 41) give some idea of the general direction of his Parisian endeavours before he became a Futurist. Severini has written that, out of all the vanguard tendencies competing for leadership in Paris at the end of the decade, he felt most strongly drawn to the Neo-Impressionists. This was because of Balla's influence. Fauvism did not appeal to him because he did not yet understand Matisse's evolution, and he still knew too little of the work of Picasso and Braque to be affected by them in any way.

The lyrical *Printemps à Montmartre* is a competent Neo-Impressionist painting; its controlled arrangement does credit to Seurat's example. But Severini substituted Signac's larger 'colour bricks' for the pointillist dots, and the picture as a whole reflects the more decorative tendencies of Seurat's later disciples, of the Nabis, or some of the Italian Divisionists. This is especially true of the delicate, somewhat academic portrait of Utter, and is also borne out by Severini's choice of a muted colour key in *Printemps à Montmartre*.

By 1910 Severini had met and mingled with many of the leading spirits of the Parisian vanguard, but artistically he was still on the fringes. Only when he became associated with the vigorous Futurists was he forced to become competitively aware of the growing power and significance of Cubism. He was introduced – probably by Marinetti – to the Left Bank artistic leaders who assembled at the Closerie des Lilas.[2] There Paul Fort presided, surrounded by the poets Apollinaire and Salmon, the artists Léger, Metzinger, the Duchamp brothers, and Gleizes, among others. Not long afterwards Braque, Severini's new neighbour, presented him to Picasso at the Lapin Agile, thus starting a friendship which lasted for many years.[3] The combination of the driving force of Futurism with the more subtle stimulation of his broadening Parisian associations begot the most fruitful years of Severini's career.

[1] *Printemps à Montmartre, les escaliers du Sacré-Coeur*. Although the painting bears a date of 1909, its style is consistent with his work of the first half of 1910.

[2] *Tutta la vita*, 102 ff. Severini states that this took place in 1911. Because his recollection of dates is frequently vague, this introduction could also have occurred in 1910, when Marinetti participated in Alexandre Mercereau's *Séance poétique* at the Salon d'Automne.

[3] Ibid., 87. This meeting probably took place in 1911, not in 1910; see above, p. 77 n. 3.

VII

THE FIRST FUTURIST PAINTINGS OF BOCCIONI, CARRÀ AND RUSSOLO: 1910 TO SUMMER 1911

THE manifestos helped to crystallize the thoughts and coordinate the efforts of all the artist-signatories, and this led to an increasing unity of approach. In Milan the interchange of ideas became so vigorous that by the end of 1911 it was difficult to single out one originator of the artistic vocabulary, though individual modes of expression remained as distinct as before. The painters' physical proximity and enthusiastic participation in Marinetti's tumultuous campaigns generated and heightened the *esprit de corps*. While these activities gave them little leisure time and occasionally even endangered their lives by provoking attacks from hostile audiences,[1] they also stiffened the resolve to succeed in their artistic mission. As well as speaking and demonstrating in Italian cities from Milan and Venice to Naples, the Milanese painters provoked public controversy by presenting at least four exhibitions before 1912.[2] Each of these was accompanied by Futurist fanfare, which invariably included some planned or spontaneous brawls. The Esposizione d'Arte Libera (Free Exhibition of Art) which opened in the Ricordi Pavilion in Milan on 30 April 1911, was the most important and decisive of the exhibitions for the development of the Milanese artists, and indirectly for Futurism as a whole.

The Esposizione d'Arte Libera and its Consequences

The purpose of the projected exhibition was outlined in a broadside dated 30 January 1911, and signed by Boccioni, Carrà and some of the other co-directors.[3] Several Italian reform movements in the nineteenth century had provided the precedents for an unjuried exhibition. The innovation lay in the fact that amateurs were invited to contribute, although this did not influence exhibition trends until years later. Following a Crocean train of thought the sponsors declared 'that the artistic sense . . . is innate in human nature and that the forms through which this is manifested simply externalize major or minor sensibilities'. The exhibition was to be

[1] Carrà, *La Mia vita*, 149.
[2] *Archivi*, I; entries of 19 March, 20 December 1910, 30 April, 12 December 1911, 472–6.
[3] The exhibition was sponsored by the Società Umanitaria, Casa del Lavoro, Milan.

79

'open to all: children, who often reflect unconsciously but with vivid signs that which strikes their imagination, as well as to workers, to men who adopt the universal language of forms and colours to communicate that which the word would never be able to express'. Professional artists were not excluded, provided they intended to 'assert *something new*'.[1]

This provocative enterprise may have been influenced by some ideas in Soffici's touching yet balanced eulogy of the Douanier Rousseau, written a few months earlier. He had begun with his usual baiting of the stodgy public: 'I adore that painting which intelligent people call stupid . . . painting of simple men, of the poor in spirit, of those who have never seen a professor's mustache . . . in which is found a strength of feeling, . . . the naked and raw expression of a plain but sincere soul, devoid of harmony but filled with reality.'[2]

The Free Exhibition was enormous: more than 800 pictures were shown. The Milanese Futurist trio were represented by fifty works, the largest number they had shown together so far. Their choice of exactly fifty was no doubt intended as a reference to the fiftieth anniversary of Italy's independence, which was then being commemorated in Rome by a World's Fair and an academic exhibition of international art.[3] A second broadside advertised the Futurist contribution to the Esposizione Libera. It advised the citizens of Milan that 'If you do not want to cover yourself with shame, giving proof of ignominious intellectual apathy unworthy of the high Futurist destiny of Milan, rush and intoxicate your spirit before *50 Futurist paintings* which the *Corriere della sera* calls "THE MADDEST COLOURISTIC ORGIES, THE MOST INSANE ECCENTRICITIES, THE MOST MACABRE FANTASIES, ALL THE DRUNKEN FOOLISHNESS POSSIBLE OR IMAGINABLE".'[4]

But when Soffici visited the exhibition in June, his Florentine chauvinism and genuinely high critical standards seem to have interfered with his professed broadmindedness. In contrast to some of the Milanese newspapers which were not unsympathetic to the Futurist experiment, Soffici wrote a merciless review for *La Voce*.[5] He found absolutely nothing in the exhibition worthy of praise, save perhaps its underlying principles. This was more than the Milanese could bear, especially since

[1] U. Boccioni, C. Carrà, etc., 'Lettera-invito per l'esposizione d'arte libera', reprinted in *Archivi*, I, 102–3.

[2] *La Voce*, II no. 40 (15 Settembre 1910), 395; reprinted in *Scoperte e massacri*, 105, 106, 108.

[3] Balla took part in the Roman exhibition.

[4] Broadside reproduced in M. Z. Russolo et al., *Russolo*, 27.

[5] 'Arte libera e pittura futurista', *La Voce*, III no. 25 (22 Giugno 1911), 597.

Soffici's biting tongue had once before been turned on Boccioni's art.[1] They immediately boarded a train for Florence and assaulted the unsuspecting Soffici and his *La Voce* friends, who were found peacefully sipping coffee at the Caffè delle Giubbe Rosse.

This skirmish has become one of the most notorious in the annals of modern art. The story has often been told. Apollinaire recorded it in his *Mercure de France* column; others, including some of the participants, have left accounts of it, but there is little agreement on the details and much less on the outcome.[2] One of the main points of disagreement is whether or not Boccioni and Soffici made peace at the end of the fight. The only indisputable result of this encounter seems to have been the inadvertent beginning of a *rapprochement* between the Florentine and Milanese groups.

The eagerness with which news of the Futurists was received by the alert Parisian vanguard often proved embarrassing or annoying to Severini, who was consequently exposed to ridicule. He later admitted that he had been 'extremely glad to be far away and not taking part in those jousts'. When he visited Milan, probably in the late summer of 1911, and saw the work of his colleagues for the first time, he all but seconded Soffici's strictures and strongly urged the group to come to Paris to study 'the directions in which they ought to proceed'.[3] His arguments were so convincing that Marinetti agreed to pay for a group trip in the autumn, and this momentous journey was to have far-reaching consequences. It brought the Futurists into direct contact with the Cubists' work, enabling them to enlarge and consolidate their own formal precepts.

1910: Boccioni, Carrà, Russolo

There was still little that could be truly called Futurist in most of the paintings completed in 1910 by the Milanese trio. Yet these transitional works are not only individually revealing but announce the chief characteristics of early Futurist art. They provided a testing ground for the dual proposition in the technical manifesto: production of an emotionally expressive art and inclusion of the time dimension.

[1] 'L'Esposizione di Venezia', *La Voce*, II no. 47 (3 Novembre 1910), 426. 'Un ultimo filo d'illusione mi ha condotto a Palazzo Pesaro a vedere se almeno i futuristi lasciassero un adito, una gattaiola, aperta alla speranza. Ma no! È stato un altro disastro. Umberto Boccioni, l'incendiario, l'anarchico, l'ultramoderno Boccioni, è un saggissimo pittorello, seguace pedestre di Chahine, Prunier, di Helleu, che so io? che non rischia nulla, sta nel solco e dipinge come si faceva nel Belgio trenta o quarant' anni fa!' This paragraph is omitted in the reprint of this article in *Scoperte e massacri*.

[2] Carrà, *La Mia vita*, 150–1; Severini, *Tutta la vita*, 118–20; *La Voce*, III no. 27 (6 Luglio 1911), 606; Apollinaire, *Anecdotiques* (Paris, 1955), 49–50, 292.

[3] Severini, *Tutta la vita*, 125. Carrà does not mention Severini's visit to Milan in his autobiography.

Typical of this stage are Boccioni's *Una Maestra di scena* (An Elocution Teacher) and *Lutto* (Mourning), Russolo's *Profumo* (Perfume) and *Lampi* (Lightning), Carrà's *Notturno in Piazza Beccaria* (Nocturne in Beccaria Square) (Pls. 42–7), all 1910 paintings.

Una Maestra di scena[1] was still a traditional portrait, but it marked a significant departure for Boccioni and caused a considerable stir when shown at his first one-man exhibition at the Ca' Pesaro in Venice in the summer of 1910. Its subject and treatment are almost diametrically opposed to *Figura al sole* (Pl. 26) of the previous year. *Una Maestra di scena* represents a figure from the night life which the Futurists regarded as an essential element of the modern metropolis. She is drawn with an unprecedented expressionist violence which reflects Marinetti's demand for artistic intensity and for an unromantic view of womanhood. Formally it derives from Mancini, Toulouse-Lautrec, Ensor, or even Daumier. The elocution teacher is garishly illuminated by a ruthless artificial light and looks squarely out of the picture. There is no resemblance to the subtle play of light that models the sculptural back and profile in *Figura al sole*. The lighting and the heavy, cascading brushstrokes deny structural articulation and make the large body flow like a viscous mass over the length of the canvas.

A similarly emotional catharsis seems to have inspired *Lutto* (Pl. 43) – the most controversial picture in the second joint exhibition of the Milanese Futurists in December 1910. The very subject was incompatible with the movement's principles, which passionately denied anything connected with the cult of the dead, i.e. the past.[2] But in spite of its *passéiste* subject and 'lugubrious darkness worthy of Munch',[3] upon closer study this painting is revealed as a first and tentative attempt at portraying a 'state of mind' in the Futurist sense. From the spontaneous outburst of sensations expressed within the limitations of a portrait in *Una Maestra di scena*, Boccioni had moved on to a fuller examination of the specific spiritual state of mourning, narrowing down his scope in order to generalize the meaning of one particular emotional complex. This search for universality was mentioned in a letter which may refer to this painting: 'If it shall be in my power (and I hope it is), emotion will be suggested with the smallest possible recourse to the objects which have evoked it. For me the

[1] *Signora Maffi*. The painting is dated 1909, but in a letter of 21 June 1910 to Nino Barbantini, the Director of the Ca' Pesaro, Boccioni says that it is one of his latest works and that the varnish was still fresh. It probably was begun in 1909. *Primi espositori di Ca' Pesaro*, 114.

[2] Marinetti adhered to this so consistently that during the First World War he forbade the publication of obituaries, even those of his closest friends and associates. *Archivi*, I, Marinetti to Pratella (20 December 1916), 374.

[3] Sam Hunter, 'Was Futurism Sentimental?', *Art Digest*, XXVIII no. 14 (15 April 1954), 10.

ideal would be a painter who, wishing to suggest sleep, does not lead the mind to the being (man, animals, etc.) which sleeps, but by means of lines and colours could evoke the idea of sleep, that is, universal sleep beyond the accidentals of time and place.'[1]

Boccioni all but eliminated the physical presence of the dead man, who is merely suggested by a part of the coffin. Thus the spectator is actively engaged in the formal rather than the anecdotal life of the picture. Attention is drawn to the strong, two-dimensional design with its jarring intersection of two dissimilar rhythms – the circular and X-shaped movement – suggestive of distorted and irregular tides of feeling. The contrast of sombre blues, purples and black with the bristling reds and yellows of the chrysanthemums (a pattern repeated in a more subdued manner in the tousled heads) accentuates these two opposing rhythms. Boccioni has depicted the inarticulate but explosive mood of mourning with something of the directness and violence of Italo-Byzantine Crucifixion or Deposition scenes (Pl. 44).[2] But wishing to stress the passage of time in this intuitive choreography of grief, enacted by the large, gesturing hands and faces, he has shown probably only two (possibly three) women from different views – the front, the sides, and the back.

Russolo was similarly working toward a formally evocative statement, if in a more elegant vein, with his *Profumo* (Pl. 45), which apparently was shown at the same time as *Lutto*.[3] Its title indicates the synaesthetic tendencies which Futurism had inherited from the *scapigliatura*. Russolo created a visual correspondence for non-visual sensations. Form, colour and light are arranged to simulate olfactory – and more remotely – auditory sensations and their development in time. The weaving line which threateningly enmeshed Nietzsche in the earlier print is now used to give an effect of transparent, rising vapours, merging with the woman's thick, shimmering hair as they fall. The Divisionist mystique of light permeates and dematerializes the apparition which hovers in the atmosphere like a musical chord, unstable, on the verge of dissolving, like one of Debussy's elusive harmonies. The ultra-femininity of this picture, with its delicate boudoir pinks and purples, has more in common with the D'Annunzian celebration of *das ewig Weibliche* than with the Futurist *mépris de la femme*, which Marinetti had just expounded at length in his novel, *Mafarka le futuriste*. In the *Dedica* to the Italian edition he railed particularly against the type of languorous

[1] Letter to Nino Barbantini (after 3 November 1910) reprinted in *Primi espositori di Ca' Pesaro*, 116. The letter is here erroneously dated September 1910, but Boccioni speaks of Soffici's *La Voce* review of 3 November 1910.

[2] Pl. 44, a preliminary drawing for *Lutto*, suggests that Boccioni began with a fairly conventional Descent from the Cross.

[3] Famiglia Artistica. *Catalago illustrato della esposizione d'arte* (Milano, 1910–11), no. 48.

H

beauty epitomized in *Profumo*. 'I wish to fight . . . the abandon of half-parted lips drinking in twilight nostalgia, the feverishness of tresses overcome by stars which are too high . . . I wish to conquer the tyranny of love . . . !'[1] But this picture too, apart from its subject, provides an important antecedent to the Futurist theory of analogies developed in 1912. Its original technique of rapid, fluid strokes – derived from Previati – and so well adapted to the intangible sensations portrayed, no doubt helped to make the Milanese painters more acutely aware of the synaesthetic potential in the visual arts.

Two nocturnal city-scapes – Russolo's *Lampi* (Pl. 46) and Carrà's *Notturno in Piazza Beccaria* (Pl. 47)[2] – reveal the Divisionist expertise of both artists, as well as their individual temperaments. Inspired by the almost religious reverence for nature of Grubicy and his circle, Russolo contrasted the weak artificial illumination used by man with the brilliance of lightning. The expansive architecture of the free flowing clouds dwarfs the puny and severe human constructions below. There is here a superficial similarity to Boccioni's 'Unanimist' city-scapes of 1908-9 (Pls. 27, 28), but the two artists' different conceptions of city life are brought out by Russolo's print, *Città addormentata* (Sleeping City) (Pl. 48), which is related to *Lampi*. While Boccioni was concerned with the active, working life, Russolo concentrated on the more esoteric, sensuous aspects of communal living.

Carrà's *Notturno* was one of a series of city scenes painted in 1910. It is devoid of any conspicuous theme and the approach is much more detached and less conceptual than that of either Russolo or Boccioni. Despite the romantic haze conveyed by the thick paint surface (which harks back to Cremona and Ranzoni), this is a careful distillation of actual observations, in which little allowance is made for psychologically expressive distortions of colour or form. Carrà's refined, subdued hues and his delicate tracing of the quivering reflections of the big arc light and of the barely perceptible shadows acutely evoke a city at night.

1910–11, 'Unanimist' Paintings: Boccioni and Carrà

A number of paintings begun during the latter part of 1910, and in general not finished until the Free Exhibition, record the gradual evolution of a distinctly Futurist idiom. The eruptive power of the collective spirit was one of the first

[1] *Mafarka il futurista*, translated from the French by Decio Cinti (Milano, 1910), 10. In October 1910 court proceedings were instituted against the book because of its alleged indecency. These are reprinted in Marinetti, *Distruzione*, transl. Decio Cinti (Nuova edizione, Milano, n.d.), 253 ff. Compare *Profumo* to Buzzi's 'A Claude Debussy', *Aeroplani* (Milano, 1909), 59, inspired by *Pelléas et Mélisande*.

[2] The Famiglia Artistica catalogue of 1910–11 lists as no. 51 Russolo's *I Lampi*, which probably is identical with Pl. 46. Carrà showed six works entitled *La città*, of which Pl. 47 may have been one.

symbolic themes, and several paintings deal with this subject. In Boccioni's case, *Rissa in galleria* (Riot in the Gallery)[1] (Pl. 49), represents the inception of this theme, and the huge *Città che sale* (The City Rises) (Pl. 52),[2] the culmination. Both were painted in 1910–11.[3] Although the immediate (and unemphasized) subject of the first picture is a fight between two women, there seems to be also a broader reference to the insurgent mood of the young artists and writers who met at the Galleria's cafés, and the need they felt to 'shatter the window-panes'.[4] In the second painting there are more general allusions to the metaphysical aspirations of Futurism and indirectly to those of Boccioni himself.

As in the industrial scenes of 1908–9, Boccioni again used light and space as the chief vehicles of expression; indeed, in both *Rissa in galleria* and *Città che sale* light acts as a catalyst to the events depicted and dynamic space acts as a foil. Thus in *Rissa*, it seems that the lightning flashes of the electric bulbs, reflecting on the glass panes, rather than the actual conflict below, are provoking the mass agitation. The mob is shown flocking like moths to the light and then being repelled by it. Its gestures and leaps, in the shape of open wedges and triangles, echo the spokes of light, and become the chief motif of spatial excitement. The remarkable complexity of the composition, which in its counterpoint of rhythms is comparable to the rhythmical experimentation advocated by Pratella in his manifesto of music, is furthered by the high vantage point. But this distance also weakens the immediate impact of the conflict below, since the tension is alleviated in the vast upper reaches of the vaults.

The keynote of *Città che sale*, which deals with men and horses labouring on a construction site, is a much greater violence. While working on this canvas Boccioni said that he now understood 'Marinetti's words: no work which does not have an

[1] There are actually three known paintings which deal with riots and much confusion exists regarding their dates and titles. *Rissa in galleria* is probably the earliest and identical with *La Baruffa*, no. 56 in the 1910–11 Famiglia Artistica catalogue, and described in *La Preservanza*, 21 December 1910 (see C. Baumgarth, 'Die Anfänge der futuristischen Malerei', *Mitteilungen des Kunsthistorischen Institutes in Florenz*, XI nos. 2–3 (November, 1964), 186). The second, *Retata* (The Raid) (Pl. 50), is apparently identical with the painting by that title shown at the 1911 Esposizione Libera. *Il Secolo*, 1 May 1911, described it as 'una sarabanda di carabinieri, di donne, di marciapiede, in un movimento rivoluzionario, nella luce torrenziale delle lampade elettriche'. It was shown as *La Rafle* at the 1912 Bernheim-Jeune exhibition and purchased by the Paris police prefect Lepine. The third, *Baruffa* (The Riot) (Pl. 51), seems to have been painted in 1911 because of its similarity to two drawings dated 18 April 1911 (J. C. Taylor, *The Graphic Work of Umberto Boccioni* (New York, 1961), nos. 176, 177).

[2] Called *Lavoro* at the Esposizione libera.

[3] In the November 1910 letter to Barbantini, cited above, p. 83 n. 1, Boccioni tells of just having begun to work on the large *Città che sale*.

[4] Argan, *Boccioni*, 14.

aggressive character can be a masterpiece!'[1] Everything about this large painting is aggressive. Nothing escapes the sun, which has been fused with the general activity to portray an overpowering force, apparently capable of creating and destroying life.[2] Thus the autonomy of the human figure, still preserved in the fragile, shadowy beings of *Rissa in galleria*, is denied. Just as the technical manifesto had demanded, the figures are X-rayed, metamorphosed, dissected. Conventional spatial concepts are threatened. Space is no longer a passive, static enclosure dependent upon perspective and context for its expressiveness. It has been set into motion, becoming a dominant theme in the whole. Instead of using the aerial viewpoint of his earlier works, Boccioni looked at the action from below, emphasizing the large triangle form at the lower left. This draws the observer into the midst of the pandemonium and forces him to become an active participant in the anguish and discomfort of hauling the unseen load up the steep incline. Technique becomes more vital and integral to the whole. While still adhering to the disciplinary principles of Divisionism, Boccioni adapted the small, regular brushstrokes of *Rissa* to slightly longer lines which intimately follow the directional drive of each form. His method was so skilful that these strokes vibrate and shift before one's eyes like metal shavings that have entered a magnetic field. Even the palette, with its fiery reds, although not new to Boccioni, expresses an unprecedented urgency. Every element in *Città* is geared to the artist's desire to create 'a great synthesis of work, light and movement'.[3]

Boccioni worked on this painting for a long time. It was his first fully Futurist statement as well as the first synthesis and summation of his previous efforts. In it he attained a temporary equilibrium between the emotional and the more objective approaches to art, found in his preceding work, as well as a balance between symbolism and expressive form. The unfinished, expanding structure at the core of *Città che sale* became a distinctly Futurist image, also celebrated in Marinetti's writings, where it was related to the older epigram of the racing car's superiority to the Victory of Samothrace.[4] This romantic attraction to the incomplete and perpetually growing structure can be seen as a modernization of the Pauline notion of God's builder

[1] *Archivi*, I, Boccioni to a lady (dated 1911 but without evidence, could also be late 1910), 233.

[2] The Futurists' Divisionist-inspired sun-worship is expressed in their Technical Manifesto: 'We proclaim ourselves Lords of Light, for already we drink from the live springs of the Sun.'

[3] Boccioni to Barbantini, cited above, p. 83, n. 1.

[4] 'La Guerre électrique', *Le Futurisme*, 116. 'Rien n'est plus beau que l'échafaudage d'une maison en construction . . . l'échafaudage symbolise notre brûlante passion pour le devenir des choses. Fi des choses réalisées et construites, bivouacs de sommeil et de lâcheté! Nous n'aimons que l'immense échafaudage, mouvant et passionné, que nous saurons consolider à chaque instant, toujours différemment, avec le rouge ciment de nos corps pétris de volonté.'

ceaselessly labouring on God's building.[1] The affinity to Saint Paul may be supported, perhaps coincidentally, by the similarity of Boccioni's immense horse and falling man to the image of the conversion of Saint Paul, from Michelangelo to Caravaggio. Saint Paul's mystical death which led to his conversion, is suggested by Boccioni's wish to embody in this painting the 'fatal striving of the crowds of workers'.[2] He seems to have been referring to the 'death' of the individual worker – his expendability and insignificance as an individual – in the service of the greater aspirations of modern urban life.

It may seem contradictory that while Marinetti was singing the praises of the 'broad-chested locomotive', of automobiles and aeroplanes, Boccioni was painting a Futurist canvas with huge, old-fashioned horses, relegating their modern mechanized successors – the steam engine and tram – to the background. But Boccioni loved horses.[3] They figure prominently in his work, and the image of the horse and horseman seems to have had the same romantic appeal for him as it had for Kandinsky. Unknown to Boccioni, the Russian artist was at the same time evolving a design for the *Blaue Reiter Almanach* which embodied this time-honoured theme.[4] Kandinsky's horse was a sleek blue Pegasus, presumably leading the rider into new aesthetic realms. Boccioni's had the same function, but his was a work horse rather than the aloof beast of ancient and aristocratic lineage which served Kandinsky. Yet Boccioni's red horse carried its attribute – the vibrating blue yoke of labour – with the same ease and naturalness with which Pegasus wore his fabled wings.[5]

Carrà's *Uscita da teatro* (Leaving the Theatre) and *Funerali dell'anarchico Galli* (Funeral of the Anarchist Galli), as well as the destroyed *Martiri di Belfiore* (Martyrs of Belfiore) (all around 1910–11), are comparable to Boccioni's 'Unanimist' scenes. The sparkling *Uscita da teatro* (Pl. 54) is the least complicated and closely related to Carrà's city-scapes of 1910. Its presentation of a collective sentiment lacks the stridency of context and handling advocated by the Futurists. However, Carrà did with freshness and astuteness take up the technical manifesto's premise that 'All things move, all things run, all things change rapidly'. The spectator's sense of equilibrium is affected

[1] 1 Corinthians, 3, 9. Cf. Erwin Panofsky's interpretation of St. Barbara's unfinished tower in *Early Netherlandish Painting* (Princeton, 1958), I, 186.

[2] Letter cited above, p. 83, n. 1.

[3] Vico Baer recalled that Boccioni always wanted to learn horseback riding. His wish did not materialize until the end of his life and it caused his death.

[4] Kenneth Lindsay, 'The Genesis and Meaning of the Cover Design of the First *Blaue Reiter* Exhibition Catalog', *Art Bulletin*, xxxv no. 1 (March 1953), 47 ff.

[5] *Gigante e Pigmeo* (c. 1909–10) (Pl. 53), which is an early statement of the theme of *Città*, brings Redon's 1889 lithograph of *Pegasus Captive* to mind.

by the subtle suggestion of uneven, slippery and snow-covered ground, on which figures scurry in differing directions, cabs jerk and slide, lights and shadows make transitory patterns – testifying vividly to this world's unsteadiness. Carrà had gained much artistic skill and he has since affectionately recalled that this intimate picture 'best expressed the idea which I held at the time of the art of painting'.[1]

In the huge *Funerali dell'anarchico Galli* (Pl. 55) Carrà laid aside the restraint of his early work and pulled all the emotional and technical stops at his disposal. This portentous painting, which occupied him at least over a year, had its origin in a specific event in which Carrà himself took part in 1904.[2] *Martiri di Belfiore*, which was shown with it at the Free Exhibition, also depicted an Italian subject, this time from the *risorgimento*, and it had already been commemorated in a poem by Carducci. After the exhibition Carrà destroyed *Martiri* and apparently overpainted some of *Funerali*, introducing a forceful proto-Cubist articulation, especially in the upper third.[3] In the death of the individual – symbolically suggested in Boccioni's *Città* and specifically referred to in Carrà's *Funerali* – both artists saw the multiple, regenerative force of the masses.[4] Carrà, however, did not wholly transcend the narrower historical and anecdotal associations of his subject, and in many ways his picture is the diametrical opposite of Boccioni's *Città*. While Boccioni exalted the light, the sun, Carrà painted a foreboding of inferno. While red was also his keynote, the colours of the *Funerali* were made sultry and threatening by dark shadows, pierced occasionally by touches of cool blues and greens. Boccioni's light-drenched beings seem to obey the stresses and strains of their muscles and nerves, while Carrà's spectral figures, though twisting and turning, seem hopelessly grounded in a perpetually running belt. The oblique line, broadened into ribbon-like shapes in *Funerali*, weaves intricate webs which entangle the viewer in the excitement of the scene. Yet as Barr has observed, this unforgettable expression of the mob's all-encompassing rebelliousness relies compositionally upon the principle of 'classic balance and counterthrusts of fifteenth-century battle pieces by Uccello which Carrà loved and was later to write about'.[5]

[1] Carrà, *La Mia vita*, 161. Carrà's painting recalls Bonnard's street scenes of the turn of the century.

[2] Ibid., 73–74. The painting has occasionally been dated 1904 and 1908–9, but Carrà probably worked on it in 1910–11.

[3] The painting has not been X-rayed, but the Museum of Modern Art's restorer has noted numerous superimposed layers of paint.

[4] Cf. the funeral and the vitality of the populace described in Romains' poem 'Le groupe contre la ville', *La Vie unanime*, 100 ff.

[5] James Thrall Soby and Alfred H. Barr, Jr, *Twentieth-Century Italian Art* (New York, 1949), 10. Thanks to Berenson, Uccello's reputation had undergone a complete reversal early in this century, and his frescoes in the Chiostro Verde were being restored. Soffici, in his article on Rousseau, mentioned above, compares these two 'primitives'. Carrà uses a quotation from Soffici as an epigraph for his 1916 essay on Uccello.

Transition to 'The Painting of States of Mind'

While Boccioni and Carrà were labouring on their large and vehement master-works which illustrated the Futurist spirit in the raw, Russolo, early in 1911, evolved the working principles for the more subtle and original concept of *la pittura degli stati d'animo*. This approach – baptized so it seems by Boccioni during the late spring[1] – led to a new and richer exploration of the key premise of the technical manifesto which called for rendition of the universal dynamism as dynamic sensation. The painting of states of mind involved a shift in focus from the more anecdotal approach of the preceding works to one in which emphasis was laid on the artist's subjective perceptions and their formally expressive revelations. Boccioni's *Lutto*, Russolo's *Profumo*, and more recently Carrà's *Nuoto* (Swimming)[2] (Pls. 43, 45, 56) had antici-pated the painting of states of mind in their search for a dynamic pictorial idiom which would be removed from specific temporal and spatial references. The in-creasingly influential writings of Bergson no doubt helped the Futurists in this emancipation from visual reality. Soffici in his short essay, 'Le due perspettive' of the autumn 1910, had paraphrased Bergson's exhortation to the artist to obey only the dictates of his spirit and to penetrate the material veil to discover 'reality'. Hence the Florentine critic recommended that the painter should make use only of *prospettiva psicologica* instead of geometrical perspective.[3]

Russolo's two large introspective canvases – *La Musica*[4] (included in the Esposizione Libera) and the later *Ricordi di una notte* (Memories of a Night) (Pls. 57, 58) – come close to illustrating Bergson's conception of 'psychic duration' as memory which links the past with the present and future. The first picture is reminiscent of Bergson's frequent metaphorical comparisons of psychic duration to music, both of which

[1] Boccioni apparently used the term for the first time publicly in his conference at the Roman Circolo Artistico Internazionale on 29 May 1911. Marinetti may have influenced the selection of the name, because Symbolist poets were deeply concerned with the expression of states of mind.

[2] *Nuotatrici, En nageant, A Swim*. The painting bears an illegible date which has been read as 1910. It was probably painted during late 1910 or early 1911 and it was shown at the Esposizione Libera. In Libero Altomare's poem *Nuotando nel Tevere*, which Marinetti frequently recited during 1910, the sensations of swimming are described. Reprinted in *I poeti futuristi* (Milano, 1912), 77–78.

[3] *La Voce*, II no. 41 (22 Settembre 1910), 399, and *Scoperte e massacri*, 192. Boccioni was thinking along similar lines; see *Archivi*, I, entry of 19 March 1911, 474. That Bergson was in the Futurists' minds is supported by Carrà, *La Mia vita*, 148, and Severini, *Ragionamenti sulle arti figurative*, 124 ff. Papini's *Filosofia dell' intuizione* was a translation of some of Bergson's writings, published in 1909, but no copy was available to me.

[4] *Dinamismo musicale*. An unpublished note by Paolo Buzzi, kindly shown to me by Signora Russolo, alleges that this picture was repainted after the Esposizione Libera, giving it the controlled structure which it had not possessed earlier. It was shown in its present form at the Rotterdam exhi-bition of May 1913.

depend upon the persistence of memory for their ever-changing cumulative effect.[1] In *Ricordi di una notte* Russolo was more daring still and attempted to paint the processes of memory itself, i.e. the flux of spiritual states.[2]

Although Russolo was an expert musician, in *La Musica* he drew heavily upon conventional and literary associations to describe the emotions it evokes. For example, he used masks with different expressions to symbolize moods.[3] The multi-armed pianist may represent Beethoven[4] and perhaps Siva Nataraja, the creator and lord of the cosmic dance in the Hindu pantheon.[5] But beyond such rather obvious symbolism, the so-called *audition coloré* seems to have been investigated. This hypothetical phenomenon had particularly fascinated the Symbolist generation and many artists and poets who followed in their wake.[6] Scriabin's colour-tone equations, Kandinsky's even more subjective correspondences between colour, sound and emotion, and Kupka's structural assimilations of sound and colour, were only a few of the experiments in this area to be carried out in the first fifteen years of the twentieth century.[7] Russolo apparently had no clearly discernible system for his colour scale nor did he have any very specific compositional methods of imitating musical form. His rudimentary image of music seems to be derived from purely intuitive principles, and the movements of sounds and of their changing emotional counterparts are plastically suggested only by appropriate colours, lines and shapes.

Russolo experimented much more boldly in *Ricordi di una notte* with the pictorial possibilities of simultaneous, interpenetrating imagery suggested by Bergson's evocative descriptions of psychic duration. The summational process by means of which

[1] Henri Bergson, *Matter and Memory*, translated by N. M. Paul and W. J. Palmer (London, 1911), *passim*, and *Time and Free Will*, translated by F. L. Pogson (London, 1912), *passim*.

[2] Undoubtedly Bergson's interpretation of memory helped to remove the otherwise backward-looking, *passéiste* overtones of such a subject.

[3] M. Z. Russolo et al., *Russolo*, 27–28. The choice of music as the subject for a painting carries on the tradition going back at least as far as the Romantics, who had esteemed music as the purest and most spiritual of the arts.

[4] Attilio Teglio, *Il Giornale*, Bergamo, 4 luglio 1911, reprinted in M. Z. Russolo et al., *Russolo*, 26. This supposition is supported by a singular resemblance between this musician and Giuseppe Grandi's much admired *scapigliatura* piece, *Beethoven giovinetto* (1874), ill. in Carlo Bozzi, 'Giuseppe Grandi', *Emporium*, XVI (Agosto 1902), 96. The plaster version is at the Milan Galleria d'Arte Moderna.

[5] Russolo was always very much interested in oriental philosophy and in 1930 after a severe spiritual crisis studied Yoga very seriously.

[6] A. G. Lehmann, *The Symbolist Aesthetic in France*, 208–9; A. B. Klein, *Coloured Light, an Art Medium* (London, 1937), *passim*.

[7] Peter Selz, 'The Aesthetic Theories of Wassily Kandinsky', *Art Bulletin*, XXXIX no. 2 (June 1957), 133–4; Lillian Longren, 'Kupka: Innovator of the Abstract International Style', *Art News*, LVI no. 7 (November 1957), 44 ff. Cf. Kupka's *Touches de piano*, dated here 1909.

Russolo recounted the events of a night is similar to Bergson's definition of inner duration as 'a qualitative multiplicity . . . an organic evolution . . . [whose] moments . . . are not external to one another'.[1] Everything seems fluid, but related to the beautiful young woman whose head dominates the canvas; she is referred to again through her long gloves at the left, and her elegant profile at the right. Associational fragments emerge indistinctly – such as the admiring male audience, shadowy houses, night strollers and running horses (intended no doubt to introduce auditory effects). The contrasting brilliance of the rising sun above and the electric lights below relate these recollections without referring to temporal and spatial succession. The 'psychological perspective' advocated by Soffici, which dictates the size and location of objects, is employed with startling resolution.[2] Russolo's technical innocence may have given him the freedom for such efforts, which resulted in a most original interpretation of the revolutionary precepts of the technical manifesto, influencing his colleagues and setting a precedent for the Surrealists.

Marinetti too was working towards a similar Bergson-inspired breakdown of the traditional unities. In the spring of 1911 he described 'Futurist free verse [as] perpetual dynamism of thought, an uninterrupted stream of images and sounds [which] alone can express the ephemeral, the unstable, the symphonic universe which is forged in and with us. It is the dynamism of our elastic consciousness entirely realized. My entire self sung, painted, sculpted without limit in its perpetual becoming. A succession of lyrical states.'[3]

Boccioni: La Risata, the Circolo Artistico Lecture in Rome

The lusty *La Risata* (The Laugh)[4] (Pl. 59) stands somewhere in between the vigorous collective hymns and the introverted painting of states of mind formulated in Russolo's *Ricordi di una notte*. Boccioni treated laughter as primarily a social activity, and only secondarily as a state of mind. As Bergson acutely observed in his *Le Rire* (1900), laughter demands a group; it invites participation in a 'kind of secret freemasonry or even complicity with other laughers',[5] since men instinctively know that it is better to laugh than to be laughed at. Laughter is an unexcelled critical tool and a weapon many more times effective than verbal attack. Boccioni – with or without

[1] Bergson, *Time and Free Will*, 226.

[2] Soffici's 'psychological perspective' has an ancient ancestry descending from primitive artists to Redon, Klinger, Romani and others.

[3] F. T. Marinetti, *Le Futurisme*, 90.

[4] *Laughter*.

[5] *Laughter*, translated by C. Brereton and Fred Rothwell, (London, 1913), 6.

knowledge of Bergson's study – probably intended *La Risata* as such a weapon – a reply to the animosity met by the Futurists. The painting suggests a state of gaiety bordering on hilarity – Futurism's antidote to the moroseness and self-indulgence of the older generation.[1]

The existing *The Laugh* is a second, reworked version executed by Boccioni probably in the autumn of 1911; the original was said to have been damaged by an irate visitor to the Free Exhibition.[2] The superficial Cubist details (mainly objects on the tables) were incorporated into the picture during the reworking and after Boccioni had been to Paris. As in Russolo's *Ricordi*, the scene is dominated by one large image of a woman and expresses her mood. But Boccioni concentrated on the active aspect of this mood, the momentary, explosive quality of a burst of laughter and its immediate multiple reverberations, rather than on a passive and extended account of its purely spiritual continuum. He still maintained the traditional unity of time and place, accentuating the shattering, space-penetrating effect of laughter by technical juxtaposition and interpenetration of images resembling montage.

By the late spring of 1911, Boccioni had so far developed his ideas of the painting of states of mind that he was ready to discuss them in considerable detail at his lecture at the Circolo Artistico Internazionale in Rome. He said that 'la PURA SENSAZIONE' was his aim in the *pittura degli stati d'animo*. The artist should try to achieve 'the acutest synthesis of all the senses in a *unique universal* one which will enable us to go back through our millenary complexity to primordial simplicity'. He believed this primal perception to be so powerful that 'the artist's individuality disappears, not because of humility or fear, but because his spirit identifies itself with reality to disclose itself as a whole by means of pure forms and pure colours which have become symbols of the universal dynamism'. Boccioni went so far as to predict that 'the easel picture will no longer be adequate and that colours will be perceived as sentiments themselves and that one will paint with coloured gases'.[3] The vaporous quality of Russolo's *Profumo* and *La Musica* and, indirectly, contemporary experiments with

[1] G. A. Borgese praised the Futurists especially for this quality, calling them 'Gli allegri poeti di Milano' in *La Vita e il libro* (Torino, 1911), II, 127. Aldo Palazzeschi's 1913 manifesto, *Il Controdolore*, gave a fuller definition to this aspect of Futurism. See below, p. 136.

[2] This damage was reported by Marinetti at the 7 May 1911 *soirée* in the Venice theatre La Fenice; *Archivi*, I, entry 7 May 1911, 475. Actually, the picture shows no trace of such an injury. Perhaps Marinetti exaggerated the incident or Boccioni started an entirely new canvas. The head immediately to the right of the laughing lady may be a self-portrait, that to her left – with moustache – Marinetti.

[3] Quoted – probably without too much change – in Boccioni, *Estetica*, 182–3; *Archivi*, I, entry of 29 May 1911, 475. Marinetti seems to have spoken of the use of coloured gases at his conference at the Paris Maison des Etudiants; *Gil Blas*, 10 Février 1912, 1. See also Boccioni, *Estetica*, 191.

colour music, may have influenced this last observation.[1] In a sense it represents the most extreme artistic interpretation of Futurist dynamism. Coloured gases would be in incessant motion and the resultant art would be completely dematerialized. Furthermore, the barrier between the art object and the spectator would cease to exist. Such a gaseous art would actively invade man's living space and vice versa. Painting would break loose from its static confines and attain physical conditions like those of music. Boccioni also spoke of the aspiration of the visual arts towards musical conceptions, selecting Michelangelo from the old masters as the one 'who potentially came closest to the state of mind. For him anatomy becomes music . . . and the melodic lines of muscles follow each other according to musical principles, not the law of logical representation.'[2] It is interesting that by 1913 Boccioni was taking Kandinsky to task for the very type of expressionist musical analogizing which had tempted him – and his colleagues – in 1911.[3] But by that time Futurism had become thoroughly permeated with the structural principles of Cubism.

Boccioni: First Versions of the Stati d'animo

Boccioni has stated that the ideas of his Roman lecture were based upon his three *Stati d'animo: Gli Addii, Quelli che vanno* and *Quelli che restano* (States of Mind: The Farewells, Those Who Go, Those Who Stay).[4] It is not known how far Boccioni had progressed with the three paintings by 29 May 1911, when he lectured in Rome. The final triptych (Pls. 81–83) was executed in the late autumn or early winter of 1911–12. Probably the three oil studies in the Galleria d'Arte Moderna in Milan (Pls. 60, 62, 64) and the three somewhat later drawings in the Museum of Modern Art in New York (Pls. 61, 63, 65) are the earliest versions of this subject.[5]

The *States of Mind* also deal with collective sentiments, i.e. the emotional complexes which unwittingly unite human beings in the modern, symbolically dynamic environment of the railways. But Boccioni has shifted from a predominantly descriptive

[1] Scriabin's *Prometheus* for orchestra, piano, organ and *clavier à lumière* was written in 1909–10 and performed on 2 March 1911 in Moscow under Koussevitzky. The *clavier à lumière* provided so many difficulties that it was not used on that occasion. Scriabin's colour-sound combinations were similar to those used by Rimski-Korsakov. Alfred J. Swan, *Scriabin* (London, 1923), 46, 98.

[2] Boccioni, *Estetica*, 183.

[3] Ibid., 173–4.

[4] The titles recall Beethoven's Sonata in E flat major, opus 81a, the so-called *Les Adieux* sonata, composed on the occasion of the Archduke Rudolf's departure from Vienna. Its three movements describe different states of mind, *Les Adieux, L'Absence*, and *Le Retour*. Boccioni may have heard Russolo or Ferrucio Busoni – later his friend and admirer – play it. Beethoven was in the mind of the reading public after the passionate biography by Romain Rolland of 1903.

[5] Other studies are illustrated in *Archivi*, II, Boccioni: pls. 236, 237, 243–6, 250, 280.

to a completely conceptualized (in the early version, very subjective) presentation of his perceptions. Benefiting from Russolo's memory montage, Boccioni's attempt to integrate an active experience with its coefficient of spiritual duration went considerably beyond his colleague's efforts. Boccioni radically circumvented objective reality so as to have 'the colours and forms . . . express themselves'.[1]

Gli Addii (Pl. 60) is possibly the first known oil study for the series; it is also the most Uninhibited. The straining oval (derived from an embrace) is the dominant motif, which is reiterated and shattered by the upward-surging lines, perhaps intended as rising gases and steam. In contrast to the almost abstract expressionist quality of this canvas, the later pencil drawing (Pl. 61) recalls Art Nouveau and especially the work of Romani and Munch.

Quelli che vanno (Pl. 62), painted in deeply resonant greenish-blue-black, vividly suggests train travel at night. The almost uniformly coloured surface is punctuated by slightly oblique lines which strike the surface like wind-driven rain and signify speed.[2] The passengers' mustard yellow heads peep through these lines as if through lighted train windows; the isolated fragments of villages flashing by bring the viewer into the speeding train by identifying his visual experiences with those of the travellers. This painting was thus one of the first Futurist attempts to render pictorially the sensation of speed – the central tenet of Marinetti's First Manifesto. The abstract shapes and linear patterns, representing rapid motion, foreshadow the later systematized 'force lines'. Again the succeeding pencil drawing (Pl. 63) reveals a loss of spontaneity. The motion is slowed by blunter shapes, but it is given horizontal continuity through the telegraph wires and rails, on which spinning wheels course as though generating energy. Instead of using the obvious profile of the locomotive and steam to indicate motion, Boccioni more subtly employed a fragment of the moving train – a detailed doorlatch placed almost surrealistically upon the rapidly vanishing surface.

The third scene, *Quelli che restano* (Pl. 64), is the least complicated of the early oil sketches formally and emotionally, and perhaps for this reason is the most resolved. With calligraphic terseness, even understatement, Boccioni evoked the bleak and drained state of mind of those who are left behind. They dangle like puppets from the overall vertical lines of their empty and monotonous light green surroundings. In the later drawing (Pl. 65) for this part of the triptych, some of the expressive directness was replaced by more explicit and descriptive details.

The order of arrangement of this tripartite painting poses a problem. In the case of the three drawings it is answered by their design: *Gli Addii* forms the centre, *Quelli*

[1] Boccioni, *Estetica*, 185.
[2] Cf. Carrà's *Nuoto*, Pl. 56.

che vanno, which continues the diagonal lines introduced at the left side of *Gli Addii*, belongs on its left and *Quelli che restano*, carrying over the vertical pattern seen on the right of *Gli Addii*, belongs therefore on its right. The oils, with their fluid compositions, do not supply such a ready answer. It is not even certain that the three discussed here were intended as a unit, although their similar size makes this seem likely.[1]

With Boccioni's first versions of the *Stati d'animo* and Russolo's *Ricordi di una notte*, the initial and completely Italian phase of early Futurist art came to an end. During these first months of concentrated joint effort, the Futurist painters (contrary to often expressed opinion) had arrived at an equilibrium between theory and practice, and had achieved a distinct, if still immature, Futurist plastic vocabulary.

[1] There is another more finished oil version of *Quelli che vanno* (*Archivi*, II, 215 no. 236) which Boccioni may have intended as a replacement of the canvas illustrated here.

VIII

SEVERINI'S WORK, 1910–11

IN 1911, Severini had proposed to indicate to his Milanese colleagues 'the directions in which they ought to proceed'. But after signing the Technical Manifesto of Painting, he too had found himself settling down to adjust his own art to Futurist theory. Fortunately for him, he was able to take immediate advantage (if only superficially at first) of the Cubist experiments which were just beginning to attract public attention and followers in Paris. Thus he was spared some of the Milanese artists' painful uncertainties; even his first Futurist canvases appeared on the surface more advanced than those painted at the same time by his colleagues in Italy, who were forced to search for new means in addition to new content. Despite this formal advantage, Severini's work of 1910–11 is quite similar to theirs. The very few early Futurist paintings by him which are known were apparently executed in rapid succession or even concurrently. The dating sequence proposed here is therefore tentative.

Le Boulevard: Severini's 'Unanimism'

Severini drew attention to the collective existence of city dwellers in one of his first Futurist pictures. The charming *Le Boulevard* (Pl. 66), probably begun at least during 1910,[1] is a serene portrayal of the city's pervasive rhythms which unite the anonymous strollers with each other and with their environment.[2] But unlike Carrà and Boccioni, Severini stressed the intellectual and formal problems, leaving the psychological and sociological implications of his perceptions untouched for the time being. *Le Boulevard* grew directly out of his Neo-Impressionist *Printemps à Montmartre* (Pl. 40) of about 1909, and formally it could be called a Futurist version of the earlier painting. While the tree-lined thoroughfare motif was retained, the descending stairs were replaced by a level avenue and the picture's dynamic effect results not from its visual

[1] It is usually dated 1910.

[2] Cf. Jules Romains, 'Une autre âme s'avance . . .', from *La Vie unanime*: 'Qu'est-ce qui transfigure ainsi le boulevard?/L'allure des passants n'est presque pas physique;/Ce ne sont plus des mouvements, ce sont des rhythmes,/Et je n'ai plus besoin de mes yeux pour les voir.' Severini recalled later that Dufy had remarked at the time on the Unanimist quality of his work, but that he then 'was ignorant of the exact significance of Unanimism'. 'Les Arts plastiques d'avant-garde et la science moderne', reprinted *Archivi*, I, 208.

source but from its mode of representation. The technique, still based upon Neo-Impressionist analysis of colour, was extended to the analysis of moving objects in space. The angle of vision was greatly enlarged by the suggestion of shifts in view-point from the right to left, above to below. This enabled Severini to record changes in the position of objects, thereby giving an account of the time element. Although direct visual stimulation and naturalistic space and light still formed the basis of this work, completely conceptual principles were incorporated at the same time. By replacing the airy Neo-Impressionist paint surface with tightly brushed, parallel strokes, which clearly delineate geometrical shapes, Severini extended the two-dimensionalization implicit in Neo-Impressionism. The flat shapes coincide in part with recognizable objects; but more importantly, they create new forms by the schematization of interrelated colour zones between objects and surroundings. The loose bond of colour between objects and ambient[1] found in Neo-Impressionism was now firmly established as a positive element in its own right. The triangle and its compounds became the chief dynamic compositional protagonists, just as they had in Boccioni's work. *Le Boulevard* is divided into three triangles: a large central isosceles form, split by the row of tree trunks which also divides the entire canvas in half, and the two secondary triangles at the upper left and right. These in turn are reiterated throughout the canvas, with varying emphasis. Further animation is provided by the colour, distributed according to the contrast and interaction of the complementaries of both warm and cool palettes.[2] As a result, an apparently infinite series of new and changing patterns is created, which, like the shifting glass configurations of a kaleidoscope, provide a simple prolonged pleasure to the viewer.

La Modiste

Severini used this highly decorative, controlled rearrangement of conventional reality even more expertly in the small *La Modiste* (The Milliner) (Pl. 67), also of about 1910–11.[3] Here he concentrated on bringing the spectator into closer contact with his picture. In contrast to Degas, whose scenes in milliners' shops convey above

[1] Although the English noun 'ambient' does not have the full connotation of the Italian, the two words will be used interchangeably, but with the Italian meaning understood. The subtle overtones of activity within the environment implied by *ambiente* make the word well suited to description of the Futurist concept of the unity and interaction of the object and its surroundings.

[2] Severini, *Ragionamenti sulle arti figurative*, 123; cf. Paul Sérusier's theories, especially Chapter II in *ABC de la peinture* (Paris, 1942), of which Severini may have heard because Sérusier belonged to the Théâtre de l'œuvre group.

[3] Severini dates this painting 1910 (*Tutta la vita*, 74), but his friends Pierre Courthion and Jacques Maritain date it 1911 in their 1930 monographs on the artist.

all a guarded privacy which the spectator cannot disturb, Severini takes him right into the milliner's world. He is impelled to look up at the milliner's looming and strongly lit torso, her gesturing head and arms, multiplied and fragmented by the lights which are reflected in the mirror. On the dressing table below these reflections are amalgamated into the dazzling array of hats and paraphernalia which confront the viewer, forcing him to take the place of the would-be customer.

Here again Severini constructed the painting geometrically. The table forms an inverted Y shape in which the milliner's torso as the central stem leads up to the small circle of light at the top. But he took pains to disguise this geometrical skeleton. By frequently shifting the outlines of the table and mirror and by mirroring the light on the left, he gave the impression of an asymmetrical composition, which is reinforced by the dissimilar patterns in each half.

The vitality of this picture is largely due to the freedom with which these diverse patterns were manipulated, as well as to the colouring, similar in principle to that of *Le Boulevard*. Severini had devised an apparently effortless counterbalance of differently directed shapes, of curving and angular, abstract and representational forms, each enhanced by contrast with the others, thus preventing the dominance of any single form and ensuring their collective mobility. This canvas anticipates the mature Futurist concept of the 'innate complementarism of form'.[1]

Towards the Painting of States of Mind

Severini's experiments with the representation of time, in its spiritual rather than its mechanical aspects, were more in line with the efforts of his Italian colleagues. *Souvenirs de voyage* (Travel Memories) (Pl. 68)[2] marked the beginning of this more complex approach. This painting is particularly difficult to date. Because of its structural indecisiveness and almost complete absence of Cubist method, it would seem to be earlier than *Le Boulevard* and *La Modiste*, but its artistic intention points to a contemporary or even slightly later date.[3] This ambiguity suggests that Severini may have worked on it over an extended period, but it was probably completed at about the same time as Russolo's *Ricordi di una notte* (Pl. 58), in the spring or

[1] See below, pp. 133, 144 ff., 161.

Both *Le Boulevard* and *La Modiste* are in some ways similar to Léger's individual adaptation of Cubism as found for example in the slightly later *La Noce* and *Les Fumeurs*, except that Léger's art is firmly grounded in Cézanne's form in addition to Neo-Impressionism.

[2] *Travelling Impressions.*

[3] Although the painting has been dated 1909, 1909–10, Severini himself dates it 1911 in his unpublished 1913–14 manifesto 'Le Analogie plastiche del dinamismo', reprinted *Archivi*, I, 77. See also *Ragionamenti sulle arti figurative*, 124.

summer of 1911. It has much in common with that painting besides the date and theme. Both artists gave dislocated images a new synthetic unity, but Russolo's subject and his treatment were still Symbolist at bottom, emphasizing the intimacy of self-communion. Severini, on the other hand, chose a much more actively Futurist theme – the memories of an entire voyage from Italy to Paris, alluding thereby to the shrinkage of the globe as a result of modern transport, which was one of Marinetti's favourite metaphors. Severini juxtaposes such diverse elements as the town hall of Pienza, the Arc de Triomphe, an autobus and steam engine, his father, a priest, the Alps and the Sacré Cœur in such a way that the picture plane becomes a tray upon which his recollections are piled up, forming something like a relief map. The old well of his home town in the left centre may have been an un-intentional symbol for the uncontrollable welling up of memories. He has painted everything that came to his mind, as though he were in the centre of the canvas and surrounded by it. At the same time Severini has incorporated a psychological perspective similar to Russolo's, in which scale is determined by the importance of the object or person in the painter's recollections.[1]

In spite of its theoretical similarities to Russolo's *Ricordi*, and its more explicitly Futurist character and ingenuity, Severini's painting did not completely suggest a state of mind. Severini's cool, intellectual temperament was apparently foreign to the expressionist approach required for such stream-of-consciousness musings, and the painting (at least from reproductions) indicates a certain lack of conviction. But before long, Severini did work out his own version of the painting of states of mind in a well-calculated synthesis of physical and psychological perceptions of time.

A significant advance towards this synthesis was made in 1911 with *Le Chat noir* (The Black Cat) which apparently anticipates *La Danseuse obsédante* (The Haunting Dancer) (Pls. 69, 70) – Severini's first full-fledged state of mind painting. In these two pictures he abandoned his attempts to bring the viewer into the canvas, seeking instead to heighten their meaning through formal control.

In *Le Chat noir*, based on the Edgar Allan Poe story of that title,[2] Severini simplified his task by employing some of the writer's iconography to convey the processes of a spiritual state. Poe's macabre narrative tells of a drunkard who blinds one of his pet cat's eyes, an act which leads to fire, destruction, and murder and culminates in the

[1] The similarly irrational juxtapositions of Chagall's and De Chirico's contemporary and later paintings are brought to mind. It is conceivable that the three artists knew each other because Apollinaire and Ricciotto Canudo (an Italian writer and critic who lived in Paris) were friends of them all.

[2] Sackville Gallery. *Exhibition of Works of the Italian Futurist Painters* (London, 1912), description of no. 29; reprinted *Archivi*, I, 112.

I

betrayal of his misdeeds by another black cat. In keeping with this story, Severini conceived his picture as a mysteriously ordained play of forces. Two images of piercingly staring black cats guard the upper half of the painting. The one on the left is still unharmed; that on the right is presumably maimed by the loss of an eye. A number of cat-like shapes, dominated by a large silhouette at the upper left centre, further suggest the animals' ubiquitous presence, which is connected with the filled glass on the table below through abstract variations on these forms. Despite Severini's dependence upon the literary source, the painting's significance rests solely upon its formal disposition. Around these recognizable elements he built a well-knit composition that enables them to function as autonomous symbols of a mysterious sequence of events. While continuing to employ some naturalistic lighting, he completely abandoned rational perspective in the construction. An arrangement of more or less pellucid geometrical planes floating close to the picture surface took its place. Here and there they are loosely fused with or skim just above or below each other, encroaching upon but not affecting the implacable cats' heads. These seem to be set in a horizontal band as though in a shooting gallery, while all other elements slide diagonally down towards the glass and ultimately towards the lower right corner. These two opposing forces are controlled by the persistently regular rhythm of the small vertical brushstrokes. Formally, there is a superficial similarity between this painting and Juan Gris' 'diagonally magnetized'[1] still lifes of 1911 and early 1912. But Gris' directional distortion originated in his precise analyses of the object *per se*. Severini was less interested in structural study than occupied with a search for emotionally evocative arrangements in which varied temporal sequences could be shown simultaneously.

Poe's chilling cats' heads reappear in a very similar way in the more deliberate 1911 *Danseuse obsédante* (Pl. 70), where they reinforce the 'haunting' effect of a night-club dancer.[2] But in this picture he relied completely upon his own resources for the imagery. It is another 'memory picture', compounded of various recollections and associations related to the dancer. As such, it too is comparable to Russolo's *Ricordi*, and it superficially resembles that picture once allowance has been made for the technical dissimilarity. *Danseuse*, however, differs fundamentally from both the Russolo and Severini's *Souvenirs de voyage*. In those two works a series of separate, but intrinsically static, memory-images were interrelated in an attempt to portray a dynamism which was solely a function of the memory process. In *Danseuse*, the images recalled were united into a dynamic whole by the addition of recollected

[1] James Thrall Soby, *Juan Gris* (New York, 1958), 20.

[2] One wonders whether Severini is also alluding to the nightclub singer May Belfort, who always carried a black kitten.

sensations of movement. This interpretation was a significant departure in the 'painting of states of mind' and one which was more suited than the previous efforts to the Futurist concept of dynamism. Boccioni was to take it into account in the final version of his *States of Mind* triptych.

Thus in *Danseuse* Severini had combined the psychological order of *Souvenirs* with a more sophisticated analysis of moving objects – initiated in *Le Chat noir* – and subjected his composition to a very simple, arbitrary framework as in *La Modiste*. The dancer's head is depicted as an object in motion (as is the cat's head), while retaining its psychological significance. On the left it is shown in profile with an enormous almond-shaped frontal eye – a device reminiscent of the figure at the left of Picasso's *Demoiselles d'Avignon*.[1] After an interval, filled by rays of light, which give a shutter-like effect, the lips and chin appear in a three-quarter view and then, interrupted only by a single band of light, the upper cheek and other frontal eye emerge, framed by a different view of the hair. With this Severini approached Picasso's analytical portraits which combine several points of view. But even Picasso's most 'disintegrated' heads coincide in one general area,[2] while Severini's dancer is seen in motion, the force of her movement further separating and fragmenting the image and demanding its optical unity from the spectator's glance, which moves rapidly from one image to the next, recreating the original movement as recalled by the artist. Furthermore, the fragments of the face are not merely transient details: they also function as symbols of this 'obsessive' woman. Each detail has an independent psychological existence, as unassailably self-contained as the cat, the light and its streaming rays, and the dancing figures in the background, which reflect the hallucinatory tug of war between the various psychic impulses that form a state of mind.

Toward a More Abstract Treatment of 'Dynamic Sensation'

Such elaborate conception and execution were foregone in the light-hearted *Danseuses jaunes* (Yellow Dancers) (Pl. 71), which is probably later than *La Danseuse obsédante*. The visual effect is more direct, as Severini generalized his scene by omitting all suggestions of local and individual traits in favour of a more universal vision. An irregular, truncated beam of light reveals in its luminous path a magically animate world, very much as a ray of sunlight suddenly brings to life the dust particles floating in the atmosphere. Triangles and parallelograms oscillate slowly across the

[1] Severini may have seen this picture in Picasso's studio which he visited during 1911; *Tutta la vita*, 88.
[2] For example, *Portrait of Braque*, late 1909, illustrated in Alfred H. Barr, Jr, *Picasso: Fifty Years of His Art* (New York, 1946), 69.

surface of the painting, creating temporary forms reminiscent of the basic ballet positions. The unity of background and figures is now absolute. The strong tension between illusionistic space and objects and abstract patterns formed by light and movement has disappeared. Severini had deepened and freed his perceptions so that reality, transformed by light, became first and foremost a quivering mosaic of multi-coloured facets which only incidentally assumed shapes resembling the furniture of the visible world. Like Boccioni he was pushing conventional subject matter into the background and reaching out towards a non-representational art. But they began from quite different premises. In the early oil versions of *States of Mind*, Boccioni worked from a spontaneous, expressionist foundation, while Severini continued to use a Neo-Impressionist and formalistic approach. But both were seeking a direct and anecdotally unencumbered analogue of the universal dynamism.

Danseuses jaunes, in its modest way, foreshadowed Severini's mature experiments with colour contrasts in 1913–14. Of course, by that time these experiments had been encouraged by Delaunay's Orphism. Yet one is tempted to wonder whether Delaunay's major step towards Orphism in the *Fenêtres* series of 1912 (Pl. 71a) was not stimulated by Severini's formal and colouristic researches including those made in *Danseuses jaunes*. This picture and the others discussed in this chapter were shown at the Bernheim-Jeune Futurist exhibition in February 1912.

La Danse du Pan-Pan à Monico (c. 1910 – early 1912): A Summary of Severini's Early Futurism

Compared with *Les Danseuses jaunes*, *La Danse du Pan-Pan à Monico* (Pl. 72) seems somewhat old-fashioned. Severini said that he laboured for over a year on this canvas – which measured three by four metres – and because of this long evolution it retained more realistic remnants. But it is also apparent that *Pan-Pan à Monico* summarized Severini's efforts at this stage and that it is comparable, not only in size but also in its Unanimist significance, to Boccioni's *Città che sale* and Carrà's *Funerali dell'anarchico Galli*.

The nightclub had become one of Severini's favourite subjects and in *Pan-Pan à Monico* he evoked its atmosphere with the authority of an old *habitué*.[1] Severini has once again moved the viewing point into the centre of the scene, handling this feat with much greater ease than in the *Souvenirs de voyage*. The dominance of the central, roughly oval area superimposed upon the surroundings is established by its large scale and its commanding colour. It is so prominent that the large dancer in red, whose knees kick out from near the picture's centre, almost makes the spectator want

[1] Severini, *Tutta la vita*, 72 ff.

to duck. Her movements, and the acrobatic gyrations of her partner in green, make her seem to swirl above and through the tables and the heads of the crowd below her. Although at least some of her motions can be followed, her partner is almost impossible to piece together. This was probably intended to entice the viewer himself into the picture, to do a turn with her. As though to suggest this, Severini showed other dancers mingling with the crowd; on the left a woman guides a hesitant visitor towards the dancing group in the centre. The carnival colour and design, which almost overpower the onlooker's visual, auditory and kinetic responses, draw him still further into the life of the painting, so that, like everything else in the canvas, he is submerged in the feverish activity and infinitely multiplied rhythms.

With regard to Cubism, there are no particularly novel developments in this picture. With the exception of the repetition of the dancers' legs, Severini made no systematic attempt to define or synthetize successive stages of movement. This was no doubt intentional, since the Pan-Pan dancers act within a different temporal frame from the rest of the picture. Severini recreated the general nightclub environment and its collective spirit as a timeless, conceptualized memory picture like *Danseuse obsédante*; but this atmosphere, or state of mind, is brought into focus through the execution of a specific and electrifying dance which permits some physical measurement. In 1913 Severini said that such a synthesis of external and internal visions, which he called 'plastic perception', formed the basis of his art. To define this concept he used Bergson's enigmatic axiom: 'to perceive is . . . nothing more than an opportunity to remember', but he illuminated it further in his own words: 'The perception of an object in space is the result of the recollection which is retained of the object itself in its various aspects and in its various symbols; . . . one gesture, one essential feature may, by suddenly throwing light upon our intuition, succeed in presenting to our vision the total reality.'[1]

When Apollinaire saw *Pan-Pan à Monico* at the Bernheim-Jeune exhibition, he declared it to be 'the most important work painted up to now by a Futurist brush'.[2]

[1] Marlborough Gallery. *The Futurist Painter Severini Exhibits His Latest Works* (London, 1913), preface; reprinted *Archivi*, I, 113.
[2] G. Apollinaire, 'Les Peintres futuristes italiens', *L'Intransigeant*, (7 Février 1912); reprinted *Chroniques d'art*, 212.

THE MILANESE ARTISTS AND CUBISM IN 1911

THERE is still a good deal of confusion and uncertainty about how and when the Milanese Futurists came into contact with Cubism. Some of the inaccuracies originated in contemporary writings, even in those of Boccioni, whose *Pittura scultura futuriste* (published in 1914) stated that he and his Milanese colleagues were acquainted with Cubism at the time of their 1910 manifestos.[1] This *ex post facto* statement is certainly not supported by their work of that year, which was innocent of any specifically Cubist references. The Italians did, however, discover Cubism in 1911, and it is possible to detect two successive stages in their thinking which were inspired by it. The first made its appearance in the summer of 1911, and lasted until the trio's first joint trip to Paris, in mid-October. The second followed this journey and extended roughly to their second Parisian visit early in February 1912.

Soffici's Article on 'Picasso and Braque'

The first stage was based entirely upon second-hand information about Cubism. It consisted of a few critical articles on the movement, isolated reproductions, and some advice from Severini. His visit to Milan in the late summer of 1911 seems to have been the most immediate cause of a decisive turn towards French experiments.

Soffici's essay, 'Picasso e Braque', which appeared in *La Voce* on 24 August, was probably the most influential article. It is important not only for its ideas but because the Futurists would almost certainly have read it. It was the first discussion of Cubism in Italian and introduced some of the aesthetic notions circulating about the new movement and some of the jargon being coined to describe it. Soffici had seen the controversial Salle 41 of the 1911 Paris Indépendants,[2] and his essay reflected some of the opinions of Metzinger, Allard and Apollinaire, all of whom had recently attempted to justify and explain the aims of Cubism.[3] Following his friend Apollinaire, Soffici drew a sharp, if somewhat unjustified, line between Picasso and Braque and

[1] Boccioni, *Estetica*, 86.

[2] Soffici, *Ricordi di vita letteraria ed artistica*, 249.

[3] Jean Metzinger, 'Note sur la peinture', *Pan*, III no. 10 (Octobre-Novembre 1910), 649–52; Roger Allard, 'Au salon d'automne de Paris', *L'Art Libre*, II no. 12 (Novembre 1910), 441–43, and 'Sur quelques peintres', *Les Marches du sud-ouest*, no. 2 (Juin 1911), 57–64.

their followers.[1] The contempt with which he treated men like Le Fauconnier, Metzinger, Léger and Delaunay may have been at least partly provoked by the fact that Allard, whom he cited and who championed them, had compared them to the Futurists. Indeed Allard was then one of the few French critics to regard the Futurists' theory with a certain amount of sympathy and interest. But so soon after the Florentine collision anything connected with Futurism was still anathema to Soffici.

Soffici considered Cubism – i.e. the art of Picasso and Braque – an extension of the partial revolution of the Impressionists and chiefly concerned with the rendering of volume in a synthetic, universal manner. This involved an 'integral projection of reality on to a plane surface', incorporating its seen, unseen and tactile aspects. Thus, according to Soffici, Picasso 'goes around the objects themselves, considers them poetically from all angles, submits to and renders his successive impressions; in sum, shows them in their totality and emotional permanence with the same freedom with which Impressionism rendered only one side and one moment'. The disregard for conventional appearances which accompanied such a 'reconstruction' of reality was seen by Soffici as the result of the artist's search for 'pure pictorial values' with which to evoke a sense of 'concreteness', turning lights and shadows into 'objects themselves'. Picasso's paintings had therefore the 'quality of a hieroglyphic with which a lyrically sensed reality is written . . . similar . . . in a way to the elliptical syntax, to the grammatical transpositions of Stefan Mallarmé'.[2]

Soffici's pronouncements on Cubism, which grew directly out of his Symbolist interpretation of Cézanne and Impressionism, formed the core of his later *Cubismo e oltre*. Severini, who came to Italy about the time when Soffici's essay appeared, and probably brought some articles and reproductions, undoubtedly gave his friends his own views on Cubism as well. As a result the Milanese artists, whose own concept of the painting of states of mind was as daring and whose theories and art had implied much of what Soffici had said, turned to a recreation of the object and its volume through a formally complex system.

Boccioni: *I Selciatori, Studio di donna fra le case, La Strada entra nella casa*

The fullest record of the early influx of Cubism is provided by Boccioni and best illustrated in these three paintings, executed before mid-October 1911. *I Selciatori* (The Street Pavers) (Pl. 73) is probably the first of this group and may be dated summer

[1] Apollinaire, 'Le Salon d'automne', *Poésie* (Automne 1910) and *L'Intransigeant*, (21 Avril 1911) in which his opinions are somewhat modified; reprinted *Chroniques d'art*, 125–6, 164–5.

[2] *La Voce*, III no. 34 (24 Agosto 1911), 636–7.

1911.[1] While still ignorant of the actual appearance of Cubist painting, Boccioni evolved here a highly intelligent combination of angular, transparent planes and a freely improvised colour dynamism based on the Divisionism of the *Città che sale*. This time his interpretation of a working scene had no anecdotal overtones, but centred on a variety of physical sensations which he sought to express. In this respect Russolo's experiments – especially in the area of sound (in *La Musica*) – may have influenced Boccioni's decision to create a visual analogue of the total effect of the street pavers' activity.

Like the musician in Russolo's picture, who is surrounded and almost absorbed by the wave-like aura of sound resulting from his activity – both manual and emotional – Boccioni's full-face worker is the asymmetrical core of the composition. Russolo's languid, regularly curving bands, symbolizing the smooth flow of music, have been transformed into a crescendo of syncopated, sharp-edged forms, expressing the irregular but continuous chipping and clanking of the pick-axes, which revolve around the purple-black quasi-oval of the labourer's hat. A second rhythm, simultaneously asserted, is that of the jerky, clockwise rotation connecting the workers' three salient left arms (like a pinwheel) with fists nearly equidistant from the painting's centre. The contrast in colour and shape between the pointed green pick-axe and the blunted orange forearm and fist (repeated to the lower right and left and in a slightly modified form at the upper right) sets this rhythm going, and the square format of the canvas, in which no one extension can dominate the others, enhances its continuity.[2]

Less resolved though no less forceful is the striking *Studio di donna fra le case – Ines* (Study of a Woman Amid Houses – Ines)[3] (Pl. 74). Here the influence of black and white reproductions of Cubist work – specifically, Delaunay's *Tour Eiffel* and Léger's *Nus dans un paysage* – has left its mark.[4] This was the first time that Boccioni, following Delaunay, had telescoped several views of buildings by breaking up their vertical continuity. The scaffolding, telegraph poles, and outlines of houses form a mandola-like shape around the focal object, as in the Delaunay, where the tower's foundations, seen from a diagonal, stand on a plane behind the framing houses. Its lower storey seems to lean back into the picture. In contrast, the upper part, rising from the centre, tilts forward on to the picture plane.[5] This forces the spectator to look at the painting

[1] It is frequently dated 1910. Courbet's *Casseurs de pierre* was shown at the 1910 Venice Biennale.

[2] It is possible that Boccioni showed different views of the same worker.

[3] *Studio di figura femminile (Ines).*

[4] These French paintings were illustrated in Allard's article in *Les Marches du sud-ouest* (Juin 1911), which Soffici mentioned in *La Voce*. Pl. 74a is similar to the *Tour Eiffel* used by Allard.

[5] John Golding, Cubism, *A History and Analysis 1907–1914* (London, 1959), 149.

in two instalments, as it were, and thus take an active part in its movement.[1] Boccioni, who did not have the Frenchman's advantage of a broad familiarity with Cézanne's art, did not know that Delaunay was presenting here an ingenious development of Cézanne's spatial manipulations. But he did grasp the dynamic and expressive function of Delaunay's break in hypothetical viewing-points, and tried to arrive at similar effects as best he could.

Apparently wishing to satisfy the expressive requirements of portraiture, he posed the problem somewhat differently by placing the figure in front of the architectural setting, as he had done in the 1907 Brocchi portrait. And instead of suggesting a change in eye-level, as Delaunay had done, Boccioni exploited again his older portrait's contrast of sculptural saliency and atmospheric insubstantiality to create animation. Thus the aggressively coloured, deeply faceted head (reminiscent of Léger's early Cubist figures) is brought out from the picture plane while the woman's body, set obliquely upon a balcony which is cantilevered into the background, appears to recede into it. The painting, though exciting visually, lacks some of the desired Futurist interdependence of figure and surroundings, in spite of Boccioni's efforts to integrate the total design through a series of V's and inverted V's. Therein may lie the crux of the painting and the reason for its incompleteness.

In *La Strada entra nella casa* (The Street Enters the House) (Pl. 75)[2] this unity is established by means of a more complex application of Delaunay's lesson. Once more Boccioni selected Marinetti's construction site and scaffolding motif, which are observed by his mother from the height of her balcony. Because the figure is seen from the back the psychological requirements of the portrait are evaded, and Boccioni was able to concentrate on her participation (as well as the spectator's) in the rest of the composition.

As in *Ines*, Boccioni used a balcony projecting into the picture space. But here, instead of forming a barrier, it has become a bridge which extends the artist's (and consequently the viewer's) space into the realm on the other side of the picture plane. The strategically placed figure acts as guide in this crossing. The Futurist had passed through the Romantics' open window into the hitherto unattainable distance. Boccioni crowded the figure into the narrowest point of the diagonal balcony, making her seem to stand just this side of the picture surface as in the Brocchi portrait.

[1] R. Allard suggested that Delaunay may have been inspired by the Futurists' Technical Manifesto of Painting; *Les Marches du sud-ouest*, 62.

[2] *Das Leben der Strasse dringt in das Haus; Der Lärm dringt von der Strasse herein; Visioni simultanee*. This painting has frequently been confused with the proper *Visioni simultanee* (Pl. 80). An old inscription on the back and an illustration in *The Sketch* (London, 6 March 1912), have established its correct identity.

But her head, which is now less volumetric than her lower back, reaches forward into the exact centre of the canvas, plunging the viewer into the heart of the action below. From there he is forced to work his way upward by retracing a labyrinthine visual path, which vaguely corresponds to actual movements made by the artist, to obtain a fuller view of the site.[1] This path is roughly described by a series of contracted squares and square-bottomed U's. Although the figure leans into the landscape, the surface plane is reasserted by the upward and outward pressure exerted by the scaffolding and the large colour bricks. As the title suggests, Boccioni was attempting to record rather literally the confused and concomitant sensations 'one would experience on opening a window: all life [sic], the noises of the street rush in at the same time as the movement and reality of the objects outside'.[2]

Carrà and Russolo

Neither Carrà nor Russolo seems to have been as much affected by this first remote acquaintance with Cubism as Boccioni. Yet its message of greater formal discipline was also reflected in their work. Whereas Cubism had led Boccioni towards a more intellectual way of seeing, in Carrà's work its influence apparently coincided with a new, more subjective approach which resulted in his individual version of the painting of states of mind, elements of which had been evident in the awkward *Nuoto*. One of the first known examples of this is *Sobbalzi di un fiacre* (Jolts of a Cab)[3] (Pl. 76), probably painted in the summer of 1911. Even more than in *Nuoto*, Carrà stressed the bodily and tactile sensations which here are associated with the cab's jolting, swaying night course over a bumpy road. With a new-found independence from visual appearances Carrà translated these into an overall acid green pictorial atmosphere, the palpability of which is enhanced by his characteristic fuzzy paint surface. Broken oblique lines and arcs suggest semi-opaque layers of dusty, foggy night air within which a mysterious drama takes place. Fragmented, dismembered and fortuitously reassembled, these new kinships of forms reveal keen and sensitive insights into the life of inanimate matter, which became extremely important in subsequent interpretations of the painting of states of mind. Carrà undoubtedly spurred Russolo and Boccioni to emulate his efforts and he may well have suggested the important sentence in the 1912 Bernheim-Jeune preface: 'We must show the invisible which stirs

[1] See Sackville Gallery, *Exhibition of Works of the Italian Futurist Painters* (London, 1912), no. 4, description; reprinted *Archivi*, I, 109. Although the artists did not write these entries, they probably were based on their statements. Cf. Balla's *Salutando*, pl. 37.

[2] Ibid.

[3] *Sobbalzi di carrozzella.*

and lives beyond densities, that which we have to our right, left, and behind us, and not just the little square of life artificially enclosed as though framed by the wings of a stage'.[1]

The poetic Russolo underwent an even more unexpected transformation than Carrà during the summer months of 1911. Rather than continuing with the romantic realism of *Lampi* or the languorous subjectivism of *Ricordi di una notte* or the philosophical speculations of *La Musica*, he now depicted an express train racing along at 'sixty miles an hour',[2] an immense speed for that time.

Treno in velocità (Speeding Train) (Pl. 77) is predominantly two-dimensional, consisting almost entirely of knife-like wedges, the shape selected by Morasso in 1902 as most appropriate for a racing car. The train is a comet-like streak of light which tears through the surrounding darkness, defined by the illumined rectangles of the car windows and their dimmed interstices. The rhythm of accentuated and un-accentuated areas is so like a poetic metre that it recalls inescapably the endlessly repetitive rhyme of the train wheels.

Russolo was probably the first Futurist painter to make a speeding machine the sole content of a painting. Boccioni, of course, dealt with this subject in *Quelli che vanno*, but there it formed only one aspect of a complex 'state of mind', and the psychic overtones with which it was combined diluted the sensation of pure speed. Russolo, on the other hand, treated this theme extremely objectively and attempted to set down a quasi-scientific record of the optical phenomena presented from within and without a moving train.[3] In doing so he was able to verify some of the pictorial equivalents of movement which he and his colleagues had discovered intuitively. By translating these discoveries into a language of clear and simple form, Russolo too paved the way for richer and sounder pictorial concepts of motion.

Paris, Mid-October 1911

When Severini visited Milan in the late summer of 1911, his colleagues told him of their plan to hold a group exhibition in Paris. Because his reaction to their work was far from favourable, they were understandably anxious about their reception in France, and on Severini's insistence, and with Marinetti's financial assistance, they

[1] *Les Peintres futuristes italiens*, 6; reprinted *Archivi*, I, 106.

[2] Sackville Gallery, *Exhibition of Works of the Italian Futurist Painters*, no. 24; *Archivi*, I, 111.

[3] The tilting back of the smokestacks and houses and some of the lights to the right of the train are shown as if seen from within the train; its own lights and those projecting to the left are seen from without.

departed for Paris to see at first hand 'where things stood in . . . art'.[1] The date for the journey was wisely chosen: the Salon d'Automne, which promised surprises after the Cubist revelation at the Indépendants of the previous spring, opened on 1 October, and Marinetti had again been invited to take part in a *séance poétique* organized by his friend Alexandre Mercereau in connection with the Salon. This *séance* was held on 11 October, and the Italian painters apparently left Milan about the same time, probably hoping that Marinetti would introduce them to some of the *avant-garde* groups in which he was welcome.

It seems from various accounts that the Futurists got about a good deal during their short visit.[2] Severini and Boccioni called on Apollinaire, who later gave a sarcastic account of this meeting in his *Mercure de France* column. Announcing the forthcoming Futurist exhibition, he expressed doubts about Boccioni's *Stati d'animo* paintings which, as described by the artist, struck him as 'puerile and sentimental'.[3] Boccioni's impressions of Paris were recorded in a letter to the Baer family written on 15 October, a couple of days after his arrival. With a typical mixture of perception and boastfulness he observed: 'I have already seen the modern painters who interest me. I shall continue to study them, but I see that I have intuitively apprehended almost everything. Only the external appearance (due to the *incredibly* enormous influence of Cézanne and Gauguin and others) makes it seem that the works of some are more venturesome than they really are. Of the Cubists I have not yet seen Picasso, Braque and some others. Of those whom I have seen – Metzinger, Fauconnier [sic], Léger, Gleize [sic] &c. – only the first really searches in an unexplored field.'[4] His selection of Metzinger as the most provocative of the Cubists he had met by then is not surprising, because Metzinger, though represented at the autumn Salon by the pallid *Le Goûter* (Pl. 88), had at least in his writings interpreted Cubism very dynamically, putting forth ideas which were attuned to (and partly inspired by) those in the Futurists' Technical Manifesto of Painting.

The Concept of 'Force-lines'

The Milanese painters' brief stay in Paris helped to guide them along the path they had taken after their first, indirect contact with Cubism – that is, a retreat from the

[1] Carrà, *La Mia vita*, 152. Boccioni, *Estetica*, 124, says that the Futurists postponed their Paris exhibition from October 1911 to February 1912 because of the Turkish war. This is probably correct, but Severini's criticism may also have contributed to their decision to delay their French début.

[2] Severini, *Tutta la vita*, 125–6; Carrà, *La Mia vita*, 152–3. It is not certain whether Russolo went along to Paris at this time; only Severini mentions his being there.

[3] (16 Novembre 1911); reprinted *Anecdotiques*, 45–46.

[4] *Archivi*, II, Boccioni to the Signore Baer and Ruberl (15 October 1911), 39.

abstract expressionist potential of the painting of states of mind and an increasingly successful reinterpretation of it through an object-based, structural art. The concept of 'force-lines'[1] – a name doubtlessly borrowed from physics and assimilated to it at least metaphorically – was the outgrowth of this shift. It represented the synthesis of the Futurists' emotionally expressive vision of the universal dynamism with the formal, analytical approach of the Cubists. Thus Boccioni's earlier, pompously entitled *trascendentalismo fisico* (physical transcendentalism),[2] which denoted the occult, non-objective aims of the painting of states of mind, was defined in the Bernheim–Jeune catalogue preface of February 1912 as the aspiration of 'all objects . . . towards infinity by their lines of force, whose continuity is measured by our intuition'. 'One is not aware that all . . . objects reveal in their lines, calm or frenzy, sadness or gaiety. These diverse tendencies give to their formative lines a sentiment and a character of weighty stability or of airy lightness. Each object reveals by its lines how it would be decomposed according to the tendencies of its forces. This decomposition is not guided by fixed laws, but varies according to the characteristic personality of the object and the emotion of the one who looks at it.'[3] From this imaginative reconsideration of the objective world the Futurists developed their mature definition of the painting of states of mind as 'the emotional architecture of the objects' plastic forces'.[4]

Preparations for the Paris Exhibition: Boccioni

Boccioni was so excited by what he had seen and heard in Paris that he literally carried out his plan to 'work like a madman'[5] and apparently completed at least six paintings in the three months between the Parisian trip and the Bernheim–Jeune exhibition. These pictures provide an instructive record of his gradual clarification and mastery of the lines of force. The most tentative and possibly the first of this group is *Le Forze di una strada* (The Forces of a Street)[6] (Pl. 78). This composition reveals a renewed concern for geometric clarity: both its arrangement around a central isoceles triangle suspended from the high light source and its triangular fragmentation of objects recall Severini's *Boulevard* and *Danseuse obsédante*. Doubtless the interest in mathematics then current among some of the Cubists, which previously

[1] The term *lignes-forces* was used for the first time in the painters' preface to the Bernheim-Jeune catalogue of 1912, 8. It has been translated as lines of force, force-lines, and line/force.

[2] Boccioni refers to his notion of *trascendentalismo fisico* in the letter cited above, p. 110, n. 4. He speaks of it as an old idea and he probably understood it as a development of *complementarismo congenito*.

[3] Bernheim-Jeune catalogue, 7–8; reprinted *Archivi*, I, 106.

[4] Boccioni, *Estetica*, 181.

[5] Letter cited above, n. 2.

[6] This painting may have been begun before the Paris trip.

had affected Severini, influenced Boccioni as well. For Severini the geometric skeleton served simply to create order. Boccioni, on the other hand, used his equally primitive mathematics to represent also the 'internal forces' that determine the objects' lines of force. This is particularly apparent in an important drawing related both to *Forze di una strada* and the slightly more advanced *Visioni simultanee* (Pls. 79, 80),[1] which clearly shows how Boccioni tried to analyse the streetcar's 'forces' by means of simple geometrical projections. Its sides open up at each end like pairs of aeroplane wings, showing the actual and implied motion of the tram, its outward and upward 'urge', its swaying progress down the street, and the consequent juxtapositions with its surroundings. This quasi-cinematographic record of its movements is comparable to Duchamp's more complex *Nude Descending a Staircase*, but Boccioni has set the entire spatial envelope in motion.

The painted *Le Forze di una strada* is far less clear and forthright than the drawing. Dark, emotionally charged colours and shapes, executed in a painterly technique vaguely reminiscent of Carrà's, are combined with crisp lines, which are now only disconnectedly suggestive of the original structural forces and are somewhat incongruous with the rest of the composition.

The lost *Visioni simultanee* (Simultaneous Visions) (Pl. 80), which incorporated some of the motifs of the above pencil study, also retained some of the structural vigour inherent in its linear network. As a result, the spectator's and the artist's realms are integrated much more fluently than in any previous picture by Boccioni. The vividly imagined vectorial forces of the pitcher and basin, precariously placed on an unseen ledge, are primarily responsible for the seemingly instantaneous propulsion of the woman's head (shown from side and front) and the viewer's eye into the centre of the canvas. Here they are held in active suspension above the street, thus keeping her and the viewer in a breathless state of perpetual involvement. Boccioni's ignorance of Cézanne seems to have worked to his advantage here, because he was forced to fall back on Art Nouveau for a subtle, intensely alive line to portray the potential mobility of the still life. While he traced several different views and stages of the objects' movement, they are subsidiary to the total synthetic effect, which indicates a new form in evolution. This marked the beginning of the Futurists' search for their mature concept of *le style du mouvement*[2] and anticipates Boccioni's daring formulation of it in some of his sculptural pieces.

As might be expected, the climax of this year's work was reached in his final versions of the *Stati d'animo* (Pls. 81–83), which are minor masterpieces and perhaps

[1] This drawing may have been executed after the *Forze di una strada* was begun.
[2] See below, p. 126 ff.

characterize early Futurism more eloquently than any other work. As shown in Chapter VII, the *Stati d'animo* were originally very expressionist, almost abstract pictures, which subsequently lost some of their spontaneity and became more representational. Now still more objective elements were added. The resultant formal clarification seems to answer unequivocally the question of the intended arrangement of the canvases. *Gli Addii* is definitely the centrepiece, flanked on the left by *Quelli che vanno* and on the right by *Quelli che restano*. *Gli Addii* underwent the most extensive reworking. The dynamic motif of the locomotive was taken over from some of the earlier versions of *Quelli che vanno*; its billowing smoke divides the scene into two exact halves. Below it is the pointed profile of the engine's boiler, appropriately directed towards the next scene, *Quelli che vanno*. Thus the masculine, machine-generated force dominates over the human, emotional and more feminine sentiment suggested by the repeated oval shape at the left representing the two embracing figures from the original version. Less emphasis is now placed on this image, and it becomes functionally related to the structural forms of the starting train, whose power, suggested by the bumper, severs the departing from those who remain. In this way the thematic and formal basis for *Quelli che restano* is prepared. All the force-lines in the central scene are products of the actual or implied physical or psychic movements generated by the locomotive. These lines are disposed in direct anticipation of the adjoining scenes and their lines of force; hence they continue uninterrupted when the pictures are hung in the proper order.

In contrast to the active and assertive *Gli Addii*, the two side canvases are chiefly devoted to the passively experienced consequences of the machine's energy. In *Quelli che vanno*, the locomotive is barely indicated and only the travellers and their affective surroundings are shown. *Quelli che restano* concentrates on the remote after-effects of the leave-taking, as did the earlier version.

Like the other artists in their paintings of states of mind (particularly Russolo), Boccioni also combined fragmentary, rationally discontinuous motifs as in a musical composition. These appear at appropriate moments in particularly evocative contexts, rather like Wagnerian leitmotifs. The 1912 preface explained: 'We have not only abandoned . . . the motif developed in its entirety according to its fixed and consequently artificial equilibrium, but we abruptly cross each motif as we please with one or more other motifs, of which we never offer the entire development, but simply the initial, central, or final notes. . . . we have [thus] not only variety, but chaos and conflict between absolutely opposed rhythms, which we nevertheless bring to a new harmony.' This 'new harmony'[1] was realized formally through a quite

[1] Unwittingly the Futurists employ the *passéiste* word 'harmony'.

remarkable adaptation of Cubism, particularly in *Gli Addii*. Boccioni represents only the engine's most awe-inspiring and unforgettable aspects – its powerful pointed front (the most solidly modelled detail in the picture) and its other end, the engineer's chamber with the emblematic and individualized numeral. The front of the engine is shown head-on and sideways and with intermediate and sectional views, according to a careful analytical Cubist method.[1] On the right, paralleling the engine and diagonally receding into depth are a series of telescoped perspective views of coaches. However, the illusion of pictorial depth is partly counteracted by the side-to-side or horizontal stream of farewell embraces[2] and the accompanying conceptualization of these lines into coloured or grey bands, suggestive also of steam, which remain on the picture surface. Similarly, the thin black outlines of the phantom train assert themselves as independent pictorial components existing on or close to the picture plane. They change into perpendiculars on the left and a few diagonals at the bottom, suggesting a very loose, open abstract network which seems to descend from the Cubist grid.

The abstract rhythms carried over from *Gli Addii* are clarified and simplified in *Quelli che vanno*. Here also the calculated tension between volume and surface pattern, between abstraction and representation, and between several meanings – wheels, movement, smoke, etc. – often ambiguously present in one form, lends great vitality to the scene, as in certain 1909–10 Cubist works by Picasso or Braque. Although the architectonic framework of this painting is more explicit than in *Gli Addii* and anticipates Gris' rigidly stationary Cubist grids of 1912,[3] it does not impede the strong and purely Futurist suggestion of velocity. Because the content of *Quelli che vanno* is more unilateral than that of *Gli Addii*, the synthesis of structural and expressive patterns made by the lines of force is even more complete than in the central canvas.

Of the three pictures, only *Quelli che restano*, perhaps because of the delicacy of the mood which it portrays, has lost force in this final restatement. The dominance of the vertical striation – the conceptual lines denoting sadness, according to the London

[1] Boccioni proceeds rather similarly to the quasi-mathematical methods described in the so-called 'legendary question' which the amateur mathematician Maurice Princet was supposed to have addressed to Picasso and Braque regarding their ways of representing objects. Although such a formulation of Cubist technique had little to do with Picasso's and Braque's intuitive approach, Princet nevertheless helped the other artists to approach Cubism more theoretically. See J. Golding, *Cubism*, 102, and C. Gray, *Cubist Aesthetic Theories*, 74 (quotes the 'legendary question' almost in full).

[2] Cf. Léger, *Nus dans un paysage* or *La noce*, illustrated in Katherine Kuh, *Léger* (Chicago, 1953), 12, 15.

[3] For example, Gris' *L'Homme au café*, or *The Watch*, illustrated in J. T. Soby, *Juan Gris* (New York, 1958), 21, 23.

Sackville Gallery catalogue – seems to have precluded any strong movement. Boccioni may have been aware of this when he gave the frames of the houses greater definition and introduced the rhomboidal and circular motifs. These juxtapositions are rather obvious afterthoughts. In the treatment of the figures of those left behind, however, Boccioni displayed much ingenuity. Through their suggested spinning motions he subtly evokes the after-sensation of vertigo experienced when watching an accelerating train from close quarters, as well as the about-face with which their anti-climactic walk begins. Their circular forms and the presence of both front lapels and back belts make the rotations with which they detach themselves and gradually disappear into the non-travelling world quite clear. Thus the tubular trousers, arms, trunks and heads of these 'mathematically spiritualized silhouettes'[1] are apparently dissolved into spiralling lines or intersecting ribbon-like shreds. These rhythmic patterns announce the infinitely more extensive interaction of muscles and abstract forms expressive of movement in the numerous studies of striding figures which occupied Boccioni during the rest of his life. However, at this point, he was probably only following the technical manifesto's recommendation to seek inspiration in the musical lines of modern street clothes.

The large numerals in two of the three *Stati d'animo* are in some ways the most noteworthy details in the triptych. Up to this point there had been no indisputable evidence that Boccioni had seen Picasso's and Braque's recent work. But since none of the other Cubists appear to have used letters and numerals in 1911, Boccioni must have studied Picasso and Braque or somehow been made aware of this significant technique. His comprehension and application of this 'synthetic' Cubist element testifies to his perspicacity. It also indicates that the synthetic basis of Futurist painting theory and its current expression in art – the painting of states of mind – had helped Boccioni to understand Cubism and the implications of such numerals.

The function of letters and numerals in Picasso's and Braque's paintings and collages has been repeatedly defined, most recently and completely by Golding.[2] To a certain extent the same definition can be applied to those in Boccioni's *Stati d'animo*. Their most obvious function is objective identification – if elusively so. The whimsical *trompe l'oeil* door latch superimposed on the abstract pattern denoting speed in the pencil study for *Quelli che vanno* (Pl. 63) and possibly the detailed treatment of the back belt on the lower left figure in the final *Quelli che restano* may have been intended to serve the same purpose. They are comparable to the realistic nails, the tassel and other objects which Braque depicted in some of his paintings after 1910, though these

[1] Sackville Gallery catalogue, no. 3, reprinted *Archivi*, I, 109.
[2] J. Golding, *Cubism*, 92 ff.

K

may have been unknown to Boccioni. Still more significant is the suggestive, associational value of these elements. Picasso and Braque undoubtedly exploited this quality, and it was also essential to the painting of states of mind, with its search for evocative symbols which in the Boccioni triptych may even have included literary (onomatopoeic) and possibly vague mathematical allusions.[1] In a purely compositional sense, Boccioni's numerals characterize the overall aspects of the respective canvases. The purity and vertical-horizontal rigidity of the three Roman numerals summarize the lucid geometric design, and suggest the shape and substance of the coach in *Quelli che vanno*. The curving numerals 6, 9 and 3 combined with the angular 4 reflect and highlight by their bright yellow the counterpoint of patterns animating *Gli Addii*. The numbers have an equally important pictorial function as emphatic accents of the picture surface and of the strong two-dimensionality of the composition. A precedent is found in Boccioni's *Rissa in Galleria* (Pl. 49), in which the lettering stresses the picture plane and counterbalances the recessional forces. And in *Stati d'animo*, where conventional spatial consistency is non-existent, it stands to reason that the sole frame of reference – the picture plane – would have to be given extra emphasis, and thus new meaning.

Apollinaire, who expected the worst of the *Stati d'animo* from hearing about them, realized when he actually saw them, in February 1912, that they were a significant contribution to progressive art. His meagre praise, however, was mostly for their use of Cubism's *dernier cri*. 'Boccioni's best painting,' he wrote, 'is the most directly inspired by Picasso's last works. It does not even lack those numbers in printers' type which add such a simple and grandiose reality to Picasso's recent productions.'[2]

La Risata (Pl. 59) was one of the paintings finished by Boccioni late in 1911.[3] It was brought up to date by the same means as those discussed in the foregoing pages. Because Boccioni retained some of the original appearance in reworking this painting, it stands as an excellent record of the long road he had travelled in less than a year: a road which led from a vehement, descriptive interpretation of Futurism to the more abstract painting of states of mind, and then to a Cubist-inspired formal refinement of the latter, implemented by the concept of lines of force.

[1] The precision of numbers and calculation which fascinated Boccioni especially at this moment may have influenced this usage. Because the figures add up to 22, Boccioni may also allude to Marinetti's favourite numbers, 11 and 22. Marinetti was born on 22 December, and his name had 11 letters, therefore most Futurist manifestos were dated on the 11th day. See P. Bergman, '*Modernolatria*' et '*Simultaneità*', 58.

[2] *L'Intransigeant* (7 Février 1912); reprinted *Chroniques d'art*, 212.

[3] See above, p. 92, n. 2.

Carrà's Preparations

Carrà appears to have been as industrious as Boccioni, completing at least four canvases in addition to retouching *Funerali dell' anarchico Galli* (Pl. 55).[1] His improvements on the latter were confined to a general systematization and tightening up of the design, which is particularly apparent in the sky. As in *Sobbalzi di un fiacre* he treated the atmosphere like a palpable substance: in it the imprints of what were now intended to be lines of force stir up a fierce tumult, intensifying the stifling heat suggested by the action.

His interpretation of the painting of states of mind through intimate perceptions of the life of inanimate matter – as shown in *Sobbalzi di un fiacre* – was strengthened by his increased knowledge of Cubism. Thus the more severe geometric design and fairly complex synchronization of several points of view in his next street scene, *Quello che mi disse il tram* (What the Tram said to me)[2] (Pl. 84), helped to illustrate – with disarming naiveté – one of the most provocative passages from the technical manifesto which describes a tram journey.

The impressive *Ritratto di Marinetti* (Portrait of Marinetti)[3] also belongs to the group of paintings upon which Carrà worked in the late autumn months, but he later thoroughly repainted it as shown in Pls. 85 and 86. The original version (Pl. 86) indicates that Carrà's likeness of the Futurist leader was at first much more vital; his features sparkled and the world literally revolved about him and his pen.[4] This painting is related to such Cubist portraits as Le Fauconnier's *Portrait de Paul Castiaux* (Pl. 86a) and Gleizes' *Portrait de Nayral*,[5] but Carrà enlivened the static Cubist compositions of these examples with a 'contest of lines' and 'battles of planes'.[6] This Futurist desideratum was still more fully achieved in *Donna e l'assenzio* (Woman and Absinthe) (Pl. 87), which has been preserved in its 1911 condition.

Donna e l'assenzio makes the most distinctly Cubist impression of all the works shown at Bernhein-Jeune's. This is due, above all, to its almost monochromatic tone, to its fragmented planes, recalling the Cubist grid, and to the arbitrary lighting and space. However, on closer inspection this first impression must be qualified.

[1] Carrà showed 11 works. Of those that are known, *La Gare de Milan* (Stuttgart Staatsgalerie) and *Le Mouvement du clair de lune* (Private Collection, Milan) may have been begun in the autumn, in addition to those discussed below.

[2] This painting probably was begun about the same time as Boccioni's *Le Forze di una strada*.

[3] *Ritratto del poeta Marinetti; Comment je sens Marinetti*.

[4] Cf. the 1912–13 drawing of Marinetti, a development of the original 1911 painting, on the cover of F. T. Marinetti, *Futuristische Dichtungen* (Berlin, 1913?).

[5] Illustrated in Albert Gleizes and Jean Metzinger, *Du Cubisme* (Paris, 1912).

[6] Bernheim-Jeune catalogue, 7; reprinted *Archivi*, I, 106.

Although the resemblance to Metzinger's *Le Goûter* (Pl. 88) is unmistakable, Carrà's portrait seems like a Futurist parody of that painting, a visual parallel to the criticism of Cubism in the 1912 catalogue: '[The Cubists] persist in painting the immobile, the frozen, and all the static states of nature; they adore the traditionalism of Poussin, Ingres, Corot, ageing and petrifying their art with a *passéiste* obstinacy which remains absolutely incomprehensible to us.'[1] Carrà gave still another twist to the Futurist night-life theme; in contrast to his colleagues he chose to render it – like Degas and Picasso – through the 'state of mind' of an absinthe drinker. The painting's greenish-brown colour resembles the deceptively insipid shade of that potent drink, and its mesmerizing and intoxicating effects are vividly alluded to by the energetic, if laboured, shifts and transformations of objects and shapes. Carrà's strength so far had lain in his powers of close observation, and this shift to an increasing conceptualization of lines, forms and spaces raised more problems than he could skilfully manage at the time.

Russolo: La Rivolta

Russolo also started a number of canvases in the autumn of 1911, but of these only *La Rivolta* (The Revolt) (Pl. 89) can be definitely identified.[2] It shows Russolo rounding out the circle of the first stage of Futurism by dealing with an aggressive collective sentiment which is expressed through the formal abstraction of lines of force. He was evidently the least affected of the Milanese trio by Cubism. Only the geometrical simplicity of his forms and his limited but brilliant colour recall the influence of French artists. But Russolo's interests were quite different from theirs. Taking advantage of his experiments for the *Treno in velocità*, he now made the arrow shape stand for the irresistible force of the people's will. The London Sackville Gallery catalogue elucidated the painting's form as 'The collision of two forces, that of the revolutionary element made up of enthusiasm and red lyricism against the force and inertia and reactionary resistance of tradition. The angles are the vibratory waves of the former force in motion.'[3] Thus both colour and shape symbolize opposition. Indirectly this picture may also refer to the Futurists' renunciation of their Symbolist predecessors, which Marinetti had proclaimed earlier in the year: 'Today we hate our glorious intellectual forefathers . . . the great Symbolist geniuses, Edgar Poe, Baudelaire, Mallarmé and Verlaine. Today we resent their having swum in the stream

[1] Ibid., 2; reprinted *Archivi*, I, 104.
[2] The lost *Une-trois têtes* and possibly *Automobile in corsa*, pl. 111, date from these months. *Automobile in corsa* was finished in 1913.
[3] Sackville Gallery catalogue, no. 22; reprinted *Archivi*, I, 111.

of time with their heads turned continuously backward towards the azure springs of the past, towards the 'ciel antérieur où fleurit la beauté' . . . We are red and we love the red.'[1]

La Rivolta may well have been intended as a companion piece to Boccioni's, Carrà's, and Severini's large major Unanimist scenes, and is about the same size. In contrast to those pictures, which were slowly developed, Russolo's canvas was hurriedly and rather poorly painted, its didacticism undisguised by painterly subtleties. However, its poster-like strength and symbolic immediacy express the anti-art side of Futurism, which Russolo was to exploit much more creatively in his Art of Noises.

[1] Marinetti, *Le Futurisme*, 82–83.

X

THE PARIS EXHIBITION AND ITS AFTERMATH:
THEORY 1912–13

FOR nearly three weeks the plush-lined salons of the Bernheim-Jeune gallery housed the thirty-four paintings by the Italian Futurists, and was the scene of numerous incidents connected with them. This renowned establishment was then still managed by the perceptive Felix Fénéon, the valiant defender of Seurat and his followers, who on the present occasion spoke up for the Futurists.[1] A trim catalogue was issued, featuring eight illustrations, a preface, and the Technical Manifesto of Painting. Severini exhibited with the group for the first time, and even a painting by Balla is listed, though it does not seem to have actually arrived.[2]

The entire Milanese contingent had come to Paris and was kept busy by the manifestations and celebrations continually arranged or encouraged by Marinetti. The reception of their work fell considerably short of the open acclaim they had secretly hoped for, but their paintings, and even more their tactics, did at least have a *successo di curiosità*.[3] At the moment this intoxicated them sufficiently to disregard the hostility and ridicule of artists, critics and public, which, while hardly surprising, was only superficially due to the Futurists' arrogant behaviour. More likely the contrast between the Cubists' austere, almost monochromatic canvases, in which little or no subject matter was discernible, and the Futurists' aggressively coloured and titled pictures must have shocked and confused those who did not yet even understand Cubism and still regarded that as extremely daring.

However, the Futurists and their work undoubtedly made a deep impression on Paris, the effects of which were not noticeable until some time later. In February 1912, only the ageing Gustave Kahn, too old for the front lines of artistic combat, had a word of more or less unqualified praise for them. Granting that the Futurists had 'found guides in Paris', he recognized that 'they have added a great deal, which comes from themselves, with much spirit and lustre', and indulgently declared that 'a movement of such considerable novelty has scarcely been seen since the first pointillists'

[1] Louis Vauxelles, 'Les Futuristes', *Gil Blas* (6 Février 1912), 4, tells of how Fénéon tried to persuade him to like their work.

[2] Ibid., Vauxelles confirms the absence of Balla's picture.

[3] Severini, *Tutta la vita*, 137.

exhibitions'.[1] Adding substance to his good will, he gave a magnificent banquet for the Futurists, replete with celebrities, speeches and wine.

Yet the Parisian *successo di curiosità* did yield some tangible results in the form of contracts for the immediate and extensive continuation of the exhibition – first in England, then in Germany and Belgium. (The Futurists were even invited to the New York 'Armory Show', but declined the invitation because its conditions could not be met.)[2] These exhibitions resulted eventually in the sale of most of the paintings, though on largely unfavourable terms.[3] The prolonged tour took the Futurists' art and ideas to a very large audience in countries, most of which, like Italy, had only recently been drawn into the French artistic orbit. There, fewer vested artistic interests had to be protected, and many young artists and intellectuals welcomed the Italians as fellow rebels, or examples.

In England, where the exhibition opened on the first of March at the Sackville Gallery, the majority of the numerous articles devoted to it showed incomprehension or were given over to attacks from the aesthetes. But even P. G. Konody, the generally unsympathetic critic of the *Pall Mall Gazette*, conceded that the Futurists were 'not only sincere, but are endowed with overabundant imagination and are free of the *fumisterie* of such painters as some young members of our own Friday Club'.[4] In the same paper there was a spirited exchange between the completely adverse Sir Philip Burne-Jones and Max Rothschild, the purchaser of several Futurist paintings. The latter, who valiantly defended the Italians, declared that 'when from one mansion [of art] there bursts forth a song of youth and originality, even though harsh and discordant, it should be received, not with howls and fury, but with reasonable attention and calm criticism'.[5]

Ray Nyst, a writer for *La Belgique artistique et littéraire*, was even more enthusiastic, and emotionally described how he became a Futurist, finding that the movement had

[1] Gustave Kahn, *Mercure de France*, XCV no. 352 (16 Février 1912), 868.

[2] See p. 148, n. 1. Severini, *Tutta la vita*, 165.

[3] A Berlin banker, Dr Borchardt, bought 24 of the remaining 28 paintings (six had been sold in Paris and London), apparently under some arrangement with Herwarth Walden of *Der Sturm* who managed the subsequent showings of the pictures in Germany, Holland, in Zürich, Vienna, Budapest, &c. (See list in Boccioni, *Pittura scultura futuriste*, 454; it has been impossible to verify this list completely.) Although the sale prices were reasonably high, payments were made in instalments and, owing to the outbreak of war, some were never completed. *Archivi*, I, Boccioni to Carrà, Russolo (29 Maggio 1912), Boccioni to Severini (end of May 1912, Giugno-Luglio 1912), Marinetti to Walden (15 Novembre 1912, 8 Settembre 1913), 243–4, 245–6, 253, 288; Carrà, *La Mia vita*, 166 ff.

[4] P. G. Konody, 'The Italian Futurists. Nightmare Exhibition at the Sackville Gallery', *Pall Mall Gazette* (1 March 1912), 5.

[5] Max Rothschild, *Pall Mall Gazette* (4 March 1912), 8.

'introduced "un frisson nouveau" . . . making the pointillists . . . belong to an ancient world, though they still open our eyes to untrodden perspectives'.[1] Another Belgian, Auguste Joly, wrote a more philosophical and discerning article in the same journal about the Futurists. He regarded them as descendants from the ancient Orphics and mystics who likewise sought 'the "sens direct" of things, of life and of thought'. Marinetti's attachment to 'primitive barbaricisms' seemed to him a search for 'a more intense communion with the primitive forces likewise forever new'.[2]

It is understandable that some of the German Expressionists were particularly well disposed toward the Futurists. Marc's and Macke's comments especially may have encouraged the Italians. 'We shall envy Italy her sons and shall hang their works in our galleries', prophesied Marc in *Der Sturm*,[3] and Macke, also deeply impressed, said 'Modern painting can bypass these ideas even less than Picasso'.[4] Even the old *Naturlyriker* Hans Thoma surprised himself by admiring the Futurists, whose work he saw in Karlsruhe. He told in a letter how 'Some . . . of the Futurist pictures struck me almost like a cry for liberation from the endless copying after nature. Thus even this programmatic "nonsense" could carry a meaning, perhaps it could even be a deliverance from much technical coarseness; some of the pictures of one of the Futurists even got as far as beauty of appearance.'[5]

But in Italy, hardly any attention was paid to the furore being stirred up abroad by her self-appointed emissaries in the spring of 1912. Only Barbantini, the far-sighted director of the Ca' Pesaro in Venice, who had given Boccioni his first exhibition in 1910, now invited all the Futurists to show as a group in his gallery in the summer of 1912. Apparently he intended to scandalize the reactionary directors of the Biennale, who had continued to exclude all bold artistic tendencies. The Roman Secessione made a vague proposal for a similar show later in 1912, but for some reason both exhibitions fell through.[6]

La Voce headquarters completely ignored the Futurists' activities at first. Then, early in June, 'i.t.' (probably Italo Tavolato) raised an angry protest against *Der Sturm's* championship of Marinetti and his troupe, and against the mistaken impression given by another German critic that this movement was being taken

[1] Reprinted on undated Futurist broadsheet, 'La Peinture futuriste en Belgique' (Luglio 1912).

[2] Reprinted on undated Futurist broadsheet, 'Le Futurisme et la philosophie' (Luglio 1912).

[3] III no. 132 (Oktober 1912), 187.

[4] Quoted in Gustav Vriesen, *August Macke* (Stuttgart, 1953), 109.

[5] Quoted in Wallraf-Richartz Museum, *Deutsche Maler und Plastiker der Gegenwart* (Köln, 1949).

[6] *Archivi*, II, Marinetti to Barbantini (Marzo? 1912), Russolo and Carrà to Barbantini (30 Aprile, 3 Giugno 1912), 43–46; *Archivi*, I, Boccioni to Carrà (Summer 1912), 246, and Boccioni to Severini (Summer 1912, 2 Ottobre 1912), 248, 249.

seriously in Italy. Despite this negative tone, the way was being prepared for an actual *rapprochement* between the two groups. In Soffici's article 'Ancora del Futurismo' of 11 July, his ambivalent attitude was undisguised. Commenting on reports he had received from Paris about the Futurists' doings, he declared that there was no 'severe enough punishment for them', and that their rhetoric, their publicity seeking, and their art could under no circumstances be condoned. But he granted that 'Futurism is a movement and movement is life', and that in spite of its faults it was a 'movement of renewal – which is excellent'.[1]

Although at first only Severini and the Futurist poet Luciano Folgore saw Soffici's opinions in a positive light, by October all the Milanese artists had agreed to work out a conciliation between the two groups. Severini, who had met Soffici through Picasso, was selected by his Futurist colleagues to take the first steps towards the 'Pace di Firenze', as Boccioni called it. Explicit instructions on how to proceed were given him by 'Il Supremo Consiglio dei Tre' (Boccioni, Carrà, and Russolo): 'Work on Florence *with great diplomacy*, . . . Think of the group and give a lofty impression of our ensemble and of the ends which guide us . . . Underline that the entire French press accuses the *Cubists* of *Futurism* and that our ascent is mathematical, inevitable.' The ultimate purpose of the proposed coalition was 'to remove misunderstandings and to create, if possible, in Italy an atmosphere more favourable to the works we shall produce [and] which we firmly believe the only ones capable of showing the way to the young Italian forces'.[2]

Severini's successful mission was subsequently reinforced by meetings between Marinetti, Boccioni and Carrà, and Palazzeschi, Soffici and Papini. Finally, the seceding *La Voce* men and the Futurists united in an effective Italian force with its own organ – *Lacerba*.[3] In February 1913 Soffici showed with the five Futurist artists at the Teatro Costanzi in Rome, this being their first fully representative exhibition in Italy.

1912. Theory: Cubism and Futurism

At this point in the history of the movement it becomes impossible to separate the evolution of theory and practice, which for almost three years had thrived on an active interchange of ideas. The explanatory preface to the Bernheim-Jeune catalogue

[1] 'Dalle riviste tedesche', *La Voce*, IV no. 23 (6 Giugno 1912), 832; and no. 28, 852.

[2] *Archivi*, I, Folgore to Soffici (after 11 Luglio 1912), Boccioni to Severini (2 Ottobre 1912), Boccioni, Carrà, Russolo to Severini (17 Ottobre 1912; Ottobre 1912), 247, 249, 250–1; Severini, *Tutta la vita*, 142–3.

[3] The Florentines' acceptance of Futurism was still provisional in the first four issues of *Lacerba*.

is a good case in point.[1] While summarizing the Futurist artistic objectives up to this moment – as noted earlier – at the same time it anticipated the course of mature Futurism which the two major theoretical statements of spring 1912 charted expressly.

It was, of course, the challenge of Cubism which affected the Futurists most profoundly in the late autumn of 1911. Realizing no doubt that they could not begin to cope with the possibilities it suggested to them before their forthcoming exhibition, and that they would be vulnerable to attack on their very different attitudes towards Impressionism and subject matter, they attempted to forestall criticism by taking the offensive. In their preface they bluntly accused the Cubists of 'a sort of masked academicism. Is it not, in fact, a return to the Academy', they asked, 'to declare that the subject in painting is absolutely insignificant? . . . While repudiating Impressionism, we energetically disapprove of the current reaction which, in order to kill Impressionism, leads painting back to old academic forms.' Moreover, to stress the abstract tendencies inherent in their own expressionist concept of the painting of states of mind, they pointed to 'spots, lines, zones of colour in our pictures which correspond to no [visual] reality, but following a law of our inner mathematics, musically prepare and augment the spectator's emotion.'

Despite these precautions, the blows fell as expected. Apollinaire, glad to have the opportunity to chastise the ambitious Italians, found Severini's work overly influenced by Neo-Impressionism, but concentrated his criticism on the Futurists' use of subject matter: 'While our *avant-garde* painters no longer paint any subject in their pictures, the subject is often the most interesting thing in the canvases of *pompiers*. The Italian Futurists scarcely pretend to renounce the benefits of the subject, and that could well be the obstacle against which their plastic intentions will come to grief.' Two days later, after an apparent reconsideration, he seemed more amenable. Although still very sharp in his article for *Le Petit Bleu de Paris*, he ended with a backhanded compliment, finding at least 'in [the Futurists'] titles indications of a more synthetic painting. All in all the new art which is being elaborated in France seems to have hardly held on to a melody and the Futurists have come to teach us – by their titles and not by their works – that it could be elevated to a symphony.'[2]

While Apollinaire was thus reluctantly beginning to examine the Italians' contribution, they in turn were delving more deeply into Cubism. Judging from

[1] Here, as in the other painters' statements, the question of authorship arises. Although Boccioni speaks of 'his preface' in a letter to Vico Baer (15 Marzo 1912; *Archivi*, II, 43), he probably did no more than to put the painters' ideas – many of which were his own – into words.

[2] *L'Intransigeant* (7 Février 1912); *Le Petit Bleu de Paris* (9 Février 1912); reprinted *Chroniques d'art*, 212, 217.

Boccioni's correspondence, he was much occupied with the notion of 'pure art' as it was understood by the French artists. Apparently he saw that the Futurist theory of expressive form (*pittura degli stati d'animo*) and the Cubist formalistic concept of pure art had not yet been adequately reconciled, although the ground had been laid by the notion of lines of force. Thus in a letter of 12 February, he asked his friend Barbantini whether such a synthesis could not be expressed by means of '*spiritualized objective elements* . . . This spiritualization will be given by pure mathematical values, by pure geometrical dimensions . . . If objects will be mathematical values, the *ambiente* in which they will live will be a particular rhythm in the emotion which surrounds them. The graphic translation of this rhythm will be a *state of form*, a *state of colour*, each of which will give back to the spectator the 'state of mind' which produced it . . . Whereas at first glance this seems (according to some) either philosophy or literature or mathematics, according to me it is *pure painting*!'[1]

Basically only a further intellectualization of the painting of states of mind theory, this approach provided a more rigorous formal foundation for the development of Futurist art. In theory, Boccioni accomplished this in his Technical Manifesto of Futurist Sculpture, which, in spite of its pertinence to a specific artistic discipline, was the fullest statement of Futurist art so far. The 'new laws' (to use Boccioni's words) which it proposed clearly showed the effect of Cubist views, indicating at the same time that Boccioni had come completely to terms with the differences between the French and Italian movements.

Because these differences are often misunderstood, it may be helpful to review them briefly here. Above all they lay in the two movements' opposing conceptions of 'reality' and in the Futurists' fundamentally expressionist approach. While the Cubists had introduced a revolutionary manner of representing objects and space – which included the element of time – they posited at bottom an ideal, classically static and architectonic absolute, discerned primarily by the intellect. In their search for truth the point of departure mattered little. The proverbial apple, guitar, portrait, landscape, etc., because they were of little emotional significance in themselves, were equally effective vehicles. The Futurists, on the contrary, whose reality was an all-pervasive dynamic relationship, could best find its essence in the least commonplace and traditional subjects or situations, because conventional attitudes were less likely to colour their experience and expression of it. 'Only the most modern choice of subject will be able to lead to the discovery of new PLASTIC IDEAS', wrote Boccioni in his manifesto. The element of novelty was accented also because Futurism still relied on it for its shock value. (In 1913 this became less important to the artistically

[1] *Archivi*, II, 40.

more experienced Futurists, as will be seen.) Although both movements thus strove towards 'pure art', to be fulfilled in increasingly non-objective terms, this had a very different meaning for each of them, in spite of the fact that for the next two years or so the Futurists tried to reach an untenable compromise.

The Technical Manifesto of Futurist Sculpture: 'The Style of Movement'

When Boccioni wrote the sculpture manifesto, presumably in the spring of 1912,[1] he had had little, if any, experience in that medium; and his text clearly shows how his statements depended on and were relevant to Futurist painting precepts. Boccioni justified this mutual reinforcement of the different disciplines by his sweeping Crocean assertion that 'There is no such thing as painting, sculpture, music or poetry; there is only creation'. His exploration of sculpture may have been prompted by Marinetti, who, fearing to lose the initial momentum of Italy's entry into the main-stream of European art, urged his colleagues on to newer and more daring efforts.[2] But Boccioni himself was determined, as he put it, to 'surpass' the Cubists, and especially Picasso, whom he much admired. He rather Napoleonically declared in a letter to Carrà that only in 'magnifying the opponent do I myself grow'.[3] When in Paris in February, he had already seen the possibilities for experiment in sculpture – an area barely touched upon as yet by Cubism. At least in retrospect it seems quite natural that this would be the next step, considering the course which Cubism was taking early in 1912. Yet it had not occurred to the vanguard sculptors to whom Severini had introduced Boccioni. Therefore the anger and surprise with which, according to Severini, they received the manifesto may have been caused by the content of the declaration rather than by Boccioni's alleged secrecy about his intentions.[4]

With the aid of Picasso's and Braque's Synthetic Cubist conceptions, Boccioni had visualized a translation of Futurist dynamism into three dimensions. 'A SCULPTURE OF ENVIRONMENT' was to replace the old concept of the isolated, pedestalled sculptural object. 'We . . . proclaim the ABSOLUTE AND COMPLETE ABOLITION OF THE FINITE LINE AND CLOSED SCULPTURE. LET US BREAK OPEN THE FIGURE AND ENCLOSE THE ENVIRONMENT

[1] Although the manifesto is dated 11 April 1912 and Boccioni certainly was much involved with sculpture at the time, the date of its actual appearance is uncertain. It may not have appeared until a few months after the printed date. Severini suggests this in *Tutta la vita*, 164, and this is supported by the absence of press notices until September. Unless noted, all quotations are from the Italian broadsheet version; reprinted *Archivi*, I, 67–72.

[2] See below, p. 128, n. 1.

[3] *Archivi* I, Boccioni to Carrà (after 12 April 1912), 240.

[4] Severini, *Tutta la vita*, 165.

IN IT', read the key sentences of the manifesto.[1] Random confrontations and inter-relations similar to those described in the Technical Manifesto of Futurist Painting and brought into their canvases illustrated this desideratum: 'From the shoulder of a mechanic may protrude the wheel of a machine, and the line of a table might cut into the head of a person reading.' Rhythms such as 'the tick-tock and the moving hands of a clock, the in-and-out of a piston in a cylinder . . . the opening and closing of a valve [are regarded] just as beautiful as but infinitely newer than the blinking of an animal eyelid'. These visions were now brilliantly implemented by Picasso's and Braque's Cubist collage methods. Boccioni thus recommended that correspondingly unconventional materials and their unexpected relationships be exploited: 'Transparent planes, glass, sheets of metal, wires, external or internal electric lights can indicate the planes, inclinations, tones and halftones of a new reality . . . static or moved mechanically . . . [and] twenty different materials can compete in a single work to effect plastic emotion.' White, grey and black were to 'augment the emotive force of planes, while the note of a coloured plane will accentuate with violence the abstract significance of plastic reality.'

The disciplinary effect of Cubism pervades the manifesto in general. Now 'the intoxicating aim' of Futurist art was not the painting of states of mind, as proposed in the catalogue preface, but the search for 'THE STYLE OF MOVEMENT'. This primarily semantic change was evidently an attempt to get rid of the sentimental overtone of the earlier phrase as well as to avoid the implications of independent, anecdotal subject matter to which Apollinaire had so vigorously objected. The new term, which had been used but not defined in the 1912 preface, underlined in the sculpture manifesto the desire for a more objective interpretation of Futurist dynamism. 'THE STYLE OF MOVEMENT [will make] systematic and definitive what Impressionism has given us as fragmentary, accidental, and thus analytical . . . [and] will embody the marvellous mathematical and geometrical elements that make up the objects of our time.' The lines of force were therefore much emphasized, but the physical transcendentalism which these were to facilitate was to be the outcome largely of 'the straight line . . . [whose] bare, fundamental severity will symbolize the severity of steel that determines the lines of modern machinery'. Architecture now replaced music as the model for Futurist art, but the expressive directness gained by the earlier figurative transposition of the spectator into the centre of the work of art was not lost sight of. Boccioni proposed in the manifesto that the artist should 'start from the central nucleus of the object that we want to create . . . to give plastic form to the

[1] This important sentence has been mistranslated in Joshua C. Taylor, *Futurism* (New York, 1961), 131. The same error is found in Sir Herbert Read's *Modern Sculpture* (New York, 1964), 129, based on it.

mysterious sympathies and affinities created by the reciprocal formal influences of the planes of objects'. The assertion of the artist's creative will was supreme in this process of building 'a bridge between the EXTERIOR PLASTIC INFINITE and the INTERIOR PLASTIC INFINITE', i.e. between matter and spirit. The work of art was to be an autonomous creation, a synthesis of the intellectually ordained and emotionally expressive which 'can only resemble itself . . . [and] the artist must not shrink from using any means that will allow him to achieve REALITY'.

Boccioni's sculpture manifesto – however difficult to put into practice – contained perhaps the most revolutionary ideas contributed by Futurism. By discarding the time-honoured sculptural principles inherited from the Phidian period (so Boccioni said) and substituting an unpremeditated and by extension formally uncentred and unending ensemble of different materials, undreamed of sculptural – artistic – possibilities were suggested. These possibilities significantly influenced not only Boccioni's contemporaries, but every succeeding generation of artists to the present.

The Technical Manifesto of Literature: A New Theory of Analogies

True to his advice to another Futurist to proceed in 'more advanced . . . crazy . . . un-expected . . . eccentric' directions, Marinetti worked out a new, radical theory of poetry in the spring of 1912. Believing that 'a *formal* revolution prepares for and assists a *fundamental* revolution . . . [because] no one knows where inspiration ceases and will begins',[1] he published this theory in his first 'technical' manifesto dated 11 May 1912.[2] Here too the give and take between the different arts was very much apparent. While Boccioni in his roughly contemporary sculpture manifesto paid tribute to Marinetti's poetic innovations, Marinetti in turn seems to have drawn inspiration from the painters' ideas and their work as well as from Pratella's researches in music. The Technical Manifesto of Literature thus amplifies the general artistic precepts of mature Futurism.

Marinetti's proclamation marked the high point in his manifesto-writing career. It is unparalleled in its lucid exposition of highly original material. He listed the con-clusions at the beginning, following them with explanations and examples written in the clipped, unadorned telegraphic style which, in an even more extreme form, he advocated for poetry. He supplanted Kahn's *vers libre*, with which he had initiated Futurism, by his own still more extreme invention, *le parole in libertà* (free words or

[1] *Archivi*, I, Marinetti to Pratella (12 Aprile 1912), 238.

[2] Unless noted, this and the succeeding quotations are taken from the Italian broadsheet version of this manifesto, reprinted with some changes in *I Manifesti del futurismo*, 88–96. I have not been able to verify the date of publication. *La Plume*, XVIII no. 392 (1er aout 1912), 330, prints an attack on it.

words at liberty); which, inducing what he termed *immaginazione senza fili* (wireless or unbound imagination), would lead to even more direct poetic expression. This invention demanded the destruction of syntax. The verb was to be used in the infinitive 'to give the sense of the continuity of life and of the elasticity of the intuition which perceives it'. Adjectives and verbs were to be suppressed so that the nouns retained their 'naked' purity and 'essential colour'. Punctuation too was to be suppressed so that conventionally determined rhythms and stops could be avoided; mathematical and musical signs were to be used instead, thereby 'accentuating certain movements and indicating their directions'.

The heart of Marinetti's new theory of poetry was his concept of analogy. A substantive was to be followed directly by its 'double . . . to which it is bound by analogy; e.g., man-destroyer-escort, woman-gulf, mob-surf, piazza-funnel', and a 'chain of analogies' was to evoke the successive movements of an object. An analogy represented to Marinetti 'the immense love which joins distant and seemingly different and hostile things. It is by means of very vast analogies that this orchestral style, at once polychrome, polyphonic and polymorphous, can embrace the life of matter.' Creative inspiration, like a radio, would thus draw upon the higher frequencies of universal life: no doubt the phrase *immaginazione senza fili* not only signified a creative process unfettered by conventions, but by analogy suggested the similarity of the poet's activity to wireless reception and transmission of seemingly imperceptible relationships and movements.

The examples of analogies given in Marinetti's manifesto recall some of the associative imagery used in the painting of states of mind, by which the painters had similarly transcended traditional limits of space and time. In a more technical sense Marinetti's innovations can of course be traced back to Rimbaud and Mallarmé, as his detractors have repeatedly pointed out, although Marinetti's ends differed radically from those of the Symbolist poets. Another possible model was Fénéon, whose unequalled skill in reducing newspaper headlines to cryptic groupings of essential nouns and verbs may have been influential.[1] And perhaps, more indirectly, Apollinaire's formal experiments in prose and poetry may have affected him, for example the *Onirocritique* of 1908. Apollinaire certainly thought so, and later called Soffici's attention to the debt in a little known letter.[2] But Marinetti in turn was given no credit when, in 1913, Apollinaire suppressed the punctuation in *Alcools* and especially when

[1] See O. Ragusa, *Mallarmé in Italy*, 112 ff.; John Rewald, 'Félix Fénéon', *Gazette des Beaux-Arts*, XXXIII no. 972 (February 1948), 118-19.

[2] Reprinted in A. Soffici, 'Ricordi di vita letteraria ed artistica: Guillaume Apollinaire (con 36 lettere inedite)', *Rete mediterranea* no. 3 (Settembre 1920), 232-3.

he expertly developed many of the new principles in *Calligrammes*. It is of course true that these ideas were generally in the air at the time, and it would be useless to search for their originators. Marinetti's introduction of mathematical and musical symbols had undoubtedly been inspired by Cubist aesthetics: their irreducible directness and primitive strength – both visually and verbally – evidently appealed to him in his search for a vital poetic language and imagery. In the technical manifesto poetry attained new heights of expressiveness by taking into account the weight and odour of the objective world as well.

Machine Aesthetics and Dehumanization of Art

Boccioni's sculpture manifesto had explored the aesthetic possibilities of the machine age world more fully than any of the preceding artists' declarations. But it was Marinetti who showed the way towards a novel, 'dehumanized' interpretation of mechanical forces. In this he was expanding his own ideas – aired in his First Manifesto, in *Mafarka il Futurista*, and in the prophetic lectures collected in *Le Futurisme* (1911) – as well as related notions suggested by the painters. Their desire to convey the emotions of an electric bulb – enunciated in the Technical Manifesto of Painting and more objectively elaborated in the concept of the lines of force – was still more de-romanticized in Marinetti's technical manifesto. To him inanimate 'matter is neither sad nor merry . . . [therefore] it is not a case of rendering the dramas of humanized matter . . . [rather let us] divine its forces of compression and of dilation . . . its torrents of massed molecules and its eddies of electrons . . . We wish in literature to express the life of the motor, the new wild animal whose general instincts we shall comprehend when we have got to know the instincts of the diverse forces which compose it.' By means of such intuitive insights into the unexplored life of the inanimate, Marinetti hoped that the artist would overcome his physical limits and 'merge . . . into the infinite of space and time' and initiate 'the mechanical kingdom' supplanting 'the animal kingdom'. Appropriately enough, Marinetti also envisaged the accompanying evolution of a new being, an immortal superman who will be 'mechanized . . . with replaceable parts'.

Another significant point of difference between Boccioni's and Marinetti's statements was the latter's markedly irrational and proto-Dada programme. Although both men continued to extol intuition as the source of creation, Marinetti went to much greater extremes, proposing a 'maximum of disorder' in the arrangement of images, stressing the unimportance of being understood, and asking the artist to 'spit each day on the Altar of Art'. While Boccioni, under the impact of Cubism, strove towards order and control, Marinetti was seeking absolute freedom and the annihilation of all rules.

1913. Theory. The 'Peace with Florence'

In 1913 all of the Futurist artists except Balla found their tongues and spoke up on artistic matters, breaking Marinetti's and Boccioni's monopoly. While little that was new was added to the 1912 restatements of Futurist theory, the personal emphases introduced in these independent summaries are relevant to the work of the individual artists and are best reviewed in connection with it. At the same time, they did disclose certain general trends of thought which were characteristic of the movement as a whole. In many ways the most decisive single event in the history of Futurism was the coalition with the ex-*La Voce* men in 1913. It brought the Futurists once again face to face with the Parisian Cubist aesthetic of the feared and admired Soffici. The renewed impact of Cubism helped to spell the end of Futurism proper, though not before a remarkable exchange of views in which ideas were clarified and reformulated.

It seems at first somewhat incongruous that the spirited, almost Dada free-for-all advocated in *Lacerba's* 'Introibo' (Pl. IV) was followed up by Soffici's solid disquisition on Cubism and Papini's level-headed analysis of Futurism.[1] 'Futurism', began Papini, 'has provoked laughter, shouting, spitting. Let us see whether it can provoke thought.'[2] Two things must be remembered in reading *Lacerba*, especially its first issues: first, that the Florentine movement, like Futurism, saw itself as entrusted with the double task of reviving the arts and educating the Italians. All the difficulties which might arise were foreseen and dismissed in one of the 'Introibo's' aphorisms: 'He who does not allow men of talent . . . to artists the absolute right to contradict themselves from one day to the next is not worthy of looking upon them.' Secondly, both Soffici and Papini evidently needed the opportunity to lay their cards on the table to justify their adherence to Futurism, as well as to distinguish their views from those of their new associates.

Soffici's three 'Cubismo e oltre' articles, published in book form with the same title in the late spring of 1913, did not depart from his original 1911 interpretation of Cubism.[3] However, he now stressed the Cubists' search for a static absolute, which indicated his own reservations about the Futurists' views. Likewise, the notion of 'pure art' – understood by him in the French sense – was amplified and centrally featured. And like Gleizes and Metzinger in their *Du Cubisme* of 1912, he made

[1] The ambiguous name of the journal itself is a clue to the often paradoxical behaviour of its staff. Soffici, who designed its title, had also found its name – without apostrophe – in an old edition of an operetta by Cecco d'Ascoli. He liked the name in this form because 'it better conserved the arcane, whole, . . . and irritating character of [the] word which signified . . . the sense of something immature, youthful, at the same time annoying the taste of the readers'. *Ricordi di vita artistica e letteraria*, 45–46.

[2] 'Il Significato del futurismo', *Lacerba*, I no. 3 (I Febbraio 1913), 6.

[3] *Lacerba*, I nos. 2, 3, 4 (15 Gennaio, 1 Febbraio, 15 Febbraio), 2–3, 2–3, 30–2.

L

Cézanne, whose cylinder, sphere and cone remark was quoted, the key figure in this development as well as a proto-Cubist. Soffici provided only a glimpse of his vision 'beyond' Cubism, and this was merely a rough paraphrase of some of the Futurists' criticisms, though without acknowledgement, and without acceptance of their premise of dynamic reality.

Needless to say, Boccioni and Carrà did not take Soffici's theorizing too kindly, especially as he did not even mention Futurism. Therefore they politely and subtly took him to task in private correspondence, attempting to convert him to their own programme. When they heard that he was planning a second edition of *Cubismo e oltre*, they hastened to offer him criticism and advice. Above all, Carrà felt that the book's title should be changed to 'Cubismo e Futurismo' or 'Oltre il cubismo'. In addition, he and Boccioni urged Soffici to incorporate all the points which he and they had made in a number of *Lacerba* articles published since the first edition, so that Futurism should be favourably contrasted with Cubism. Carrà thought that by doing this Soffici would show that their group had abandoned 'the ... rank timidity of provincials ... We must have faith and courage in ourselves as artists and Italians. To reject nationalism would mean to subject ourselves to the nationalism of others.'[1]

Futurism Codified

Soffici's incisive theoretical statements seem to have challenged the Futurists to cast their own thoughts in tighter and less equivocal terms, if their aim of surpassing Cubism was to be realized. But the colossal figure of Cézanne, considered the father of Cubism, to whom Futurism could barely be related, posed a major obstacle for them. Carrà tried to overcome it by making Cézanne 'the one who closed the past', as he put it in a letter to Soffici in April. 'The new era of pictorial dynamics shall begin with us, for he was the last giant of static painting ... I wish to react against that French tendency which places Cézanne at the beginning of a new epoch. That he is the generating father of Cubism I admit, because both have a static concept of the plastic world. But the initiator, no, by God!'[2] A *Lacerba* article, 'Da Cézanne a noi futuristi', elaborated on this idea and completed the enumeration of contrasts between Cézanne's principles and those of Futurist art, begun in an earlier essay. But both essays propounded a manner of pictorial construction which might be described as a refiltering of Futurist dynamism, as originally outlined in the Technical Manifesto of Painting, through the art of Cézanne and the theories of Seurat, Signac, Gleizes and Metzinger, and Soffici. Colour was the prime pictorial consideration, and Carrà

[1] *Archivi*, I, Boccioni to Soffici (15 Maggio 1913), 267; Carrà to Soffici (12 Giugno, 23 Luglio 1913), 271–2, 279.

[2] *Archivi*, I, Carrà to Soffici (24 Aprile 1913), 263.

LACERBA

Anno I, n. 1 Firenze, 1° gennaio 1913 Costa 4 soldi

INTROIBO

1.

Le lunghe dimostrazioni razionali non convincono quasi mai quelli che non son convinti prima — per quelli che son d'accordo bastano accenni, tesi, assiomi.

2.

Un pensiero che non può esser detto in poche parole non merita d'esser detto.

3.

Chi non riconosce agli uomini d'ingegno, agli inseguitori, agli artisti il pieno diritto di contraddirsi da un giorno all'altro non è degno di guardarli.

4.

Tutto è nulla, nel mondo, tranne il genio. Le nazioni vadano in isfacelo, crepino di dolore i popoli se ciò è necessario perché un uomo creatore viva e vinca.

5.

Le religioni, le morali, le leggi hanno la sola scusa nella fiacchezza e canaglieria degli uomini e nel loro desiderio di star più tranquilli e di conservare alla meglio i loro aggruppamenti. Ma c'è un piano superiore — dell'uomo solo, intelligente e spregiudicato — in cui tutto è permesso e tutto è legittimo. Che lo spirito almeno sia libero!

6.

Libertà. Non chiediamo altro; chiediamo soltanto la condizione elementare perché l'io spirituale possa vivere. E anche se dovessimo pagarlo coll'imbecillità saremmo liberi.

7.

Arte: giustificazione del mondo — contrappeso nella bilancia tragica dell'esistenza. Nostra ragione di essere, di accettar tutto con gioia.

8.

Sappiamo troppo, comprendiamo troppo: siamo a un bivio. O ammazzarsi — o combattere, ridere e cantare. Scegliamo questa via — per ora.

9.

La vita è tremenda, spesso. Viva la vita!

10.

Ogni cosa va chiamata col suo nome. Le cose di cui non si ha il coraggio di parlare francamente dinanzi agli altri sono spesso le più importanti nella vita di tutti.

11.

Noi amiamo la verità fino al paradosso (incluso) la vita fino al male (incluso) — e l'arte fino alla stranezza (inclusa).

12.

Di serietà e di buon senso si fa oggi un tale spreco nel mondo, che noi siamo costretti a farne una rigorosa economia. In una società di pinzocheri anche il cinico è necessario.

13.

Noi siamo inclinati a stimare il bozzetto più della composizione, il frammento più della statua, l'aforisma più del trattato, e il genio mancato e disgraziato ai grand'uomini olimpici e perfetti venerati dai professori.

14.

Queste pagine non hanno affatto lo scopo né di far piacere, né d'istruire, né di risolvere con ponderatezza le più gravi questioni del mondo. Sarà questo un foglio sfacciato, urtante, spiacevole e personale. Sarà uno sfogo per nostro beneficio e per quelli che non sono del tutto rimbecilliti dagli odierni idealismi, riformismi, umanitarismi, cristianismi e moralismi.

15.

Si dirà che siamo ritardatari. Osserveremo soltanto, tanto per fare, che la verità, secondo gli stessi razionalisti, non è soggetta al tempo e aggiungeremo che i Sette Savi, Socrate e Gesù sono ancora un po' più vecchi dei sofisti, di Stendhal, di Nietzsche e di altri "disertori".

16.

Lasciate ogni paura, o voi ch'entrate!

declared that 'we Futurists combat the Cézannesque objectivism of colour, as we reject that classical [objectivism] of form . . . We propose a perspective of colour free from the imitation of objects . . . as coloured images.' Futurist paintings were to render the whole body of sensations – 'the plastic universal' – by means of 'the three ways in which the plastic world is revealed: light, ambient, volume'. Moreover, to enhance the liveliness of the work of art, Carrà proposed a complex counterbalance of pictorial components, such as the opposition of horizontals and verticals with curves, oblique lines, etc.[1]

Boccioni in his *Pittura scultura futuriste*, written in 1913, made similar judgements on Cézanne and also used him as a foil for Futurism.[2] In his case, unlike Carrà's, the reflections on Cézanne seem to have left a profound mark which became noticeable only a year or so later. Boccioni too attempted to state precisely what he understood by plastic dynamism. It was seen as a function of *complementarismo dinamico* – a modernization of the vague original term *complementarismo congenito* in the painters' technical manifesto – and now explained as 'synthesis of colour analyses (Seurat's, Signac's and Cross's divisionism) and form analyses (Picasso's and Braque's divisionism) . . . [or] complementarism of form and colour'. It is clear from the artistic principles outlined by both Carrà and Boccioni that they now subscribed to a much more distinctly formal, almost art for art's sake point of view, reflecting their increasingly strong leaning towards Soffici's French values. Thus both Futurists agreed that all pictorial components, though dictated by the artist's intuition and evoking objects in their surroundings, were (as Boccioni put it) 'bound and obedient to the unitary discipline of the work of art'.[3]

Finally, in the unpublished manifesto 'Le Analogie plastiche del dinamismo', first projected in the autumn of 1913, Severini set down some principles for his art. As Severini's title suggests, his manifesto was modelled on Marinetti's theory of analogies, and its artistic implementation resembled Boccioni's and Carrà's precepts, with which he was thoroughly familiar. His restatement of them reflected even more clearly Delaunay's and Apollinaire's discussion of Orphism and Léger's ideas about pictorial contrasts.[4]

[1] 'Piani plastici come espansione nello spazio', *Lacerba*, I no. 6 (15 Marzo 1913), 53–55; 'Da Cézanne a noi futuristi', *Lacerba*, I no. 10 (15 Maggio 1913), 99–101; reprinted *Archivi*, I, 145–7, 160–3.

[2] Boccioni, *Estetica*, 82–83, 85, 152–3.

[3] Ibid., 143, 146.

[4] *Archivi*, I, 76–80. Although Marinetti and the other Futurists knew and apparently approved of the contents of the manifesto, for some reason it was never printed. See the long correspondence about it in *Archivi*, 1: Marinetti to Severini (Autumn 1913), 293–4, 295; Severini to Sprovieri (6 Febbraio 1914), 314; Marinetti to Severini (14 Marzo, 24 Aprile 1914), 320–1, 329.

Soffici Becomes a 'Complete Futurist'

Only a very slight push was apparently needed to convert Soffici to the Futurist concept of a dynamic reality. He had already started to shift his position before Carrà, Boccioni and Severini had finished putting their ideas on paper. Soffici's 'Teoria del movimento nella plastica futurista', published in *Lacerba* on 15 April 1913, was his first concession in this direction. He regarded Futurism as the Hegelian synthesis of two 'apparently irreconcilable ideals' – the Impressionist thesis and the Cubist antithesis. Nor did he stop there. By the end of the year, when the Futurists, under his and direct Cubist influence, had almost completely lost interest in a particularly significative subject matter, Soffici, belatedly following their lead, began to extol the importance of a modern subject matter as the source of new 'plastic rhythms'.[1] The circle was complete, at least for the time being; the second edition of Soffici's *Cubismo e oltre* appeared early in 1914 and duly bore the title *Cubismo e futurismo*. The work of all six Futurist artists (Balla and Soffici included) was illustrated, and Soffici's two 'Futurist' essays mentioned above were added to the original text, thus satisfying the demands of his colleagues.

Proto-Dada Ingredients in 1913 Theory

There was a second intellectual and artistic tendency in 1913 which ran counter to that of reason and order. This exasperated, almost paroxysmal undercurrent was evident somewhat paradoxically in nearly all the written statements of that year, in which rationality and irrationality vied for precedence. Marinetti's 1912 Technical Manifesto of Literature was the immediate spark for the proto-Dada spirit, but this was fanned by the ebullient *Lacerba* 'Introibo' of early 1913, as well as by Russolo's manifesto, *L'Arte dei rumori* (The Art of Noises), which gave this spirit an explicit artistic form. Written in March, it was supposedly conceived during a performance of Pratella's Futurist music at the Teatro Costanzi in Rome.[2] Russolo's manifesto added noise to Marinetti's velocity as the uniquely expressive and ubiquitous attributes of the modern world. In formulating his art of noises – then a contradiction in terms – Russolo was following the exhortation made in Marinetti's 1912 technical manifesto to utilize 'all brutal sounds, all expressive screams of the violent life which surrounds us . . . [to produce] the "ugly" . . . and [to] kill solemnity everywhere'. Russolo discarded all conventional rules of music, proposing an unlimited number

[1] *Lacerba*, I no. 8 (15 Aprile 1913), 77–78; reprinted in *Scoperte e massacri*, 213; 'Il soggetto nella pittura futurista', *Lacerba*, II no. 1 (1 Gennaio 1914), 8.

[2] The manifesto is dated 11 March 1913 and is addressed to 'Caro Balilla Pratella, grande musicista futurista'. Reprinted in *I Manifesti del futurismo*, 123–32.

and variety of onomatopoeic and non-onomatopoeic sounds to be disposed in accordance with the artist's untrammelled creative imagination. In the course of 1913–14 he refined these ideas into a complex system of noise-making and performances were given on the specially constructed *Intonarumori* (Noise Organ). Russolo subsequently evolved a very intricate compositional form which foreshadowed the far more extreme experiments made before and after the Second World War by such musicians as Edgar Varèse, John Cage, Morton Feldman, Earle Brown, and many others.

Two months after Russolo's manifesto, Marinetti came forward with a more radical version of his technical manifesto, now entitled *L'Immaginazione senza fili e le parole in libertà*,[1] which significantly extended the typographical and onomatopoeic elements of his earlier theory. To intensify communication of 'lyrical intoxication' three or four colours of ink and twenty different type faces were suggested, to be augmented by 'free expressive orthography . . . freely deforming, remodelling the words by cutting or lengthening them . . . enlarging or diminishing the number of vowels and consonants'. Such instinctive, rationally incomprehensible verbal constructions would, so Marinetti hoped, become abstract statements of 'a pure emotion or a pure thought', foreshadowing the Surrealists' 'automatic' expressions. With this manifesto Marinetti openly invaded the domain of the visual arts, even specifying certain compositional principles which, however, echo Boccioni's 1912 architectonic precepts.[2]

Apollinaire had become interested enough in Futurism to write a manifesto of his own, *L'Antitradition futuriste*, dated 29 June 1913.[3] This is often mentioned as an important and original contribution; actually, Apollinaire produced only a terse and visually handsome 'free word' restatement of Marinetti's aesthetic and literary doctrines, to be elaborated shortly in his own *Calligrammes*.

[1] Dated 11 May 1913; published in *Lacerba*, I no. 12 (15 Giugno 1913), 121–4. Reprinted *I Manifesti del futurismo*, 133–46. The following quotations are from it.

[2] For example in Marinetti's point 14: 'Nausea della linea curva, della spirale e del tourniquet. Amore della retta e del tunnel.'

[3] The manifesto's date succeeds by nine days the opening of Boccioni's first sculpture exhibition at the Galerie La Boëtie, Paris. *Lacerba*, I no. 18 (15 Settembre 1913), 202–3, printed it in Italian. The editors of *Archivi* (I, 257) suggest that Apollinaire had actually written the manifesto before 1 January 1913, the supposed date of Marinetti's letter to Soffici which announces its completion. It is extremely improbable that Apollinaire would have been willing to wait six months for the appearance of his manifesto, especially at this moment when Marinetti was trying to make peace with Apollinaire. In view of this and another letter by Marinetti to Soffici (dated 30 June 1913, *Archivi*, I, 278), in which he speaks of the immediate necessity to publish the manifesto in Italian in *Lacerba*, it seems possible that the date for the first letter was misread. It was taken from a postage stamp, where dates are very often unclear and incomplete. See also P. Bergman, op. cit. 355–9.

Carrà, who had grown more and more vociferous as the year passed, in August attempted to outdo Marinetti and Russolo with his first manifesto, *La Pittura dei suoni, rumori, odori*. He projected some new, completely unclassical principles for such a 'total art', as he called it.[1] Contradicting some of the rational precepts which he, Boccioni, and Soffici had laid down earlier that year, he declared that 'THE PAINTING OF SOUNDS, NOISES, AND ODOURS DENIES . . . Greys, browns . . . the pure horizontal, the pure vertical . . . The right angle . . . The *cube* . . . [and] WANTS . . . Reds, Reeeds that screeeeeeeam . . . greeeeeeens that shrieeeeeek . . . The dynamic arabesque . . . The sphere, the whirling ellipse . . . the spiral and all the dynamic forms which the . . . artist's genius can discover.' An enormous range of sensations beyond the visual was to be evoked by means of abstract ensembles consisting of such intensely alive colours and forms. To achieve this the artist had to live in a creative frenzy, becoming 'a vortex of sensations, a pictorial force, and not a cold, logical intellect . . . painting sounds, noises and colours the way drunkards sing and vomit!'

Marinetti, continuing to forge ahead with his quest for creative liberty, now turned to the theatre for revitalization. The prophetic *Il Teatro di varietà*, dated 29 September 1913,[2] supplanted his dramatists' manifesto of 1910. Now time-honoured theatrical forms were replaced with those of the music hall which, 'created with us by Electricity, fortunately has no tradition, no masters, no dogmas'. The music-hall's primitive and ingenuous character and the unity of actors and audience on which it thrived, inspired Marinetti with the desire to perfect it into his extreme '*Theatre of shock, of the record and of "fisicofollia"*'. Here 'all classic art [was to be] prostitute[d] systematically on the stage' – for example, a Beethoven symphony executed in reverse, all of Shakespeare reduced to one act; and to ignite the audience's participation 'free seats [were to be] offer[ed] to notoriously . . . irritable or eccentric ladies and gentlemen'.

Such assaults on the trite and mechanical in modern man's reaction to art (and life) were continued by Aldo Palazzeschi's manifesto, *Il Controdolore*, of 29 December 1913.[3] The poet postulated a similarly drastic revaluation of experience and suggested that man's maturity and profundity be measured by the '*amount of laughter . . . [he] will succeed in discovering in grief*'. A new type of education for the young was proposed,

[1] Dated 11 August 1913; published *Lacerba*, I no. 17 (1 Settembre 1913), 185–7. Reprinted *Archivi*, I, 73–76. The following quotations are from it.

[2] Published *Lacerba*, I no. 19 (1 Ottobre 1913), 209–11. The broadsheet version, reprinted in *I Manifesti del futurismo*, 158–66, is somewhat longer. The following quotations are from it.

[3] Published *Lacerba*, II no. 2 (15 Gennaio 1914), 17–21, with slight changes from the Futurist broadsheet.

which would focus upon death, thus supplying 'enough to laugh about for a lifetime . . . the man who suffers, the man who dies are the largest sources for human joy'.[1]

Thus, in his search for purity and freedom, the Futurist assumed the venerable role of the clown. The same exploitation of the absurd and the unexpected was to be the chief premise of the Dada movement in 1916–20, as well as the 'theatre of the absurd' of the 1950s and 60s. New and promising avenues were being discovered, but these were also a sign of the strains within Futurism.

[1] Cf. J. L. Forain's 'Programme' in which he announced – among other things – that he wished 'to show the ridiculousness of certain sorrows, the sadness of a great many joys'. Forain's sharp political satire was increasingly successful during the later 1880s and 1890s and his prints were widely known. Gustave Geffroy, *La Vie artistique* (Paris, 1894), III, 227.

XI

PAINTING 1912–13: SEVERINI

So far as the Futurists' work was concerned, 1912 was primarily a year of con-
solidation. After the Paris exhibition they reassessed their aims in the light of
their increased knowledge of Cubism. Their efforts in the second half of the year
gained them much technical assurance, and they introduced some important changes
which prepared the way for the major achievements of 1913.

That year was in all respects the climactic year of Futurism. More and better work
was done than ever before. The movement's influence spread throughout Italy and
Europe, assisted by a series of events which were designed to swell this already flourish-
ing reputation. The year opened with the appearance of the heretic *Lacerba*, which
offered the Futurist programme and news in bi-weekly instalments and rarely failed to
report at least one memorable incident per month sponsored by the movement – an
exhibition, a *soirée* or a manifesto. In the course of the year group exhibitions were
held in Rome, Rotterdam, Berlin and Florence, and Severini had one-man shows in
London and Berlin, as did Boccioni in Paris and Rome. To keep pace with the demands
of this heavy schedule, the artists worked frantically, and now competitively as well,
each trying to outdo the others with new ideas. These were published in essays and
manifestos each of which, according to Severini, 'came out without being known to
the others, as if each feared being robbed or outdone by another',[1] and indicated the
artists' growing desire to assert their creative individualities. The group's energies
were further taxed by major and minor conflicts, ranging from personal squabbles
and jealousies[2] to international arguments with Apollinaire, Léger, Delaunay and
others, some of which were drawn out into long polemics printed in *Lacerba* and
Der Sturm;[3] most of them arose from petty misunderstandings and egotisms. Mari-
netti's tact and diplomacy were severely tried in his attempts to keep these various
disagreements under control. With truly remarkable impartiality he produced un-
limited help and propaganda for the activities of the entire group, while continuing

[1] *Archivi*, I, Severini to Soffici (27 Settembre 1913), 292.
[2] Misunderstanding sprang up between Severini and Carrà over the authorship of ideas in *Pittura
dei suoni, rumori e odori*; between Severini and the *Lacerba* group because his paintings were not – as
were Boccioni's and Carrà's – illustrated in Soffici's *Cubismo e oltre*; between Severini and Boccioni,
and so on. *Archivi*, I, 291–3, 341; Severini, *Tutta la vita*, 185, 165, and *passim*.
[3] See Appendix.

to storm from capital to capital, lecturing and reading his poetry and producing manifestos or *parole in libertà*. But by the end of the year the effect of these prolonged efforts began to show, hastening the inevitable disintegration of the movement during 1914.

Severini: Spring to Autumn 1912 – Paris and Pienza

By February 1912 Severini had developed a more consistent personal style than his Milanese colleagues. This was chiefly due to his living in the sympathetic artistic surroundings of the French capital and it enabled him to reap results more quickly than they at first. But he too paid greater attention to Cubism in 1912, wishing apparently to overcome his neglect of what he called Picasso's 'analytical abstraction';[1] he was no doubt referring to the Spaniard's more deeply searching methods of work.

Two paintings of dancers and two portraits (Pls. 90–93), probably executed in the spring and summer of 1912, reveal the strength of his mature capacities. Here Severini abandoned the multi-coloured mosaic effect of his earlier work in favour of a simpler and more precise arrangement which created a deliberate vitality. In *White Dancer* and *Blue Dancer*[2] (Pls. 90, 91) he concentrated on expressing a consistently rhythmic beat, the heart of the dance. The sharply staccato kicks of the *White Dancer's chahut* are indicated by the repetitive, many-faceted and slicing forms which emanate from the small unstable sphere and triangle in the very centre of the canvas: this area seems to generate the motion in the scene. Reminiscent of the fast, top-heavy swings of a metronome, whose ticks are recorded both above and below its fulcrum, the delicately greyed and tinted planes and modelled shapes connect the isolated spots of primary colour, black and ochre on the circumference, which represent the actions of the dancer. The *Blue Dancer* is apparently performing a tango, and the picture is thus 'slower' and much more compact. The insistently massed blue suggests the controlled calmness of the dance; the beats are now emphatically linked by appropriately curving forms peculiar to the gestures of this specific dance rhythm.

The most significant change from Severini's earlier dancer paintings is in the treatment of light, which does not come from a visible external source, but from the dancers themselves. Whereas in the earlier works light was the independent catalyst

[1] See above, p. 138, n. 1.

[2] Because of the great number of titles used for both paintings, I have designated them by the English titles found in recent American catalogues. *White Dancer* has been called *Seconda danzatrice, Chahuteuse, Ballerina, Dynamism of a Dancer* (*Bal Tabarin*). *Blue Dancer* has been called *Prima danzatrice, Danzatrice in blu, Danseuse blu, Danzatrice.* Cf. Metzinger's *La Danseuse au café*, exhibited at 1912 Salon d'Automne.

of motion, the dancers are now the seeming sources of light as well as of movement, metaphorically and pictorially. The spreading white skirt of the *White Dancer* replaces her body, literally enveloping the picture surface and representing the effects of her motion as well as the pure white light itself. This white surface is articulated by waves of light and movement, now conceived as identical, which disperse the solid form of the dancer with doubled force towards the sides of the picture. In *Blue Dancer* this dualistic representation of light is cunningly augmented by the patches of sequins applied to the skirt. Thus the white light seems to arise not only from its broken contours but from the glistening sequins – even closer to the eye of the viewer – which catch and reflect changing light patterns more richly than pigment, heightening the suggestion of exotically vibrant light and motion. This ingenious device is a direct outcome of several attempts in the late nineteenth and early twentieth centuries to heighten the effect of light and movement on a flat surface. On occasion this had led to the use of metallic paint, a device which was to be further explored by Pollock in the fifties and many others after him, with medieval gold leaf as an important prototype. Severini's appliqué paralleled Cubist collage in some of its artistic intentions and was also related to Boccioni's multi-material sculpture.[1]

Still more formally exacting than these two small rhythmic masterpieces are the two portraits (Pls. 92, 93). Once again there is a noticeable similarity between the methods of Severini and Gris, although it is again necessary to emphasize the significant distinctions between the two. One of the chief aims in Gris' study for *L'Homme au café* (Pl. 94) was the intellectual – though far from pedantic – clarification of his sitter's physical image by merging several views of the static face seen from different vantage points. These are centrally massed, held fast by a rigid and almost completely closed linear grid and the observer is asked to reconstitute these views into a new whole.[2] Severini, on the other hand – and this is particularly clear in *Portrait of Mme M.S.*[3] (Pl. 93) – captured the different aspects of his sitter in slanting, open-ended triangular

[1] The use of tinsel, gold leaf, and other materials in painting was supported by Art Nouveau tendencies, and Previati (like his mentor Alberti) was opposed to it (*Primi principii scientifici*, 231–2). Severini tells how the idea of applying various materials to his pictures came to him after a conversation with Apollinaire. The poet had called his attention to the Italian primitives' halos made of real jewels and pearls and to a St Peter (attributed to Crivelli) at the Brera who carried real keys, and remarked how such contrasting elements 'augment the life of the paintings and their dynamics' (*Tutta la vita*, 175). See also Lincoln F. Johnson, Jr, 'Time and Motion in Toulouse-Lautrec', *College Art Journal*, XVI no. 1 (Fall 1956), 21.

[2] J. Golding, *Cubism*, 101.

[3] Mme M.S. was the wife of R. R. Meyer-See, formerly manager to Martin Henry Colnaghi, then joint founder and director of the Sackville Gallery and subsequently owner of the Marlborough Gallery, London.

wedges, which expand rather than contract. His rendering suggests not only the possibility of his own and the subject's actual changes of position, but more significantly, takes into account all the factors which, as he said in 1913, influenced his perception: 'remembrance, ambience, and . . . emotion . . . [showing us] . . . matter, mass and the integral value of objects in a manner . . . other than that . . . [of] scientific analysis'.[1]

Autoritratto (Self Portrait) and *Mme M.S.*[2] are excellent ironic charactizations. In both the viewer experiences a strong sense of participation, a visual and psychic communication with a tangible human presence; this is especially vivid in the more freely interpreted *Mme M.S.* By a highly imaginative selection of the various angles and aspects of the lady, originating in his memory *montages*, Severini obtained a visual equivalent of the instinctive evaluating process inherent in human relationships. Thus one finds oneself exploring the unknown physiognomy, searching for clues to its formation, and discovering unexpected relationships, such as the continuity between the dog's dark eyes and Mme M.S.'s bright buttons, or between Severini's monocle and the flat semi-circle of the upended top of his hat. And one is almost hypnotically drawn to apparently incidental details like the woman's brooch – wittily paired with her lips – which stands out not only because of its position on the uppermost plane, but also because it is painted in heavy pigment sprinkled with metallic dust. This insignificant detail has been made the key to the sitter's personality, and, somewhat sarcastically, to that of the spectator, attracted by all that sparkles.

Small studies like these paved the way for a second consummation of Severini's efforts, *Hiéroglyphe dynamique du Bal Tabarin* (Dynamic Hieroglyphic of the Bal Tabarin) (Pl. 95). He apparently painted the whole thing while visiting his parents in the quiet, ancient town of Pienza in the late summer and early autumn of 1912.[3] As though aware of the impending fate of his first great night club panorama – *La Danse du Pan-Pan à Monico* (Pl. 72) – he recreated a similar milieu, while eliminating almost all that was still tentative and self-conscious in the earlier work. The atmosphere is light-hearted and gay, perhaps even more French than before. The correspondences between various types of sense experience were now firmly and effectively employed,

[1] Marlborough Gallery, *The Futurist Painter Severini Exhibits His Latest Works* (London, 1913), introduction; reprinted *Archivi*, I, 113. Because of the precision of his method, Severini wondered whether he was working 'along Cubist or . . . Futurist lines'. *Tutta la vita*, 153.

[2] *Rythme abstrait de Mme M.S.*; *Mon rythme* for *Self Portrait*.

[3] Severini, *Tutta la vita*, 159. The exact dates of Severini's trip are difficult to establish; he was definitely in Italy in October, but he was back in Paris by 9 November 1912. *Archivi*, I, Boccioni et al. to Severini (17 October 1912), 250; *Archivi*, II, Boccioni to Vico Baer (9 November 1912), 46. *Bal Tabarin* and the other four paintings discussed above were exhibited at the Rotterdam Futurist exhibition, 18 May–15 June 1913.

and Severini explained in 1913 that he – like his colleagues – was then 'obsessed by the painting of noises, . . . [and that] Micheton, Intermede mome . . . were words [often] heard . . . which I deemed of great emotional importance.'[1] His printed words suggest the hectic, confused noises of a night club, and like the sequins, used again here, call attention to the picture surface, preserved as a consistently two-dimensional plane, unlike that of the *Pan-pan*. As in *White Dancer*, a white, roughly oval area forms the centre of the composition, alluding here to the petticoats revealed in the vigorous movements of the dance. Ambiguity and humour are introduced by making the pink, intensely corporeal buttock the focal point of the picture and opposing it to the insubstantial delicate blue passages around it.[2] The spectator is lured into this frolicking scene not, as in earlier works, by any literal suggestion of his spatial transposition, but by Severini's heightened ability to set up a relationship between spectator and artist, wherein the onlooker identifies himself with the creative experience. This experience, for Severini, consisted of that 'communion, . . . [that] sympathy which exists between ourselves, the centre of things, and things themselves.'[3] Whoever chose the title for this painting had a good sense of its import; like a hieroglyph it conceals its message, which can be deciphered only slowly and perhaps never fully.

Paris: Autumn 1912 to Summer 1913

Severini's return to Italy in 1912 had important consequences for the Futurist circle, because of the example of his work and ideas as well as his effort to reconcile the Futurists and the men from *La Voce*. Yet he in turn was again subjected to his colleagues' views, and their effect is apparent in the work he prepared for his London exhibition after his return to France. The search for a more synthetic representation of motion, which was preoccupying the Milanese artists late in 1912, was conspicuous in the many paintings and drawings Severini seems to have produced in rapid succession with a burst of creativity. He now conceived of a large-scale, bold linear pattern which pulled entire scenes together. Somewhat reminiscent of the Milanese force-lines, this usually consisted of big, flat arcs, ellipses, or segmented circles, integrated with subsidiary angular or near-angular forms, all of which indicated a break from the severe Cubist vocabulary. Lettering, sequins, and, more importantly, built-up painted relief, intensify the suggestion of movement. The general effect of this group of pictures is one of unprecedented ease and liveliness, as well as of

[1] See above, p. 138, n. 1.

[2] A similar detail is found in *White Dancer*. There are other humorously erotic references in *Geroglifico*, e.g. the girl on the scissors.

[3] Marlborough Gallery, *Severini*, introduction; reprinted *Archivi*, I, 117.

increased richness and warmth of colour, in distinct contrast to the predominantly cool and brittle works of the previous years.

In *Nord-Sud Métro* and *Autobus*[1] (Pls. 96, 97) of late 1912 or early 1913 Severini came closest to Boccioni's and Carrà's reconciliation of 'the exterior and the interior of things'.[2] The compositions depict a head-on confrontation which achieves an immediate *rapport* with the spectator, who might be a passenger in the vehicle. Both paintings have a certain whimsical charm, keenly and perceptively conveying the sights, sounds and smells of Parisian public transport.

But Severini was much more at ease in the cabaret world and *Danzatrice a Pigal* (Dancer at Pigal's) and *Danzatrici spagnole a Monico* (Spanish Dancers at Monico's)[3] (Pls. 98, 99) reveal more lucidly the full extent of his new departure. He explained his aims in the London Marlborough Gallery catalogue in a comment which refers to preparatory drawings rather than paintings. In the awkward English given there he said: 'An overpowering need for abstraction has driven me to put on one side all realization of mass and of form in the sense of pictural [sic] relief. By the simple indication of values and of mass I have arrived at the arabesque . . . These . . . are plastic rhythms.'[4] Indeed the dizzyingly powerful circles set off by the Dancer at Pigal's suggest the strength and tension of a well-tempered spring which literally seems to pop out of the picture, being built up in relief in parts of the central area.[5] In *Danzatrici spagnole* he depicted a more complicated kinetic graph of motion whose contrapuntal pattern of parallel and intersecting lines of force creates a sense of continuity comparable to a Chinese scroll. The pitfall of such a graceful, non-structural art is empty decoration, which Severini was not always able to avoid as successfully as in these two examples.

[1] *Nord-Sud Railway, Nord-Südring, Il 'Nord-Sud' (velocità + rumore); Der Motorbus, L'Autobus, (velocità + rumore);* (See *Archivi*, I, 333.) *Autobus* is dated 1913 in Severini, *Tutta la vita*, ill. opp. p. 192. A drawing in the Rothschild Collection, Ossining, New York (Taylor, *Futurism*, no. 102, 147), is dated 1913, but seems a postlude rather than a study for *Nord-Sud Métro*. Cf. Romains' 'L'Omnibus' in *Puissances de Paris* (Paris, 1911), 75 ff.

[2] See above, p. 138, n. 1.

[3] *Ballerina del 'Pigal' (Musica + Ambiente + Danza). Ballerine spagnole al 'Monico' (Musica + Ambiente + Danza). Danzatrice a Pigal* now bears a date of 1912 and *Danzatrici spagnole a Monico* of 1913. Nos. 96–99 were shown at the Marlborough Gallery exhibition which opened on 7 April 1913, and are illustrated in the catalogue. This entire exhibition was on view from June to August 1913 at *Der Sturm*, Berlin, and it was included – with a few exceptions – in the *Prima esposizione di pittura futurista*, Naples, May–June 1914.

[4] Reprinted *Archivi*, I, 117.

[5] In a letter of 16 December 1965 Severini explained that the relief was built up with 'colle Totain et Blanc de Meudon très épais'.

Plastic Analogies of Dynamism, 1913–14

The intense activity of the early months of 1913 was cut short by Severini's trip to London in April for the opening of his exhibition at the Marlborough Gallery and by the loss of his studio in the Impasse Guelma.[1] Afterwards Severini was much occupied with plans for his marriage to Jeanne Fort, daughter of the poet, which finally took place in August. The witnesses were Apollinaire, Merrill, Vallette and Marinetti (who appropriately arrived from Milan in a white automobile). In September the newly-weds went to Italy, where they remained against their will for nearly a year, as Severini had contracted a serious lung disorder.

In the early summer months of 1913 Severini had already begun to reconsider his most recent work, and the handsome *Ritmo plastico del 14 luglio* (Plastic Rhythms of the 14th July)[2] (Pl. 100), painted just before he left for Italy, shows the effects. The Neo-Impressionist in Severini, now thoroughly disciplined by Cubism, reappeared in this bright picture of a French Bastille Day celebration. Simple, interpenetrating geometric shapes again made up of stippled colour allude to the French tricolour, fireworks, and perhaps also the sun and moon, suggesting the holiday's continuation through day and night. This predominantly abstract evocation of the festive spirit – the fragment of a straw-hatted head at its core, presumably the citizen-artist, being the only unequivocally realistic detail – marked a fresh course for Severini. With the aid of Marinetti's theory of analogies and Delaunay's attempts to capture the movement of luminous reality, Severini crystallized this development into his own concept of 'plastic analogies of dynamism'.

The suggestion of a dynamic relationship between complementary images, implicit in *Ritmo plastico del 14 luglio*, became explicit in *Mare = danzatrice* (Sea = Dancer) (Pl. 101) of late 1913 or early 1914. It dealt with the simplest type of 'plastic analogy' of universal dynamism, or *analogie reali* as Severini called them in his unpublished manifesto.[3] They were based on associations of object-situations not unlike those used in his memory pictures. *Mare = danzatrice* was probably painted while he

[1] Severini, *Tutta la vita*, 176 ff.

[2] *Dynamism of the 14th July, 14 Luglio*. This theme with its distinguished Impressionist and Post-Impressionist statements was also treated by Gleizes, by Romains and by the composer Albert Doyen. The present frame, made by Severini in 1960, is a replacement of the original one which he made in 1913. The painting was exhibited at the *Erster Deutscher Herbstsalon*, Berlin, 1913, *Esposizione di pittura futurista*, Galleria Futurista, Rome, 1914, Doré Galleries, London, 1914, San Francisco Panama-Pacific International Exposition, 1915.

[3] *Archivi*, I, 76–80. Unless indicated, all quotations below are from it.

was living by the sea at Anzio, where he had gone to recover from his illness.[1] To one so keenly sensitive to rhythm, the sea brought night club dancers to mind, especially since Severini was consumed by homesickness for Paris, 'my adopted city . . . the only place I can live'.[2] The quality of a glistening, rippling movement superimposed upon a steady, inexorable rhythm, which is common to both the sea and the dance, was caught by an intricate play of complementary forms, lines and colours, opposed to each other either as single units or as composite groups or else by a combination of both. The design followed the principles outlined in his manifesto (written about this same time) by which he hoped to express his 'plastic sensibility become universal'.

Allowing free reign to his imagination and fine sense of colour, Severini created several spontaneous and jubilant hymns to light, as exemplified by *Espansione sferica della luce (centrifuga)* (Spherical Expansion of Light (centrifugal)) (Pl. 103), completed in 1914. He was especially pleased with two paintings from this series, and proudly told Dr Sprovieri, who was planning to exhibit them, that 'these . . . small pictures have achieved a great beauty and transparency of colour'.[3] *Espansione sferica* fully illuminated Severini's aspirations pronounced in the first sentence of his manifesto, 'We wish to enclose the universe in a work of art. Objects no longer exist.' In this painting specific, material objects have been transformed into elementary and pure relationships between luminous sensations. The centre of energy – the radiant yellow field of light at the heart of the picture – attracts and rejects a fluctuating world of delicately varied colours. Canvases such as this one attempted to express the grandest analogy, which omitted all the intervening analogical steps. The picture's non-representational content had now become an analogy to, or an abstract recreation of, the universal dynamism. They could be called Orphist as well as Futurist, the only distinction being their energetic expression of flux, viewed perhaps more dispassionately by Delaunay and his followers.

Having reached the narrow borderline between a totally non-objective and a

[1] The date and title of *Danzatrice = mare*, as it is now called, are somewhat problematic. Because of the similarity of this work to the example of an *analogia reale* given in Severini's manifesto, and because of the fairly literal representation of waves and beach cabins (especially in the drawing, Pl. 102), this canvas may be one of the first to deal with this theme. Hence it is probably datable after 26 November 1913, when Severini was still in Pienza, and before 6 February 1914, when writing from Anzio he mentions a painting 'Mare = danzatrice' as being in the hands of Dr Sprovieri. (*Archivi*, I, 314.) A painting and three studies called 'Mare = ballerina' were shown at the Galleria Futurista in Rome in February–March 1914, at the Doré Galleries, London, 1914, and in San Francisco, 1915.

[2] *Archivi*, I, Severini to Soffici (27 September 1913), 293.

[3] *Archivi*, I, Severini to Sprovieri (6 Febbraio 1914), 314, lists the title of Pl. 103 as given here, but the identity of the canvas mentioned by him with the one illustrated cannot be established.

realistically inspired art in which the object is completely transcended, Severini, for some reason, did not cross over into unexplored territory, but returned to a relative realism. Perhaps he shared Boccioni's attitude, expressed in a *Lacerba* article, that the time was not yet ready for a completely 'abstract code'.[1] Or possibly he had found that the vitality of the tension between realism and abstraction was as necessary to him artistically as it was to the Cubists. Most of Severini's pre-war work was based on either his first type of analogy – the *analogie reali* – or a subtler kind of correlation which he called *analogie apparenti*. This second type was exemplified by *Mare = danzatrice + mazzo di fiori* (Sea = Dancer + Vase of Flowers) (Pl. 104),[2] the inspirational process of which Severini again described: 'The plastic expression of the sea, which as real analogy evokes in me a dancer at the first glance, as apparent analogy gives me a vision of a great vase of flowers. These apparent analogies . . . help to intensify the expressive value of the plastic work.'

This kind of free association fulfilled Severini's theory of analogies, which he later defined more simply as 'a complementarism of images, used . . . to . . . create a new one'.[3] His search for a 'new image' distinguished 'plastic analogies' from the simpler associations of his memory pictures, which were used for mutual emphasis rather than for the communication of a broader, more universal idea.

Mare = danzatrice + mazzo di fiori is more sculpturally and even architectonically conceived than almost any previous work by Severini and resembles the simplified monumental forms of Boccioni's late 1913 canvases. Discarding the distinctions between traditional media, Severini now added a semi-circular piece of painted aluminium to the bottom centre of the picture.[4] From this cool, silvery base rises a structural crescendo of unfurling blue-black lilac and red forms which prepare for and support the brilliant splash of yellow on top. An unexpected mood of gentle nostalgia adds further interest and unity to the image, just as the unforeseen addition of the bunch of flowers and flower pot emphasizes its formal strength. This pervasive mood is complementary to the objective phenomena upon which the picture is ultimately

[1] 'Fondamento plastico della scultura e pittura futuriste', *Lacerba*, I no. 6 (15 Marzo 1913), 52; reprinted *Archivi*, I, 144.

[2] *Dancer = Sea + Vase of Flowers. Danseuse + Mer + Voiles. Danzatrice + mare = vaso di fiori.* This painting has been dated 1913, but 1914 seems more probable. Severini continued to work on his sea analogies even in 1915 in preparation for his Paris exhibition which opened on 15 January 1916 at the Gallery Boutet de Monvel.

[3] Severini, *Tutta la vita*, 208.

[4] This is an outcome of his relief-like paintings (Pl. 98). Cf. Archipenko's 'Sculpto-Painting' and the multi-material constructions by Boccioni, Balla and Marinetti of 1913–15. According to the owner, the present piece of painted aluminium replaces the original piece of painted tin, which had rusted.

based – the effects of the setting sun striking the wild night-bound sea, the climactic splendour of full blooms, and the flashes of transitory joy in a dancer's movements. But in a broader sense the melancholy overtone predicts the deterioration and impending exhaustion of Severini's Futurism.

PAINTING 1912-13:
THE MILANESE ARTISTS AND SOFFICI

Russolo

AFTER the closing of the Paris exhibition late in February 1912, Boccioni accompanied the Futurist paintings to London, Berlin and Brussels,[1] while Russolo and Carrà returned home to Milan. Both artists found the provincialism and lack of sympathy of the local artistic milieu even more unbearable than before. Russolo complained in a letter to Boccioni of having his 'head full of debts and IOU's . . . [and wondering] what the use of it all was'.[2] But in spite of his discouragement, during 1912 and 1913 Russolo continued to pursue the singular line of work which had already shown him to be the most resistant of the Milanese trio to the influence of Cubism. Paintings like *La Musica* (reworked in 1912, Pl. 57), *Riassunto dei movimenti di una donna*[3] (Synopsis of a Woman's Movements) and *Solidità della nebbia* (Solidity of Fog) (Pls. 105, 108, both of 1912) seem to indicate a conscious avoidance of the art of Picasso and Braque, which was then guiding and inspiring Boccioni and Carrà. Instead of adapting the Cubists' angular, splintered construction to his own vocabulary, as the other two had done, Russolo harked back to the flowing Art Nouveau arabesques of his earlier work, which he reinterpreted and systematized into concentric and contiguous circular or free-form shapes. If these have no exact Parisian counterpart, they are not dissimilar in spirit to those used by certain members of the Puteaux group – the repeated arcs and disks in Delaunay's *Saint Séverin* series, the supple forms and lines expressive of motion in Duchamp's *Nude Descending a Staircase*, or the circles in Kupka's abstract *Fugues*.[4]

Riassunto dei movimenti di una donna and *Solidità della nebbia* also illustrate Russolo's

[1] The exhibition opened at the Sackville Gallery, London, on 1 March; at the galleries of Herwarth Walden's *Der Sturm*, Berlin, on 12 April; at the Salle Giroux, Brussels, on 1 June. Boccioni returned to Paris between the London and Berlin showings, and may again have stopped there after the Brussels opening.

[2] *Archivi*, I, Russolo to Boccioni (9 Aprile 1912), 236-7.

[3] *Plastische Übersicht der Bewegungen einer Frau, Plastic Summary of a Woman's Movements, Plastic Synthesis of the Actions of a Woman*. Boccioni dates this painting 1911 in *Pittura scultura futuriste*, but at present it bears a date of 1912.

[4] Russolo may well have seen either originals or reproductions of these in Paris in 1912.

oscillation between the representation of physical and spiritual movements, already noted in his work of 1911. As the title *Riassunto dei movimenti di una donna* suggests, Russolo was attempting to work out an intellectual proposition, which he handled in a manner approaching that of Duchamp's first oil study for *Nude Descending a Staircase* (Pl. 106). While Duchamp's figure cascades gracefully down the curving stairs, Russolo's lady (clothed in street dress in accordance with Futurist rules) executes an energetic three hundred and sixty degree turn, urging the viewer, and originally the artist, to move in the same way. Comparison with the apparently antecedent print (Pl. 107) shows how schematized the figure is. As in Severini's *White Dancer*, the combined rhythm of her form and action is prolonged into reverberating, insubstantial wave-like patterns which create a delightfully ingenuous and perhaps unintentional analogue to the magnetic field of a moving woman as perceived by a roving male eye.

The colour in this painting – almost entirely restricted to various shades of deep blue-black and highlighted only by a few electric accents of pink and yellow – was carried through in *Solidità della nebbia*. Here, however, a very different key of blues was chosen and a totally different mood conveyed. Rather than human activity, the catalyst is atmosphere itself, seemingly alive, which engulfs and penetrates the scene within it. Carrà had called attention to the poetic possibilities of fog in *Sobbalzi di un fiacre* (Pl. 76). Russolo now transformed the atmosphere into a potent conductor of universal dynamism. The gradual approach and ultimate union of two independent, slowly expanding, curving rhythms – those of the street light above and the pavement below – effectively symbolizes this silent process which overcomes all secondary movement.[1]

To the numerous exhibitions of 1913 Russolo submitted several canvases reflecting the brash, assertive mood of Futurism. *Linee forze della folgore* (Lines of force of a Thunderbolt), *Le Case continuano in cielo* (The Houses Continue into the Sky) and *Automobile in corsa* (Speeding Automobile)[2] (Pls. 109–11), executed that year, dealt with more aggressive subjects and reintroduced angular forms into the hitherto

[1] Cf. Jules Romains' 'Rien ne cesse d'être intérieur': 'La rue est plus intime à cause de la brume./ Autour des becs de gaz l'air tout entier s'allume;/Chaque chose a sa part de rayons;/ . . . Les êtres ont fondu leurs formes et leurs vies/Et les âmes se sont doucement asservies./Je n'ai jamais été moins libre que ce soir/Ni moins seul.' *La Vie unanime*, 30–31.

[2] *Linee forza di un fulmine*; shown for the first time in Rome, February 1913. *Compenetrazione di Case + Luce + Cielo; Dynamic Expansion: Houses: Lights; Maisons + lumières + ciel*; apparently shown first at Futurist exhibition at Rotterdamsche Kunstkring, May–June 1913. *Composition; Dynamism of a Motor; Full Speed*; apparently shown first at Futurist exhibition sponsored by *Lacerba* at Gonnelli Gallery, Florence, November–January 1913–14.

predominantly curvilinear designs, greatly increasing their power. In two of these pictures the union of earthly and celestial spheres, implied in *Solidità della nebbia*, became the chief dramatic action. The first, *Linee forze della folgore* (Pl. 109), was based on the early *Lampi* (Pl. 46). But now the image of lightning in a city sky was interpreted in a manner which recalled Marinetti's fantasy 'La Guerre électrique' and would have pleased Benjamin Franklin. The potentially available 'atmospheric electricity immanent above us'[1] has become the forceful protagonist linking man and the universe. Lightning descends in expanding wedges, and its complement, the detonating energy of thunder, builds a vast and fantastic striated dome over the city. This striking image of elemental power subject to an order of its own is represented with admirable originality. It is unfortunate that Russolo destroyed this picture in one of the moments of insanity which overcame him at the end of his life.[2]

A more balanced, though no less vigorous, exchange between heaven and earth takes place in the handsome *Le Case continuano in cielo* (Pl. 110), which was probably painted after the lightning scene. Boccioni's tentative *Forze di una strada* of 1911 may have inspired Russolo's conception, especially the general arrangement of interacting force-lines and force-forms. Russolo's strong sense of order, undoubtedly augmented by his knowledge of musical disciplines, was fully revealed in the calculated formalism of this picture, which climaxed his unspoken strivings from 1911 onwards for a maximum economy of means. The arched triangle, or Gothic ogive, which is the chief compositional element, suggests the unity and transitions between ground, buildings and sky. An effective counterbalance between inward and outward movements was achieved principally by means of this curvature, supported by the spectral gradations and contrasting directions of the beams of light. Russolo played down all specific connotations and painted the vision of an unknown, ethereally pure world. *Le Case continuano in cielo* represents his version of *le style du mouvement*; it is also his masterpiece, completed at the moment when he was beginning to turn from this vision of the sublime to another universal image, that of ubiquitous noise. *Automobile in corsa* (Pl. 111) was probably one of Russolo's last paintings in 1913, though it now bears a 1911 date.[3] Russolo's treatment grew directly out of his *Treno in velocità* and *Rivolta* (Pls. 77, 89), in which velocity and force first appeared as abstract wedge shapes. This canvas as it now stands seems to indicate his decreasing interest in painting. After the publication of his manifesto on the Art of Noises,

[1] Translated and reprinted in *Guerra sola igiene del mondo*, 129. Cf. L. Folgore's poem, 'L'Elettricità', *I Poeti futuristi* (Milano, 1912), 254 ff.

[2] Conversation with Signora Maria Russolo, 1960. It was destroyed in 1943.

[3] It is dated 1913 in Boccioni's *Pittura scultura futuriste*.

Russolo almost completely gave up painting until 1942.[1] With that pronouncement he officially rejected further competition with the painters and became master of an uncontested area of his own, thus resolutely asserting his artistic individuality.

Boccioni and Carrà: 1912 to mid-1913

In 1910–11, Boccioni's and Carrà's developments had been superficially similar; this relationship held also in their mature Futurist work. At the same time their temperamental differences became fully crystallized, adding to the growing tension between their individual artistic commitments and their dedication to the Futurist ideals.

Six paintings (Pls. 112–20) summarize their achievements between the Paris début and the Roman exhibition in February 1913. The first pair, Boccioni's *Materia* (Matter) and Carrà's *Galleria di Milano* (Milan Galleria) (Pls. 112, 113) carry on directly where both artists had left off in the winter of 1911–12,[2] though some advance in technical skill is noticeable, especially in the assimilation of certain Cubist elements. Both paintings are in sombre hues, with a few more vivid highlights. Both give an unprecedentedly strong architectonic effect, but Carrà, with his natural affinity to the Cubist spirit and the greater capacity for self-effacement demanded by it, went beyond Boccioni in his integration of the French point of view. The intelligence and subtlety with which he employed their two-dimensional analysis of the object, their chiaroscuro and lettering, transcended the empty imitations of many of Picasso's and Braque's acolytes. Yet his thoughtful emulation of Cubism represents only one aspect of *Galleria*. Like *Donna e l'assenzio* (Pl. 87) it quickly sheds its Cubist austerity to reveal a Futurist nature. The shifting, receding, and advancing planes become a turbulent mob scene taking place in the dimly lit, domed and vaulted passages of the great gallery.[3] In the lower part of the painting there are still remnants of naturalistic illumination and conventional concepts of space. But this timidity is left behind in the upper two-thirds of the canvas, where the abruptly rising and spreading din seems to rend the architecture. A lively *mêlée* of forms and letters, provoking auditory and verbal associations, effectively summarizes the tumult in the lower sphere. It was here that Carrà began to experiment with his interpretation of 'pure art' as a dynamic disposition of formal elements.

Although in March 1912 Boccioni seriously thought of settling in Paris,[4] his

[1] In his 1916 column in the Milanese *Gli Avvenimenti* (*Archivi*, II, 20), Boccioni mentioned that Russolo had stopped painting in 1914, but returned to it in 1916. No 1916 works are known to me. In M. Z. Russolo et al., *Russolo*, 31, 97, both 1941 and 1942 are given for his resumption of painting.

[2] Both pictures may have been begun before the Paris exhibition.

[3] Cf. Boccioni's *Rissa in galleria* (Pl. 49).

[4] *Archivi*, II, Boccioni to Baer (15 Marzo 1912), 42.

work shows that he did not adopt any of the current French methods without radi-
cally altering them to his individual needs. This is borne out by *Materia* (Pl. 113), in
spite of the clearly beneficial effect of Cubist disciplines, obvious when it is compared
with *La Strada entra nella casa* (Pl. 75) of just a few months before. While Carrà, in
Galleria, concentrated upon the expression of volume through planes, lines, and
modelling, Boccioni, then preoccupied with sculpture, was thinking primarily in
terms of mass, of material, as his title implies. He obtained the desired 'solidification
of Impressionism' by treating the picture surface as a continuous, yet variegated and
seemingly material substance resulting from the 'simultaneity of object + ambient +
atmosphere'.[1] Thus the precepts and to some extent the images of the sculpture mani-
festo (as well as the Technical Manifesto of Painting) were visually followed through;
not only was 'the figure opened up' (the horse jumps right through her knees), but
the whole world was simultaneously precipitated upon it. Yet unlike the superficially
similar and roughly contemporary *Costruzione orizzontale* (Horizontal Construction)[2]
(Pl. 114), *Materia* retained a deeply significant subject matter. Both paintings apparently
started out as seated half-length likenesses of Signora Boccioni, but *Costruzione
orizzontale* evolved into a rather dry testing ground of his ideas regarding the expres-
sion of 'pure art' in terms of calculable mathematical values. The canvas of *Materia*
was repeatedly enlarged in the course of development and Signora Boccioni was
transformed into a majestic *madre*, or even a modern worker's *maestà*, suspended high
above the city, yet still part of it. While the colours of *Costruzione orizzontale* are
silvery and cool, *Materia*'s dark and warmly glowing hues add to its emotional
religious effect. The supernatural aura of the woman's presence is also emphasized by
the irrational, almost Mannerist, play of light and space around her head,[3] and by the
enigmatic contrast between the heavy folded hands[4] – forced through the picture
plane – and the graduated recession of her torso.

 In contrast to these two monumental, but comparatively static pictures, Boccioni
and Carrà stressed vigorous motion in another pair painted later in 1912, each of
which depicts a rider on a red horse. Boccioni's *Elasticità* (Elasticity) and Carrà's
Velocità scompone il cavallo[5] (Speed Disintegrates the Horse) (Pls. 115, 116) reveal a
number of changes which are due at least in part to Severini's visit to Italy in the late

 [1] Boccioni, *Estetica*, 159.
 [2] *Volumi orizzontali, Dimensioni orizzontali.* This painting is closely related to the lost sculpture
Testa + casa + luce (Pl. 145).
 [3] See e.g., Giulio Romano's *Holy Family*, illustrated in Frederick Hartt, *Giulio Romano* (New Haven,
1958), pl. 94.
 [4] Cf. Rodin's numerous studies of hands.
 [5] *Dynamic Space of a Jockey, Horse and Rider.*

v. Broadsheet announcing the second Futurist *soirée* in Rome, 9 March 1913, at the Teatro Costanzi

summer of 1912. He arrived in their midst with several of his most recent canvases and armed with 'all possible information on the Cubists, Picasso and Braque . . . [including] the latest photographs of works' from Kahnweiler's, requested by Boccioni.[1] The crisper, cleaner delineation of form and airier and lighter colour of both *Elasticità* and *Velocità* reflect Severini's contemporary work (as well as that of Delaunay, La Fresnaye and other Cubists).

Carrà's small watercolour was one of his first exact studies of motion and he resorted to the cinematographic method of showing its successive stages. Thus, rather like Severini in the *White Dancer*, he portrayed the horse and rider on the verge of being hurled into space. Only the rider's foot, presumably spurring on the plunge forward, remains hardly changed in the relatively calm circular centre. This point immediately holds the viewer's attention and becomes the pictorial hub of activity.

Boccioni's canvas is likewise organized around a salient centre of action, located in the horse's belly and made more prominent through the deep blackness of the rider's boots. But *Elasticità* is a full-scale oil in which Boccioni was able to go beyond Carrà to develop a more synthetic image of his perception of movement. Moreover, Boccioni has added some philosophical comments of his own, as was his custom. Much about this picture either complements or opposes the ideas underlying *Materia*. Instead of harking back to the image of the Virgin, Boccioni has pictured the heroic new citizen, albeit in the guise of the historic knight, with horsepower (i.e. electricity) under his control.[2] While the massive female icon in *Materia* appears to transcend the shattering assaults of time and matter through its suggested spiritual fortitude, the rider responds positively to these stresses by 'opening up' and extending himself in all directions. Like energy in its limitless flow, he and his horse (his inspiration) are physically inseparable from their surroundings – steam, steel, electricity, the city. The suppleness and evenness of motion implied in the idea of elasticity are pictorially evoked through the skilful interplay of the strong two-dimensional, linear design with the underlying compositional geometry. By stressing the square shape of the canvas with a second inscribed square with vertices at the midpoint, a rotary move-

[1] *Archivi*, I, Boccioni to Severini (Summer 1912), 246. He also asked for 'that publication which they sold at the door of the Indépendants and which they ought to give you . . . at the Clauserie del Lilla [sic]'. Was he referring to the catalogue of the Salon or possibly to Gleizes and Metzinger's *Du Cubisme*? Severini, *Tutta la vita*, 157, mentions bringing his 'two dancers . . . a self-portrait' with him to Italy (probably Pls. 90–92).

[2] Cf. Marinetti, *Le Futurisme*; reprinted in *Guerra sola igiene del mondo*, 104: 'Con noi comincia il regno dell'uomo dalle radici tagliate, dell'uomo moltiplicato che si mescola col ferro, si nutre di elettricità e non comprende più altro che la voluttà del pericolo e l'eroismo quotidiano. Cf. Romains' image, 'Je me sens à cheval sur des forces'. *La Vie unanime* (Paris, 1908), 30.

ment is suggested, which the lines and bright colours keep going. This flexibility heightens the joyous, youthful quality of *Elasticità* and the ideals which it conveys.[1]

The frequent accusations of cinematographic inspiration then levelled against the Futurists may have helped to direct Boccioni towards the more synthetic rendering of dynamism shown in *Elasticità*.[2] In Boccioni's case, this involved no radical change of principles. The lines of force, as conceived by him, were from the beginning a synthetic concept and precociously employed in the last version of *Stati d'animo*. In *Elasticità* they have become an animated overall arabesque, whose efficacy as a visual symbol expressive of motion has been strengthened by Boccioni's more rigorously analytical studies of physical objects such as *Materia* or *Costruzione orizzontale*.

Carrà did not lag behind in evolving a more synthetic statement of rapid motion, as can be seen in *Forze centrifugale*[3] (Centrifugal Forces) (Pls. 118, 119). This was probably painted in the autumn of 1912, but survives only in a 1959 copy. Like Boccioni's *Elasticità* its subject is also a favourite early theme – that of *fiacres*. The interweaving of cabs, horses, and people is enormously speeded up, but the centrifugal force is not nearly so prominent as the picture's title would suggest. Rather, the painting's taut arrangement resembles some of Braque's or Picasso's still lifes or portraits of 1909–10, in which the complex conglomerations of planes in the upper centre of the composition, ebb and unravel as they reach the lower area. Carrà expressed himself more abstractly than Boccioni, interspersing only a few isolated representational fragments and reducing most of the objects to quite regular, generally flat geometric planes. His quasi-Cubist use of subject matter merely as a formal point of departure was carried still further in the elegant *Ritmi di oggetti* (Rhythms of Objects) (Pl. 120).[4] As on previous occasions, Carrà's very concessions to Cubism imply a personal and Futurist criticism of it. While accepting the still life – the classic testing stone of 'pure art' and the Cubists' objective stand-by – in *Ritmi di oggetti* he challenged the French artists by setting this standard subject in motion to convey the omnipresence of universal dynamism.

[1] A related drawing (Pl. 117), is frequently reproduced sideways because of the signature placed there. Although the signature may not be authentic, the drawing is formally coherent from both sides and suggests that Boccioni may have thought of a design which would be meaningful from more than one side. At this time Picasso is said to have put his signature on whichever side seemed most satisfactory to him.

[2] Boccioni countered such attacks especially in two *Lacerba* articles, 'Fondamento plastico della scultura e pittura futuriste' and 'Il Dinamismo futurista e la pittura francese', I (15 Maggio, 1 Agosto 1913), reprinted *Archivi*, I, 144, 167. Severini's definition of dynamism given in the introduction to his Marlborough Gallery Catalogue is also directed against these accusations; *Archivi*, I, 115.

[3] *Forze centrifughe*. It is dated 1912 in Boccioni's *Pittura scultura futuriste*.

[4] The painting has a later signature and a date of 1911. It was first shown at the February 1913 exhibition in Rome, and could not have been painted much before summer or autumn 1912.

When Roberto Longhi saw this painting hung with *Galleria di Milano* and *Velocità scompone il cavallo* at the historic Futurist exhibition in Rome in 1913, he was impressed by the evolution which the trio demonstrated. In his review for *La Voce* he remarked upon Carrà's growth from the 'Cubism' of *Galleria* to 'a succession of separate static moments of the subject' in *Velocità*, until, in *Ritmi di oggetti* 'he . . . succeeded in representing movement . . . [by] availing himself of the luminous elements dear to him from earlier works . . . thereby giving the linear arabesque a general effect of rotation'.[1]

Ritmi di oggetti fully exemplifies Carrà's new synthetic approach to 'the style of motion', which he defined in the spring of 1913 as 'a language, a handwriting of bodies in space . . . an expansion of bodies as plastic forces . . . [giving the] sense of *perpetual mobility* which is appropriate to everything that lives'.[2]

1913. Some Masterpieces

In the early months of 1913 Carrà and Boccioni were occupied with verbal distinctions between Cubism and Futurism in reply to Soffici's vigorous pronouncements in his 'Cubismo e oltre' articles. At the same time they were also testing his aesthetic principles in their art.

Carrà tried them out in two quite dissimilar pictures – *Donna + bottiglia + casa (Espansione sferica nello spazio)* (Woman + Bottle + House (Spherical Expansion in Space))[3] and *Simultaneità* (Simultaneity)[4] (Pls. 121, 122). Both searched for an artistic vocabulary with which to do justice (if very differently) to Soffici's chief premise – the solidity of the objective world – and both had as subject the female nude. This indicated not only that to Carrà subject matter was unimportant in itself, but also that the Futurist prohibition of the nude mattered little to him now. In *Donna + bottiglia + casa* Carrà made a completely unabashed move towards Cubism even down to the use of an oval frame. This splendid analytical composition, with its carefully worked out interrelationships of objects and spaces, could compete with Picasso's and Braque's works of 1911. It also showed an unmistakable kinship with Soffici's

[1] 'I Pittori futuristi', *La Voce*, v no. 15 (10 Aprile 1913), 1053.

[2] 'Piani plastici come espansione sferica nello spazio', *Lacerba*, I no. 6 (15 Marzo 1913), 54; reprinted *Archivi*, I, 147, 146. Of the paintings discussed above all, save possibly *Costruzione orizzontale*, were shown in Rome, 1913, and all, save *Materia*, were shown in Rotterdam, 1913.

[3] *Donna + casa + bottiglia come espansione plastica nello spazio*. The painting is lost.

[4] *Ragazza alla finestra, Donna al balcone*. The painting now bears a date of 1912, but in Boccioni's *Pittura scultura futuriste* it and *Donna + bottiglia + casa* are dated 1913. *Simultaneità* was apparently shown for the first time at the Berlin September 1913 Herbstsalon, *Donna + bottiglia + casa* is listed for the first time in the November–January 1913–14 exhibition in Florence.

art, for example, with *Scomposizione dei piani d'un lume* (Decomposition of the Planes of a Lamp) (Pl. 135), which Carrà much admired and which Marinetti purchased at his urging.[1] Though Carrà's canvas was more daring and advanced, it shared with Soffici's an architectonic approach and sobriety. It was at about this time that Carrà became aware of his great personal and intellectual agreement with the Florentines, admitting in a letter to Soffici that 'before knowing you and Papini . . . I had not heard such warm and affectionate voices. To tell you the truth, I felt a bit alienated.'[2]

While airing his personal sentiments and his Cubist leanings, Carrà was at the same time ready to challenge Cubism once more, which in a sense he did in *Simultaneità* (Pl. 122). Almost point for point each distinguishing characteristic of *Donna + bottiglia + casa* was denied in *Simultaneità*. Instead of the abstract, static, and planar quality of the former, he reintroduced a strongly three-dimensional and vital opposition of representational and abstract forms, omitting almost all verticals and subordinating the horizontals to dynamic curves and oblique lines. The painting's crispness and clarity were the result of Carrà's expressed wish 'to combat in myself the *tendency toward tenebrism* as a necessity for the study of solidity . . . I tried to achieve in the colouristic construction the solidity of certain light marbles and of certain white and ambered bones.' Indeed this robust nude, painted limpidly in 'a general tone scale of rose-silver-mother-of-pearl',[3] turns her sensuously curved back to the spectator and beckons him unmistakably into the picture. However, he is discouraged almost in the same moment by becoming aware of the sculptural hardness of her body and of her tight and airless surroundings.

Simultaneità is without doubt one of Carrà's finest surviving Futurist works. It maintains a perfect balance – often tantalizingly close to contradiction – between the intellect and the senses, between a solid, stable conception of form and the suggestion of actual or potential movement, between a painterly and a sculptural approach, between Cubist refinement and Futurist boisterousness – in sum, between Cubism and Futurism themselves. This painting, with its enticing ambiguities, illustrates the conflicting interests in Carrà's mind and foreshadows the enigmatic qualities of his *pittura metafisica*.

Boccioni's art likewise fell briefly but strongly under the spell of Cubism in late 1912 and early 1913. As will be seen in the next chapter, this was at least partly due to his struggles with sculpture. In his examination of solid form he was not drawn to

[1] *Archivi*, I, Carrà to Soffici (2 Maggio, 15 Giugno 1913), 265, 273. Soffici's painting was shown in Rome in February 1913.

[2] *Archivi*, I, Carrà to Soffici (20 Maggio 1913), 268.

[3] *Archivi*, I, Carrà to Soffici (15 Giugno, 24 Aprile 1913), 274, 263.

hermetic Cubism like Carrà, but seems to have been struck by Picasso's post-scripts to *Les Demoiselles d'Avignon*, by his sculptural paintings reflecting African art and by some of the analytical works of 1909, including possibly the bronze *Head*. *Antigrazioso* (Anti-Graceful) (Pl. 123), probably of 1912–13, testifies to these sources.[1] Thick impasto was slashed on in a manner recalling Cézanne's earlier work. Every-thing is firm and almost completely static. In contrast to much of his earlier work in which light played a wilful role, Boccioni now subjugated it to the sculptural forms of the figure, using it to reveal rather than to disintegrate intricate surface arrangements.

This Cubist interlude seems to have helped Boccioni to reach a climax with two representations of the human figure in motion, although they themselves make al-most no direct reference to Cubism. The first of these is the sculpture, *Forme uniche della continuità nello spazio* (to be discussed below); the other is the painting, *Dina-mismo di un footballer* (Dynamism of a Soccer Player)[2] (Pls. 165, 124). The latter, which he apparently laboured on during most of 1913 and enlarged on all four sides, must have paralleled the evolution of his striding sculptured figures of 1912–13.

If *Dinamismo di un footballer* is compared with *Elasticità* the increased maturity and the climactic quality of the more recent painting are strikingly evident. *Elasticità*, in spite of its great formal strength and control, still drew its meaning from a non-plastic source – the literary ideal of modern man's domination of the world. In *Footballer*, too, subject matter is significant – idealizing the exertion of sport, another of Marinetti's heroic themes[3] – but this painting was far more abstractly conceived, and therefore represented a powerful 'plastic analogue' of the original idea.

Dinamismo di un footballer shows especially clearly how the Impressionist concept of the object as a nucleus of coloured vibrations was enlarged by the Futurists into something like a 'field theory of aesthetic space', as Banham has described it.[4] Boccioni explains this point even more clearly than Carrà: 'We conceive . . . the object as a nucleus (centripetal construction) from which the forces (force-lines-forms) which define it in the ambience (centrifugal construction) depart, and thus determine

[1] Dated 1912 in Boccioni's book. It was exhibited at Rotterdam, May–June 1913.

[2] Exhibited London, 1914, San Francisco, 1915. The lozenge-shaped parts of the body are reminiscent of Picasso's 1907–8 figures.

[3] See references in Marinetti's Technical Manifesto of Literature and *L'Immaginazione senza fili*. Gleizes exhibited a *Football Player* at the 1913 Herbstsalon and Delaunay *L'Equipe de Cardiff* at *Der Sturm*, January–February 1913.

[4] Reyner Banham, *Theory and Design in the First Machine Age* (New York, 1960), 112: 'a space which exists as a field of force or influence radiating from the geometrical centre of the objects which give rise to it'.

its essential character.'[1] In the painting there is an inward-turning spiral – suggestive of the figure's mainspring of energy – which begins with the pointed, wing-like hand on the left, passes the head, the left thigh, and ends in the region of the groin (the geometric centre), to which the downward passage of the left light calls attention. This motion is immediately countered by the three major, slightly angular arcs which emerge from this core. They describe the progressive extension of the smoothly interlocking members of the athlete's body into the environment. The effect of the *Footballer* is much more sculptural than in *Elasticità*, and the line, used so much for expressive purposes in the earlier work, is relied on much less, having been replaced by 'forms of force'. The bright, translucent colours and the calculated use of light help both to retard and to intensify the suggestion of disintegration of form through motion by heightening or destroying the effects of solidity. The luminous blue wedges of 'sky' cut right through the player, making his steely limbs apparently weightless; they seem to lift him into the air where he spins and hurtles, his barely visible head protected by powerful shoulder blades.

Boccioni chose a square canvas for this painting,[2] but one wonders why he did not use a round or even a curved one. Having abandoned traditional means of representing light and depth, he was trying to express at least tentatively an endless curved space in which the artist was 'the centre of spherical currents which entwine him from all sides'.[3] With this pseudo-Riemannian spatial concept the stage-like distance and finite associations of Renaissance space were set aside, and communication with the spectator greatly intensified.

Second Half of 1913: *The Antigrazioso*

In such highly finished productions as *Simultaneità* and *Dinamismo di un footballer*, Boccioni and Carrà came uncomfortably close to the ease and perfection of the old masters and their imitators whom they had vehemently rejected. The *grazioso* (graceful, gracious) ideal of the past seemed to have been on the verge of overwhelming the iconoclastic Futurist *antigrazioso*.[4] With the spartan courage advocated by their movement, they tried once again to forget and undo their achievements of

[1] Boccioni, *Estetica*, 66.

[2] In *Selciatori* and *Elasticità* Boccioni seems to have begun to think of the shape of the canvas as a dynamic ingredient in the work, anticipating the diamond-shaped canvases of Severini (1915), Mondrian, Van Doesburg and the 'shaped canvases' of the 1960s. See Pl. XV.

[3] Boccioni, *Estetica*, 151 and ff.

[4] Boccioni equated *antigrazioso* with barbaric force: 'Noi italiani abbiamo bisogno del barbaro per rinnovarci ... Noi dobbiamo sconquassare, atterrare e distruggere la nostra tradizionale armonia che ci fa cadere in un "grazioso" ... Noi neghiamo il passato perche vogliamo dimenticare e dimenticare in arte vuol dire rinnovarsi'. *Lacerba*, I no. 6 (15 Marzo 1913), 51; reprinted *Archivi*, I, 142–3.

the preceding months so as to be able to rediscover the new, even if this meant that 'the fire we carry within us will end by burning us up'.[1] On a less exalted plane the move towards a new form of violent self-expression which began roughly in the summer of 1913 indicated, especially in Carrà, the desire to 'leave classicism behind',[2] as he put it in a letter. More specifically, it meant the reassertion of expressionist tendencies in Futurism over the Cubist principles with which Boccioni and Carrà had been struggling. Marinetti's *parole in libertà, immaginazione senza fili* and Russolo's new barbarism – the art of noises – showed the way. To these, it will be remembered, Carrà added in August 1913 his own ecstatic vision of a 'total art', the painting of sounds, noises and smells, which extolled the *antigrazioso*.

Carrà's lost *Trascendenze plastiche* (Plastic Transcendencies) (Pl. 125),[3] painted probably during the late spring or summer of 1913, was a decisive step towards this new form of expression. Its composition is quite similar to Boccioni's *Footballer*, except that there is no easily recognizable trace of conventional reality. Working from the only surviving source – the old photographs – it is hard to guess what it represented; it might have been based on a still life or a dancer. Although this painting is as lucidly organized as *Simultaneità*, Carrà avoided all those elements which in the earlier painting still produced a relatively stable effect.

The full force of his new departure was manifested in a series of drawings which may be dated to the second half of 1913 (Pls. 126–8).[4] Many of these are executed in dark and heavy ink wash which helps to bring out the desired brutality and is well suited to the frequent theme of a boxer. *1° Scarabocchio espressivo – SIMULTA-NEITÀ D'UN GIOCATTOLO* (1st Expressive Scrawl – Simultaneity of a Toy) (Pl. 128), reproduced in *Lacerba* in January 1914,[5] by its title and approach demonstrates the sarcastic violence of his intentions, discussed in a contemporary letter to Soffici: 'It is necessary . . . to publish in *Lacerba* drawings which go as far as the sensitized scrawl – We must conquer the academic stupidity of drawing. Just lately I have made one of these sensitized scrawls – It pleases me much more than the other "drawings" which now look idiotically NICE to me. I feel a strong desire to vomit.'[6]

[1] Boccioni, *Estetica*, 193.

[2] *Archivi*, I, Carrà to Soffici (26 Luglio 1913), 280.

[3] Listed and illustrated in 1914 London catalogue and listed in 1914 Rome and 1915 San Francisco catalogues. Perhaps identical with *Plastische Emanation* of 1913 Herbstsalon catalogue.

[4] Pl. 127, like many other contemporary drawings, now bears a 1912 date. It was illustrated in *Lacerba*, I no. 19 (1 Ottobre 1913), 215.

[5] II no. 1 (1 Gennaio 1914), 9.

[6] *Archivi*, I, Carrà to Soffici (10 Novembre 1913), 301. This letter was in part a response to a refined xylograph by Soffici (illustrated in *Lacerba* I no. 21, 1 Novembre 1913), 243, which Carrà evidently found wanting.

Ironically, like most of these drawings, *Expressive Scrawl* retained underneath the controlled Cubist disposition of form, light and shade. It was not until the early summer of 1914 that Carrà was able to work out a satisfactory solution to his new aims, and once again he was helped by a study of Cubism.

In Boccioni too the change of approach made itself felt around the summer of 1913. But in his case the outcome was less unexpected: as on previous occasions, it was a sign that the emotional side of his vacillating artistic temperament was again in the ascendant. Still preoccupied with the search for a pictorial image of velocity, Boccioni now concentrated on the representation of a racing bicyclist. A series of drawings, which became progressively more abstract until only an ideograph remained, prepared for his *Dinamismo di un ciclista* (Dynamism of a Bicyclist) (Pls. 129–32).[1] He had applied in a novel and extreme manner the lesson of painterly boldness, learned from Picasso (and Cézanne) and tested in *Antigrazioso* (Pl. 123), with the result that *Dinamismo di un ciclista* is closer to German Expressionism than to Cubism. Indeed, one cannot miss the resemblance – colour and all – to Kandinsky's *Improvisations* and *Compositions*, some of which Boccioni had seen in Berlin in 1912.[2] Of course the Futurist extroverted frame of reference and Kandinsky's world-renouncing outlook put his and Boccioni's pictures into quite different classes. But the concern with a pre-vocal experience of the world was also present in Futurism – as is witnessed by the early Futurist concept of the painting of states of mind – and at this point it was again interpreted very subjectively. A comparison of the two 1913 *Dynamisms* – the *Footballer* and the *Bicyclist* – makes this change quite clear. In the first, a basically Impressionist though highly intellectualized approach dominates, and forms are defined by suggested action within a luminous, airy matrix. In the second, no external light to speak of exists apart from that generated and reflected by the pigments themselves, nor is there any suggestion of air. Life and meaning are created through the direct communication of the artist's perception in vehement strokes of colour on the two-dimensional surface.

Two oils of powerful nudes (Pls. 133, 134), probably of late 1913 or early 1914,[3] indicated that Boccioni did not allow the free and instinctive manner to gain the upper hand. Emotion is very much to the fore in these two paintings – underscored by the titles, *Ambiente emotivo di un nudo* (Emotional Ambient of a Nude), which were

[1] Exhibited Florence 1913–14, Rome, London, 1914, San Francisco, 1915.

[2] *Archivi*, I, Boccioni to Carrà – from Berlin – (after 12 Aprile 1912), 239. Boccioni had read Kandinsky's *Über das Geistige in der Kunst* (*Estetica*, 173–4), and had called on Nolde while in Berlin. (P. Selz, *Emil Nolde* (New York, 1963), 30).

[3] Pl. 133, *Dinamismo di un corpo umano*, is illustrated in Boccioni's book and dated 1913.

given to them or related works in 1914.[1] But Boccioni sought to control the expression of his feelings by forcing them to comply with the rational principles with which he had redefined *complementarismo dinamico*. These principles were all corollaries of his statement that 'Each form carries within itself the aspiration to complete itself with a complementary form . . . necessary to the integral expression of its temperament'.[2]

It is significant that during the second half of 1913 both Carrà and Boccioni reintroduced the term *pittura degli stati d'animo* into their writings and that the banished nude regained its place as an expressive vehicle. This indicated that the artists had now sufficient formal mastery of their dynamic vocabulary to feel that subject matter was as irrelevant to them as it was to the Cubists. With the difference – and this they pointed out from the beginning – that their vision concerned with motion was above all geared to significant spiritual revelation. 'Art does not seek to accumulate knowledge,' wrote Boccioni, 'the artistic emotion demands drama. The emotion in modern painting and sculpture sings of gravitation, displacement, the reciprocal attraction of forms, masses and colours, that is to say, *movement*, that is to say, interpretation of forces.'[3] The critique of Cubism implied by these statements is also demonstrated in Boccioni's two nudes, despite their distant relationship to Picasso's powerful Negro period. These two sculptural figures are giants who dwarf and almost overpower the spectator. They seem so large that only a close-up view is possible. Gone is the eagerness of *Elasticità*, the willed swiftness of the *Footballer*, and the untrammeled *élan* of the *Bicyclist*. These ominous, dark red beings move with an ineluctable rhythm and seem like grandiose personifications of churning dynamos. A *terribilità* which recalls Michelangelo, the artist who humbled Boccioni when he was still a beginner, had re-entered his work and with it also indications that Boccioni's Futurism had nearly run its course.

Ardengo Soffici

When the Futurists invited Ardengo Soffici to exhibit with them in Rome in February 1913, he was also holding a retrospective of his work since 1908 at *Der Sturm* in Berlin, where he shared the galleries with Delaunay. Thus by 1913 the Florentine critic, who had played such an important part in the lives of the Milanese artists, had reached maturity not only as a writer but also as a painter. In the short, youthfully pontifical 'Commentary on My Work', which appeared in *Der Sturm* in February

[1] Dr. Sprovieri, who arranged the 1914 exhibitions in Rome and Naples, told me in conversation that he originated these titles, but that he could no longer identify the pictures.

[2] Boccioni, *Estetica*, 145. Both the 1914 London and the 1915 San Francisco catalogues list a Boccioni painting entitled *Nude: Complementary Dynamism of Form: Colour*.

[3] Boccioni, *Estetica*, 73.

1913, he openly declared himself a follower of the Cubist 'school'. He expressed the hope that the 'intellectual history' of his paintings would reveal his contribution to the developments from Impressionism to Cubism which, he predicted, 'modern painting will have to carry on to the end'.[1]

Typical of Soffici's paintings exhibited in Rome and Berlin was the solidly executed *Scomposizione dei piani di un lume* (Decomposition of the Planes of a Lamp) (Pl. 135), admired not only by Carrà but also by Longhi, and cited as an excellent example of Cubism.[2] In it Soffici's background and orientation are well summarized: his muted colour, his firm lines, and his treatment of volume attest to his study of Cézanne, as well as of Gleizes', Metzinger's and even Picasso's adaptations of Cézanne.[3] Soffici's artistic knowledge was, however, supported by a fine pictorial intuition and a sensitivity to paint which saved this and other similar works from falling into an academic *pastiche*.

In *Linee e volumi di una strada* (Lines and Volumes of a Street) and *Sintesi di un paesaggio autunnale* (Synthesis of an Autumnal Landscape)[4] (Pls. 136, 137), both of 1913, his own, or rather the Futurists', criticisms of Cubism were taken into account. Soffici diminished the static quality of his work, and his treatment of the Tuscan land- and city-scape lost some of the Cézannesque severity. Especially in the city-scape, the brighter colour, the piercing spotlight, and the lettering introduce greater animation; but compared with the Futurists' city scenes his efforts appear mild and hesitant. In both canvases Soffici worked quite abstractly, but as a result some of the structural authority of the linear skeleton was lost, and it became an arbitrary and occasionally only decorative black line. Severini strongly criticized Soffici's work in a letter of September 1913, pointing out that the 'hazy black contour which separates the forms from each other harms their expansion, their reciprocal fusion, and forces them to be heavy and static in spite of themselves – That contour gives relief to the form, making it incisive and exalting it, but good-bye dynamism.'[5]

The lost *Ballo dei pederasti (Dinamismo plastico)* (Ball of the Pederasts (Plastic Dynamism)) (Pl. 139) of the latter part of 1913,[6] and his contemporary critical

[1] III nos. 146–7 (Februar 1913), 266.

[2] *La Voce*, V no. 15 (10 Aprile 1913), 1052.

[3] Cf. Pl. 138. See other illustrations of Soffici's early work in *Rete Mediterranea*, no. 1 (Marzo 1920), 41 and no. 2 (Giugno 1920), 181.

[4] *Paesaggio autunnale. Sintesi pittorica di un paesaggio d'autunno. Linee e volumi di una strada* was shown in Rotterdam, Florence (dated 1913 in catalogue), Rome and London. *Autumnal Landscape*, illustrated and dated 1913 in Boccioni's book, was first shown in Florence and then in Rome.

[5] *Archivi*, I, Severini to Soffici (27 Settembre 1913), 293.

[6] *Compenetrazione di piani plastici (Tarantella dei pederasti)*, *Simultaneous Dynamism of an Apache Ball*. It is illustrated and dated 1913 in Boccioni's book. Exhibited in Florence, Rome and London.

writing, show how far he had moved towards Futurism. The purposely shocking, ironic title was perhaps its most dynamic element. It may well allude to Marinetti's 1910 London Lyceum Club lecture in which he attacked the hypocritical treatment of Wilde in the face of the widespread, and to him laudatory, homosexuality among young Englishmen.[1] References are made to 'Ted', 'Loyd's' (sic), and other English words and names, as well as a large 'ENG' at the left centre. But the new (for Soffici) sensation of energy and even of loud disorder created by the staccato repetition of small lines and shapes owes much to Carrà and Severini, and the composition in two unstable diagonals is not unlike some of Villon's 1912 works. Most important, the writer in Soffici prompted him to exploit in this picture not only the visual and auditory possibilities of the letters and words, but their poetic function as *parole in libertà* as well. So far none of the other Futurist painters had dared to employ letters and words quite so freely and suggestively. Soffici's efforts in this direction probably initiated the development of the so-called *dipinto parolibero* (free-word painting) of 1914 and the more uninhibited typographical arrangements of the written *parole in libertà*. This is Soffici's most significant artistic contribution to Futurism.

With the *Ballo dei pederasti* and the formally related *Simultaneità di donna carretto strada* (Simultaneity of a Lady Pushcart Street) (Pl. 140), in which the influence of Carrà's late 1913 drawings is apparent, Soffici's Futurist experiments in painting came to an end. Although he continued to write and perfect Marinetti's *parole in libertà*[2] and between about 1914 and 1920 composed something like a postscript to Futurism – *Primi principi di una estetica futurista*[3] – his next move as a painter was in a quite different direction.

In the succeeding decades Soffici's dry brand of Cubo-Futurism of 1912–13 came to represent 'Futurism', as it was commonly regarded, much more than the authentic Futurism propagated by the original signatories of the painters' manifesto. Emulators found this superficial adaptation of both Cubism and Futurism easier to comprehend and imitate than the difficult work of the more deeply committed exponents of both movements.

[1] Published in *Le Futurisme*; reprinted in *Guerra sola igiene del mondo*, 72. Marinetti praised any mode of life which attacked bourgeois values. See Valentine de Saint Pont's *Manifesto futurista della lussuria* of 11 January 1913 (*Manifesti del futurismo*, 118 ff.) and Italo Tavolato's *Contro l'amóre sessuàle* (Firenze, 1913?) which is shown in the painting.

[2] Published as *BÏF§ZF + 18. Simultaneità e chimismi lirici* (Firenze 1915).

[3] First published in *La Voce* (1916) and reprinted in 1920 as a book in a somewhat augmented form. See *Archivi*, I, 557–89.

XIII

BOCCIONI'S SCULPTURE: 1912-13

PROBABLY more than three-quarters of Boccioni's sculptures have disappeared – a deplorable loss to Futurism. Of the eleven pieces listed in the catalogue when he made his début as a sculptor at the Galerie La Boétie in Paris in June 1913, only three remain: *Antigrazioso*, *Sviluppo di una bottiglia nello spazio* and *Forme uniche della continuità nello spazio* (Pls. 151, 154, 165). Only four sculptures in all have survived.[1] Boccioni's career as a sculptor was extremely short and equally intense. On 15 March 1912 he wrote to Vico Baer: 'At the moment I am obsessed by sculpture! I believe I have perceived [the way to] a complete renewal of this mummified art.'[2] One and a half years later, he described *Forme uniche* as 'my most recent . . . and most liberated work'.[3] It was to be his last major sculpture. He may have executed minor pieces after that, and in 1914 he projected new ideas on paper, but only the fragile *Costruzione dinamica di un galoppo: cavallo + casa* (Pl. 202) is known.

Boccioni's sculptural activity grew organically out of his experiences as a painter, and as such was entirely based on Futurist theory. Although this new expression was prompted by the Synthetic Cubism of Picasso and Braque, Boccioni's first efforts owe little directly to the Cubists, or for that matter to Medardo Rosso, who is sometimes said to have been an important influence. Rosso, duly and patriotically cited in the sculpture manifesto, had, of course, opened important new vistas to the Futurists in 1910, and his art and ideas had provided one of the chief sources of the painters' theories. But by 1912 his concepts were so completely integrated into Futurist art that it was no longer a matter of influence.

[1] The fate of Boccioni's sculptures is something of a mystery. It seems that after his death an irresponsible (envious?) artist friend threw them into the Naviglio in Milan. Only those survived which had been sold beforehand, or which Marinetti – according to his widow – managed to retrieve from the stream. Boccioni held two additional sculpture exhibitions after Paris: at Dr Sprovieri's Galleria Permanente Futurista in Rome, December–January 1913–14 (10 pieces listed in Boccioni's letter, *Archivi*, I, 308 and 12 in catalogue), and at the Galleria Gonnelli, Florence, March–April 1914 (catalogue identical with Roman one). *Sviluppo di una bottiglia nello spazio* (*mediante il colore*), listed in all three catalogues, and *Forme umane in movimento*, listed in the last two, seem never to have been photographed. A hitherto unknown head (wood) was shown at the 1960 Venice Biennale, and is illustrated in R. de Grada, *Boccioni. Il mito del moderno* (Milano, 1962), Pl. 76. It does not seem authentic.

[2] *Archivi*, II, 43.

[3] *Archivi*, I, Boccioni to Sprovieri (4 Settembre 1913), 287.

One of Boccioni's first pieces was a very ambitious assemblage, *Fusione di una testa e di una finestra* (Fusion of a Head and a Window)[1] (Pl. 141), which quite specifically carried out some of the demands of the sculpture manifesto. In a broader sense it was an elaboration of such 1911 paintings as *Studio di donna fra le case* or *Visioni simultanee* and, more specifically, of a 1910 portrait, *Controluce* (Counterlight) (Pls. 74, 80, 142). Boccioni conceived of sculpture primarily as an aggregate of elements which coincide to create a new aesthetic whole. The figure, as in *Controluce* and related preparatory drawings (Pls. 143, 144), is seen standing against a window through which light floods into the room and is now merged with and crowned by the cross shape of the window frame; powerful rays of light obscure and divide her face, shown from both front and side. As in the 1911 paintings, light has a specific shape, here reminiscent of the gold rays used by baroque sculptors, who likewise sought to stabilize and control as far as possible the effects of external illumination.[2] The manifesto had recommended the introduction of actual architectural elements to obtain the much-desired structural quality. Apart from making straight lines predominate, Boccioni rather naively included a miniature house, window-moulding with a real metal catch, and diagonally cut glass window-panes. This enumeration of objects simultaneously perceived was completed by a braided bun of apparently real hair, and finally the diagonally revolving form at the right representing the woman's shoulder and obviously introduced for its curvilinear rhythm. Yet in spite of the ingenuity of Boccioni's idea and method, the bold details of this abstract formation do not quite overcome the self-consciousness of the finished piece.

The formidable *Testa + casa + luce* (Head + House + Light) (Pls. 145–6),[3] although also somewhat tentative, had greater unity, and in this respect recalls *Costruzione orizzontale* (Pl. 114), with its calculated order. Boccioni accomplished this in *Testa + casa + luce* by limiting the variety of materials and by a more lively sculptural manner. He had probably found that many different materials were harder to control in practice than in theory and so confined himself to one dominant texture in the central bulk of the sculpture, reserving others for peripheral details such as the balcony railing, moulding and pointed sticks extending from the building at the top.

[1] Probably identical with *Compénétration de tête, fenêtre et lumière* in 1913 Rotterdam catalogue. Dated 1911 in his *Pittura scultura futuriste*, but it seems more likely that it was executed in the spring 1912. The dates and chronology of Boccioni's sculpture are problematical, and the sequence suggested here is tentative.

[2] The religious note introduced by the window cross and the triangular, halo-like window-pane is reminiscent of *Materia* (Pl. 113).

[3] Dated 1911 in Boccioni's book. Probably not actually executed until spring 1912. The two photographs shown here seem to represent different experimental stages.

These projecting elements, which open the figure still more to the surroundings, also counteract the massive weight of the central form.

Boccioni had begun to get the feeling of sculpture and its possibilities. At the same time, or only slightly later, he tested this new understanding on a more universal image, *Sintesi del dinamismo umano* (Synthesis of Human Dynamism)[1] (Pls. 147-8), the first of his full-length striding figures. He seems to have had in mind the example of the *Victory of Samothrace* (of which there was a cast in the Brera), as well as Rodin's *Balzac, St John the Baptist Preaching*[2] (Pls. 150, 149), and Meštrović's or Bourdelle's bulgingly-muscled males. Possibly the conceptualized, trimly delineated forms of motion in Severini's dancers also helped Boccioni to depict the human body in action. The multiple calves and feet resemble the legs of Severini's *White Dancer* (Pl. 90), but the total sculptured effect of the web of motion connecting these force-lines is also quite like the animated and delicately modelled drapery which clings to the legs of the *Victory of Samothrace*. Boccioni's figure gives the impression of advancing at a relatively slow, stately pace. It becomes gradually heavier towards the top, very much like the majestic *Balzac*, whose *contrapposto* is similarly extended into a complex and massive climax. However, whereas in the Balzac this is the proud head, Boccioni extended his important secondary rhythms to the entire figure, and the head, with its table or tower, is only a complement. This is, after all, not the portrait of a great artist, but another embodiment of the Futurist superman, whose insignificant face, like that of Marinetti's hero Gazumrah, the son of Mafarka the Futurist, lacks 'ideal harmony'.[3]

This first figure undoubtedly had a certain grandeur, but its unwieldy and rather literal effect diminished the one quality which Boccioni wanted to express above all else – a sense of life. At this time he became very anxious about his sculpture; in a moment of self-doubt in the summer or autumn of 1912, he wrote to Severini: 'I work much but seem to conclude nothing . . . Today I have worked six consecutive hours on sculpture and I do not understand the result . . . Planes upon planes, sections of the muscles and of the face and then? And what about the total effect? Does what I create live? Where is it going to finish? Can I ask enthusiasm and comprehension from others when I myself wonder about the emotion which springs from what I am doing. Enough, there always is a revolver.'[4]

Further progress on these ambitious symbols of mankind was dependent upon the

[1] Dated 1912 in Boccioni's book.

[2] Rodin's sculpture was to be seen at the Roman International Exhibition of 1911, and in February 1912 a bronze cast of *The Walking Man* was given to the French Embassy in Rome where it was set up amid much publicity. A. E. Elsen, *Rodin* (New York, 1963), 173-4, 212. Boccioni mentions Rodin's *Balzac* and *Burghers of Calais* in his sculpture manifesto.

[3] *Mafarka il futurista*, 301. [4] *Archivi*, I, 248.

results of some more modest projects, in which Boccioni made exacting studies of the two types of motion which he considered to be the interacting (and actually inseparable) components of dynamism: '*moto assoluto*' (absolute motion) and '*moto relativo*' (relative motion). The two kinds of movement represent different aspects of the perception of objects in space. Boccioni regarded 'absolute motion' as the expressive 'plastic potential of the object itself, strictly bound to its own organic substance . . . [its] porousness, . . . rigidity, . . . colour, temperature . . . form: (planear, concave, . . . &c.) . . . the breath and heartbeat of the object'. The second type, 'relative motion', was the ceaselessly changing relationship between the object and its environment, which took the rapidly overlapping succession of perceptions and the speed of modern life into account. It was therefore geared towards the discovery of a new form, which would 'express that new absolute: *velocity* which the truly modern temperament cannot disregard'.[1] While carrying out these experiments in the next months, Boccioni became increasingly aware 'that the problem of dynamism in sculpture does not derive . . . solely from the diversity of materials but principally from the interpretation of form'.[2] His trip to Paris in November 1912,[3] during which he was again exposed to the austerities of Cubist painting, may have further encouraged him in the use of simpler materials, which he had already begun to work with in the summer. After his return he seems to have worked exclusively in plaster, and suggestions of various surrounding textures were greatly reduced and intimately integrated with the total formal concept.

One of the first works to show the change was the powerful portrait of Signora Boccioni (Pl. 151), entitled *Antigrazioso* like the painting (Pl. 123) because of the unflattering, anti-academic approach. It may have been begun before Boccioni's visit to France, and to a certain extent still relied upon the sculptural principles of *Testa + casa + luce*, with its piling up of forms seen from numerous angles. The greater spontaneity of *Antigrazioso* indicated a far deeper awareness of three-dimensional forms and of their evolutionary possibilities resulting from absolute and relative motions. Although Boccioni may have received some guiding suggestions from Picasso's *Woman's Head* of 1909 (Pl. 152), that once revolutionary piece looks classically calm and gracious compared with the Futurist's explosive portrayal. The vitality of the artist's mother appears to conquer the solidity and inertness of the material and – as in *Materia* (Pl. 113) – forces it to bear the changing imprints of her states of mind. The subtlety

[1] Boccioni, *Estetica*, 105–13.
[2] Galleria Gonnelli, *Esposizione di scultura futurista del pittore e scultore futurista U. Boccioni* (Firenze, 1914), Prefazione; reprinted *Archivi*, I, 118. The same preface was used in all three sculpture shows.
[3] *Archivi*, II, Boccioni to Baer (9 Novembre 1912), 46.

with which these rapid shifts of mood and position are shown – by means of variations and contrasts of precise and soft modelling, deep and shallow openings, etc. – points to an astounding technical fluidity and proves Boccioni's extraordinary sculptural talent.[1]

Boccioni examined sculptural form even more rigorously in a very objective restatement of the same theme, *Vuoti e pieni astratti di una testa* (Abstract Voids and Solids of a Head) (Pl. 153) of late 1912 or early 1913.[2] In this relatively static representation Boccioni thought almost exclusively in terms of the basic language of the sculptor, which Rodin picturesquely described as consisting of 'bumps and depressions'. Boccioni came very close to a Cubist portrait in his intelligent and witty substitution of convex for concave forms and vice versa. Although the result is lighthearted and humorous, Boccioni's procedure was deliberate and was explained in his preface to the 1913 Paris catalogue: by abolishing 'existing distances, as for example between a figure and a house 200 metres away, we shall have . . . the prolongation of a body in the ray of light which strikes it and the entrance of a *void* into the *solid* which passes through it. I achieve this by uniting *blocks of atmosphere* with the most concrete elements of reality. Thus, if a spherical skull (plastic equivalent of a head) is traversed by the façade of a house, the interrupted semi-circle and the square of the façade which interrupts it form a new figure.'[3] Boccioni may have benefited from Brancusi's or Archipenko's uncluttered forms stripped to their essentials, but *Vuoti e pieni astratti* must be regarded as a key work in the development of Cubist sculpture as well as in Boccioni's own *oeuvre*. So far no other sculptor had been able to translate the essentially two-dimensional Cubist experiments into three dimensions. Yet Boccioni's head was a relief and basically pictorial; he therefore went on and applied his knowledge to an object in the round in *Sviluppo di una bottiglia nello spazio* (Natura morta) (Development of a Bottle in Space (Still Life)) (Pl. 154), also of late 1912 or early 1913.[4]

To Boccioni as to Carrà, then at work on *Ritmi di oggetti* (Pl. 120), the still life must have posed the problem of the dynamic interaction of absolute and relative motion in the most fundamental and no doubt most difficult form. But both artists achieved incontrovertibly Futurist results, foreshadowed in Boccioni's case by the still life in

[1] M. S. Barr, *Medardo Rosso*, 63, and note 111, has called attention to Boccioni's and Picasso's asymmetrical handling of the human features, which seems to be a development of the ideas of Rosso and other late nineteenth-century artists.

[2] Dated 1912 in Boccioni's book. This favourite theme is treated quite similarly in the painting *Testa + luce + ambiente*, datable 1913, illustrated *Archivi*, II, no. 384, 244.

[3] *Archivi*, I, 120.

[4] *Sviluppo di una bottiglia nello spazio* (*mediante la forma*) (*Natura Morta*). Dated 1912 in Boccioni's book. Boccioni always added 'Natura morta' after the title; was this an ironic designation?

Visioni simultanee (Pl. 80). A drawing probably related to the sculpture (Pl. 155)[1] clearly demonstrates how Boccioni arrived at deformations and displacements resulting from the potential and actual 'plastic thrusts' of the bottle and table, deduced in part by suggested changes in vantage point. *Sviluppo di una bottiglia nello spazio*, like *Dinamismo di un footballer*, is a lucid and provocative statement of the Futurist concept of the object as a nucleus of radiating forces which define its aesthetic space. Considered as a stage in Boccioni's artistic growth, it indicated that in sculpture as in painting he was developing an increasingly synthetic mode of representing motion by means of 'a sign, or better a unique form, that substitutes for the old concept of division, the new concept of continuity'.[2] As a composition *Sviluppo di una bottiglia* has unprecedented lyrical and architectural power, stemming from its delicate reconciliation of levels and densities. These range from the rapidly curving and elliptical forms to the 'slower' angular, tilting, and horizontal elements, skilfully emphasized by the interplay of concave and convex which suggest inside and outside views and their combinations. Boccioni's early training at the technical school seems to have aided him once again, because the little bottle is as interesting in groundplan and sections as in its revolving elevation. Some of Sant'Elia's architectural ideas may well have been inspired by this work.

Boccioni returned to the bottle motif twice more, but only *Forme-forze di una bottiglia* (*Natura morta*) (Forms of Force of a Bottle) (Pl. 156) is known from photographs.[3] In comparison to this writhing, self-willed construction – now beyond doubt a *natura vivente* and truly the 'dynamism' of a bottle – *Sviluppo di una bottiglia nello spazio* looks heavy and timid. As *Forme-forze di una bottiglia* opens out and twists upwards, it loses almost all suggestion of its specific material presence and becomes a vehicle for the plastic interpretation of its transcendent aspirations, very much as Gaudí's chimneys and ventilators on top of Casa Mila (Pl. 157) manage to symbolize the upward course and airy dispersal of their contents. Salvador Dali once said half facetiously, but with great perception, that Boccioni would have been one of the few artists capable of completing Gaudí's Sagrada Familia.[4] Boccioni's sculpture was

[1] It is also reminiscent of and contemporary with the bottle in *Scomposizione di figure a tavola*, *Archivi*, II, no. 375, 241.

[2] Boccioni, 'Fondamento plastico della scultura e pittura futuriste', *Lacerba*, I no. 6 (15 Marzo 1913), 52; reprinted *Archivi*, I, 144. Cf. Lucini, 'Art . . . represent the series of movements synthetically in an entirely new . . . vibrant line . . . The schematic result is . . . a strange . . . continuous figure, which has not been seen before'; excerpt in Baumgarth, *Geschichte des Futurismus*, 165.

[3] The unknown one was called *Sviluppo di una bottiglia nello spazio* (*mediante il colore*) (*Natura morta*).

[4] Oral report to the author of Dali's lecture at the Museum of Modern Art, New York, on the occasion of the Gaudí Exhibition, 1958. Gaudí's work, shown at the 1910 Salon of the Societé Nationale des Beaux-Arts, Paris, was discussed in *Vita d'arte*, v no. 25 (Gennaio, 1910), 25–33.

certainly distinguished by a similar feeling for the organically monumental. All of his pieces, but especially the bottles and above all *Vuoti e pieni astratti*, became guide posts to sculptors such as Duchamp-Villon, Archipenko, Laurens, Lipchitz, Epstein, Gabo, Pevsner, and possibly even Picasso, whose subsequent work in one way or another reflected Boccioni's influence.[1]

The Three Striding Figures: Unique Form of Velocity

In *Muscoli in velocità*, *Espansione spiralica di muscoli in movimento*, and *Forme uniche della continuità nello spazio* (Pls. 162, 163, 165) Boccioni made monumental all his discoveries about the rendering of dynamism – 'the synthesis of transformations which the object undergoes in its two motions, relative and absolute'.[2] The three striding figures seem to have been executed during the first five months of 1913 and reveal a much bolder and more abstract interpretation of the 'unique form of motion' than was found in Boccioni's earlier, exploratory *Sintesi del dinamismo umano* (Pl. 147). Again Rodin's figures, notably *The Walking Man* (Pl. 164), seem to have affected Boccioni's approach, and this is particularly evident in the pose (including the fragmented arms) of *Espansione spiralica*. The older sculptor's conception of movement, explained by him as 'the transition from one pose to another . . . a metamorphosis . . . [showing] a part of what was and . . . a part of what is to be',[3] may well have supported Boccioni's similarly directed efforts. This conception is shown in the large group of important drawings which accompanied his sculptures (Pls. 158–61).[4] In these Boccioni attempted either to 'hold fast human forms in movement', or to 'synthesize the unique forms of continuity in space';[5] in other words, to sharpen his command of line and form describing the event and its after-effect and anticipating the future sequence of the human body in motion.

Muscoli in velocità (Speeding Muscles)[6] and *Espansione spiralica* (Spiral Expansion) (Pls. 162–3), though formally related, convey the dynamic *élan* of their figures in

[1] For example, Duchamp-Villon's *The Horse*, 1914, Archipenko's *Boxing*, 1913, Laurens' Cubist reliefs, Lipchitz' Cubist sculpture beginning with *Sailor with Guitar*, 1914, Gris' *Torrero*, 1917, Epstein's *Rock Drill*, 1913, Gabo's and Pevsner's celluloid portraits after 1916, Picasso's *Glass of Absinthe*, 1914, etc.

[2] See above, p. 167, n. 1.

[3] Auguste Rodin, *Art* (from the French of Paul Gsell by Romilly Fedden, London, 1912), 69–70.

[4] See illustrations in J. C. Taylor, *The Graphic Work of Umberto Boccioni* (New York, 1961), nos. 233 ff. These nudes relate also to *Dinamismo di un footballer* and the nudes of late 1913 (Pls. 124, 133–4).

[5] Gonnelli Gallery, *Boccioni*.

The idea of metamorphosis may have been in Boccioni's mind when he sketched Pl. 161, suggesting a fleeing Daphne, perhaps inspired by Bernini's famous sculpture in the Borghese Gallery, Rome.

[6] *Muscles in Quick Motion* used in 1914 London and 1915 San Francisco exhibition catalogues.

quite different ways. The distinction is comparable in some respects to that between *Elasticità* and *Dinamismo di un footballer* (Pls. 116, 124). In *Espansione spiralica* a linear rhythm similar to that of the lines of force in *Elasticità* predominates. It is created by the irresistible upward spiralling of the sharp-edged contours which begin at the oval base and suggests the swift petal-like unfolding of the object in motion. In contrast to the rather delicate, Art Nouveau quality of this piece, *Muscoli in velocità* – like *Footballer* – gives the impression of overpowering physical force and will. Large salient shapes, the so-called 'forms of force',[1] supplement the composition's linear components, achieving a sense of great exertion. This is augmented by the vehement opposition of angular and curved motifs, which express the apparently conflicting impulses of weight and expansion, symbols to Boccioni of the conflict between matter and spirit. The theme of struggle is above all stated by the enormous tension between the broad stride and the narrower, but equally taut angle starting at the hips and produced by the forward motion of the upper body. These strained gestures, sustained by the formal build-up of the work, transform it into the 'architecture of emotion'[2] its author had in mind. Not everything about *Muscoli in velocità* is so strenuous. The elongated bunches of muscle readily respond to the stresses dictated by will and speed; they reveal another aspect of the 'forms of force' emphasized by Boccioni, namely, the great pliability and the potentiality of 'real form' from which it springs.[3]

With these two sculptures the climactic achievement of *Forme uniche della continuità nello spazio* (Unique Forms of Continuity in Space) (Pls. 165–7)[4] was prepared. In many ways, this final striding figure was a powerful synthesis of those preceding it, reconciling the flexibility and lightness of *Espansione spiralica* with the determination and force of *Muscoli in velocità*.[5] Thus the enormous stride was mitigated by a flame-like elongation of the thighs and calves, which could consequently support the proudly erect, but short, upper body without any loss of vitality. The strong torso welcomes and is constructed for strong air pressure; its powerful but open chest has a firm breast bone like that of a bird, which projects forwards and upwards as though to protect the head with a knob suggesting the hilt of a sword, or the mask of a fencer

[1] The concept, a corollary of 'lines of force' is mentioned for the first time in the preface to the Paris exhibition of 1913.

[2] Boccioni, *Estetica*, 181.

[3] Preface to sculpture exhibition catalogues, *Archivi*, I, 119.

[4] J. C. Taylor, *Futurism*, 143, no. 52, discusses different casts of this piece. While Boccioni was alive none of his plasters was cast in bronze.

[5] The Futurists, including Soffici, had a predilection for syllogisms, and perhaps Boccioni's creative process intuitively followed some such reasoning. See the syllogistic tables in his *Pittura scultura futuriste*, 62.

or motorcyclist. In this and other alterations of the human body to portray its adaptation to speed, there is a striking reminder of Marinetti's prediction of the 'non-human model' of the future, based on Lamarck's evolutionary hypothesis. This new, 'mechanical' being would be 'built to withstand an omnipresent speed . . . He will be endowed with unexpected organs adapted to the exigencies of continuous shocks . . . [There will be] a prow-like development of the projection of the breastbone which will increase in size as the future man becomes a better flyer.'[1]

Boccioni had created an expressive image of this new savage who was not to conflict with nature, but be in total harmony with its forces. The nobly alive body, constructed of concave and convex forms which visually suggest the effortless overlapping and merging of fire or water, also has the confident power of a gale of wind. *Forme uniche della continuità nello spazio* was perhaps the most exalted statement of the cathartic and resuscitative aims of Futurism, which demanded not only a new world with new values, but a new man as well. Artistically too, this was Boccioni's most resolved work. He once remarked that he regarded sculpture as a less intellectual medium than painting.[2] This attitude may well have liberated him to some extent and enabled him to strike a more suitable balance between his emotions and his intellect. Of those who saw Boccioni's sculpture at the Galerie La Boëtie in Paris in June 1913, perhaps only his admirer, the pianist-composer Ferruccio Busoni, intuitively understood its profound originality when he wrote to his wife a few days later: 'Compared to *this* art . . . Schönberg's *Pierrot Lunaire* is a tepid lemonade!'[3]

[1] *Guerra sola igiene del mondo*, 97–8.
[2] *Archivi*, ɪɪ, Boccioni to Baer (21 Giugno 1913), 48.
[3] Ferruccio Busoni, *Briefe an seine Frau* (Erlenbach-Zürich, Leipzig, 1935?), 279.

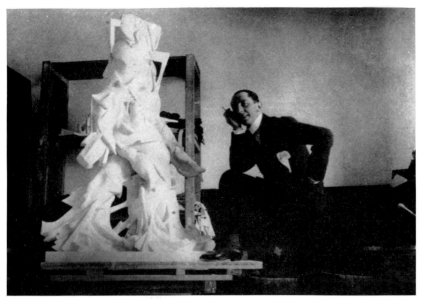

VI. Boccioni in his studio with *Sintesi del dinamismo umano.* (1913?)

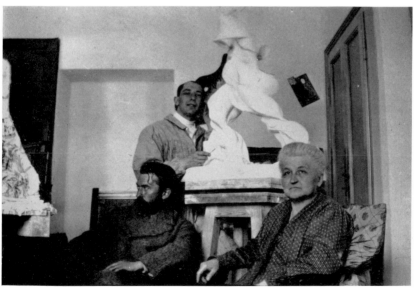

VII. Boccioni in his studio with *Espansione spiralica di muscoli in movimento.*
Seated: Signora Boccioni and Balla. (1913?)

XIV

GIACOMO BALLA: 1912–13

Balla's Work Before 1912

BALLA did not take any active part in the Futurist movement until February 1913, when he was included in the comprehensive exhibition at the Teatro Costanzi in Rome. Until then he had merely signed the artists' statements *in absentia*. The one painting by him listed in the Bernheim–Jeune catalogue – *Lampe électrique* – was mysteriously absent and was not shown until 1913. It is as difficult to determine why this picture was not exhibited as it is to discover the reasons for Balla's aloofness from the Futurist mainstream until 1912. Undoubtedly his family obligations and financial difficulties had something to do with it. In 1910 Boccioni reported to Severini that Balla, their friend and teacher, 'sells nothing and is obliged to give lessons and is almost starving'.[1] Necessity forced Balla to humour the jury and public of the 1911 World's Fair in Rome by submitting a very academic portrait. Even the conservative Vittorio Pica regarded this as too extreme a concession and regretted 'that a valiant *avant-garde* painter like Balla failed to understand how wrong it was for his good reputation to exhibit the wooden portrait of the mayor of Rome'.[2]

Lampe électrique of 1909[3] (Pl. 168), Balla's only surviving early Futurist painting, shows that he had continued to develop the bold ideas of his pre-Futurist work. This picture epitomizes the spirit of the movement's early phase, with its mixture of Art Nouveau forms and Divisionist technique. The island of brilliance inspired by one of the first electric street lights in Rome definitely outshines the palely romantic moon.[4] Poetically and modestly, though nonetheless pointedly, it might have specifically illustrated Marinetti's *Tuons le clair de lune* of spring 1909. In an effort to describe the vitality of the lighted atmosphere Balla markedly developed the Divisionist technique. Needle-sharp wedges of pairs of strokes weave a crystalline web in their keyhole-shaped domain which is bordered by the soft, amorphous depths of the surrounding night, suggested by a heavy mesh of black, dark blue and green lines.

[1] *Archivi*, I, Boccioni to Severini (after 1 August 1910), 232.
[2] *L'Arte mondiale a Roma nel 1911* (Bergamo, 1913), CLIV.
[3] *Lampada – Studio di luce, Lampada ad arca, Street Light*. Dated 1909.
[4] Reply to 1952 questionnaire sent to Balla by the Museum of Modern Art: 'This lamp was one of the first electric lamps installed in Rome in Piazza Termini during the first years of the 1900s, called by all unartistic and painted by me for the first time'.

First Studies of Motion. Trip to Düsseldorf

It was not until 1912 that Balla began to take the next significant steps. Once set on his course, he developed with amazing rapidity and originality, all the while only vaguely aware of his Futurist colleagues' activities.[1] The search for valid pictorial equivalents of motion was naturally his main concern, and with his extensive know-ledge of photography, the analytical depiction of successive stages of movement seemed the obvious approach. Never a pedant, in spite of his extreme patience and meticulousness, Balla soon found a subject for his new interests. It was the little dachshund belonging to his pupil, the Contessa Nerazzini, whom he visited in May in Montepulciano. Balla's pleasure at seeing the small dog scurrying along at its mistress's side inspired *Guinzaglio in moto* (Leash in Motion)[2] (Pl. 169), which he painted with a child-like purity that disguised the artistic refinements of his method.

Photography helped him like Degas,[3] to select unusual and dramatic angles of vision to convey a sense of continuity beyond the picture frame, and he therefore showed the animal from a very low viewpoint. This not only accentuates the amusing contrast in size and pace between owner and pet, but gives the spectator an intimate experience of a dog's (or a child's) view of the world as a gentle but perpetual pro-gression across a surface of unknown dimension. The carefully adjusted interplay of the sinuously elongated rhythms of the dog's body, the horizontal pattern of the woman's feet (complementary to the dog's back), and the diagonally rotating leash which repeats the dog's total shape, provides an easily grasped pictorial unity. These curving motions are set off by the slightly oblique and straight, but fleeting, lines of the pavement. Keeping colour contrast to a minimum and restricting strong value contrast to the figures against the background, Balla further brought out the un-relieved monotony of the dog's promenade.

Later in 1912, while staying in Düsseldorf with another friend and pupil, Balla used a similar technical approach for the more serious subject of a violinst – *Ritmi dell' archetto* (Rhythms of the Bow)[4] (Pl. 170). As his title implies, Balla, unlike Russolo and

[1] The only Futurist affair which he seems to have attended before then was Boccioni's Circolo Artistico Internazionale lecture in Rome, 29 May 1911.

[2] *Cane al guinzaglio; Dinamismo di un cane al guinzaglio.* Exhibited Rome, Rotterdam, Berlin, 1913.

[3] Cf. Degas' *Place de la Concorde*, Paris, c. 1873, illustrated J. Rewald, *History of Impressionism*, 264.

[4] *Dynamic Rhythm; Rhythm of the Violinist; Le Mani del violinista.* Probably autumn 1912. Exhibited Rome, Rotterdam, Berlin, 1913. His former student, Frau Grete Löwenstein, formerly of Düsseldorf (now of Ascona), with whom he stayed, has kindly supplied me with most of the information given here about his German experience. The late Herr Löwenstein, who was a lawyer and an ardent amateur violinist, served as model for this picture. Although Frau Löwenstein recalled only one trip to Germany, Balla seems to have made two, one during July and another in November 1912. *Ritmi dell'archetto* was probably painted on the second visit. See *Archivi*, II, 521 Corrigenda.

his other colleagues, was not concerned with an analogue of musical sound. Following his scientific turn of mind, he concentrated instead on the physical activity responsible for the sound. Balla thus attempted to evoke the effect of violin playing by showing the fingering left hand 'moving in different positions and inserted into the landscape of the continuously active bow', as he put it in a letter from Düsseldorf.[1] Mesmerized by these rhythmic motions and their reverberations, which appear to spread beyond the picture frame, the viewer is stimulated to add his own musical associations to suit his mood or temperament. The artist has encouraged this by omitting all other specific details of the violinist and by composing his picture so that the spectator becomes the performer through psychological and even suggested visual identification with the action.

Balla's German pupil and her husband had asked Balla to decorate their study with a frieze, which he apparently painted only in black and white. He may possibly have intended *Ritmi dell'archetto*, or some painting like it, as a part of the total decorative ensemble, for which he also designed the furniture.[2] This may explain the unusual shape of the painting and its frame (probably made by Balla himself), as well as the conspicuous architectural moulding in the upper area. This horizontal crossbar acts as a stabilizing foil to the frantic activity below and, by its smoothly receding edge, draws one into the picture. The shape of the painting also demonstrates Balla's search for meaningful formal equivalents to various effects of sound, motion, and light. In *Lampe électrique* he had emphasized the counter-gravitational appearance of light rays through a keyhole form which presses against the top and upper sides; now he sensed that another top-heavy shape – the inverted, truncated triangle – would express the rising and expanding flow of kinetic and auditory waves. The frame, forming upright triangles to the left and right, thus becomes less substantial towards the top and was for Balla, as for Seurat, a complement to the picture which it 'liberated not closed and oppressed'.[3]

In *Ritmi dell'archetto* Balla made much use of chiaroscuro, which was the basis of the muted palette he continued to use for several years. The colour and quality of

[1] Letter quoted in Raffaele Carrieri, *Il Futurismo* (Milano, 1961), 114.

[2] Information given in a 1958 letter from Frau Löwenstein. While the book was in press, Frau Löwenstein very graciously sent the hitherto unknown old photographs of the study – with its frieze of Rhine views – designed by Balla (Pls. VIII, IX). Pl. 171, called '*Studio d'arredamento per la casa Löwenstein a Düsseldorf* (1912)', in Torino, Galleria Civica d'Arte Moderna, *Giacomo Balla* (April 1963), on. 253, is thus definitely a later drawing. Balla designed stage sets from 1914 onwards as well as interiors including the almost breathtaking décor of his last apartment in via Oslavia, Rome, ill. *L'Illustrazione Italiana*, LXXXV no. 1 (Gennaio 1958), 59.

[3] Balla, paraphrased in Guglielmo Jannelli, 'futurballa', *Futurismo*, II no. 34 (30 Aprile 1933), 1. According to his daughter, Balla made most of his frames.

films or photographs may have suggested this technique and no doubt appealed to Balla because of its suitability for depicting the effects of motion.

Studies of Light

Balla did not, however, limit himself to chiaroscuro in representing motion. While at work on the violinist's hands, and perhaps because of some sort of stimulus received in Germany, he began to make elaborate studies of light, seen in terms of intricate harmonies of closely valued colour.[1] A letter and card addressed to his family from Düsseldorf were decorated with iridescent colour triangles held fast by a strict geometric framework. 'First enjoy a little bit of iridescence,' he wrote, 'because I am certain that you will like it; it is the result of an infinite number of trials and experiments and the pleasure it gives was finally found in its simplicity. The study which went into this work will bring about changes in my work, and the rainbow will be capable – through my observation of reality – of possessing and giving an infinity of colour sensations, etc. etc. . . .'[2] These important colour studies provided a basis for his post-1914 style and for that of the second generation of Futurists.

The first efforts, begun in Germany late in 1912, were subsequently expanded into a large series of studies called *Compenetrazioni iridescenti* (Iridescent Interpenetrations), exemplified by Pls. 172–4.[3] Variously shaped triangles and their compounds, either delicately or strongly hued, were dovetailed or hinged to one another through an endless variety of colour contrasts creating an illusion of movement on the surface plane. In his dedication to the colour riches of light Balla also captured some of its inexhaustible vitality, and in a way these studies anticipate Severini's more intellectually ambitious analogies of late 1913 and 1914. The similarity in principle of Balla's iridescences to Delaunay's prismatic *Fenêtres* series (Pl. 71a) is also obvious, although Balla's compositions are at once more ordered and more abstract. Delaunay's fame had begun to spread throughout Germany in 1912, mostly as a result of his association with the Munich *Der Blaue Reiter* group the preceding year. He had found a devoted disciple in one of its members, the Rhinelander August Macke, whom Delaunay

[1] These studies may originally have been an outcome of the decorative project. Ettore Colla, 'Pittura e scultura astratta di G. Balla', *Arti visive*, (Settembre–Ottobre 1952), probably the first to call attention to these after the Second World War, entitled them 'cartoni per affreschi'. Balla may have received some stimulation from Previati's extensive discussion and illustration of iridescent, geometric colour patterns seen when light traverses mica plates or pressed glass, which had been heated and quickly chilled. (*I Principii*, especially 71–2.)

[2] *Archivi*, I (November ? 1912), 255.

[3] *Penetrazione iridescente*. Balla painted a great many studies of this kind through 1914. One of these – no longer identifiable – was apparently shown in Rome, 1913.

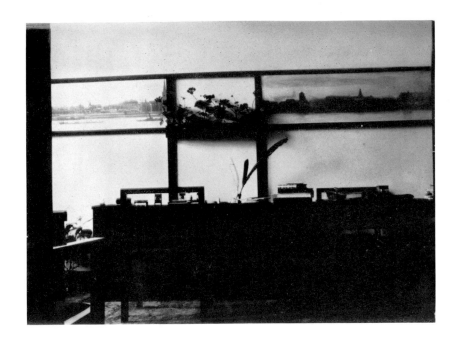

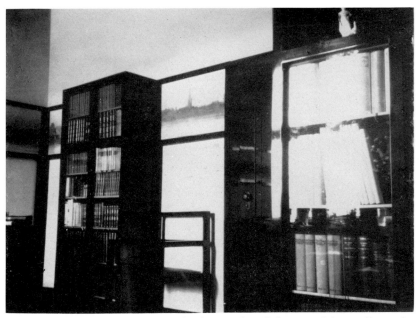

VIII–IX. Two views of the study designed and decorated by Balla in the
Löwenstein home, Düsseldorf. (1912)

even visited on the way to the opening of his exhibition at the *Der Sturm* gallery early in 1913. But it would be unwise to speculate too much about such possible connections. Balla saw the 1912 Cologne Sonderbund Exhibition at which *Der Blaue Reiter* and *Die Brücke* groups as well as Van Gogh, Cézanne, Munch, and many other modern European artists were represented. From his comments to his family about it he seems not to have been very much impressed.[1] But he undoubtedly heard discussions of the German Expressionists and their interest in symbolism of colour and form in the cultivated home of his hosts, who owned paintings by Christian Rohlfs and Fritz von Uhde.[2]

Studies of Light Plus Motion

In 1912 Balla still had no intention of developing a completely abstract art and *Bambina che corre al balcone* (Girl Running on the Balcony)[3] (Pl. 175), probably of the latter part of the year, partly fulfilled his aim of broadening his painting by combining his study of iridescences with observation from nature.[4] The breakdown of light into colour components is represented by a lively checkerboard pattern of large square or rectangular colour bricks. These coincide, but not at all precisely, with a diagram of his daughter prancing on the balcony outside his studio which overlooked the Borghese gardens. In spite of this apparently casual association of colour and design, preparatory drawings (Pl. 176) and some lines still visible on the canvas show that Balla had first made very exact analyses of the girl's movements, related to Marey's and Muybridge's chronophotography, in which trajectories were drawn between successive positions.[5] This intellectually derived structural pattern does not inhibit the effect of light-hearted enjoyment, now on a more purely artistic plane than it had been in the earlier *Guinzaglio in moto*. With the aid of an increased knowledge of colour movements gained from his *Compenetrazioni iridescenti*, Balla was able to employ colour so imaginatively that in this picture all sense of physical presence was left behind. Only the buoyant atmosphere – an amalgam of youthful animal

[1] Letter quoted in R. Carrieri, *Il Futurismo*, 114–15.

[2] Rohlfs (1849–1938) was then teaching at Osthaus' Folkwang Museum in Hagen. Early in the century he had come in contact with Neo-Impressionism and executed some paintings reminiscent of Cross. After 1910 he was drawn into the Expressionist orbit and evolved a very personal variant of their ideas using vibrating colour and light. Uhde (1848–1911) was a German 'Impressionist' whose art retained some social and mystical overtones.

[3] *Fillette multiplié par le balcon, Bambina × balcone, Fanciulla che corre*. Dated 1912. Definitely shown in Rotterdam, 1913. Its presence at the 1913 Rome show has not been verified. See Pl. XI.

[4] See above, p. 176, n. 2.

[5] J. T. Soby and A. H. Barr, Jr, *Twentieth-Century Italian Art*, 12.

spirits, verdant nature and azure sky – remains to evoke the exhilaration of a sunny day.

Neither this subject, nor the flight of swallows which was Balla's next preoccupation, was Futurist in the sense of being 'modern' and aggressive. But in peaceful, enduring Rome the intense, high-speed world of the twentieth century was less in evidence than in Milan. The steady rhythms of life – youth and age, the passing seasons – were more meaningful to a reticent, gentle man like Balla. To him the dizzying, whirring flights of swallows around the eaves at dusk in spring and summer were probably a more important sign of renewal than the inventions of the age of technology. Numerous drawings (Pl. 177), watercolours and gouaches prepared and accompanied a series of oils of flying swallows. Balla was nearly as obsessed as Leonardo with the flight of these graceful aviators and he tirelessly examined and increasingly conceptualized its mechanics and effects. He approached this problem with the same humility and single-mindedness with which he had sought inspiration in the colour harmonies of a ray of light.

One of the more finished oil studies, *Volo di rondini* (Flight of Swifts) of c. 1913 (Pl. 178), shows a few characteristic schematizations of the movements of some purple-toned birds gliding in front of a very delicate pink and blue pattern painted in broad brush strokes through which the bare, coarse canvas is visible. The expressive power of this juxtaposition in some ways recalls Klee's inimitable flashes of instinctive wisdom combined with precise intellectual assertions.

Probably one of the first complete realizations of the swallow theme was *Linee andamentali + successioni dinamiche* (Paths of Movement + Dynamic Sequences) (Pl. 179),[1] which must have been finished by late autumn 1913 because it was illustrated in Boccioni's *Pittura scultura futuriste*.[2] This is a very complex image of movement which incorporated a number of simultaneous points of view and the tracings of various motions. The intensity of this painting reflects the work and ideas of Balla's Futurist colleagues; this is especially evident in the forceful design, which is made up of interacting angular and curved motifs derived from the architectural setting. The predominantly sober browns and greys establish a shadowy yet dramatic evening atmosphere into which an intricate maze of wing-beats is quite abstractly woven. The several layers of undulating, redoubling and seemingly undirected flight-patterns of these birds provide counterpoints for each other and for the meandering course of

[1] Probably identical with *Walking Lines-Dynamic Sensations* of 1914 London catalogue and with *Walking Lines: Dynamic Successions* of 1915 San Francisco catalogue. Dated 1913.

[2] The book appeared March 1914, but Boccioni states in a letter of 1 Octobre 1913 (*Archivi*, I, 296) that 'Tutti abbiamo le nostre fotografie al completo per il volume'.

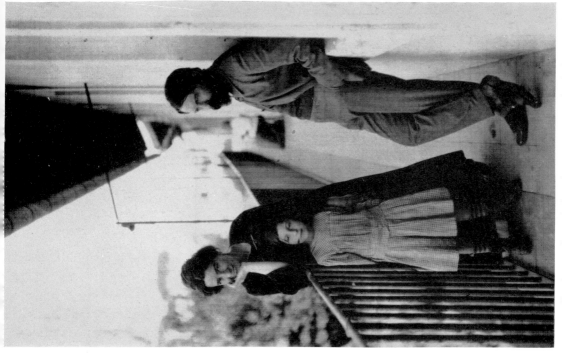

xi. Balla, his wife and daughter Luce on the balcony of his studio. (Summer 1911)

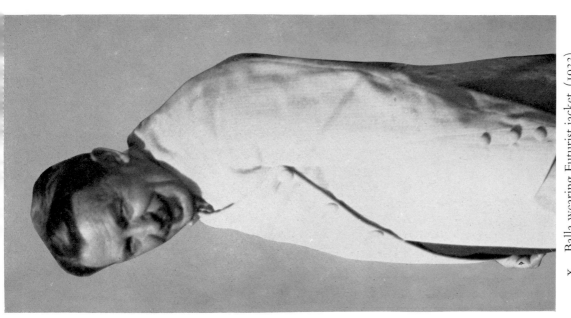

x. Balla wearing Futurist jacket. (1922)

the artist's eye. Balla explained (in the very poor English of his translator) that 'the white lines in the painting represent the way of walking of the person',[1] and he was presumably seeking to recreate his own experience of the confusing, but not confused, workings of nature.

1913: Towards Synthetic Statements of Velocity

Some time in the winter of 1913 Balla took another decisive step which led not only to a much more synthetic representation of motion, but also to an explicitly Futurist statement in terms of automobiles and speed. The general trend of Futurist art towards a more abstract, conceptual expression was at least partly responsible for this change. In addition, the work of a young Roman photographer, Anton Giulio Bragaglia, may have hastened Balla's progress. Inspired by Futurist doctrines, Bragaglia about 1912 began some photographic experiments in what he called *foto-dinamismo*, which particularly resembled Balla's analytical studies of movement. He publicized his theories in lectures and finally in a book, which appeared in the summer of 1913. The Futurist artists were put out by Bragaglia's work, which the enraged Boccioni termed 'a useless presumption'. 'Avoid all contacts whatsoever with Bragaglia's *fotodinamica*', was Boccioni's advice to Dr Sprovieri, their agent at the Futurist gallery in Rome, 'it damages our aspirations towards the liberation from the schematic or successive reproduction of statics and motion . . . [and is] an elementary introduction to what Balla HAS DONE. What he will do will certainly be superior . . . hence what is the use to us of the graphomania of a positivist photographer of dynamism?'[2]

The defenceless Balla needed assistance. Not only was Bragaglia detracting from the merit of his efforts, but according to Mario Sironi (b. 1885) – an old friend of Balla's and Boccioni's – Dr Sprovieri and the Futurist poet Folgore were critical of him, judging him often very subjectively. At the same time Sironi reported on Balla's 'magnificent developments', saying that 'he has now thrown himself into the opposite direction from that which he had followed . . . I sympathize with him – like myself he is forced to live in isolation, ignorant of what is going on. Blessed is he who

[1] Museum of Modern Art, New York, 1952 questionnaire.

[2] *Archivi*, I, Boccioni to Sprovieri (4 Settembre 1913), 288. Bragaglia's book, *Fotodinamismo futurista*, was advertised in *Lacerba*, I no. 13 (1 Luglio 1913), 147, whereupon the six Futurists put a note into *Lacerba*, I no. 19 (1 Ottobre 1913), 211, disclaiming all similarity between *fotodinamismo* and their *dinamismo plastico*. See *Archivi*, I, Marinetti to Soffici (July ? 1913), 283. In spite of this disagreement, Bragaglia later was a loyal supporter of Balla. His photographic experiments have much merit, anticipating Survage's abstract photography and later stroboscopic experiments.

O

instead of confessing this ignorance draws strength from it and moves ahead on his own.'[1]

By 'magnificent developments' Sironi may have meant Balla's numerous studies of velocity, splendidly exemplified in the four illustrations in Boccioni's book; all but one of the originals are now lost or impossible to identify (Pls. 180–3).[2] Following his usual practice, Balla continued his exhaustive studies of this subject even after he had completed these four works.

Of the four pictures, *Penetrazione dinamiche d'automobile* (Dynamic Penetration of an Automobile) (Pl. 182) appears to have – so far as we can tell from old photographs – the strongest associations with its representational source, a boxy old vintage car, more clearly recognizable still in the related *Auto in corsa* (Speeding Car) (Pl. 184). The faint outlines of a driver and the stately car are seen from the back and the side and suggest both a penetration into depth (as in Severini's autobus scene, Pl. 97) and a horizontal progression across the plane, presumably perceived from without, as in paintings by Boccioni, Carrà and Russolo (Pls. 82, 84, 77). Balla exhausted the dynamic possibilities of these two 'penetrations' much more fully than his fellow Futurists. By shifting the focal point to the left, he was able to use the entire right side to expand the wide range of spatial, kinetic and sensorial associations. The viewer's initial attraction to the vortex on the left is sustained by an increasing involvement in the details of the experience depicted on the right. The calculated geometric scheme of motion, which had been disguised in *Bambina che corre al balcone*, was now given a prominent role. But Balla no longer relied solely on scientifically deduced tangents and trajectories; he used bold, intuitive diagonals, parallel horizontals and verticals and ellipses which connect seen and unseen rhythms. These may or may not have any basis in the objective world, although accidentally or intentionally they resemble some of its forms. For example, the large, slightly shaded triangles on top of Pl. 184 could represent either tilting houses, their lines of force, or completely abstract expressive lines, or any combination of objects and sensations. Similarly the rectangles might be related to the silhouette of an old car or the street, and the curving forms might be wheels, dust clouds, or simply imaginative correlates of sound and motion. This very ambiguity is the source of much of the vitality of these pictures as well as of those by other Futurists.

Velocità astratta (Abstract Velocity) and *Plasticità di luci × velocità* (Plasticity of

[1] *Archivi*, I, Sironi to Boccioni (15 Ottobre 1913), 298.

[2] Pl. 183, *Spessori d'atmosfera*, is specifically identifiable – though now apparently lost – because it was sold from the London 1914 exhibition. See Marinetti's reports on this sale, *Archivi*, I (June ? 1914), 340. Cf. *Archivi*, II, Balla nos. 72, 75, 79, 82.

Light × Speed) (Pls. 180–1) are closely related. Both convey the sensation of racing along at an incalculable speed in a pneumatically cushioned vehicle, almost lighter than air. While this is emphasized beyond the more tangible associations of locale and specific space traversed, the faint outlines of the car can be distinguished in *Velocità astratta*. Balla may have drawn some inspiration from Boccioni's vivid presentation of spinning wheels in the pencil drawing for *Quelli che vanno* (Pl. 63) and from his subsequent transformation of this rhythm into a sequence of large, segmented circles; Russolo's liquid forms may have yielded some suggestions as well. But the freedom and discretion with which Balla selected and developed his vocabulary were products of his single-minded experiments over more than a decade, and of the industry with which he built up a strictly personal artistic language. His only aids were the accidental factors of his isolation and his maturity at the time when Futurism arrived at its climax. Not only was he spared an extreme involvement in its earlier struggles, which would have been foreign to his nature, but he was able to take advantage of the fully developed Futurist machine aesthetic, available to him as an entity rather than in its tentative stages. Possibly because of this coincidence, Balla was able to distil the phenomena of the mechanized world into unexpected pictorial analogues, and to produce the most undogmatic revelations of velocity ever to spring from a Futurist brush.

Spessori d'atmosfera (Densities of the Atmosphere) (Pl. 183) was the most abstract and advanced of all the four works of 1913 illustrated in Boccioni's book. It was directly concerned with the most universal manifestation of dynamism, described by Marinetti as 'the lyrical obsession with matter . . . its forces of compression, of dilation, of cohesion and of separation, its wheels of assembled molecules or its vortexes of electrons'.[1] Yet Marinetti's robust and impatient temperament was scarcely attuned to the artistic presentation of these innermost, hidden processes and Boccioni transformed them into a super-struggle, a gigantomachy. Balla, on the other hand, approached these concealed wonders with the detached simplicity with which he had discovered the little dachshund running by its owner's side, remaining throughout the true 'primitive of the new sensibility' whom the Futurist painters had demanded back in 1910 in their technical manifesto.

[1] Technical Manifesto of Literature.

THE FINAL YEARS: 1914–15

O N the surface, at least, Futurism continued to prosper. The triumphal spirit which had swept the movement through 1913 carried it, with the aid of Marinetti's management, through much of 1914. Futurist works were on view in Rome, Florence, Naples and London, and finally in San Francisco.[1] Manifestos, demonstrations, concerts, and publications succeeded each other with unabated rapidity during 1914 while the Futurist audience and following grew: in England and Russia young men declared allegiance to its spirit if not to its letter;[2] in Italy artists and writers sought admission to the group or borrowed from its work and ideas without official acknowledgment.[3] New techniques based on the theories of 1912 and 1913 were developed and extended into untried areas. Marinetti ventured into the plastic arts and made constructions which he called 'dynamic combinations of objects'[4] (Pl. XII). His *parole in libertà* (Pl. XIII) became increasingly assimilated into the general Futurist painting programme and Boccioni and Carrà wrote free-word compositions.[5]

[1] The 1915 San Francisco exhibition was the last joint showing of the group; Soffici was no longer included.

[2] See Marinetti and Charles Nevinson, 'Vital English Art', manifesto, reprinted *Lacerba*, II no. 14 (15 Luglio 1914), 209–10. It was an outcome of the 1914 Futurist exhibition in London and Marinetti's conferences connected with it. Nevinson belonged to Wyndham Lewis's Vorticism of 1914 – an English version of Futurism with a specific local character – but was dropped for being too 'Futurist' (Geoffrey Wagner, *Wyndham Lewis* (London, 1957), 145). In Russia a Futurist group assembled around the brothers Burliuk and the poet Mayakovsky. Marinetti's trip to St Petersburg and Moscow early in 1914 stirred this association into very lively activity. In spite of its name and obvious dependence upon Italian Futurist doctrines, the Russians regarded their association as a completely indigenous development. According to *Lacerba*, II no. 7 (1 Aprile 1914), 110, Marinetti's *Le Futurisme* was put out in Russian in 1914 by the publishing house Prometeo.

[3] In April–May 1914 Dr Sprovieri's gallery in Rome held the *Prima Esposizione Libera Futurista* at which many young Italian (and some foreign) artists participated. A number of these, such as E. Prampolini, M. Sironi, A. Martini, G. Rossi, G. Morandi, later joined the movement, mostly only for a short while. Pratella seems to have made the selection of works. *Archivi*, I, 326, 327, 332; *Archivi* II, 345 ff., for lists of names and works of these later adherents.

[4] Title given to these assemblages in 1914 London catalogue. Marinetti did some by himself, some jointly with the poet Francesco Cangiullo, and some with both Balla and Cangiullo.

[5] Boccioni's first appeared in *Lacerba*, I no. 22 (15 Novembre 1913), 254–6; Carrà's, *Lacerba*, II no. 3 (1 Febbraio 1914), 38–9.

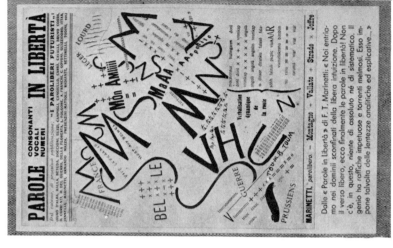

XIII. F. T. Marinetti. *Parole in libertà:*
Montagne + Vallate + Strade × Joffre.
Broadsheet dated 11 February 1915

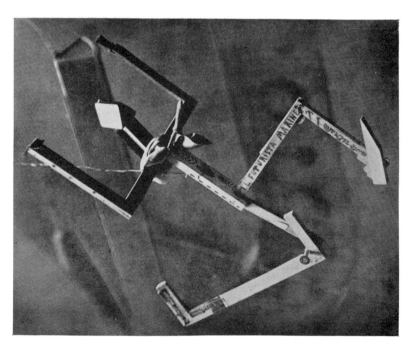

XII. F. T. Marinetti. *Self Portrait. (Dynamic Combination*
of Objects). (1914). Whereabouts unknown. (From *Sketch,*
London, 13 May 1914)

Balla executed his first stage and costume designs,[1] and both he and Severini experimented with assemblage. Lastly, through the talented Antonio Sant'Elia, architecture was introduced into the movement, completing the Futurist house of arts.

Behind this impressive front a very different picture presented itself. After three years of exhausting activity, all the artists were fretting under the demands of collective enterprise and longing for peace, with time for reflection on their own. The only exception was Balla, who in a sense had just begun. This discontent was aggravated by jealousies and conflicting interests, and these were widened by new alignments of sympathies outside the small original nucleus of Futurist artists.

Symptoms of Disintegration

The first open sign of the critical situation within the movement came in February 1914 in an article by Papini. Barely two months after his unconditional acceptance of Futurism, he became uncomfortable in his new status and sceptically re-examined his motives. Prezzolini's harsh but intelligent attack on him and on *Lacerba*, printed in *La Voce* in January 1914,[2] may have set off these reflections. In his article Papini voiced his suspicion of the recent synthetic tendencies in Futurist literature, music and painting, and of their philosophical implications. Its title – 'The Circle Closes' – was drawn from his contention that creation had become a matter 'of substituting for the lyrical or rational transformation of objects the objects themselves, . . . [hence] art gives back reality; thought abandons itself to action . . . art . . . turns into raw nature'.[3] Papini's new doubts were of course closely connected with his own intellectual vacillations between pragmatism and a thwarted idealism, but they also revealed his latent traditionalism; he still based his ideas of creation on academic standards.

Although his assemblage was cited (in company with Severini's collages, Russolo's *intonarumori*, and Marinetti's *parole in libertà*) as only one of many dubious innovations, Boccioni, who was extremely defensive about the movement, took this as a challenge calling for an immediate reply. 'Your article . . . is unworthy of you and of the first page of *Lacerba*, the Futurist journal', began his angry open letter to Papini, printed in the next issue of the paper. In his brusque manner he redefined the purposes of the methods under attack. Synthetic techniques were a means to 'create . . . *new realities, not traditional repetitions of appearances*. But in art new emotional elements cannot

[1] Used for the 29 March 1914 presentation of F. Cangiullo's *Piedigrotta* at Dr Sprovieri's gallery (*Lacerba*, II no. 7 (1 April 1914), 110).
[2] 'Un Anno di "Lacerba",' *La Voce*, VI no. 2 (28 Gennaio, 1914), 3–17, and the next two issues.
[3] 'Il Cerchio si chiude', *Lacerba*, II no. 4 (15 Febbraio 1914), 49–50; reprinted *Archivi*, I, 190, 189.

be found without direct recourse to reality. You instead have mistaken the new ele-
ments of reality introduced into art . . . for a return to brute material.' He mocked
Papini for being such a *passéiste*: 'Confess that you have made a blunder, or at least
that you have shouted just like any senator: "liberty is fine . . . but where will that
liberty lead to?" '[1]

When this polemic broke loose Marinetti was in Russia. Although he approved of
the substance of Boccioni's statement, he regretted the reply, foreseeing that the con-
troversy would not end here, and realizing how precarious the alliance between
Florence and Milan was.[2]

The ball had been set rolling, and its pace was soon quickened by a chain of
fortuitous circumstances. Early in March, Carrà, Soffici and Papini, who had become
close friends, were invited to stay in the Paris apartment of the Baroness Hélène
Oettingen, which also served as editorial office for *Les Soirées de Paris*, edited by
Apollinaire. During the month's sojourn they renewed and broadened their interests
in recent French art. Through Soffici and their hostess they met Apollinaire, Jacob,
Picasso, Matisse, and others, and they visited the Salon des Indépendants and the
Pellerin and Uhde collections, famed respectively for their Cézannes and Rousseaus.[3]
Luck would have it that Boccioni's long awaited volume, *Pittura scultura futuriste*
(*Dinamismo plastico*), just off the press, reached the Italians while they were in Paris.
Boccioni's impassioned yet remarkably well reasoned exegesis and defence of
Futurism, and especially of Futurist art, far outshone in imagination and presentation
Soffici's *Cubismo e futurismo*, which appeared at the same time. The desire to 'surpass'
Cubism which spurred Boccioni's art was evidently also the driving force behind his
writings: *Pittura scultura futuriste* unquestionably ranks with Apollinaire's *Les Peintres
cubistes: méditations esthétiques* as a vital document of early twentieth-century art,
compensating in technical precision and moving enthusiasm for Apollinaire's poetic
imagery and finish. The significance of Boccioni's book could hardly have escaped
Carrà, Soffici and Papini, who read and discussed it critically. Carrà was greatly
offended by its contents. He felt slighted by the inadequate acknowledgement of his
ideas, especially in relation to his concept of the Painting of Sounds, Noises and
Odours.[4] Regarding the book as 'grounded on the wrong principles and superficial

[1] 'Il Cerchio non si chiude', *Lacerba*, II no. 5 (1 Marzo 1914), 67; reprinted *Archivi*, I, 191, 192.

[2] *Archivi*, I, Marinetti to Severini (21 Marzo 1914), 321.

[3] Carrà, *La Mia vita*, 184 ff. The Baroness wrote under the name of Roch Grey. Carrà states here that
this trip took place in April, but *Archivi*, I, 318 reprints letters by Carrà from Paris dated 12 March 1914.

[4] *Archivi*, I, Carrà to Boccioni (11 Marzo 1914), 317. Boccioni had quoted Carrà's manifesto in his
book, but had twice suggested that it was a development of his own theory of plastic states of mind and
of his notion of physical transcendentalism (Boccioni, *Estetica*, 185, 186).

from the pictorial point of view',[1] he immediately gave vent to his injured pride in letters to Boccioni, Severini and Marinetti.[2]

Papini, already incensed with Boccioni, expressed Carrà's sentiments as well as his own in 'Open Circles', with which he resumed the polemic from Paris. He used his superior writing skill and trained mind to humiliate the rough and ready Boccioni, without admitting that in the meantime he had come around to accept the synthetic tendencies in the Futurist arts. Because of this, he shifted the ground of the debate to minor, personal issues, indirectly related to Boccioni's book. Carrà's and even Soffici's opinions were now perceptible when Papini censured Boccioni for regarding himself as the group's spokesman, accusing him of being a potential 'moralist', and a 'professor of history and aesthetics', with his 'tendency toward order . . . the *classical* which is absolutely repulsive to me, Carrà and Soffici'.[3] The break was made and Carrà's alignment with the Florentines openly established.

On his return from France Carrà openly confronted Boccioni, who apparently denied any malice and finally apologized.[4] Upset by the whole Papini–Carrà episode, Boccioni fled to Paris in April, feeling much abused. From here he complained to the sympathetic and generous Vico Baer that 'I have had ways of confirming the mistrust which surrounds my name. No one knows me except to be hostile to me . . . almost: friends have not helped me. But do I perhaps have friends? I shall have to work more and more for myself. This is sad.'[5] The quarrel between Carrà and Boccioni was never made up.[6] Carrà's resentment was closely bound up with the awareness that his artistic interests and those of Futurism were increasingly at odds. Severini seems to have been equally divided in his allegiance, and during the spring of 1914 when Marinetti (and apparently also Boccioni) failed to come to his aid while he was in desperate straits at Anzio, he asked that he be 'left to work in peace'.[7] Both artists had grown impatient with 'the tireless and not very reflective activity of Marinetti and Boccioni, . . . a profoundly *passéiste* . . . nature', as Carrà put it, adding that Marinetti's social and pedagogical concerns were 'of no value to us who wish to be

[1] *Archivi*, I, Carrà to Severini (3 June 1914), 339.

[2] *Archivi*, I, Carrà to Severini (13 Marzo 1914), 318–19.

[3] 'Cerchi aperti', *Lacerba*, II no. 6 (15 Marzo 1914), 83–5; reprinted *Archivi*, I, 196.

[4] See above, n. 1.

[5] Unpublished letter, datable about 15 April 1914, from Paris, in the possession of the Museum of Modern Art. Date confirmed by a letter from Carrà, *Archivi*, I, 328.

[6] Unpublished letter to Vico Baer, datable autumn 1915, from the front, in the possession of the Museum of Modern Art. Boccioni asks that in case of his death Carrà should have no part in carrying out his wishes which are outlined here. See also *Archivi*, I, Carrà to Soffici (25 Marzo 1915), 354–5.

[7] *Archivi*, I, Severini to Marinetti (1914), 329.

pure artists'.[1] On 28 April 1914, Palazzeschi, the only Florentine among the original group of Futurist poets, announced his withdrawal from the movement in *La Voce* and thereafter sympathized more and more with Papini's and Soffici's attitudes towards Futurism.[2] For the next few months, however, these internal disagreements were temporarily overshadowed by the international political situation, which absorbed much of the Futurists' attention.

Politics and War Propaganda

Although Futurism owed much of its general character and some of its ideas to radical political movements, actual politics had played only a minor part in its functions before the autumn of 1913. Until then its artistic and personal sympathies were not confined by narrow political partisanship, although the Futurists were from the beginning boisterously chauvinistic and shared in the general anti-Austrian sentiments, which later became an all-embracing anti-Teutonism like that of France. The glorification of war and cultivation of a fighting spirit had been part of the Futurists' original programme, but this was above all an aspect of their desire for an active and courageous creative life. It was through art and artistic activity that new values were to be discovered for society. Or, in Papini's words, Futurism's goal was the 'renewal of spirits through a new art and a new vision of the world'.[3] Thus Marinetti, who always seemed to have time and energy to spare, rushed to Tripoli in the autumn of 1911 to serve as a correspondent in the Italo-Turkish war,[4] and in the winter of 1912 he went to the Balkans to observe the fighting there. He claimed that his poetic reforms were directly inspired by his experiences in the trenches. They were first tentatively tried out in *La Bataille de Tripoli* of 1911, and then developed into fully-fledged *parole in libertà* – the booming *Zang Tumb Tumb, Adrianopoli, Ottobre 1912*, of 1913, which was based upon the shorter poem 'Battaglia peso + odore', published with the August 1912 Supplement to the Technical Manifesto of Literature.[5]

By the end of 1913 both the international and the internal Italian political situation had become so intensified that it got the better of the generally balanced Marinetti. Before the Italian elections of October 1913, which he feared would be arranged in favour of Giolitti, he decided to announce his own sentiments in a Futurist political

[1] See above, p. 185, n. 1.

[2] 'Dichiarazione', *La Voce*, VI no. 8 (28 Aprile 1914), 43.

[3] 'Postilla', *Lacerba*, I no. 20 (15 Ottobre 1913), 223.

[4] His reports were published in *L'Intransigeant*.

[5] *La Bataille de Tripoli* (Milano, 1912). *Zang Tumb Tumb, Adrianopoli, Ottobre 1912,* (Milano, 1914); parts of this poem were recited during his 1913 *soirées*. Supplement to Technical Manifesto of Literature, *Risposte alle obiezioni*, reprinted in *I Manifesti del futurismo*, 96–103.

manifesto, published in *Lacerba* on 15 October, and also signed by Boccioni, Carrà and Russolo.[1] It was immediately criticized by Papini and Soffici. The first, suspicious of all political programmes, censured Marinetti's attempt to turn a splendid artistic plan of action into an inferior political one. And Soffici, true to the anarchic spirit of *Lacerba*'s 'Introibo', took exception to Marinetti's nationalistic motto, 'The word ITALY must prevail over the word FREEDOM'.[2]

As war fever mounted in the spring and summer of 1914, the entire Milanese group was infected by it. The urgency which had characterized Futurism as an artistic force could now be sustained only by translation into direct physical action. The assassination of Franz Ferdinand and subsequent declaration of war came as a relief, for it provided a real outlet for their passions, which were focused on opposition to Italy's pro-Austrian stand. Marinetti transformed the Futurist *soirées* into violent but gay anti-neutrality demonstrations. The first of these took place in Milan on 15 September 1914 at the Teatro dal Verme. Boccioni, seated high up in the balcony, tore an Austrian flag to shreds and threw it down into the audience, while Marinetti waved an Italian banner. They repeated similar stunts with Russolo and others the following evening in the Piazza del Duomo and in the Galleria. This led to their arrest and imprisonment. When they were released after a few days they were fêted like heroes by their friends. Their liberty was only provisional and the movement was denied the right of assembly, but this did not seem to worry Marinetti, who continued to hold pro-intervention meetings in other Italian cities.[3]

In Rome, in the meantime, Balla had composed his first individual manifesto, *Il Vestito antineutrale* (Pl. XIV), dated 11 September 1914. The dark clothing worn by the modern citizen was dismissed as depressingly neutral and funereal, as well as uncomfortable, unhygienic and therefore enslaving. Balla proposed an easily renewable and brightly coloured (although not yellow and black) outfit; it was to be tailored simply and asymmetrically, with only a few necessary buttons so as to permit active movement and engender a joyous, dynamic mood. Balla's interest in theatrical costuming is apparent, and the tone of his manifesto is more that of a stage designer than a political agitator. This was in a sense also true of Marinetti's rallies, which culminated in December 1914 in a grand meeting at the University of Rome where

[1] This was not the first political statement of the movement, but it was the most elaborate so far. See *Archivi*, I, 31 ff.

[2] Papini, 'Postilla', *Lacerba*, I no. 20 (15 Ottobre 1913), 223; Soffici, 'Giornale di bordo', *Lacerba*, I no. 21 (1 Novembre 1913), 246.

[3] Marinetti, ed., *Noi futuristi* (Milano, 1917), 129-30; *Archivi*, I, Boccioni to his family (16, 19 Settembre 1914), 346-7, Marinetti *et al.* to Soffici (23 Settembre 1914), 348.

costumes based on Balla's designs were worn by the Futurists.[1] The following spring Balla too threw himself whole-heartedly into pro-intervention activities and was twice arrested.

The pressure of events and Marinetti's persuasiveness also brought the Florentines around to an active political stand. Immediately after war broke out, *Lacerba*, its name printed in flaming red letters, announced in an editorial that it was transforming itself into a political journal, to help foment an anti-Austrian spirit in Italy. Papini's independent mind would not conform so easily, and although Marinetti asked Soffici to see that Papini introduced 'absolutely nothing sceptical or pessimistic concerning Italy', the latter slyly continued to air in *Lacerba* some pointed and devastating queries about Italy's and Europe's purposes in this war.[2] Nevertheless, as the months passed, *Lacerba* became increasingly and doggedly pro-interventionist, while at the same time the Futurists ceased to collaborate on it.

Antonio Sant'Elia

When Marinetti invited Antonio Sant'Elia to join the Futurists in the late spring of 1914, he may have hoped to infuse new life into the artistic programme as well as demonstrating the unflagging vitality of the movement to the public. Anxious therefore to advertise this new addition to their group, Marinetti implored Soffici to reserve a prominent place in *Lacerba* for Sant'Elia's manifesto of Futurist architecture – composed in due course – because 'There are a great many people in Milan and in all Italy awaiting our ideas on architecture'.[3] This manifesto and Sant'Elia's ideas generally have caused a very heated controversy in recent years, centring essentially on whether Sant'Elia was ever a truly 'convinced' Futurist and questioning even his authorship of the manifesto. Instead of entering into this rather futile debate, well summarized in recent literature,[4] I shall briefly examine those aspects of his views and art which are definitely Futurist in spirit.

[1] Described in Balla's manifesto which was issued as Futurist broadsheet. Because this meeting took place in December the manifesto probably could not have been distributed in September. Severini seems to have set a precedent by wearing socks in complementary colours (*Tutta la vita*, 85; mentioned on 16 November 1911 in Apollinaire's *Anecdotiques*, reprinted, 1955, 49). See also Sonia Delaunay's multi-coloured costumes of 1912 (R. Delaunay, *Du Cubisme à l'art abstrait*, 199), which may have inspired Malevich's costumes and sets for Kruchenikh's opera, *Victory over the Sun*, produced December 1913 in St Petersburg (C. Gray, *The Great Experiment: Russian Art 1863–1922* (New York, 1962), 136, Pl. 99). Marinetti was in Russia early in 1914.

[2] *Archivi*, I, Marinetti to Pratella (12 Agosto 1914), 488, under entry of that date; Marinetti to Soffici (6 Agosto 1914), 343.

[3] *Archivi*, I, Marinetti to Soffici (21 Luglio 1914), 342.

[4] See bibliography in *La Martinella di Milano*, XII no. 10 (Octobre 1958), 533–5; Reyner Banham, *Theory and Design in the First Machine Age*, 127 ff.

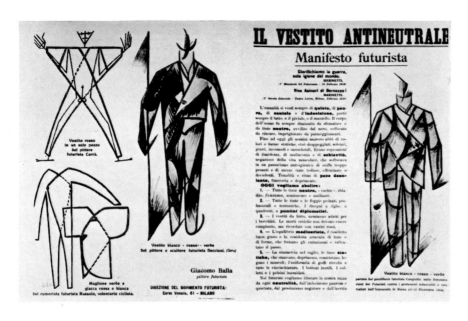

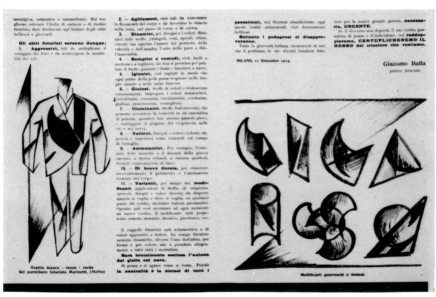

XIV. Giacomo Balla, *Il Vestito antineutrale. Manifesto futurista.* Dated 11
September 1914

Sant'Elia was born in 1888 in Como, but moved to Milan at the age of seventeen. He was trained at the Brera and in 1912 received an architectural diploma and a gold medal from the Scuola di Belle Arti of Bologna. A little later he opened his practice in Milan, but seems to have worked mostly in association with other architects, which makes it almost impossible to identify his contribution to their projects. However, a large number of drawings of the years 1912 to 1914 reveal an uncommonly fertile imagination and a thorough knowledge of the advanced architectural and urban theories then internationally current. Many of these designs were exhibited at the first exhibition of the Nuove Tendenze group held in May–June 1914 at the hospitable quarters of the Milanese Famiglia Artistica. Judging from the catalogue's introductory declarations written by each of the members, the association's aims were modelled on those of the Futurists.[1] Sant'Elia, who knew Carrà especially well,[2] contributed a statement so fundamentally Futurist in outlook that it became the substance – with but a few changes – of his *L'Architettura futurista* manifesto, dated 11 July 1914, and printed in *Lacerba* on 1 August.[3]

Characteristic of his kinship with Futurism is his almost exclusive concern with the modern city (and its various components), 'spiritually and materially ours, in which our tumult can take place without seeming to be a grotesque anachronism'. He shared also the Futurists' urge to 'create and build *ex novo*', and was guided by a very Marinettian machine aesthetic. Thus modern man 'materially and spiritually artificial must find . . . inspiration in the new mechanical world we have created, of which architecture must be the fairest expression, the fullest synthesis, the most effective artistic integration'. Some years before Le Corbusier he likened 'the modern building . . . to a gigantic machine', and his poetic description of stairless skyscrapers with external lifts has come to epitomize Futurist architecture. Like Marinetti,[4] as well as Adolf Loos and other modern pioneer architects, Sant'Elia spoke out against superimposed decoration (including painting and sculpture), because '*the decorative value of Futurist architecture depends solely on the use and the original disposition of raw or bare or violently coloured material*'. New materials (and techniques) were to yield 'a new ideal of beauty . . . [thus] the house of cement, glass, iron . . . [will be] enriched only by the inherent beauty of its lines and its plastic relief, extraordinarily *ugly* in its mechanical

[1] Reprinted *Archivi*, I, 122–7.

[2] Carrà, *La Mia vita*, 175 ff. 'Un ricordo di Luigi Russolo', *La Martinella di Milano*, XII no. 10 (Ottobre 1958), 536–9.

[3] Reprinted *Archivi*, I, 81–5. See Umbro Apollonio, *Antonio Sant'Elia* (Milano, 1958), 23–8, for text of earlier statement. Unless noted, the succeeding quotations are taken from Sant'Elia's two statements.

[4] F. T. Marinetti, *Guerra sola igiene del mondo*, 120, 128.

simplicity'. These ideas ran parallel both to Boccioni's concept of sculpture, including his exploration of new materials, and to Marinetti's attempts to strip poetry to its verbal essentials and discover fresh meanings in the unadulterated strength of words. Original spatial concepts were to be incorporated into the plan of the Futurist city, which, following the painters' theory, was to open up the earth, pierce the sky, and create new unities. Its houses 'as high and large as necessary and not as prescribed by municipal law . . . [must] rise from the brim of a tumultuous abyss: the street . . . will no longer stretch out like a platform at the level of the janitors' dwellings, but will sink on several levels into the earth, accommodating the metropolitan traffic, and joined where crossings are necessary by metal footbridges and rapid escalators [*tapis roulants*]'. Everything about this capacious, throbbing city would be dynamic, avoiding 'perpendicular and horizontal lines, cubic and pyramidal forms which are static, grave, oppressive'. This echo of the Futurist painters' formal language was even more audible in Sant'Elia's advocacy of elliptical and oblique lines, which paraphrased Carrà's 1913 manifesto; they 'have an emotional potential thousand times superior to that of perpendiculars and horizontals'.

As a last blow to architectural tradition, the principle of durability was denied. Sant'Elia's magnificent city of the future was to be as expendable as the artists who created it. 'THE HOUSES WILL LAST FOR LESS TIME THAN WE DO. EACH GENERATION WILL HAVE TO BUILD ITS OWN CITY', read the key sentences of the manifesto's last proclamation, probably added by Marinetti. It was especially this point, so noticeably absent from the earlier version of the manifesto, which nourished the great argument about Sant'Elia's Futurism. To the Futurists, with their avowed belief in a continually evolving art, this statement had, of course, to follow, but it is difficult to imagine any architect planning such short-lived constructions. Sant'Elia himself, according to Carrà, did not approve of these sentences and was reputed to have believed the opposite.[1] Yet the manifesto's international fame and influence after the war rested to a large extent on this assertion, and the built-in obsolescence, common in American and European construction after 1945, is a reasonable if perhaps undesired fulfilment of this attitude. Sant'Elia was spared the painful experience of seeing his creations superseded by newer ones, because none of his projects were ever carried out and he was killed in 1916.

Sant'Elia's drawings of the 'New City' accompanying his manifesto (Pls. 186-7) bear out his affinity to Futurism as fully as his words.[2] He seems however closer to the spirit of mature Futurist art of 1913-14, with its Cubist underpinning, than to its

[1] *La Mia vita*, 178.
[2] As can be seen on Pl. 186, these studies were originally entitled *La Città nuova*.

earlier Art Nouveau-inspired expressionism, the architectural counterparts of which he had absorbed and surpassed on his own by 1912. Looking at these designs as pictorial documents, their compositions on the two-dimensional surface suggest especially Carrà's work after 1912, having a similar arrangement of interacting centripetal and centrifugal movements which focus on a slightly off-centre cluster. Sant'Elia utilized the oblique perspective view in his drawings to play down the static effect of the architecturally unavoidable horizontals and perpendiculars. He also introduced the now familiar step-profile for his skyscrapers and further enlivened their slanting outlines by relating them to athletic arches with parabolic or other dynamic curvatures. Advertising signs form an integral part of the buildings (Pl. 188). These great urban complexes were intended to incorporate great varieties of speed, movement and communications; they were to express the Futurist aesthetic with its interest in simultaneity and the resultant multiplicity of rhythms and meanings. The caption for Pl. 186, the most detailed perspective of the New City, underlines this Futurist quality. It reads: '*Building* with external lifts, gallery, covered passageway over three street levels (tram line, motor road, metal crossing), beacons and wireless telegraphy receivers.'

The architect's more spontaneous sketches for diverse urban edifices (Pl. 190) – railway stations, dirigible hangars, and also undesignated, almost fantastic constructions – have a starkness and suppleness of form, as well as great graphic beauty, which vies with Boccioni's figure studies of 1913. Next to skyscrapers, the power house was Sant'Elia's most recurring theme, reflecting the Futurists' preoccupation with electric energy – the generator of their dynamism. A number of coloured designs (e.g. Pl. 191) strikingly translate the fervour of the Futurist image into architectural language which, as Sant'Elia worded it, sought 'to render the world of things as a direct projection of the world of the spirit'. He conceived of his work not as 'an arid combination of practicality and utility, but . . . [as] art, that is, synthesis and expression'. Embracing thus the Futurist expressionism, Sant'Elia looked ahead to 'the anti-Functional mood of Le Corbusier and Gropius in the Twenties', as Banham has pointed out.[1]

First Half of 1914: Carrà's and Soffici's collages

The trip to Paris early in March had a liberating effect upon Carrà and Soffici, who had reached something of an *impasse* at the end of 1913. Carrà was encountering difficulties in realizing his concept of 'total art' with which he had hoped to discover new forms, and early in February 1914 complained to Soffici, 'I have done little –

[1] R. Banham, *Theory and Design in the First Machine Age*, 130.

too little. I have worked enough, but have concluded NOTHING, alas. To the devil with stubborn pictorial materials.'[1] But he returned from Paris temporarily refreshed and encouraged, having been offered a contract by Kahnweiler,[2] and began what he believed to be 'a cycle of works absolutely different from the preceding ones'. A few weeks later he proudly told Soffici that he had just finished three of these new works, 'executed with coloured papers and coloured stuffs . . . [one of them with] forms of coloured cardboard in relief'. *Sintesi circolare di oggetti* (Circular Synthesis of Objects) (Pl. 192), reproduced in *Lacerba*, may well have been the collage of which he spoke.[3]

Soffici too began to experiment with these new techniques as is witnessed by his handsome *Cocomero, fruttiera bottiglia* (Watermelon, Fruit Dish Bottle) (Pl. 193), likewise illustrated in *Lacerba* in the spring.[4] Apparently, as a result of discussing Papini's disapproval of the use of 'raw nature' in art, Carrà and Soffici were induced to try it themselves, especially as nearly all the Cubists were doing it. But their adaptation of Synthetic Cubism differed radically from that of Boccioni and Severini in 1912–13. The latter had subordinated these techniques to strictly Futurist principles; Carrà and Soffici quite unabashedly accommodated themselves to a decorative, art for art's sake approach, with which collage had become increasingly identified in some French circles.

Carrà's *Sintesi circolare di oggetti* and Soffici's *Cocomero, fruttiera bottiglia* are calmer and more contemplative than their earlier pictures, and both have a cultivated naiveté which may have been the result of their renewed interest in Rousseau, whose work had recently come to their attention.[5] Soffici's collage marked the beginning of his break with Futurism. Perhaps he realized that his temperament was basically foreign to Futurism, and *Cocomero* as well as the related collages of 1914–15 show that he had fully found himself as a painter. The talent revealed in Soffici's best early creative writing – *Lemmonio Boreo, Ignoto Toscano*, etc. – had finally received a commensurate plastic form. Soffici's strength as an artist and writer lay in his skilful and quite Tuscan use of expressive materials, while remaining faithful to his Paris-oriented aesthetic.

[1] *Archivi*, I, Carrà to Soffici (9 Febbraio 1914), 315.

[2] Carrà, *La Mia vita*, 196.

[3] *Archivi*, I, Carrà to Soffici (15 Aprile, May ? 1914), 328, 338. Pl. 192 was illustrated *Lacerba*, II no. 13 (1 Luglio 1914), 201. The artist stated in a letter of December 1965, that *Sintesi circolare* was identical with *Natura morta con sifone di selz*, which he sold to Diaghileff, and upon his death it passed into the Massine collection. See *La Mia vita*, 172.

[4] II no. 10 (15 Maggio 1914), 149.

[5] The Baroness Oettingen and her brother, the painter Serge Férat (Jastrebzoff), owned a number of Rousseaus, and she later wrote a book on this artist. Soffici wrote an important article on Rousseau in 1910; see above, p. 80, n. 2.

Carrà's sparse *Sintesi circolare* is even more explicitly Cubist than Soffici's contemporary collage, and with its subtle equilibrium between opposing formal elements foreshadows the chief premise of his post-Futurist work: 'plastic representation is constituted of two elements; "stasis" and "movement" '.[1] The delight of this collage stems from the intentional play upon the double meaning of its representational and formal components, which function both visually and verbally as something of an autobiographical joke.[2] Carrà mockingly illustrates his drunkenness, which has distorted his judgement, by the juxtaposition of his slanting calling card, the askew and shifting glass and the fairly stable siphon, which decreases in substance as it merges into the downward curving table. Next to it, on the right, the perpendicular measuring scale (implied by the numbers) rises from the newspaper heading 'Sport', as if to allude to the drinking record which seems to be set.

The much livelier *Ritratto di Ardengo Soffici* (Portrait of Soffici) (Pl. 194), probably from this series, showed that Carrà understandably was much more deeply committed to Futurism than his friend and hesitant to forsake its dynamic principles. It also indicated that Carrà was discovering a fertile artistic territory in this new medium, which was borne out by *Dipinto parolibero – Festa patriottica* (Free-Word Painting – Patriotic Celebration) (Pl. 195), completed early in July.[3] Very possibly the war excitement helped Carrà (almost in spite of himself) to achieve this important climactic work in which he sought to 'give the plastic abstraction of civic tumult', as he wrote to Severini,[4] who was engaged in similar free-word experiments during the spring of 1914 (Pl. 196). With verbal aptness and biting humour, Carrà combined the urge to freedom and spontaneity of expression, as proclaimed in his manifesto, with his innate and increasingly assertive urge towards order. This picture provides a visual counterpart to Russolo's *Spirali di rumori intonati* (Spirals of Intonated Noises), the noise compositions which had just provoked much controversy at their first public performance in Milan.[5] The immediate and almost blinding impact of Carrà's picture, like the startling opening sounds of Russolo's *intonarumori*, seemed calculated to shatter the senses. But once the viewer has recovered from the initial shock,

[1] Carrà, *Pittura metafisica* (2ª edizione riveduta, Milano, 1945), 57.
[2] Cf. Picasso's *Still Life with a Calling Card*, 1914, illustrated in A. H. Barr, *Picasso*, 85.
[3] *Manifestazione interventista*. Illustrated *Lacerba*, II no. 15 (1 Agosto 1914), 233.
[4] *Archivi*, I, (11 Luglio 1914), 341. Carrà calls his collage here *Festa patriottica-poema pittorico*.
[5] M. Z. Russolo *et al.*, *Russolo*, 51 ff. On 21 April 1914 the first public performance of Russolo's *intonarumori* was held at the Teatro dal Verme, resulting in the usual violent outbursts. Two days later Russolo insulted a critic who had reviewed this concert; he was arrested and had to pay a fine. The three *spirali di rumori intonati* performed were: *Risveglio di una città*, *Si pranza sulla terrazza del Kursaal*, *Convegno d'aeroplani e d'automobili*. *Lacerba*, II no. 5 (1 Marzo 1914), 72-3, prints part of the score for *Risveglio*.

the composition unwinds itself into a controlled and carefully considered pattern and series of sub-patterns. On purely aesthetic grounds these patterns are as remarkable for their expressive precision as for their capacity to hold the prolonged attention of the spectator. *Festa patriottica*, which unexpectedly was the most Futurist of all Carrà's works, was also his swan song to the movement, for thereafter his interests moved into areas discovered or rediscovered during 1914, and finally, in 1917, he turned to the extreme opposite of Futurism – the quietism of *pittura metafisica*. To the Dadaists Carrà left an important heirloom which they willingly and gratefully accepted.

1914. Boccioni: Ecstasy and Order

So far as his art was concerned, 1914 did not begin so problematically for Boccioni as for Carrà. He carried on his studies of motion, but in the course of the year important changes occurred in his work which suggested that he too had reached a critical moment. During 1914 – mostly in the first half – Boccioni set forth his final versions of the horse (or horse and rider) in three different media – oil, collage and assemblage. These concluding works on this motif disclose considerable fluctuations of mood and hence of approach, but it is difficult to establish dates for any of them except for the collage. They include the deliberate design of the elongated horse in the city (Pl. 197); the suave assemblage of its gallop (Pl. 202); an impetuous, distraught representation (Pl. 198); and finally a virtual explosion of the horse (Pl. 199). The one common denominator of all these works, including the sculpture, is the exalted state of mind which they convey. In *Dinamismo plastico: cavallo + caseggiato* (Plastic Dynamism: Horse + Building) (Pl. 197) this is suggested by the extremely elongated format, the monochrome colour and the severity of the design, which resembles that of Balla's precise but more objective images of speed. More explicitly this renewed upsurge of forceful pictorial discipline seems like a confirmation of Marinetti's newest manifesto, *Lo Splendore geometrico e meccanico e la sensibilità numerica* of 15 March 1914. Here the Futurist concept of 'beauty' was definitely made contingent upon 'order, discipline, method . . . the concurrence of energies converging in a single . . . trajectory'.[1] It seemed that Marinetti (or at least one side of him) was now willing to give in to the general tendency of order and control.

Although Boccioni's horses followed this trend, some of them at the same time displayed an aesthetic ecstasy very like that expressed in Carrà's 1913 manifesto. This

[1] Published in *Lacerba*, II no. 6 (15 Marzo 1914), 81–3, and no. 7 (1 Aprile 1914), 99–100; partly reprinted *Archivi*, I, 47–8.

is particularly apparent in *Forme plastiche di un cavallo* (Plastic Forms of a Horse)[1] (Pl. 199). The colours are riotously brilliant, competing and contrasting with something of the shrillness advocated by Carrà. Moreover, Boccioni's forms and their arrangement are closer to Carrà's paroxysmal principles than to his own more restrained *complementarismo dinamico*. The ephemeral illusionism of this painting resembles that of a firework, and seems to depict a sort of spectral Pegasus which is at the same time a Trojan Horse, threatening to disintegrate the moment it has taken shape before the eyes and mind. It may have reflected some of Boccioni's anxieties about the war and his own work.

This visionary element, also found in the rest of the series, is curiously related to a semi-religious pre-Futurist drawing, called *Allegoria macabra* (Macabre Allegory) (Pl. 200).[2] A watercolour study for *Cavallo + cavaliere + caseggiato* (Horse + Rider + Building) (Pl. 201) repeats this early sketch almost exactly and suggests the same sense of impending doom, found also in *Forme plastiche di un cavallo*, which now seems to be a premonition of his own death.

Costruzione dinamica di un galoppo: cavallo + casa (Dynamic Construction of a Gallop: Horse + House) (Pl. 202), which is the least tense of the group, seems nonetheless elusive and distant. This construction has suffered much in the course of years. It displays a sophisticated approach to assembled sculpture, quite different from that of his 1912 works. Boccioni's intervening development as a sculptor, and as an artist generally, is indicated by the skilled handling of various media and of abstract forms representing velocity. With this piece Boccioni apparently concluded his sculptural efforts. He had begun with the still embryonic Synthetic Cubism of Picasso and Braque, which he then developed in a Futurist direction, while still using traditional materials. Finally, as a result of his own growth and fresh contact with full-blown Synthetic Cubism and Picasso's constructions, Boccioni created a dynamic piece of Futurist assembled sculpture.[3]

The Synthetic Cubist inspiration is also present in a number of collages with which he like Carrà experimented during 1914. But works like the two small portraits

[1] Dr Sprovieri kindly informed me that this painting is identical with *Ambiente emotivo di un cavallo* exhibited in Rome and Naples in 1914.

[2] It is a study for the allegorical ink drawing *Beata Solitudo, Sola Beatitudo*, 1907-8, illustrated in J. C. Taylor, *Graphic Work of Boccioni*, no. 17. The figure of death on horseback brings to mind Trecento frescoes or the great Palermo fresco, once attributed to Pisanello.

[3] *Cavallo + case. Plastic Dynamism: Horse + Rider + Houses.* The title used in the text was employed in the catalogue of the large posthumous Boccioni exhibition at the Palazzo Cova, Milan, 28 December 1916 to 14 January 1917. Picasso made multi-material constructions from winter 1912-13 onwards and may in turn have been stimulated by the ideas of Boccioni's sculpture manifesto.

P

(Pls. 203, 204)[1] reveal that Picasso's early Cubist work of 1907–9 came to his attention as well. As a result, there is little or none of the decorative *l'art pour l'art* quality which had infiltrated some of Carrà's and Soffici's contemporary collages. Both portraits are singularly inventive translations of Picasso's plastic Negro style into the planar terms of Synthetic Cubism, in which neither the forcefulness of Picasso nor the Futurist vitality has been lost.

Boccioni did not stop with the Negro works in his 'rediscovery' of Picasso; in other 1914 paintings reminders of Picasso's adaptations of Cézanne, and even the influence of Cézanne himself, are discernible (Pls. 205–207). The striking blocky figure, lilac amidst green plants, in *Costruzione spiralica* (Spiral Construction) (Pl. 207) has the three-dimensional solidity of some of Picasso's landscapes or still lifes of 1908, such as *Landscape with Figures* (Pl. 208), which were free developments of Cézanne. But Boccioni's colour, though no less structural, is not so austere. *Costruzione spiralica* is something of a postscript to the unfinished *Studio di donna fra le case – Ines* of 1911 (Pl. 74). All the problems in the early portrait, left open mainly for lack of knowledge of Cubism, were resolved in this magnificently co-ordinated, de-personalized torso of a woman – though again somewhat at the expense of Futurism. Both *Bevitore* (Drinker) and *Sotto la pergola di Napoli* (Beneath the Naples Pergola) (Pls. 205, 206)[2] show an even more conspicuous assimilation of Cézanne in subject (a distant variant of the Card Players), approach, and to a certain extent in execution. The uptilting of planes with its insistence on the two-dimensional picture surface and the airy brushstrokes of *Sotto la pergola* are Cézannesque. On the other hand, its softly rounded foliage and the curtain in *Bevitore* are quotations from Picasso's adaptations of Cézanne, as is the extreme liberty used in the reshuffling of visual reality, which is of course also Futurist.

Boccioni's look into the recent past may have been provoked by the small illus-trated volumes on Cézanne, Picasso, and Rousseau, which were published late in 1913–14 in the *Maestri moderni* series, edited by Soffici for the flourishing *Libreria della Voce*.[3] Beyond this, Boccioni's receptivity at this point in his career to the mes-sage of Cézanne and its Cubist derivations probably indicates that he was aware of

[1] Pls. 203, 204 have been variously titled: *Dinamismo di una testa di donna, Dinamismo di una testa di uomo; Scomposizione-composizione dinamica di una testa* (for the woman), *Scomposizione di una testa* (for the man). They are occasionally dated 1913, and the woman has been dated 1912, but early 1914 seems much more likely.

[2] The dates for Pls. 205–207 are somewhat problematical. The execution of *Sotto la pergola* may have carried over into 1915; it probably was not begun until after the Futurist exhibition in Naples, May 20–June 10 1914.

[3] Soffici had continued as editor of the *Libreria della Voce* even after leaving the journal.

his 'ignorance' of this important link in the modern tradition,[1] stressed especially by Soffici and the French. Realizing this at a moment of apparent creative and physical exhaustion, Boccioni seems to have tried to consolidate his knowledge before moving ahead. Yet in these and other paintings of 1914 Boccioni remained very much himself and was still striving to endow his subject with some Futurist meaning. But it is clear that Futurist dynamism – speed, modern subjects, and so on – was no longer his chief and consuming interest. As in Carrà's case, other and more fundamental pictorial problems were preoccupying him, suggesting that perhaps he too felt the irresistible pull of the classical tradition.

1914–15. Guerrapittura and Futurist Art During the War

After the first excitement over the declaration of war had worn off and the Milanese had had their fill of anti-Austrian pro-intervention demonstrations, their creative interests were reasserted. As always, it was Marinetti who attempted to chart a new course of artistic action. In November 1914, having made up with Severini, who had returned to France earlier in the autumn, he described in a long letter how Futurist art might be put into the service of war: 'It is necessary that Futurism . . . become the plastic expression of this Futurist hour . . . probably there will be less abstract paintings and sketches; they will be a little too realistic, a sort of advanced post-Impressionism . . . Boccioni and Carrà agree with me and believe that *immense artistic novelties may be possible*. We urge you . . . to interest yourself pictorially in the war and in its repercussions in Paris. Try to live the war pictorially, studying it in all its marvellous mechanical forms (military trains, fortifications, wounded, ambulances, hospitals, parades, &c.). You have the good fortune to find yourself in Paris now. Take absolute advantage of it, abandoning yourself to the enormous military anti-Teutonic emotion which excites France.'[2]

For some reason Severini was more willing and able than any of the other Futurists to follow Marinetti's appeal without any reservations. Perhaps he was inspired by his father-in-law's (Paul Fort) war poetry – *Poèmes de France* – which, in Severini's words, were 'a continuous, implacable invective against the Germans and their methods of invasion and war, and a shining glorification of French virtues'.[3] Although Severini's health and finances continued to be extremely precarious and his life was complicated by his wife's pregnancy, the Parisian milieu suited his temperament, and within a year he had completed a large number of war paintings. With these and a few of his

[1] See above, p. 63, n. 2.
[2] *Archivi*, I, Marinetti to Severini (20 Novembre 1914), 349–50.
[3] Severini, *Tutta la vita*, 231.

P*

more light-hearted earlier pieces he organized his 'First Futurist Exhibition of the Plastic Art of War' in January 1916 at the small Galerie Boutet de Monvel, where he also gave a lecture.[1] Since Marinetti still had not published Severini's manifesto, *Le Analogie plastiche del dinamismo*, this was a long-awaited chance to voice some of his ideas, and he was pleased when his talk was printed in *Mercure de France* in February 1916.

Severini's war paintings stemmed from what was practically an inversion of his 'plastic analogies' concept. Instead of commencing with an object which evoked other objects and ultimately an idea, thus suggesting the continuity of objects through change, he now began with a specific idea and intensified it through a quite literal analogy suggested by relevant objects, thus effecting 'a kind of plastic ideography'. He explained that in his *La Guerre* series (for example, Pl. 209) he had 'tried to express the idea [of] *War* by a plastic ensemble composed of these *réalités*: cannon, factory, flag, mobilization order, aeroplane, anchor . . . [because] these *réalités* are symbols of general ideas.'[2] Employing the 'free-word painting' techniques he had used in the swirling *Danza serpentina* (Serpentine Dance)[3] (Pl. 196) of spring 1914, he added letters, words, numbers, mathematical signs, evocative of the calculations and vast areas involved in the war. *La Guerre* (Pl. 209) has a somewhat laboured poster effect, but Pls. 210–11, which were based on direct visual experience, have much artistic strength. In 1915–16 Severini lived by a railway line, and observed 'day and night trains loaded with war materials, or with soldiers and wounded'. The unusual views in both paintings, which might be those seen from a low-flying plane, but are probably based on his position at the window, add intensity and interest. Compositionally speaking, however, he merely used the tried and tested arrangement of *Modiste* (Pl. 67) and earlier portraits, in which superimposed and receding planes appear to stream downwards, dispersing and reassembling in the process. The icy colours and clear-cut forms of *Armoured Train* (Pl. 210) convey the cutting, unemotional precision of gunfire, whereas in *Red Cross Train* (Pl. 211)[4] something of the human compassion, the

[1] Ibid. 240. The catalogue of this exhibition was not available to me.

[2] Severini, 'Symbolisme plastique et symbolisme littéraire', *Mercure de France*, CXIII no. 423 (1er Février 1916), 466 ff.; reprinted *Archivi*, I, 209.

[3] Illustrated in *Lacerba*, II no. 13 (1 Luglio 1914), 202. Severini, *Tutta la vita*, 210, says that Marinetti chose the title. Perhaps Marinetti alluded to Loie Fuller's famous dance of that name. Severini vaguely remembers the original title as 'Composizione di parole e forme (Danseuse = mer)'.

[4] Severini's drawing *Flying over Rheims* (1915?) (Metropolitan Museum, New York) harks back to his experience as a flyer in about 1909–10. The actual subject may have been suggested by Paul Fort's 'La Cathédrale de Reims', condemning the Germans for the bombardment of the Cathedral; *Poèmes de France* (Paris, 1916), 1–23.

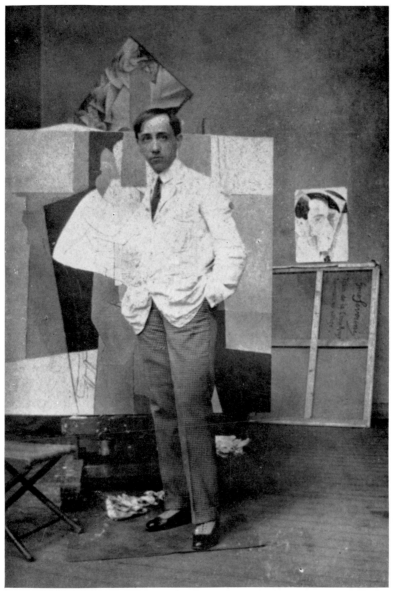

xv. Severini in his Paris studio. (*c.* 1917). *Dancer–Helix–Sea* (1914–15) on wall at left

anguish, and the confusion of war is made visible through the mixture of cold and warm colours and the juxtaposition of various telling fragments of objects. Altogether these canvases are notable modern additions to the ancient genre of war scenes.

Severini sold only one painting from the exhibition, which scarcely relieved his plight; but his work generated some excitement in deserted Paris, and helped to renew his acquaintance with artists who had remained and who were setting the pace for the arts after the war. As Severini was drawn into the circle of Lhote, Lipchitz, Ozenfant, Cocteau, and others, his thoughts turned gradually but definitely away from Futurism towards Cubism and finally a calmer, rational art.[1] This change was intimated by another article published in *Mercure de France* in 1917, in which he declared that 'The effort we must make today . . . is to establish an equilibrium between intelligence and sensibility, for in my opinion, intelligence . . . [is] in the process of losing a too *limited* share, and I think that very harmful from the artistic and even social point of view.'[2]

Carrà responded to the war mood with a group of drawings, collages and free-word paintings, which appeared in his *Guerrapittura*. This book came out in March 1915,[3] and Carrà apparently intended it as a counterpart to Boccioni's *Pittura e scultura futuriste*. It also contained some *parole in libertà* and a number of his earlier *Lacerba* essays, many of which had nothing to do with war, but merely presented Carrà's view of Futurism. In order to heighten the belligerent effect of his *Guerra pittura* he added an extra consonant and accents to his name–Carrrà''. Yet in spite of the aggressive title and some of the polemical essays, the illustrations, which referred to the war explicitly, were on the whole refined and distant, almost contradicting the supposed intention of the book. This is brought out in the most ambitious of the group – *Inseguimento* (Pursuit) (Pl. 212). It is a strangely ambiguous collage, suggesting an atmosphere of dream or of childlike make-believe rather than one reflecting the difficult battle fought by Joffre on the Marne, to which it refers. The horse, though shown in an active position, seems essentially passive, or even static: it is like a wooden toy, floating in soft, airy surroundings. Its red-trousered rider looks more like a jockey than a warrior. They are appropriately surrounded by, but almost completely separated from, newspaper and programme clippings which report sporting events and amusements. Rather than glorifying war, as it was supposed to do, the resulting

[1] Summarized in his *Du Cubisme au classicisme. Esthétique du compas et du nombre* (Paris, 1921).
[2] 'La Peinture d'avant-garde', *Mercure de France*, CXXI no. 455 (1er Juin 1917), 451 ff.; reprinted *Archivi*, I, 215.
[3] See *Archivi*, I, Carrà to Soffici (25 Marzo 1915), 355.

picture is ironical and Dada.[1] When Carrà was working on these drawings and collages he had already begun to study the paintings of Giotto, and was occupied with 'concrete forms . . . placed in space';[2] at the same time his doubts about Futurist dynamism mounted daily.

Boccioni, who had taken part so enthusiastically in the intervention rallies, created only one example of war art, suggesting that he too preferred to devote himself to detached, purely artistic matters. However, his one piece, Carica dei lancieri (Cavalry Charge)[3] (Pl. 214), a papier collé also of late 1914, is a powerful and convincing statement about the dynamics of battle. Its meaning is reinforced by the newspaper items employed, which report on the war and French advances. It forms part of the horse and rider series on which he had worked during the year. The mobile horse, multiplied to infinity to evoke the united strength of the battalion, retains some of the agony and terror of the 1907 Allegoria macabra (Pl. 200). With its enormous craning neck and snorting head it is an ancestor of the dying horse in Picasso's Guernica, a symbol for the pointless destruction of war.

As might be expected, Balla drew the most positive – though the least overtly warlike – consequences from the appeal to put art at the service of the embattled nation. Shortly after the outbreak of hostilities he began a number of paintings depicting the recent partial eclipse of the sun by the planet Mercury (Pl. 215).[4] Transforming this objective phenomenon into an expression of the tensions and high aspirations of the times, and of the Futurists, he made it a glistening, smouldering display of cosmic pyrotechnics, into whose ordered but complexly interwoven vortices the spectator is forcefully drawn. Balla was asserting the inextinguishable strength and purity of the sun, unaffected by the antics of lesser cosmic bodies, and thus he created a totally unpretentious but profoundly Futurist act of faith.

Balla demonstrated his political sentiments more actively during 1915, and Bandiera sull'altare della patria (Flag on the Altar of the Fatherland) (Pl. 216) was an attempt to express a patriotic message through a specific, abstract symbolism of colour and form.

[1] Drawing no. 10 in Guerrapittura (Pl. 213) is entitled 'La notte del 20 gennaio 1915 sognai questo quadro (Angolo penetrante de Joffre sur Marne contro 2 cubi germanici)'. Here, too, a perhaps unintentionally ambiguous meaning is suggested by combining the reality of war with the dream experience.

[2] Archivi, I, Carrà to Soffici (27 Dicembre 1915), 368. Roberto Longhi, Carlo Carrà (2ª edizione, Milano, 1945), states that Carrà gave his article on Giotto to La Voce while working on the drawings for Guerrapittura.

[3] Illustrated in Grande Illustrazione, no. 13 (Gennaio 1915), 4.

[4] The eclipse occurred on 7 November 1914. Torino, Galleria Civica d'Arte Moderna, Giacomo Balla, 72, 144.

He showed a flag-like shape as a protective *baldacchino* expanding over small ripples of what might be the earth and mankind (given the Italian tricolour) before merging into the upper reaches. The painting is deprived of the freshness of Balla's earlier work by its rather tight rendering (anticipatory of the hard-edge style of the fifties) and by the reference (perhaps unintentional) to those myths of ancient and enduring Roman grandeur which had always fed the fires of Italian nationalism.[1] On the other hand, Balla's efforts to enlarge upon Boccioni's ideas of sculpture and upon Carrà's and Marinetti's concepts of 'total art' provided more fertile ground and kept Futurism creatively alive during the war. He had been experimenting for some time with constructions in various materials;[2] now he joined with a younger artist, Fortunato Depero (1892–1960), in a manifesto, *Ricostruzione futurista dell'universo*, dated 11 March 1915 (Pls. 217–18).[3] Balla's completely abstract 'reconstructions', illustrated in the manifesto, are now destroyed. They seem to have been arrestingly bold; made of various materials, they were apparently movable and even made noises. He explained that they were an outcome of his studies of 'the velocity of automobiles in which I discovered the essential laws and lines of force. After more than twenty pictures which dealt with this investigation, I understood that the single plane of the canvas did not permit the suggestion of the dynamic volume of speed in depth . . . [and] I felt the need to construct the first dynamic plastic complex with iron wires, cardboard planes, cloth and tissue paper, etc.' Both the curvilinear and angular compositions show a penetrating and unconventional approach to diverse materials and, more significantly, an entirely new conception of sculpture. Balla anticipated the work of Gabo and Pevsner, not only in his rudimentary reconstruction of 'universal vibration' through simple, geometrical forms, but in his rejection of 'physical mass as an element of plasticity', as the Russians worded it in 1920.[4] However, the *outré*, Dada quality of a great deal of the Balla-Depero manifesto, which no doubt was a feature of these constructions, seems to have prevented their being taken more seriously at the time by other artists, and later by Balla himself. Yet they had proved again his artistic autonomy, allowing him to transcend the narrow limits of patriotism and discover in the general war atmosphere possibilities for a new and original human environment.

[1] The block shape in the centre is reminiscent of the Ara Pacis.
[2] See above, p. 182, n. 4.
[3] Reprinted *Archivi*, I, 49.
[4] N. Gabo and A. Pevsner, *Constructivist Manifesto*, excerpts quoted in R. Goldwater and M. Treves, *Artists on Art*, (New York, 1945), 454.

The End of Il Primo Futurismo. The Futurists as Soldiers

Throughout the autumn of 1914 Marinetti tried to maintain peaceful relations with the Florentines, but the personal conflicts between the two groups continued, along with the *Lacerba* circle's realization of their basic sympathy with the *La Voce* group. When Prezzolini stepped down from the editorship of *La Voce* in the late autumn 1914, he took the occasion to observe that the two Florentine publications had become more and more alike: '*La Voce* is now more artistic and critically oriented and *Lacerba* more serious and without Futurism.'[1] In a long editorial, ' "Lacerba", il Futurismo e "Lacerba" ', which appeared in their journal on 1 December 1914,[2] Papini and Soffici agreed with Prezzolini's statement about *Lacerba* and with it openly acknowledged their break with Milan. They reviewed their collaborations with the Futurists from the first loose and suspicious alliance to their closely united activity in the latter part of 1913, and finally to the signs of the awakening conflict in February 1914, when Papini's 'The Circle Closes' appeared. Like Carrà they blamed their change of heart on Marinetti and Boccioni, whom they accused of trying to establish 'an immobile church with an infallible creed'. Marinetti and Futurism as a whole were charged with prescribing 'a precise recipe, a method imposed under pain of heresy, a trademark'. Papini and Soffici took most of the credit for the movement's accomplishments, claiming that because they were 'cultured men . . . they succeeded in turning the confused aspirations of their companions into clear ideas and live polemic prose'. Not even Marinetti's political fervour, which had previously helped to change *Lacerba*'s outlook, was appreciated; the Futurists' interventionist rallies were ridiculed as resulting in nothing more than Balla's Manifesto of Anti-Neutral Clothing.

An even more vitriolic diatribe against some of the Milanese was printed two months later in *Lacerba*.[3] In 'Futurismo e Marinettismo', Papini, Soffici and now Palazzeschi as well, distilled the general arguments of their earlier declaration into a specific attack on Marinetti, Boccioni, Balla and Russolo and all that they represented. 'Lacerban' Futurism (seen as the 'true' movement), whose inner circle included Carrà, Severini, Soffici, Pratella, Papini, Palazzeschi, and Tavolato, was opposed to 'Marinettismo', to which all the rest belonged. The authors then defined the aesthetics of the two groups by contrasting their own forbears with those of the Milanese circle. Lacerban Futurism – so they said – looked back to Voltaire, Baudelaire, Mallarmé, Rosso, Renoir, Cézanne, Matisse, while Marinettism descended from Rousseau,

[1] 'Congedo', *La Voce*, VI no. 22 (28 Novembre 1914), 3.

[2] II no. 24 (1 Decembre 1914), 323–5.

[3] A. Palazzeschi, G. Papini, A. Soffici, 'Futurismo e Marinettismo', *Lacerba*, III no. 7 (14 Febbraio 1915), 50.

Hugo, Verhaeren, Segantini, Signac, Rodin, and de Groux. In general, their distinctions were extremely arbitrary and on the whole revealed more malice than thought.

Carrà, who, together with Soffici and Papini, had been invited to collaborate in the final series of *La Voce*, probably agreed in substance with some of the opinions of his Florentine friends, but was nevertheless outraged by the general tone of the article. He notified Soffici that he refused to have any part 'in the dispute about what you call "MARINETTISMO E FUTURISMO" because I immediately saw it all degenerate into reprehensible personal gossip'.[1] Even though his interests were moving to other areas, he was still loyal to the creative spirit and value of Marinetti's Futurism and refused to see this denied.

Marinetti was undoubtedly taken aback by this assault from the Florentines, but never long at a loss for words or hesitant to act, he asked Mario Sironi, who had moved to Milan, to take Soffici's place in the 'Gruppo dirigente' of the movement, and late in March he informed Severini that he planned to found immediately 'an absolutely Futurist journal'.[2] Less than two months later Italy declared war, and Marinetti and most of the other Futurists were called to arms.

It was fortunate in a sense for Marinetti that Italy entered the war when it did, because it saved him and the Futurists from having to accept the fact that the movement as they had known it had ceased to exist. Boccioni, Marinetti, Russolo, Sant'Elia, and other artist friends enlisted as voluntary cyclists, and were assigned to the same unit.[3] They faced action together in early autumn 1915, and their Futurist fighting spirits were put to an extreme test. Boccioni's letters from the front record his experiences with a mixture of youthful, overawed excitement and understandable anxiety: 'I live in terrible noise. I have been under fire. Marvellous! Ten days of marching in high mountains with cold, hunger, thirst!... Sleeping in the open in the rain at 1400 [metres] ... 240 [pieces of] shrapnel have fallen on my unit... received with ironical laughter ... War is a wonderful, marvellous, terrible thing! In the mountains it... seems like a fight with the infinite. Grandiosity, immensity, life and death! I am happy!'[4]

In December 1915 their battalion was disbanded and the Futurists returned to Milan on leave. During this temporary respite Boccioni threw himself into his work, painting, writing, and lecturing a great deal. While staying with his close friend Ferrucio Busoni at Pallanza on Lago Maggiore in the early summer of 1916, he executed a series of canvases, of which the stately, distinctly Cézannesque portrait of the

[1] *Archivi*, I, Carrà to Soffici (15 Marzo 1915), 354.

[2] *Archivi*, I, Marinetti to Severini (26 March 1915), 356. Several new Futurist journals appeared in the next two years, but none was directed by Marinetti.

[3] Their unit was subsequently transformed into an alpinist one.

[4] *Archivi*, I, Boccioni to Contessa Piccini (Autumn 1915), 366.

pianist-composer is the most balanced (Pl. 219). Some of the smaller, strongly expressionist studies indicate a search for a more personal idiom, but Futurism had been definitely abandoned. Suddenly, at thirty-four, Boccioni felt the burden of his role as a creative leader weigh heavily upon him. The artist for whom no obstacle had been too great in blazing a new trail now retreated into himself and wearily wrote to Pratella from Pallanza: 'The burden of having to elaborate in oneself a century of painting is terrible. So much more so when one sees the new arrivals to Futurism grasping the ideas, mounting them and running at break-neck speed.'[1]

Boccioni's second call to active duty came in July 1916, interrupting his work. He returned somewhat hesitantly, but refused to ask for the exemption which an old lung disorder would certainly have secured for him.[2] He was now assigned to the artillery and stationed in Sorte, outside Verona. Boccioni was apprehensive of the expected transfer to the front, and the dull military routine did not distract his mind from the intense activity and reflection of the past months. In August he observed, 'I shall leave this existence with a contempt for all that is not art. There is nothing more terrible than art. All that I see at present is play compared to a well-drawn brushstroke, a harmonious verse, a well-placed musical chord. Everything compared to that is a matter of mechanics, of habit, of patience, of memory. There exists only art.'[3] These lines give the essence of the spirit which fired Boccioni, and they may well stand as the credo of the movement. Not long afterwards, Boccioni fell from his horse during a military exercise and died from the injuries on 17 August. Two months later Sant'Elia was killed in action, and in the next year Marinetti and Russolo were seriously wounded, thus bringing their final joint venture to a tragically heroic end.

In spite of these great losses, Marinetti was determined not to let his movement die. As soon as he was physically able he once again consecrated 'all intellectual, bodily and financial powers to the Futurist movement . . . which needs an ever bigger impulse and an ever bigger defence',[4] as he had once said. With a new and younger group of recruits, in which, of the surviving artists, only Balla took an active part, Marinetti embarked upon his second, ill-starred campaign to keep Italy alive and up-to-date in the arts. In spite of the barren years which followed, *il primo futurismo* had accomplished its purpose of giving a new meaning and form to Italian art. Only during the past decade and a half has the boldness and significance of this revolutionary feat begun to be recognized.

[1] *Archivi*, I, Boccioni to Pratella (16 Giugno 1916), 372.
[2] In conversation with the late Vico Baer.
[3] Statement by Boccioni quoted originally in Herwarth Walden, 'Umberto Boccioni', *Der Sturm*, VII no. 6 (September 1916), 71. Reprinted *Archivi*, I, 373.
[4] *Archivi*, I, Marinetti to Severini (26 Marzo 1915), 355.

APPENDIX

On the Futurists' Controversies

The quarrel between Apollinaire and the Futurists, which is very complex, seems to have originated in the rivalry between Marinetti and Apollinaire, and, more broadly, in the collision between Apollinaire's Parisian and the Futurists' Italian chauvinism. The issues were further clouded by Apollinaire's love for Italy and by Marinetti's and some of the Futurists' admiration for France and her recent artistic achievements. The series of attacks and reconciliations, which mark the relations between Apollinaire and the Italians, began with Apollinaire's sarcastic comments made upon meeting Boccioni in October 1911. (See above, p. 110.) In 1912, Apollinaire, always on the alert for the new and startling, became so interested in Futurist ideas that, perhaps for personal reasons as well, he wanted to adopt the word Futurism for all the diverse manifestations of modern art. (Severini, *Tutta la vita*, 185.) Marinetti would apparently not hear of it. Apollinaire then seized upon the name Orphism, and ascribed all that had seemed desirable to him in Futurism – and to a certain extent in Cubism – to Delaunay's innovations. This brought forth an angry cry from Boccioni ('I Futuristi plagiati in Francia', *Lacerba*, 1 no. 7 (1 Aprile 1913), 66–68). The Futurists were sensitive about having been made second-class Cubists in Apollinaire's *Les Peintres cubistes*, and his not listing them among the 'Orphic Cubists'. There is no question that Apollinaire had incorporated into his statements about Orphism the Futurists' orgiastic world view as well as their jealously guarded word 'simultaneity', which they had been the first to use in print in a painting context. (See Preface to Bernheim-Jeune Gallery Exhibition, February 1912.) A temporary peace between the Futurists and Apollinaire was reached in mid-1913, apparently as a result of Marinetti's mediations (*Archivi*, 1, Marinetti to Soffici (date uncertain), 257–58; 278). Apollinaire showed his good will toward the Italians by publishing under their auspices his famous manifesto *L'Anti-tradition futuriste*, dated 29 June 1913. However, his allegiance continued to waver between the French and Italian artists.

The quarrels with Delaunay and Léger were in a sense peripheral to the ones between Apollinaire and the Futurists. In Delaunay's case it revolved around his use of the term 'simultaneity', especially his adoption of it in 1913 for the title of his 'sculpture simultanée'. Apollinaire now accused Delaunay of having taken the word from the Italians, and Boccioni and Delaunay carried on a lively polemic on this score in *Der Sturm* (IV nos. 190–91; 194–95 (Dezember 1913 – Januar 1914) 151; 167). (See also Delaunay, *Du Cubisme à l'art abstrait*, 135 ff; Roger Shattuck, 'Une Polémique d'Apollinaire', *Le Flâneur des deux rives*, no. 4 (Décembre 1954) 41–45; Lionello Venturi, 'Boccioni e Delaunay', *Commentari*, x no. 4 (Ottobre-Dicembre 1959) 238 ff.)

Léger, like Apollinaire, was basically in sympathy with the Futurist point of view, and, according to Severini, wished to join the movement (*Tutta la vita*, 173). But in his first conference at the Académie Wassilief when defining the ways in which dynamism could be rendered pictorially, he stated that the Impressionists were the first to think in these terms,

and gave no credit at all to the Futurists. Boccioni felt again that his movement had been slighted. In *Lacerba* (1 no. 15 (1 Agosto 1913) 170) he said: 'l'Italia è considerata all'esterno come la Beozia europea. Noi sentiamo violentemente il dovere di gridare alto la precedenza dei nostri sforzi . . . Le nostre manifestazioni artistiche non hanno mai la "chance" che dà la marca di Parigi.' (Léger, 'Les Origines de la peinture et sa valeur representative', *Montjoie*, nos. 8, 9–10 (29 Mai; 14–29 Juin 1913).)

A further, mild international altercation broke out in July 1913, when the Parisian painter MacDelmarle published in *Comoedia* an unsolicited Futurist manifesto, *Manifeste futuriste contre Montmartre*. Severini apparently accused him of appropriating Futurist ideas, but Marinetti intervened and supported MacDelmarle, ingeniously capitalizing upon this polemic by republishing the statement in *Lacerba*, 1 no. 16 (15 Agosto 1913), 173–74.

SELECTED BIBLIOGRAPHY

Because the essential *Archivi del Futurismo* contain a full, if not exhaustive, bibliography, only the most important and/or accessible items are given here.

Altomare, Libero (Remo Mannoni), *Incontri con Marinetti e il Futurismo* (Rome: Corso 1954).

Apollinaire, Guillaume, *Anecdotiques* (Paris: Stock 1926, Gallimard 1955).

—, *Chroniques d'Art* (Paris: Gallimard 1960).

Apollonio, Umbro, *Antonio Sant'Elia*. Documenti, note storiche e critiche a cura di Leonardo Mariani (Milan: Il Balcone 1958).

Argan, Giulio Carlo, *Umberto Boccioni*. Scelta degli scritti, regesti, bibliografia e catalogo delle opere a cura di Maurizio Calvesi (Rome: De Luca 1953).

Ballo, Guido, *Boccioni* (Milan: Saggiatore 1964).

—, *Preistoria del Futurismo* (Milan: Maestri 1960).

Banham, Reyner, *Theory and Design in the First Machine Age* (New York: Praeger 1960).

—, 'Sant'Elia', *The Architectural Review*, CXVII no. 701 (May 1955), 295–301.

Bardi, P. M., *Carrà e Soffici* (Milan: Belvedere 1930).

Barr, Alfred H., Jr, *Cubism and Abstract Art* (New York: Museum of Modern Art 1936).

Baumgarth, Christa, *Geschichte des Futurismus* (Reinbeck bei Hamburg: Rowohlt 1966).

—, 'Die Anfänge der futuristischen Malerei', *Mitteilungen des Kunsthistorischen Instituts in Florenz*, XI nos. 2–3 (November 1964), 167–92.

Bergman, Pär, *'Modernolatria' et 'Simultaneità'. Recherches sur deux tendances dans l'avant-garde littéraire en Italie et en France à la veille de la première guerre mondiale* (Uppsala: Studia Litterarum Upsaliensia 2, Bonniers 1962).

Bellonzi, Fortunato, *Saggio sulla poesia di Marinetti* (Urbino: 1943).

—, 'Filippo Tommaso Marinetti', *La Fiera Letteraria*, IX no. 7 (14 Febbraio 1954).

Blast (London: 1914–15).

Bobbio, Aurelia, *Le riviste fiorentine del principio del secolo. (1903–1916)* (Florence: Sansoni 1936).

Boccioni, Umberto, *Pittura scultura futuriste (dinamismo plastico)* (Milan: Poesia 1914). *Opera completa* (Foligno: Campitelli 1927), same as above with additional articles, letters, &c., ed. by F. T. Marinetti; *Estetica e arte futuriste* (Milan: Il Balcone 1946), same as above without articles, letters.

Borgese, G. A., 'Gli allegri poeti di Milano', *La vita e il libro* (Turin: Bocca 1911).

La Biennale di Venezia, IX no. 36–37 (Luglio-Dicembre 1959).

Bragaglia, Anton Giulio, *Fotodinamismo futurista* (Rome: Nalato (1913)).

Cahiers d'Art (Paris: xxv no. 1 (1950)).

Calvesi, Maurizio, 'Il futurismo di Boccioni: formazione e tempi', *Arte antica e moderna*, II (Aprile-Giugno 1958), 149–67.

Carrà, Carlo D., *Guerrapittura* (Milan: Poesia 1915).

—, *Pittura metafisica* (Florence: Vallecchi 1919; 2ª edizione riveduta, Milan: Il Balcone 1945).

—, *Ardengo Soffici* (Rome: Valori Plastici 1922).

—, *La mia vita* (Rome: Longanesi 1943; 2ª edizione, Milan: Rizzoli 1945).

—, *Il rinnovamento delle arti in Italia* (Milan: Il Balcone 1945).

—, *Aroldo Bonzagni*. Note di Aldo Carpi (Bologna: Cappelli (1961)).

Carrieri, Raffaele, *Pittura, scultura d'avanguardia* (*1890–1950*) (Milan: Conchiglia 1950).

—, *Avant-garde Painting and Sculpture* (*1890–1955*) *in Italy* (Milan: Comus 1955).

—, *Il futurismo* (Milan: Milione 1961).

Clough, Rosa Trillo, *Looking Back at Futurism* (New York: Cocce Press 1942).

—, *Futurism. The Story of a Modern Art Movement. A new Appraisal* (New York: Wisdom Library 1961).

Colla, Ettore, 'Pittura e scultura astratta di G. Balla', *Arti visive*, no. 2 (Settembre-Ottobre 1952).

Coquiot, Gustave, *Cubistes, futuristes, passéistes* (Paris: Ollendorf 1914).

Costantini, Vincenzo, *Pittura italiana contemporanea dalla fine dell'ottocento ad oggi* (Milan: Hoepli 1934).

Courthion, Pierre, *Gino Severini* (Milan: Hoepli 1930).

Crispolti, Enrico, *Il secondo futurismo: 5 pittori + 1 scultore, Torino, 1923–1938* (Torino: Pozzo 1962).

Curjel, Hans, 'Bemerkungen zum Futurismus.' *Kunstwerk-Schriften*, Vol. XXIII (Baden-Baden, 1951), 5–13.

Delaunay, Robert, *Du cubisme à l'art abstrait*. Documents inédits publiés par Pierre Francastel et suivis d'un catalogue de l'oeuvre de R. Delaunay par Guy Habasque. (Paris: S.E.V.P.E.N. 1957).

Däubler, Theodor, *Im Kampf um die moderne Kunst* (5. Auflage, Berlin: Reiss 1920).

Dorazio, Piero, *La fantasia dell'arte nella vita moderna* (Rome: Polveroni e Quinti 1955).

Drudi Gambillo and Fiori, Teresa, eds., *Archivi del futurismo* (Rome: De Luca, Vol. I, 1958; Vol. II, 1962).

Eddy, Arthur J., *Cubists and Post-Impressionism* (Chicago: McClurg 1914).

Einstein, Carl, *Die Kunst des 20. Jahrhunderts* (Berlin: Propyläen 1926).

Fechter, Paul, *Der Expressionismus* (Munich: Piper 1919).

Falqui, Enrico, *Il futurismo – il novecentismo* (Turin: I.L.T.E. 1953).

—, *Bibliografia e iconografia del futurismo* (Florence: Sansoni 1959).

Fezzi, Elda, 'Carrà e la sua modificazione del cubismo', *Critica d'arte*, no. 13–14 (Gennaio-Marzo 1956), 118–24.

La Fiera Letteraria (Rome: IX no. 7) (14 Febbraio 1954).

Fillia (Luigi Colombo), *Pittura futurista. Realizzazioni – affermazioni – polemiche del movimento futurista italiano* (Turin: 1929)

—, *La nuova architettura.* (Turin: Unione tipografico-editrice torinese 1931).

—, *Il futurismo.* (Milan: Sonzogno, 1932).

Flora, Francesco, *Dal romanticismo al futurismo.* (Piacenza: Porta 1921; 2nd ed. Milan: Mondadori 1925).

Frattini, Alberto, 'Marinetti e il futurismo', *I contemporanei*, Vol. 1 (Milan: 1963).

Giedion-Welcker, Carola, *Contemporary Sculpture: An Evolution in Volume and Space* (New York: Wittenborn 1955).

Giani, Giampiero, *Il futurismo 1910–1916* (Venice: Del Cavallino 1950).

de Grada, Raffaele, *Boccioni. Il mito del moderno* (Milan: Club del Libro 1962).

Gray, Camilla, *The Great Experiment: Russian Art 1863–1922* (New York: Abrams 1962).

Golding, John, *Cubism: A History and an Analysis 1907–1914* (London: Faber and Faber 1959).

Haftmann, Werner, *Malerei im 20. Jahrhundert* (Munich: Prestel, Vol. I, 1954; Vol. II, 1955).

Hermet, Augusto, *La ventura delle riviste (1903–1940)* (Florence: Vallecchi 1941).

Huneker, James G., *Ivory, Apes and Peacocks* (New York: Scribner's 1932).

Huyghe, René, ed., *Histoire de l'art contemporain: la peinture* (Paris: Alcan 1935).

Lacerba (Florence: 1913–1915).

Lehrmann, Graziella, *De Marinetti à Maiakovsky* (Fribourg: 1942).

Lemaître, Georges, *From Cubism to Surrealism in French Literature* (Cambridge: Harvard 1941).

Lemaître, Maurice, ed., *Luigi Russolo. L'Art des bruits* (Paris: Richard-Masse 1954).

Lewis, Wyndham, *Time and Western Man* (London: Chatto and Windus 1927).

Lissitzky, El and Arp, Hans, *Die Kunstismen* (Zürich, Munich, Leipzig: Rentsch 1925).

Longhi, Roberto, *Scultura futurista – Boccioni* (Florence: La Voce 1914).

—, *Carlo Carrà* (Milan: 2ª edizione, Hoepli 1945).

Lucini, Gian Pietro, *Il verso libero* (Milan: Poesia 1908).

—, *Revolerate.* Con una prefazione futurista di F. T. Marinetti (Milan: Poesia 1909).

Manifesti del movimento futurista. Broadsides issued first by Poesia, then by Direzione del movimento futurista, Milan. (See *Archivi del futurismo* or C. Baumgarth, *Geschichte des Futurismus*, for chronological lists of their appearance.)

Marchi, Virgilio, *Architettura futurista* (Foligno: Campitelli 1924).

Marchiori, Giuseppe, *Pittura moderna italiana* (Venice: Alfieri 1950).

—, *Scultura italiana moderna* (Venice: Alfieri 1953).

Mariani, Leonardo, 'Disegni inediti di Sant'Elia', *L'Architettura*, I nos. 2, 5 (Luglio–Agosto 1955, Gennaio–Febraio 1956), 210–15, 704–7.

Marinetti, Filippo Tommaso, *La conquête des étoiles* (Paris: La Plume 1902).

—, *Destruction* (Paris: Vannier 1904).

—, *La momie sanglante* (Milan: Verde e Azzurro, n.d.).

—, *D'Annunzio intime* (Milan: Verde e Azzurro, n.d.).

—, *Le roi Bombance* (Paris: Mercure de France 1905).

—, *La ville charnelle* (Paris: 8e édition, Sansot 1908).

—, *Les dieux s'en vont d'Annunzio reste* (Paris: Sansot 1908).

—, *Mafarka le futuriste* (Paris: Sansot 1910).

—, *Poupées électriques* (Paris: Sansot 1909).

—, *Le futurisme* (Paris Sansot 1911).

—, *Le monoplan du pape* (Paris: Sansot 1912).

—, *La bataille de Tripoli* (Milan: Poesia 1912).

—, *Zang Tumb Tuuum Adrianopoli Ottobre 1912. Parole in libertà* (Milan: Poesia 1914).

—, *Les mots en liberté futuristes* (Milan: Poesia 1919).

—, ed., *I poeti futuristi con una proclama di F. T. Marinetti e uno studio sul verso libero di Paolo Buzzi* (Milan: Poesia 1912).

—, ed., *I manifesti del futurismo* (Florence: Lacerba 1914).

—, ed., *Futurismo e fascismo* (Foligno: Campitelli 1924).

—, ed., *Noi futuristi. Teorie essenziali e chiarificazioni* (Milano: Quintieri 1917).

—, ed. *Marinetti e il futurismo* (Rome, Milan: Augustea 1929).

Maritain, Jacques, *Gino Severini* (Paris: Gallimard 1930).

La Martinella di Milano, XII no. 10 (Octobre 1958), 523–43.

Martini, Carlo, '*La Voce*'. *Storia e bibliografia* (Pisa: Nistri Lischi 1956).

Moretti, Alfredo, *Futurismo* (Turin: Paravia 1939).

Nicodemi, Giorgio, *Romolo Romani* (Brescia: Geroldi 1927).

Pacchioni, Guglielmo, *Carlo Carrà* (Milan: Milione 1945; 2nd ed. 1959).

Panteo, Tullio, *Il poeta Marinetti* (Milan: Società editoriale milanese 1908).

Papini, Giovanni, *Il mio futurismo* (2a edizione Florence: Lacerba 1914).

—, *L'esperienza futurista* (Florence: Vallecchi 1919).

—, *Ardengo Soffici* (Milan: Hoepli 1933).

Pavolini, Corrado, *F. T. Marinetti* (Rome: Formiggini 1924).

Poesia (Milan: 1905–1909).

Pratella, Francesco Balilla, *Musica futurista per orchestra*. Riduzione per pianoforte (Bologna: Bongiovanni 1912). Cover by Boccioni.

Prieberg, Fred K., *Musica ex machina* (Frankfurt-Berlin: Ullstein 1960).

Ragusa, Olga, *Mallermé in Italy: Literary Influence and Critical Response* (New York: Vanni 1957).

Rodker, John, *The Future of Futurism* (London: Kegan Paul, Trench, Trübner 1926).

Rosenblum, Robert, *Cubism and Twentieth-Century Art* (New York: Abrams 1960).

Russolo, Luigi, *Al di là della materia* (Milan: 1938; 2ª edizione Ferriani 1961).

Russolo, Maria Zanovello, Nebbia, Ugo, and Buzzi, Paolo, *Russolo, l'uomo l'artista* (Milan: Corticelli 1958).

Samuel, Horace B., *Modernities* (London: Kegan Paul, Trench, Trübner 1914).

Sarfatti, Margherita, 'Umberto Boccioni', *Rassegna d'Arte*, xvi nos. 3-4 (1917), 41-50.

Sartoris, Alberto, *Antonio Sant'Elia* (Milan: Scheiwiller 1930).

Schirilò, Vincenzo, *Dall'anarchia all'accademia. Note sul futurismo* (Palermo: La Tradizione 1932).

Settimelli, Emilio, *Marinetti, l'uomo e l'artsta* (Milan: Poesia 1921).

Severini, Gino, *Du cubisme au classicisme* (Paris: Povolozky 1921).

—, *Ragionamenti sulle arti figurative* (Milan: Hoepli 1936).

—, *Tutta la vita di un pittore* (Milan: Garzanti 1946).

Soby, James Thrall and Barr, Alfred H., Jr, *Twentieth-Century Italian Art* (New York: Museum of Modern Art 1949).

Der Sturm (Berlin 1910–1932; especially 1910–1916).

Soffici, Ardengo, *Cubismo e oltre* (Florence: La Voce 1913); republished in enlarged edition as *Cubismo e futurismo* (Florence: La Voce 1914).

—, *Giornale di bordo* (Florence: Vallecchi 1915).

—, *BÏF§ZF + 18. Simultaneità e chimismi lirici* (Florence: Vallecchi 1915, 1919).

—, *Scoperte e massacri. Scritti sull'arte* (Florence: Vallecchi 1919).

—, *Primi principi di una estetica futurista* (Florence: Vallecchi 1920).

—, *Rete mediterranea* (Florence: Vallecchi 1920).

—, *Carlo Carrà* (Milan: Hoepli 1928).

—, *Ricordi di vita artistica e letteraria* (Florence: Vallecchi 1930).

—, *Autoritratto d'artista italiano nel quadro di suo tempo*. Vol. i, *L'uva e la croce;* Vol. ii, *Passi tra le rovine;* Vol. iii, *Il salto vitale;* Vol. iv, *Fine di un mondo* (Florence: Vallecchi 1951, 1952, 1954, 1955).

Taylor, Joshua C., *Futurism* (New York: Museum of Modern Art 1961).

—, *The Graphic Work of Umberto Boccioni* (New York: Museum of Modern Art 1961).

Vaccari, Walter, *Vita e tumulti di F. T. Marinetti* (Milan: Omnia 1959).

Valsecchi, Marco, *U. Boccioni* (Venice: Cavallino 1950).

Venturi, Lionello, *Italian Painting from Caravaggio to Modigliani* (Geneva: Skira 1952).

—, *Gino Severini* (Rome: De Luca 1961).

Veronesi, Giulia, 'Otto Boccioni inediti', *Emporium*, cxxii (Dicembre 1955), 243–49.

Vitali, Lamberto, *L'incisione italiana moderna* (Milan: Hoepli 1934).

Viviani, Alberto, *Il poeta Marinetti e il futurismo* (Turin: Paravia 1940).

—, *Giubbe rosse (1913–1914–1915)* (Florence: Vallecchi 1933).

La Voce (Florence: 1908–1916).

Walden, Herwarth, *Einblick in Kunst: Expressionismus, Futurismus, Kubismus* (Berlin: Der Sturm 1917).

Walden, Nell and Schreyer, Lothar, *Der Sturm. Ein Erinnerungsbuch an Herwarth Walden und die Künstler aus dem Sturmkreis* (Baden-Baden: Klein 1954).

Wright, Willard, H., *Modern Painting. Its Tendency and Meaning* (New York, London: John Lane 1915).

Zevi, Bruno, *Storia dell'architettura moderna* (Turin: Einaudi 1950).

UNPUBLISHED MATERIAL

Balla, Giacomo, 'Demolizione della casa di Balla', written around 1926. In the possession of Signorine Luce and Elica Balla, Rome.

Boccioni, Umberto, Diary, 2 Vols., 6 January to 21 December 1907. In 1960 in the possession of the since deceased Signora Raffaella Boccioni-Callegari, Verona.

Boccioni, Umberto, Letters to Vico Baer. In the possession of the Museum of Modern Art, New York.

EXHIBITION CATALOGUES

Paris. Bernheim-Jeune & Cie. *Les peintres futuristes italiens.* (February 1912).

London. Sackville Gallery. *Exhibition of Works of the Italian Futurist Painters.* (March 1912).

Berlin. Der Sturm. *Zweite Ausstellung: Die Futuristen, U. Boccioni, C. D. Carrà, L. Russolo, G. Severini.* (April–May 1912).

Brussels. Galerie Georges Giroux. *Les peintres futuristes italiens.* (May–June 1912).

(Travelling Exhibition). Gesellschaft zur Förderung moderner Kunst m.b.H. Künstlerische Leitung: Zeitschrift Der Sturm. *Die Futuristen, U. Boccioni, C. D. Carrà, L. Russolo, G. Severini.* (1912–13).

London. Marlborough Gallery. *The Futurist Painter Severini Exhibits His Latest Works.* (April 1913).

Rotterdam. Rotterdamsche Kunstkring. *Les peintres et les sculpteurs futuristes italiens.* (May–June 1913).

Berlin. Der Sturm. *Sechzehnte Ausstellung: Gemälde und Zeichnungen des Futuristen Gino Severini.* (June–August 1913).

Berlin. Der Sturm. *Erster Deutscher Herbstsalon.* (September–November 1913).

London. The Doré Galleries. *Post-Impressionist and Futurist Exhibition.* (October 1913–January 1914).

Florence. Galleria Gonnelli. *Esposizione di pittura futurista di 'Lacerba'.* (November 1913–January 1914).

Florence. Galleria Gonnelli. *Esposizione di scultura futurista del pittore e scultore futurista U. Boccioni.* (March–April 1914).

Rome. Galleria Futurista. Direttore: G. Sprovieri. *Esposizione di scultura futurista del pittore e scultore futurista U. Boccioni.* (December 1913).

Rome. Galleria Futurista. Direttore: G. Sprovieri. *Esposizione di pittura futurista. Boccioni, Carrà, Russolo, Balla, Severini, Soffici.* (February–March 1914).

London. The Doré Galleries. *Exhibition of the Works of the Italian Futurist Painters.* (April–May 1914).

Naples. Galleria Futurista. Direttore: G. Sprovieri. *Prima esposizione di pittura futurista. Boccioni, Carrà, Russolo, Balla, Severini, Soffici.* (May–June 1914).

San Francisco. *Panama–Pacific International Exposition.* (Summer 1915).

Rome. Sala d'Arte A. Angelelli. *Esposizione fu Balla e Balla futurista.* (December 1915).

Milan. Galleria Centrale d'Arte. Palazzo Cova. *Boccioni: pittore e scultore futurista U. Boccioni.* (December 1916–January 1917).

Milan. Galleria Chini. *Mostra personale del pittore futurista Carlo Carrà.* (December 1917 – January 1918).

INDEX

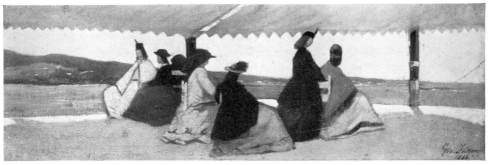

1　Giovanni Fattori. *Rotonda de Palmeri*. 1866. Oil on canvas, $4\frac{7}{8}'' \times 14''$ (Sight)

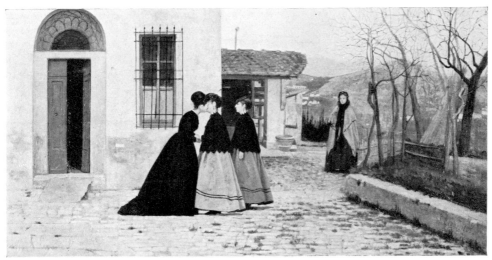

2　Silvestro Lega. *La Visità*. 1868. Oil on canvas, $12\frac{1}{4}'' \times 23\frac{3}{4}''$

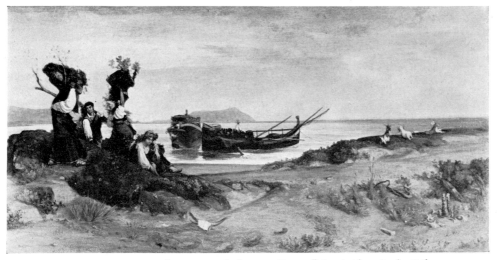

3　Giovanni Costa. *Donne che portano la legna a Porto d'Anzio.* (*c.* 1852). Oil on canvas, $31\frac{1}{2}'' \times 47\frac{1}{2}''$

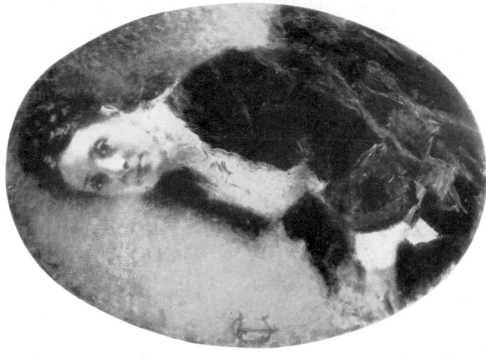

5 Tranquillo Cremona. *Ritratto della Signora Deschamps.* (1875). Oil on canvas, 37¾″ × 27½″

4 Daniele Ranzoni. *Ritratto della Signora Tonazzi.* (1888)

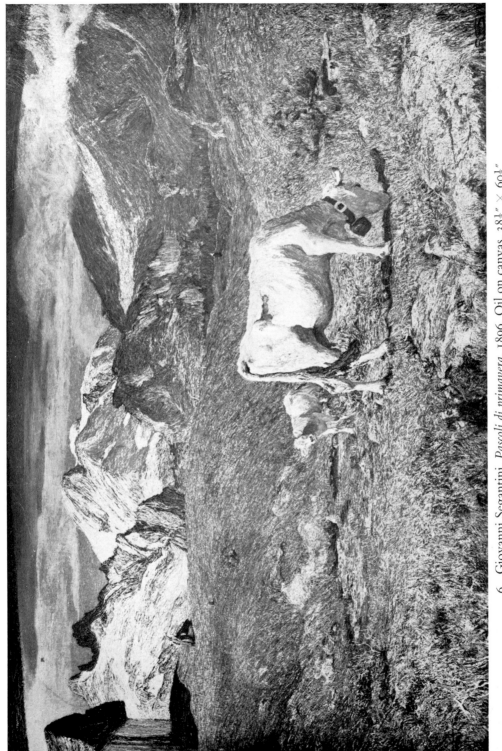

6 Giovanni Segantini. *Pascoli di primavera.* 1896. Oil on canvas, $38\frac{1}{2}'' \times 60\frac{1}{2}''$

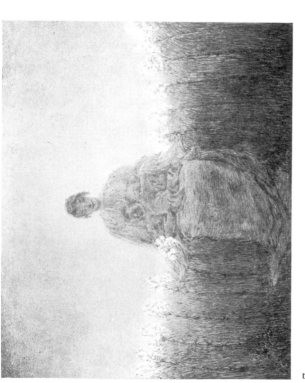

7 Gaetano Previati. *La Madonna dei gigli*. (1894). Oil on canvas,
 71" × 7′ 5"

8 Gaetano Previati. *Via Crucis*. (1902). Oil on canvas,
 $22\frac{1}{2}$" × $17\frac{1}{2}$"

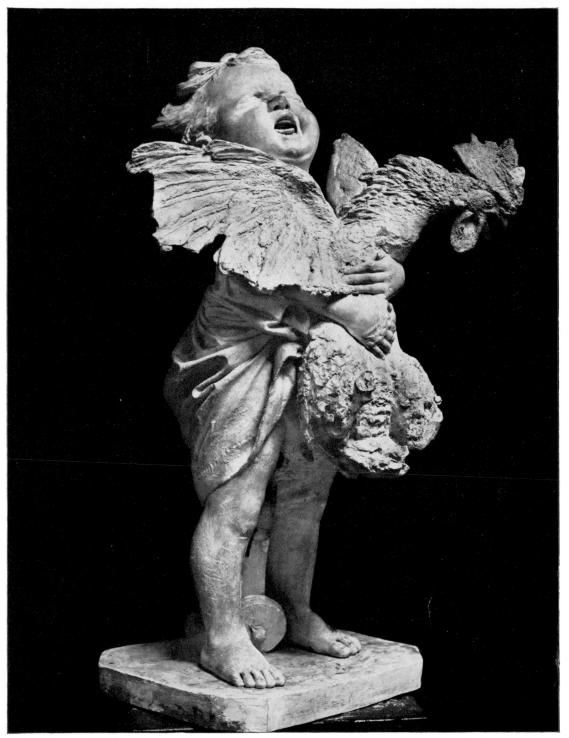

9 Adriano Cecioni. *Bambino col gallo*. (1868). Plaster, $31\frac{1}{2}''$ high including base

11 Medardo Rosso. *Bacio sotto il lampione*. (1882). Bronze, 18⅞" high including base

10 Giuseppe Grandi. *Pleureuse*. (Date unknown). Bronze, 12¼" high including base

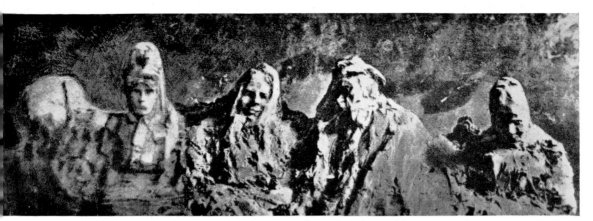

12 Medardo Rosso. *Impressione d'omnibus.* (1883–4). Destroyed

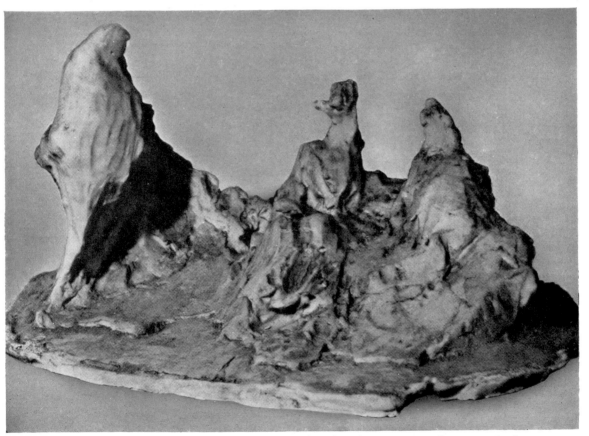

13 Medardo Rosso. *Conversazione in giardino.* (1893). Wax over plaster, 17″ high

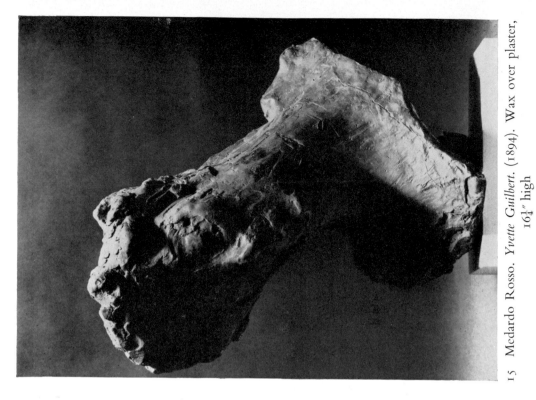

15 Medardo Rosso. *Yvette Guilbert.* (1894). Wax over plaster, $16\frac{1}{4}''$ high

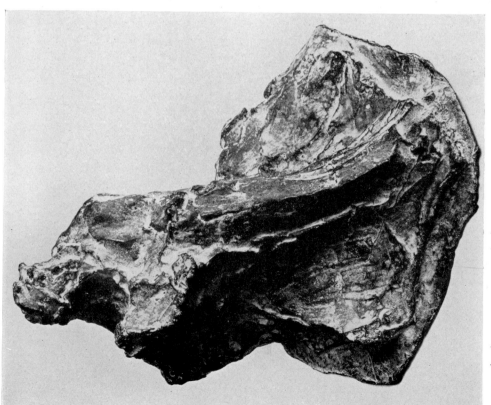

14 Medardo Rosso. *Uomo che legge il giornale.* (1894). Bronze, 10″ high

18 Umberto Boccioni. *Allegoria del Natale.* (1908).
Ink drawing reproduced in *L'Illustrazione Italiana*,
xxxv no. 52 (27 Dicembre 1908), 617

16 Umberto Boccioni. *Il Sogno: Paolo e Francesca.* (1908). Oil on canvas,
$55\frac{1}{4}'' \times 51\frac{1}{4}''$

17 Umberto Boccioni. Study for *Il Sogno: Paolo e Francesca*. 1908. Pencil, pen and black ink with blue and ochre wash on white ruled paper, $6\frac{3}{8}'' \times 12\frac{1}{8}''$

19 Umberto Boccioni. Study for *Allegoria del Natale*. (1908). Pencil, pen, brush, and India ink on white wove, $9\frac{7}{8}'' \times 6\frac{5}{8}''$

22 Umberto Boccioni. *Treno a vapore*. 1908. Oil on canvas, 9″ × 23″

20 Umberto Boccioni. Study for *Campagna Lombarda* (*Sinfonia campestre*). (1908). Pencil on white wove, $4\frac{1}{4}$″ × $6\frac{1}{4}$″

21 Umberto Boccioni. *Street with Houses*. (*c.* 1908–9). Crayon on white wove, $6\frac{5}{8}$″ × $4\frac{1}{2}$″

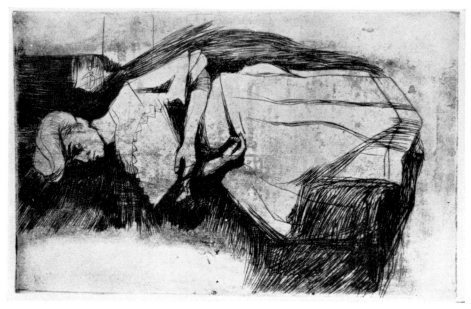

24 Umberto Boccioni. *Seated Woman Holding Fan.* (c. 1909–10). Etching and drypoint, $9\frac{3}{8}'' \times 6''$

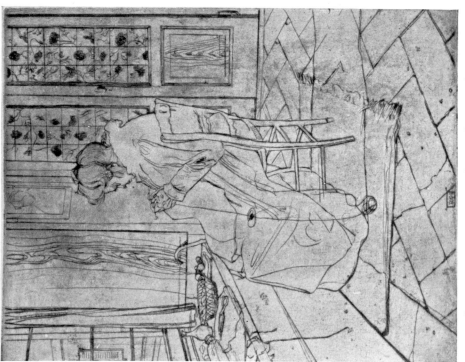

23 Umberto Boccioni. *Boccioni's Mother Crocheting.* 1907. Etching and drypoint, $14\frac{5}{8}'' \times 12\frac{1}{8}''$

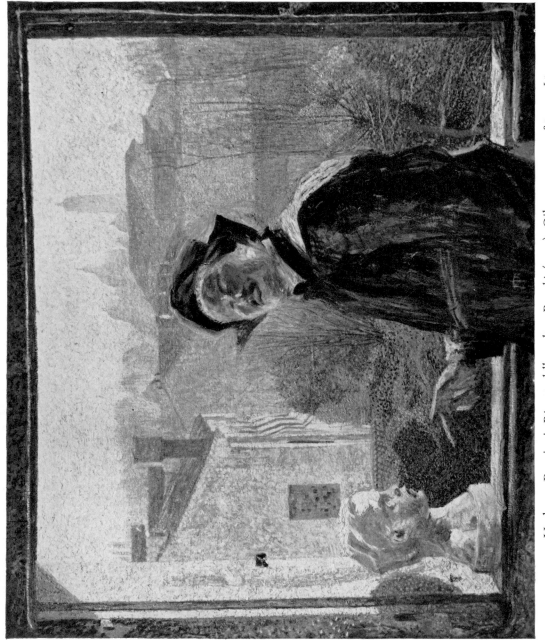

25 Umberto Boccioni. *Ritratto dello scultore Brocchi.* (1907). Oil on canvas, 41¾″ × 49⅝″

26 Umberto Boccioni. *Figura al sole*. 1909. Oil on canvas, $24\frac{1}{2}''\times21\frac{3}{4}''$

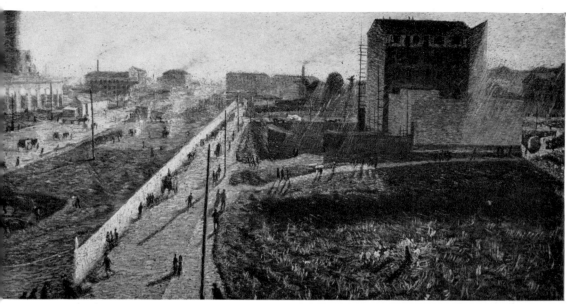

27 Umberto Boccioni. *Officine a Porta Romana*. (1909). Oil on canvas, 29⅝″ × 57¼″

28 Umberto Boccioni. *Mattino*. (1909). Oil on
canvas, 24″ × 21½″

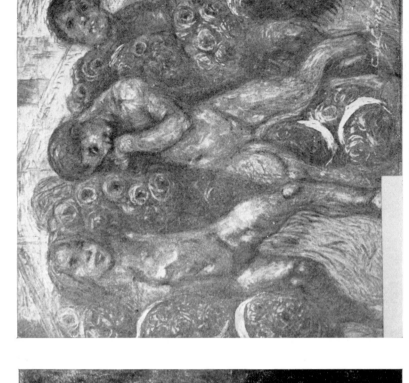

30 Carlo D. Carrà. Cover of the 1909 Annual Exhibition Catalogue of the Famiglia Artistica, Milan. (Whereabouts and medium of the original unknown)

29 Carlo D. Carrà. *Ritratto del padre.* (1903). Oil on canvas

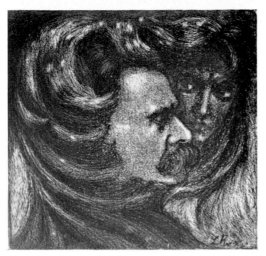

31 Luigi Russolo. *Nietzsche*. (*c.* 1909). Etching, $4\frac{7}{8}'' \times 5''$

32 Romolo Romani. *L'Incubo*. (1904–5). Pencil on paper, $24\frac{3}{4}'' \times 19''$

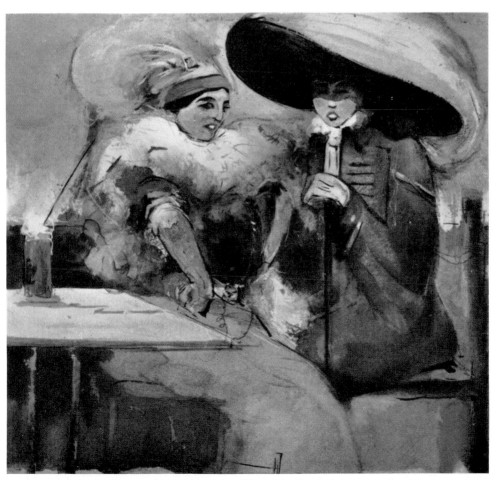

33 Aroldo Bonzagni. *Signore al caffè*. 1908. Gouache on paper, $9'' \times 11''$.

34 Giacomo Balla. *Fallimento.* (c. 1902). Oil on canvas, $46\frac{1}{2}'' \times 63\frac{1}{4}''$

35 Giacomo Balla. *Lavoro*. (*c.* 1902). Oil on canvas, 68¾″ × 49¼″

37 Giacomo Balla. *Salutando*. (*c.* 1908). Oil on canvas, $41\frac{1}{2}''\times 41\frac{1}{2}''$

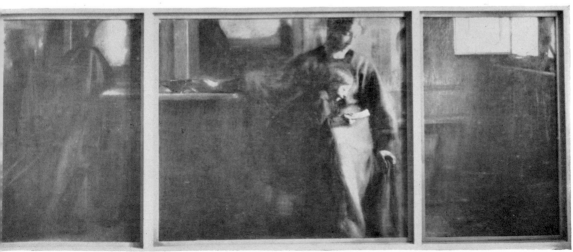

38 Giacomo Balla. *Gli Affetti*. (*c.* 1910). Oil on canvas, $51\frac{1}{2}''\times 118\frac{3}{4}''$ including frame

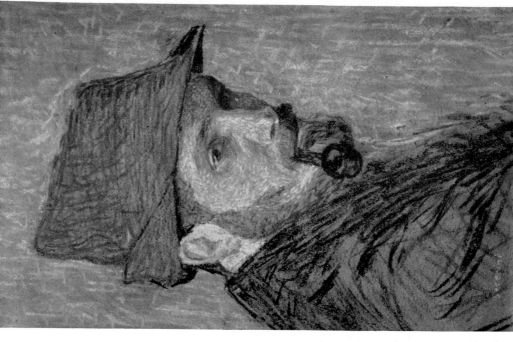

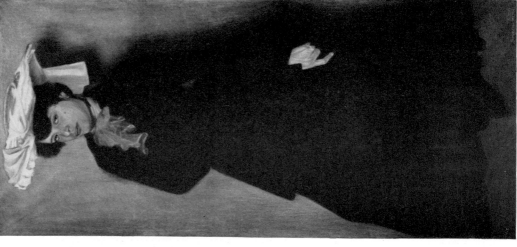

41 Gino Severini. *Portrait du peintre Utter.* (*c.* 1909). Pastel on paper

39 Gino Severini. *La Bohémienne.* 1905. Pastel, on cardboard, 63″ × 29¼″

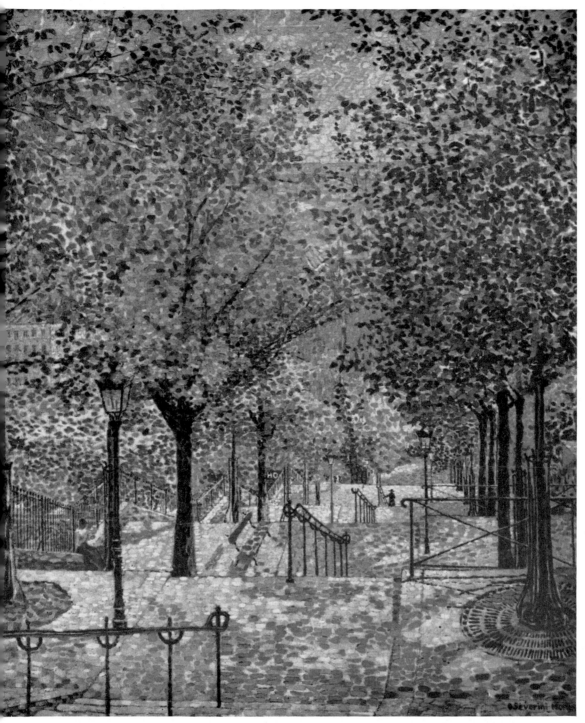

40　Gino Severini. *Printemps à Montmartre.* 1909. Oil on canvas, $28\frac{1}{4}'' \times 23\frac{5}{8}''$

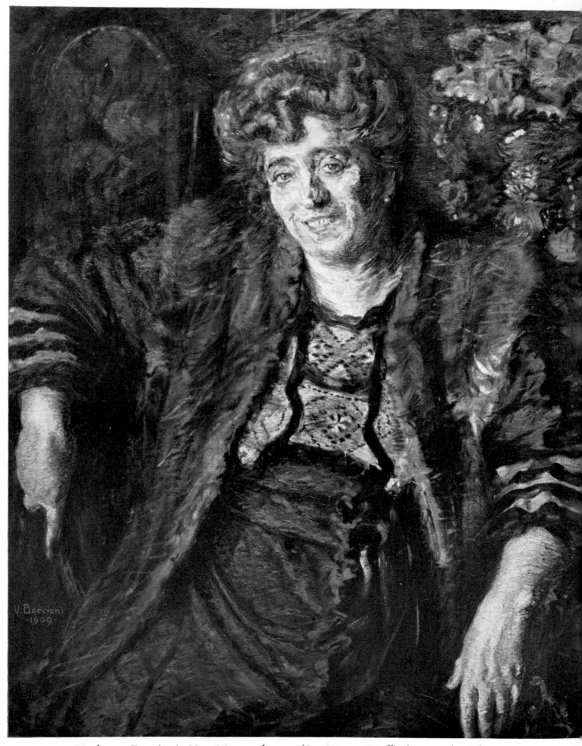

42 Umberto Boccioni. *Una Maestra di scena* (*La Signora Maffi*). (1909–10). Oil on canvas

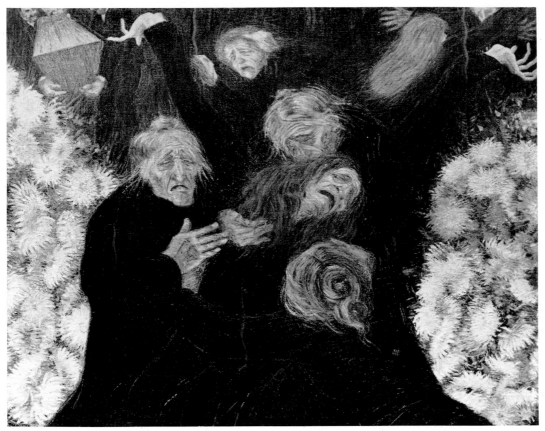

43 Umberto Boccioni. *Lutto*. (1910). Oil on canvas, $41\frac{1}{2}'' \times 53''$

44 Umberto Boccioni. Study for *Lutto*. (1910). Pen and ink on
white wove, $6\frac{1}{8}'' \times 7\frac{3}{8}''$

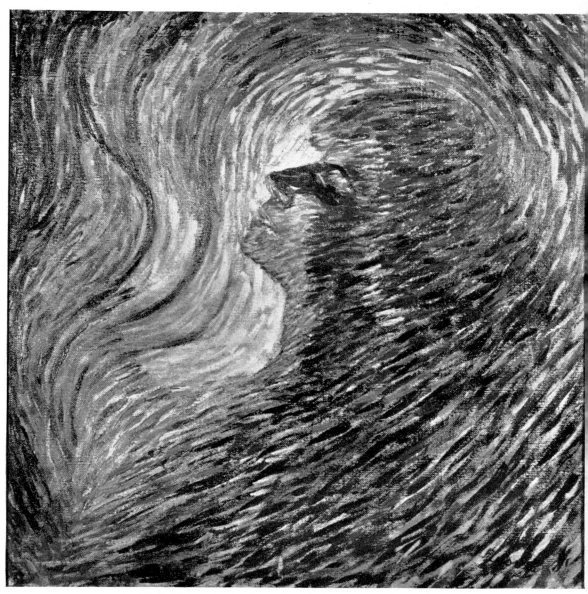

45 Luigi Russolo. *Profumo*. (1910). Oil on canvas, $25\frac{1}{2}'' \times 24\frac{3}{4}''$

46 Luigi Russolo. *Lampi.* (1910). Oil on canvas, $39\frac{1}{2}'' \times 39\frac{1}{2}''$

48 Luigi Russolo. *Città addormentata.* (c. 1909–10). Etching and aquatint, $6\frac{1}{2}'' \times 9\frac{7}{8}''$

47 Carlo D. Carrà. *Notturno in Piazza Beccaria.* 1910. Oil on canvas. $23\frac{3}{8}'' \times 18\frac{1}{8}''$

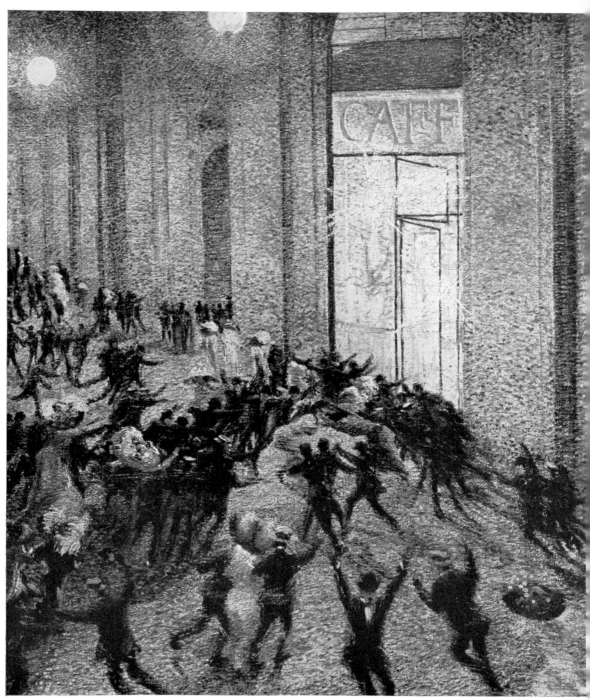

49 Umberto Boccioni. *Rissa in Galleria*. (1910). Oil on canvas, 30″ × 25¼″

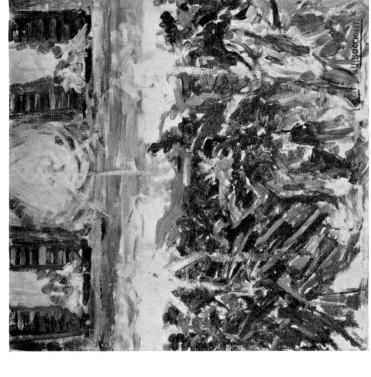

51 Umberto Boccioni. *La Baruffa.* (1911). Oil on burlap, 19⅞″ × 19⅞″

50 Umberto Boccioni. *La Retata.* (1911)

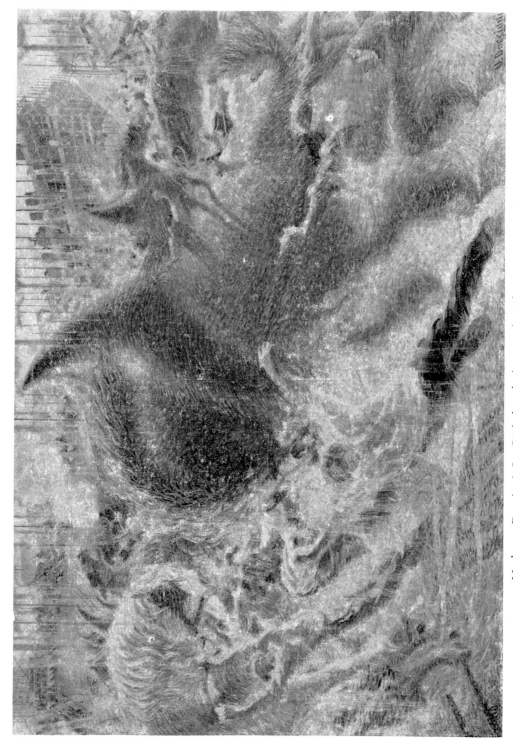

52 Umberto Boccioni. *La Città che sale.* (1910–11). Oil on canvas, 6′ 6½″ × 9′ 10½″

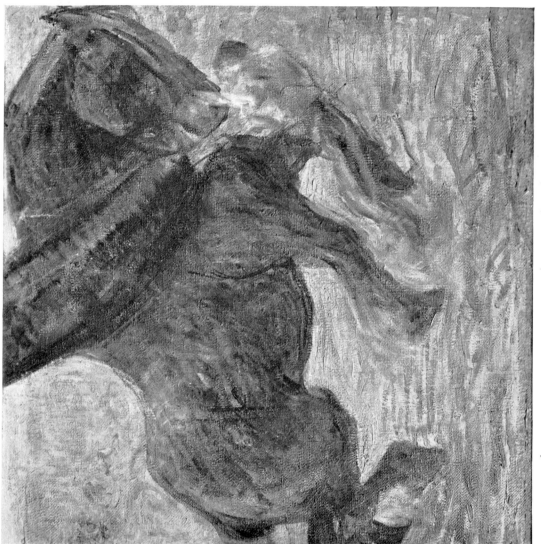

53 Umberto Boccioni. *Gigante e pigmeo*. (c. 1909–10). Oil on canvas, 27¾″ × 39½″

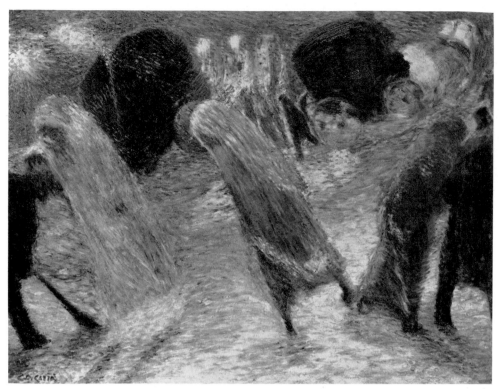

54 Carlo D. Carrà. *Uscita da teatro*. (1910–11). Oil on canvas, $23\frac{3}{4}'' \times 35\frac{1}{2}''$

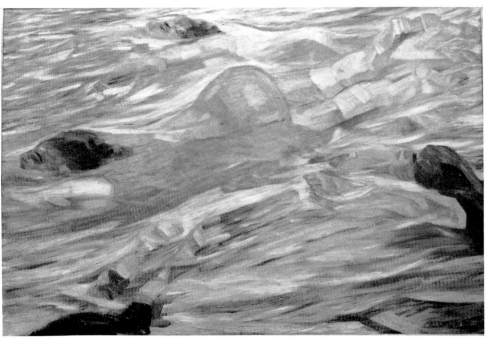

56 Carlo D. Carrà. *Nuoto*. (1910–11). Oil on canvas, $41\frac{1}{2}'' \times 61\frac{1}{4}''$

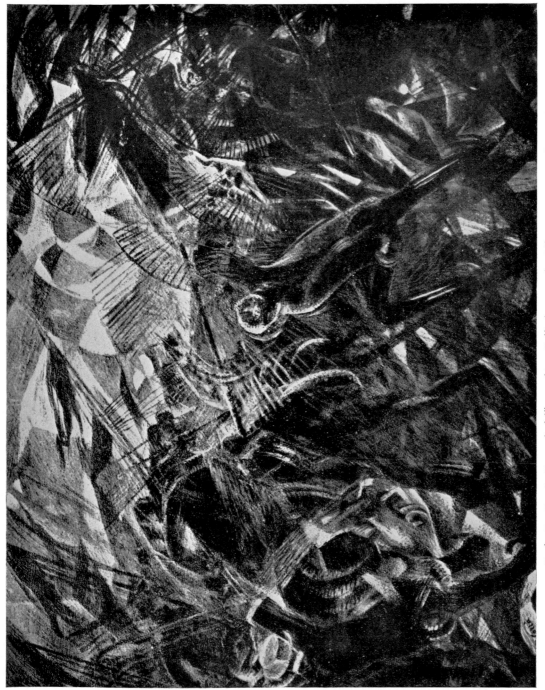

55 Carlo D. Carrà. *Funerali dell' anarchico Galli.* (1910–11). Oil on canvas, 6' 6¼" × 8' 6"

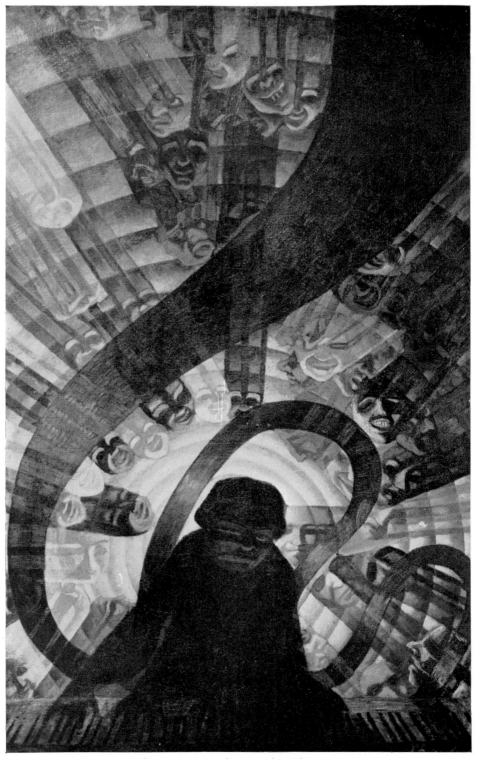

57　Luigi Russolo. *La Musica*. (1911–12). Oil on canvas, 7′ 2″ × 55″

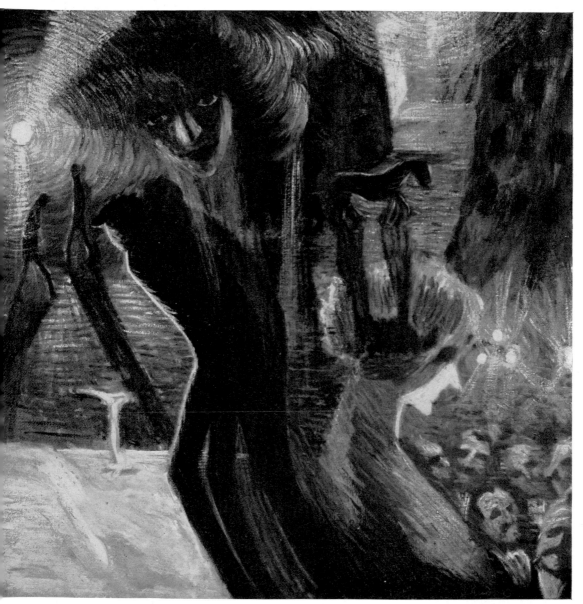

58 Luigi Russolo. *Ricordi di una notte*. (1911). Oil on canvas, $39\frac{3}{4}'' \times 39\frac{3}{8}''$

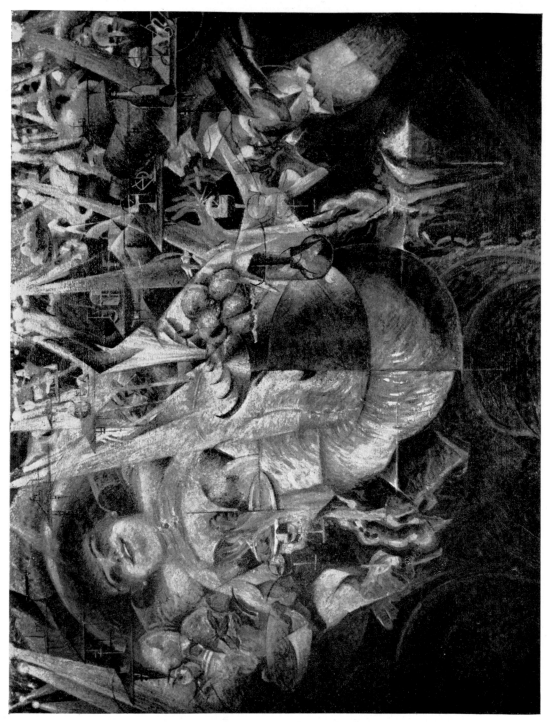

59 Umberto Boccioni. *La Risata*. (1911). Oil on canvas, $43\frac{3}{8}'' \times 57\frac{1}{4}''$

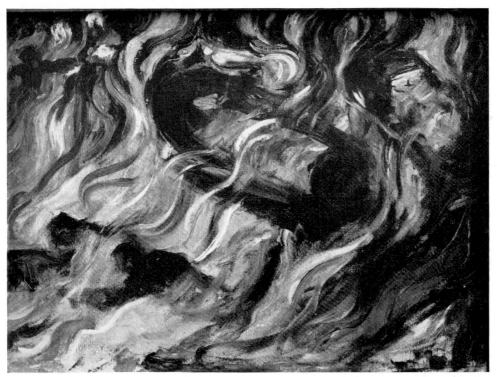

60 Umberto Boccioni. *Stati d'animo: Gli Addii.* (First version; 1911). Oil on canvas, $28\frac{1}{8}'' \times 37\frac{3}{4}''$

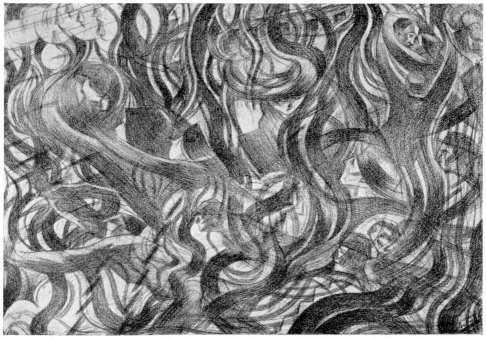

61 Umberto Boccioni. Study for *Stati d'animo: Gli Addii.* (1911). Pencil on paper, $23'' \times 34''$

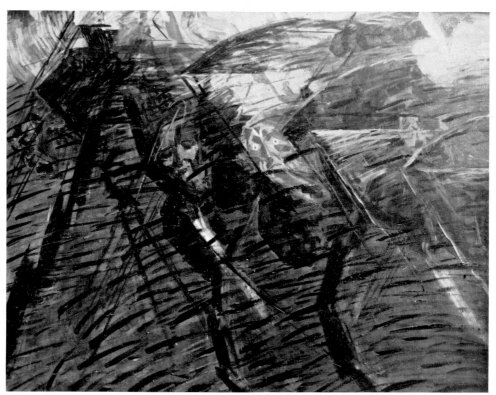

62 Umberto Boccioni. *Stati d'animo: Quelli che vanno.* (First version; 1911). Oil on
canvas, $28\frac{1}{2}'' \times 35\frac{1}{2}''$

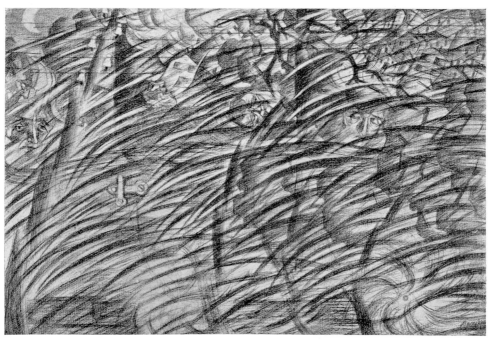

63 Umberto Boccioni. Study for *Stati d'animo: Quelli che vanno.* (1911). Pencil on
paper, $23'' \times 34''$

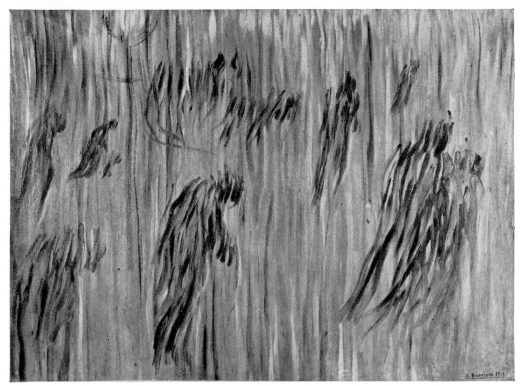

64 Umberto Boccioni. *Stati d'animo: Quelli che restano*. (First version). 1911. Oil on canvas, $28\frac{1}{8}'' \times 37\frac{3}{4}''$

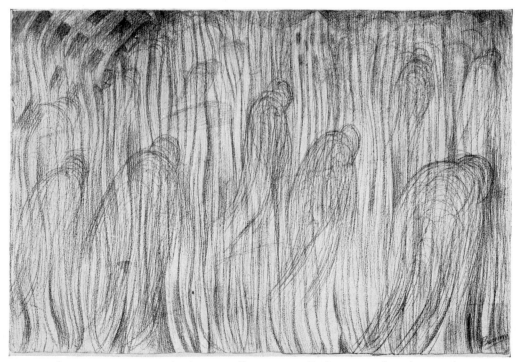

65 Umberto Boccioni. Study for *Stati d'animo: Quelli che restano*. (1911). Pencil on paper, $23'' \times 34''$

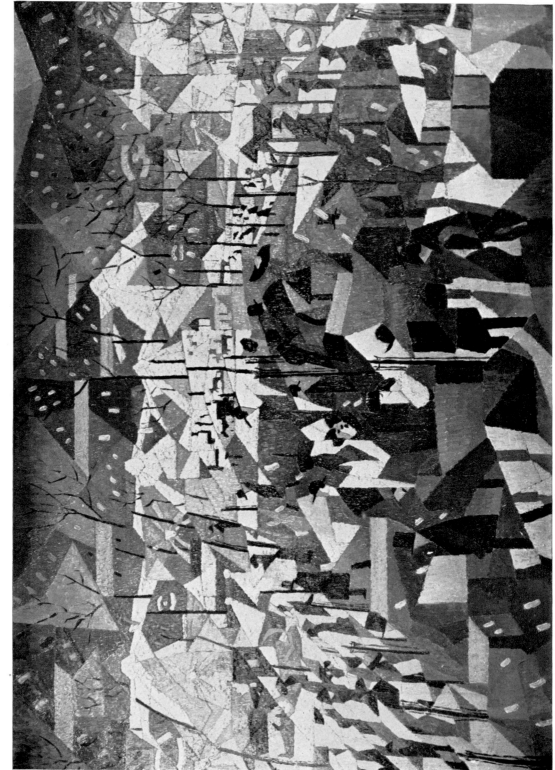

66 Gino Severini, *Le Boulevard*. (*c*. 1910). Oil on canvas, $25\frac{1}{8}" \times 36\frac{1}{8}"$

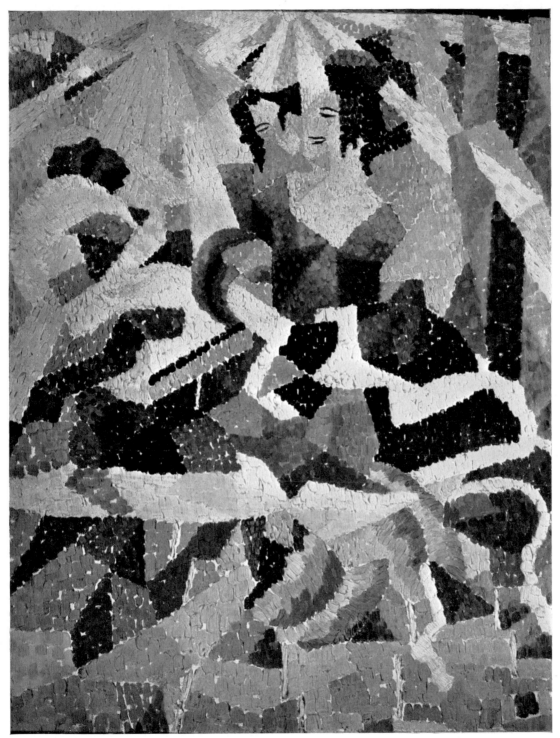

67 Gino Severini. *La Modiste*. (1910–11). Oil on canvas, $25\frac{3}{8}'' \times 18\frac{7}{8}''$

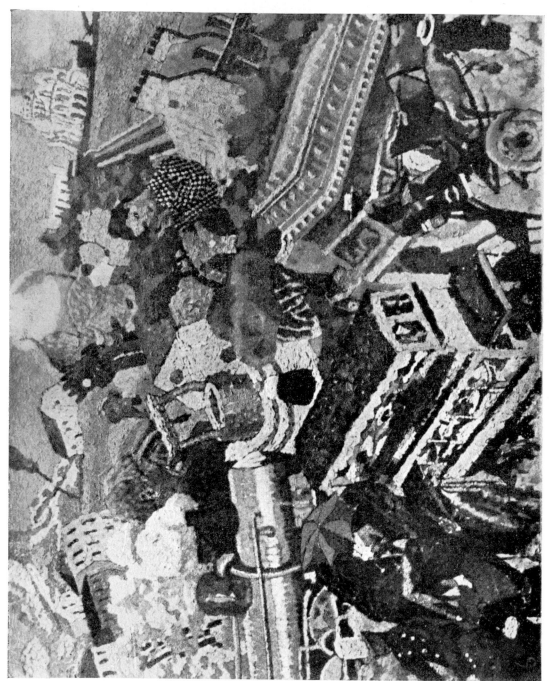

68 Gino Severini. *Souvenirs de voyage.* (1910–11)

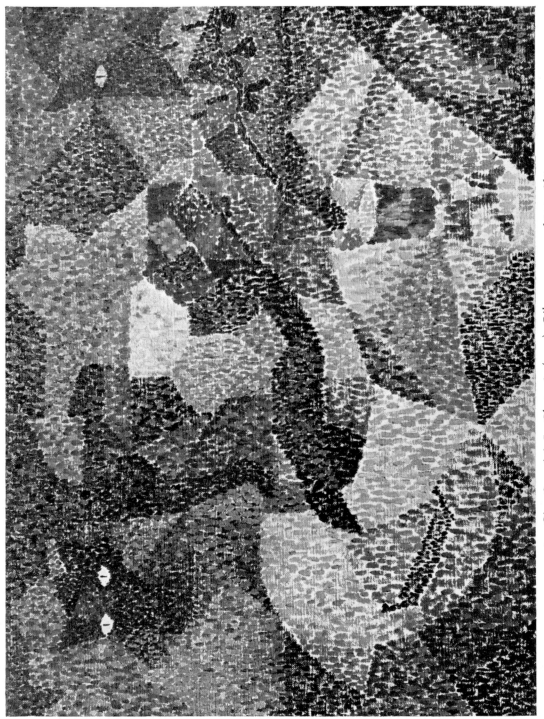

69 Gino Severini. *Le Chat noir*. (1911). Oil on canvas, $21\frac{1}{4}'' \times 28\frac{1}{2}''$

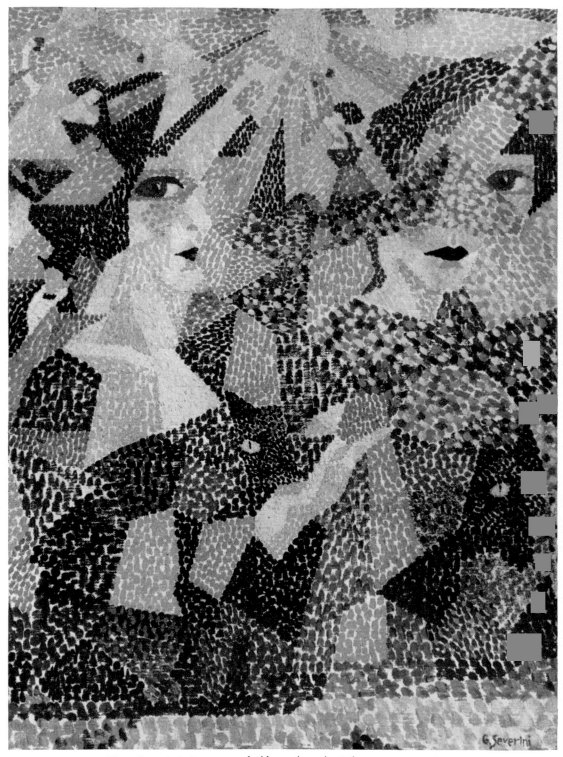

70 Gino Severini. *Danseuse obsédante*. (1911). Oil on canvas, $28\frac{3}{4}'' \times 21\frac{5}{8}''$

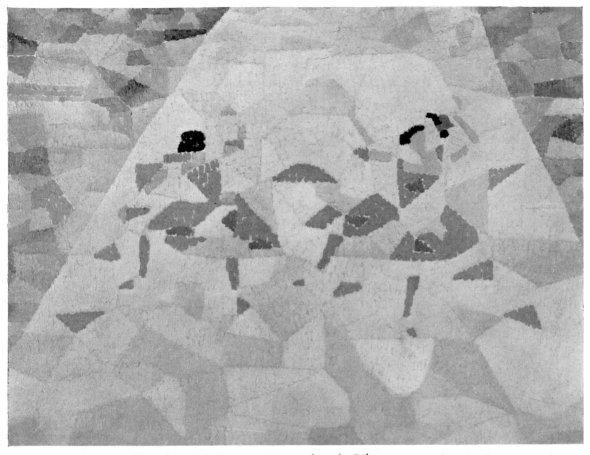

71 Gino Severini. *Danseuses jaunes.* (1911). Oil on canvas, 18″ × 24″

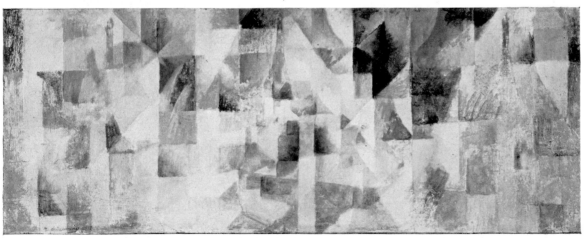

71a Robert Delaunay. *Three-Part Windows.* 1912. Oil on canvas, $13\frac{1}{2}$″ × $35\frac{5}{8}$″

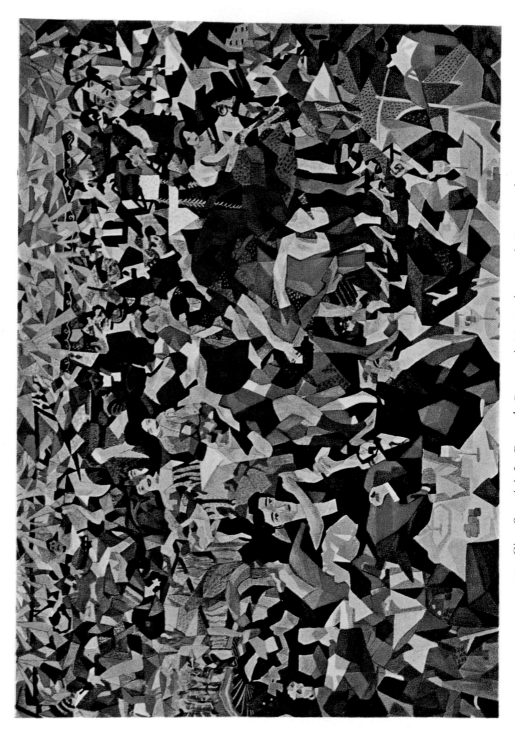

72 Gino Severini. *La Danse du Pan-pan à Monico.* (1910–12). Destroyed

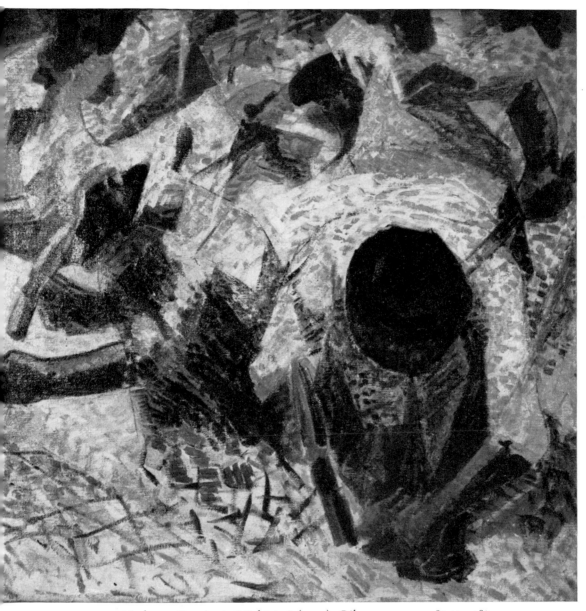

73 Umberto Boccioni. *I Selciatori*. (1911). Oil on canvas, $39\frac{3}{8}'' \times 39\frac{3}{8}''$

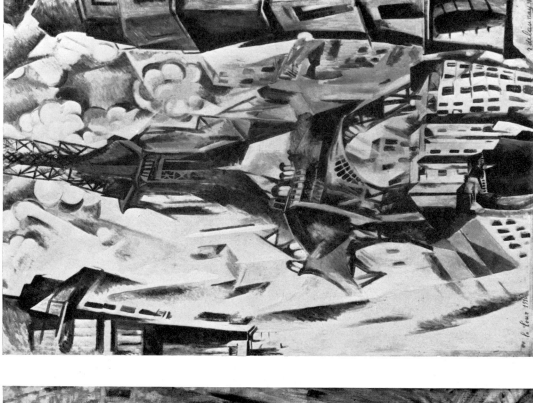

74a Robert Delaunay. *Tour Eiffel.* 1910. Oil on canvas,
79¾″ × 54⅝″

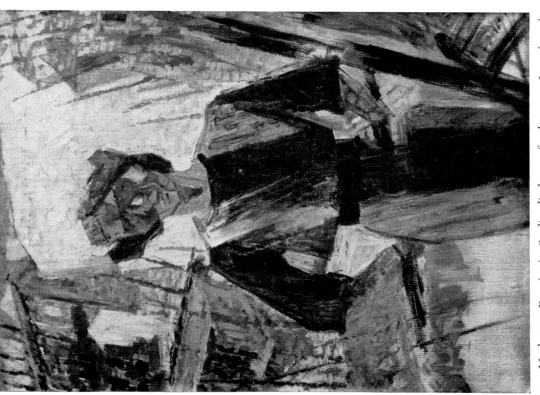

74 Umberto Boccioni. *Studio di donna fra le case – Ines.* (1911).
Oil on canvas, 53⅛″ × 37″

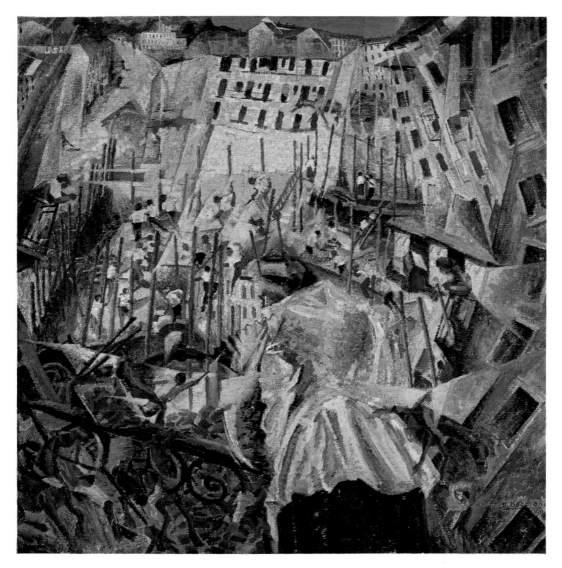

75 Umberto Boccioni. *La Strada entra nella casa.* 1911. Oil on canvas, $39\frac{1}{2}'' \times 39\frac{1}{2}''$

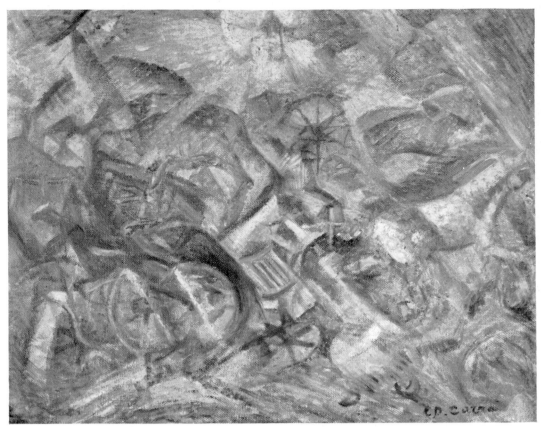

76 Carlo D. Carrà. *Sobbalzi di un fiacre*. (1911). Oil on canvas, $20\frac{3}{8}'' \times 26\frac{1}{2}''$

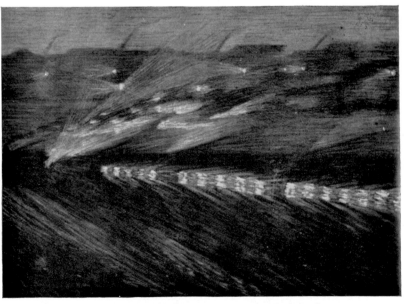

77 Luigi Russolo. *Treno in velocità*. (1911)

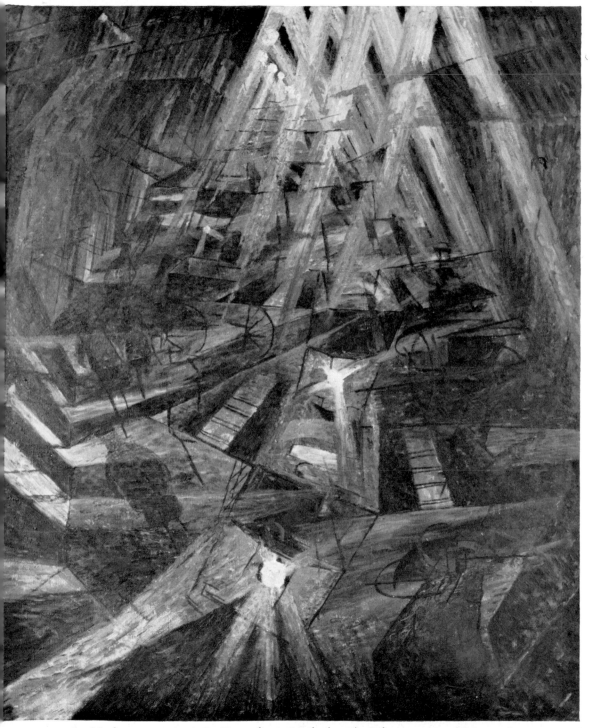

78 Umberto Boccioni. *Le Forze di una strada*. (1911). Oil on canvas, $39\frac{1}{2}'' \times 31\frac{7}{8}''$

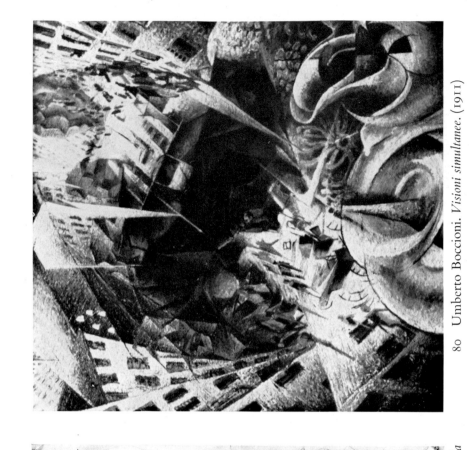

80 Umberto Boccioni. *Visioni simultanee.* (1911)

79 Umberto Boccioni. Study related to *Le Forze di una strada* and *Visioni simultanee.* (1911). Pencil on paper, $17\frac{1}{4}'' \times 14\frac{5}{8}''$

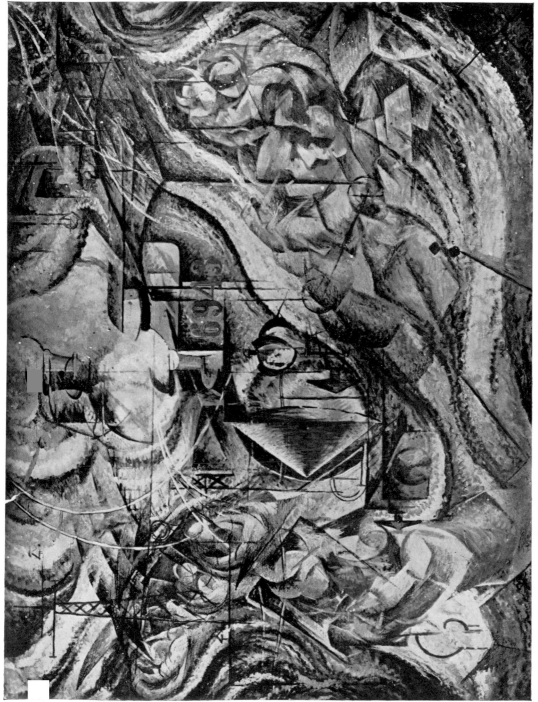

81 Umberto Boccioni. *Stati d'animo: Gli Addii.* (1911). Oil on canvas, $27\frac{3}{4}" \times 37\frac{7}{8}"$

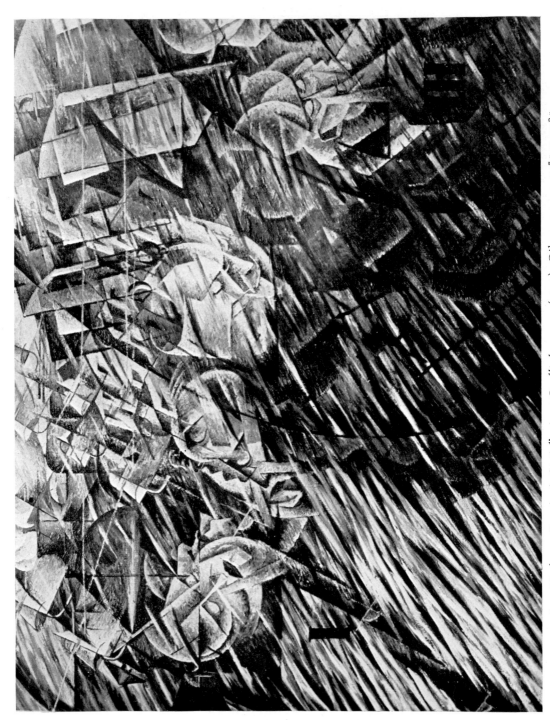

82 Umberto Boccioni. *Stati d'animo: Quelli che vanno.* (1911). Oil on canvas, $27\frac{7}{8}'' \times 37\frac{3}{4}''$

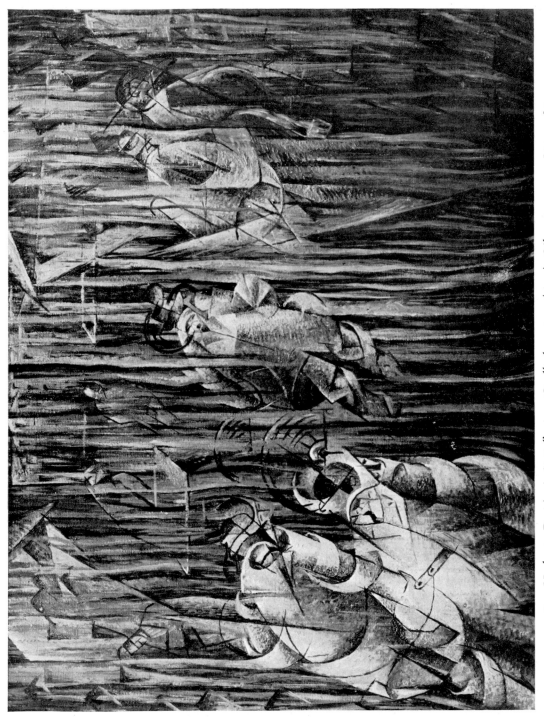

83 Umberto Boccioni. *Stati d'animo: Quelli che restano.* (1911). Oil on canvas, $27\frac{7}{8}'' \times 37\frac{3}{4}''$

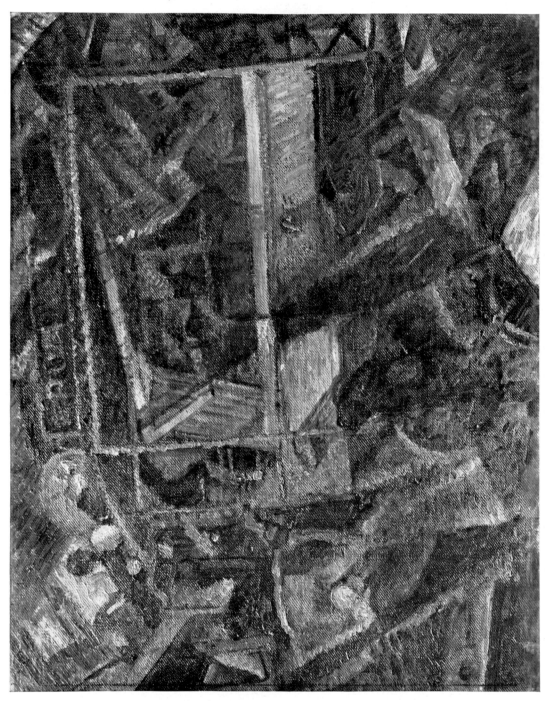

84 Carlo D. Carrà. *Quello che mi disse il tram.* (1911). Oil on canvas, $20\frac{1}{2}'' \times 27''$

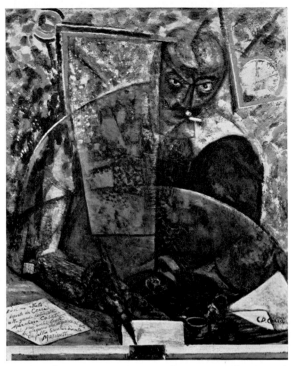

85 Carlo D. Carrà. *Ritratto di Marinetti*. (1911 and later changes). Oil on canvas, $35\frac{3}{8}'' \times 31\frac{1}{2}''$

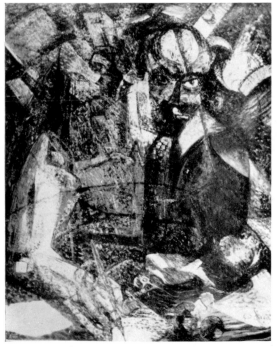

86 Carlo D. Carrà. *Ritratto di Marinetti*. (Original 1911 version)

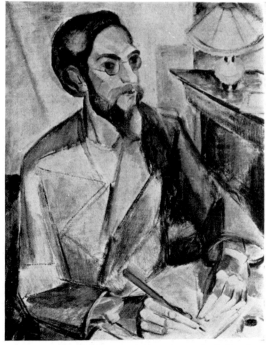

86a Henri Le Fauconnier. *Portrait de Paul Castiaux*. (1910). Oil on canvas, $40\frac{1}{2}'' \times 31\frac{1}{2}''$

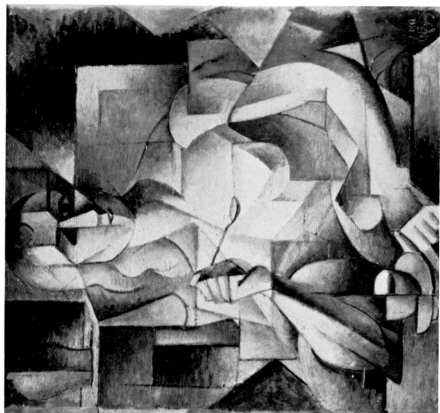

88 Jean Metzinger. *Le Goûter*. 1911. Oil on wood, $29\frac{3}{4}'' \times 27\frac{3}{8}''$

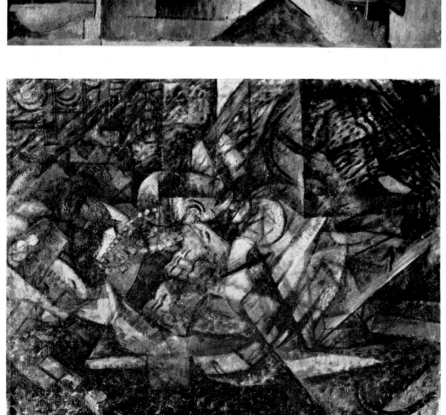

87 Carlo D. Carrà. *Donna e l'assenzio*. (1911). Oil on canvas, $26\frac{5}{8}'' \times 20\frac{5}{8}''$

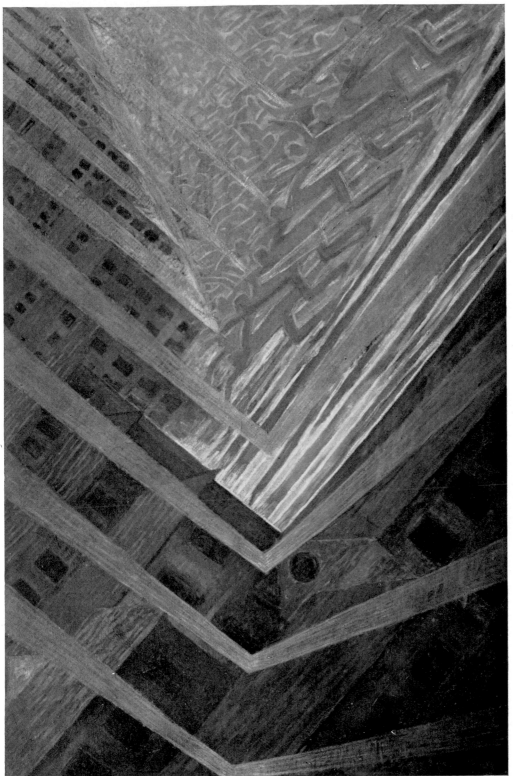

89 Luigi Russolo. *La Rivolta.* 1911. Oil on canvas, 59″ × 7′ 6½″

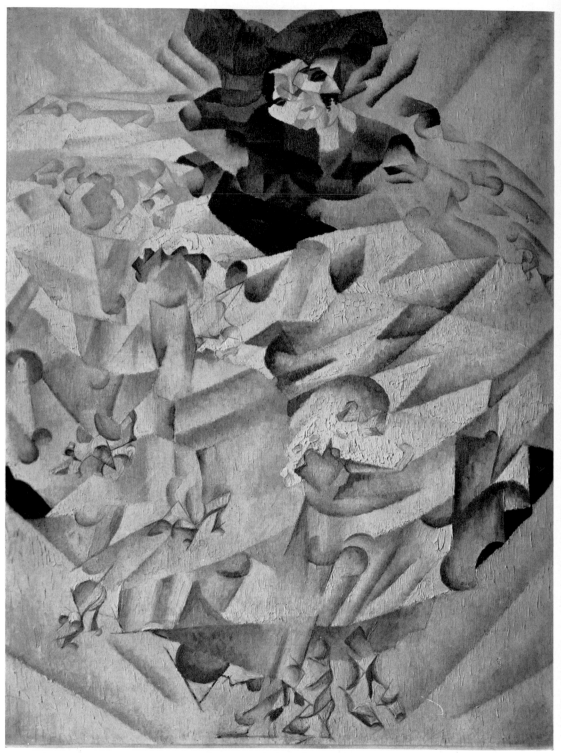

90 Gino Severini. *White Dancer*. (1912). Oil on canvas, $23\frac{5}{8}'' \times 17\frac{3}{4}''$

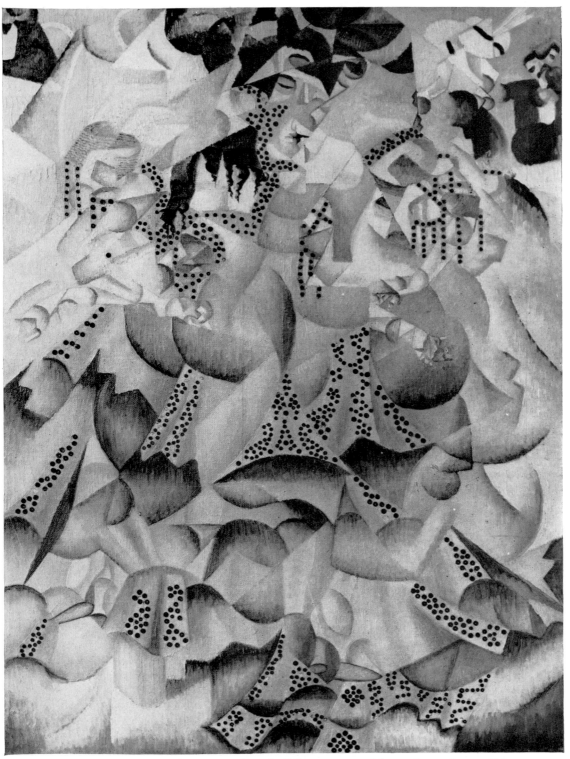

91 Gino Severini. *Blue Dancer*. (1912). Oil on canvas with sequins, $24\frac{1}{8}''$ × $18\frac{1}{4}''$

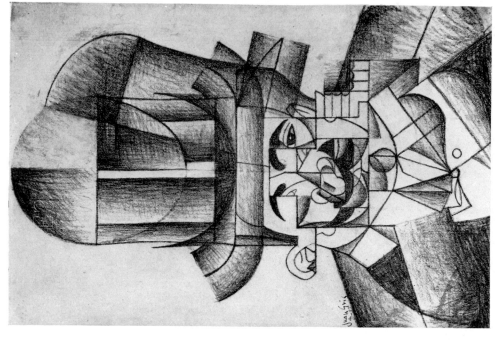

94 Juan Gris. Study for *L'Homme au café*. 1912. Pencil on paper, 18″ × 12″

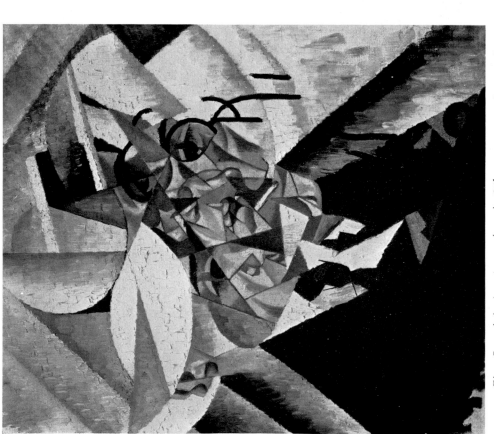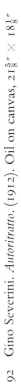

92 Gino Severini. *Autoritratto*. (1912). Oil on canvas, 21⅝″ × 18⅛″

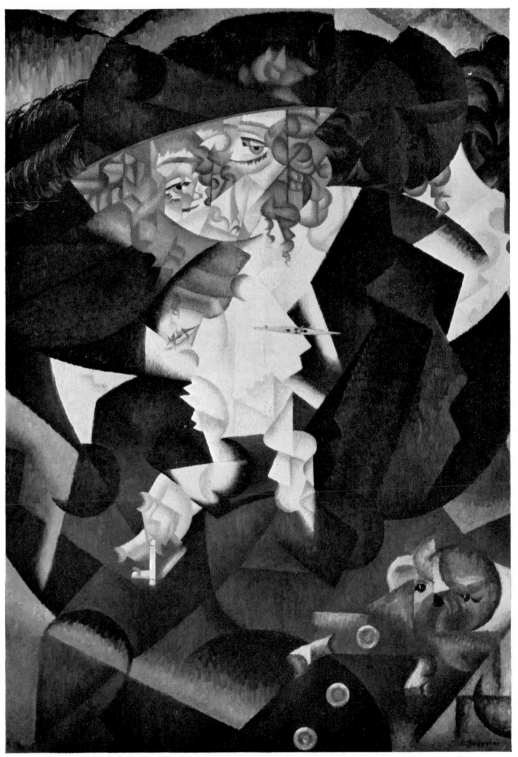

93 Gino Severini. *Portrait of Mme M.S.* (1912). Oil on canvas, $36\frac{1}{4}''\times 25\frac{1}{2}''$

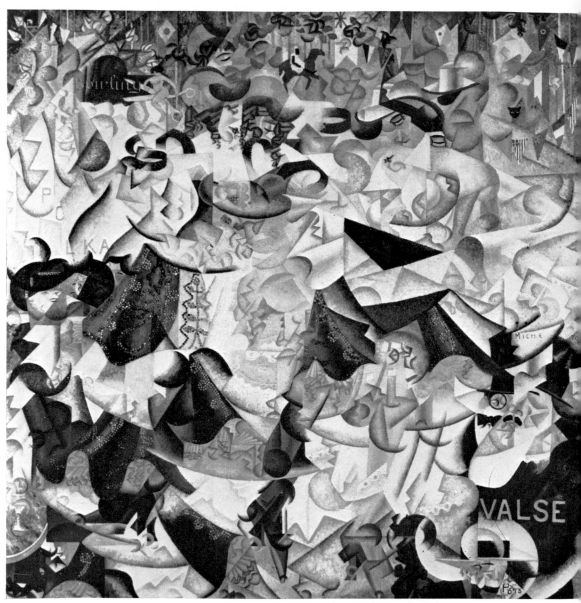

95 Gino Severini. *Hiéroglyphe dynamique du the Bal Tabarin.* (1912). Oil on canvas, with sequins. $63\frac{5}{8}'' \times 61\frac{1}{2}''$

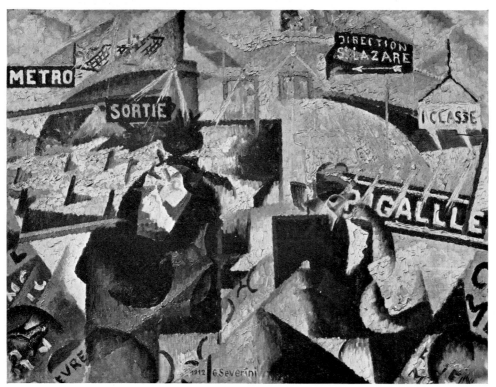

96 Gino Severini. *Nord-Sud Métro*. 1912. Oil on canvas, 19¼″ × 25¼″

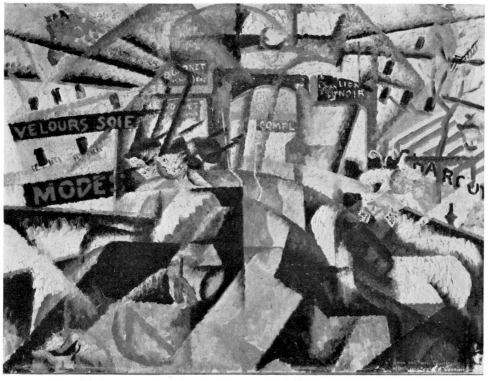

97 Gino Severini. *L'Autobus*. (1912–13). Oil on canvas, 22½″ × 28¾″

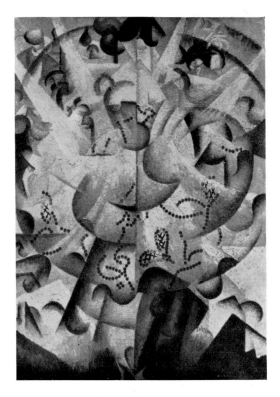

98 Gino Severini. *Danaztrice a Pigal*. 1912.
Oil on canvas with built up relief

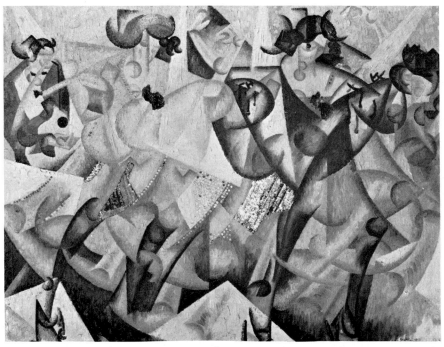

99 Gino Severini. *Danzatrici spagnole a Monico*. 1913. Oil on canvas, with
sequins, $34\frac{3}{4}'' \times 45\frac{1}{2}''$

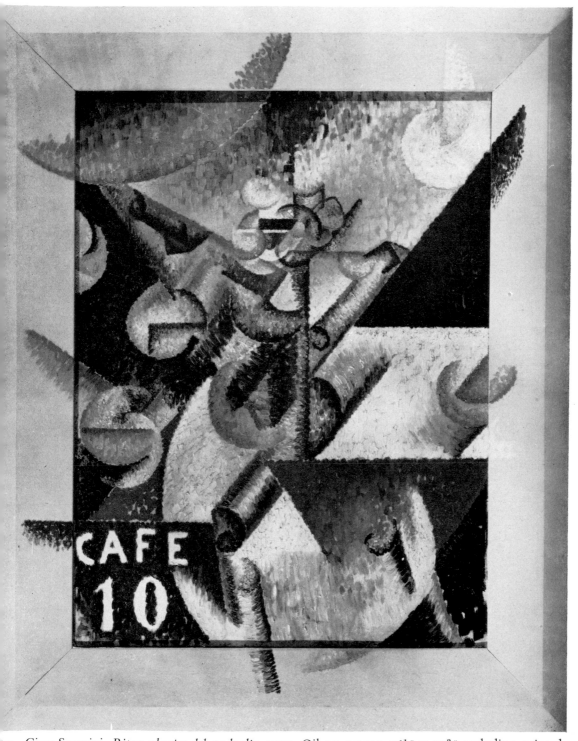

90 Gino Severini. *Ritmo plastico del 14 luglio*. 1913. Oil on canvas, $26\frac{1}{8}''\times 19\frac{3}{4}''$ excluding painted frame

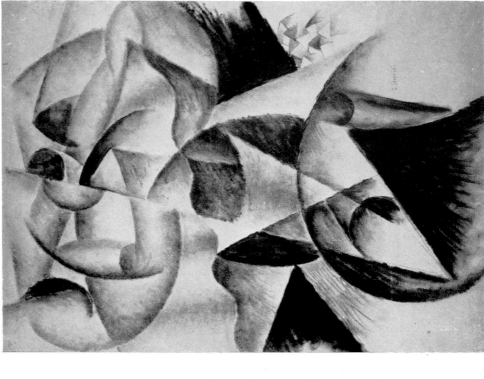

102 Gino Severini. Study for *Danzatrice = mare*. (1913). Charcoal on paper, $27\frac{7}{8}'' \times 19\frac{7}{8}''$

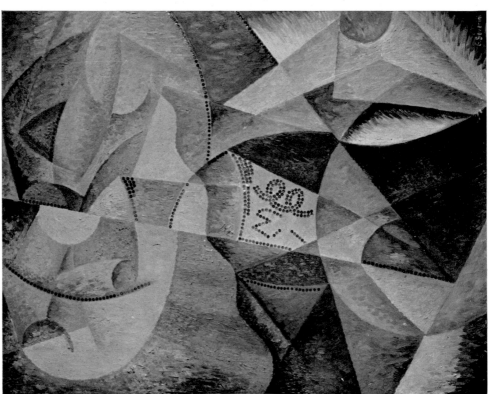

101 Gino Severini. *Danzatrice = mare*. (1913–14). Oil on canvas, with sequins, $36\frac{1}{2}'' \times 28\frac{3}{4}''$

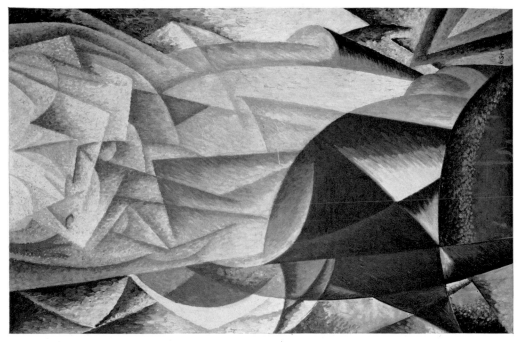

104 Gino Severini. *Mare = danzatrice + mazzo di fiori.* (1914). Oil on canvas, with aluminium, $36\frac{1}{4}'' \times 23\frac{5}{8}''$

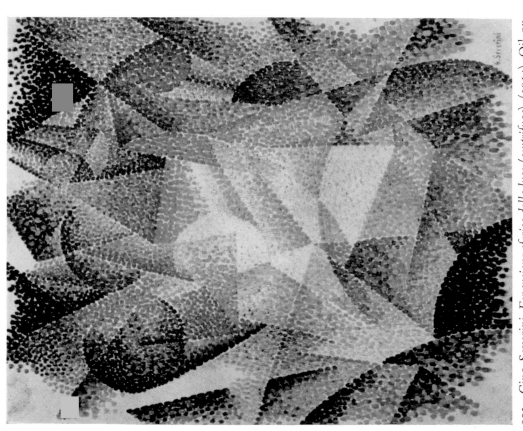

103 Gino Severini. *Espansione sferica della luce (centrifuga).* (1914). Oil on canvas, $24\frac{3}{8}'' \times 19\frac{5}{8}''$

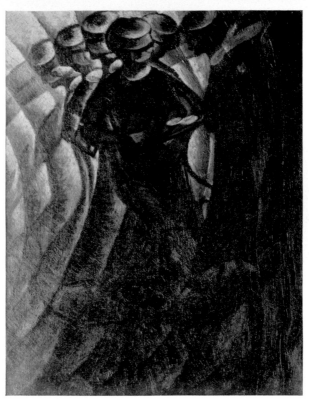

105 Luigi Russolo. *Riassunto del movimenti di una donna*. 1912. Oil on canvas, $33\frac{1}{2}'' \times 25\frac{1}{2}''$

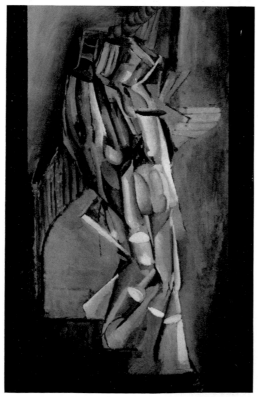

106 Marcel Duchamp. *Nude Descending a Staircase, No. 1*. 1911. Oil on cardboard, $37\frac{3}{4}'' \times 23\frac{1}{2}''$

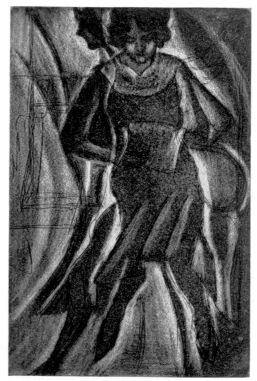

107 Luigi Russolo. *Movimenti di una donna*. (*c.* 1911). Etching and aquatint, $8'' \times 5\frac{1}{4}''$

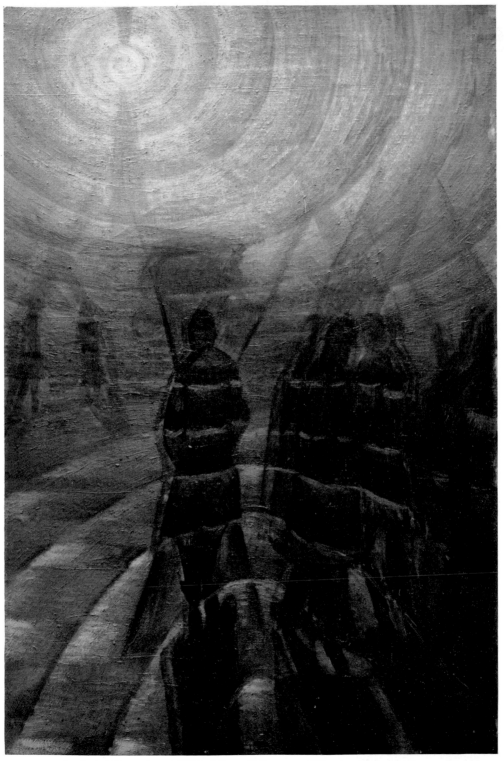

108 Luigi Russolo. *Solidità della nebbià*. 1912. Oil on canvas, $39\frac{1}{4}'' \times 25\frac{3}{4}''$

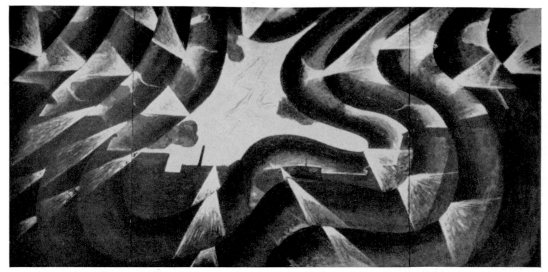

109 Luigi Russolo. *Linee forze della folgore*. (Late 1912?) Destroyed

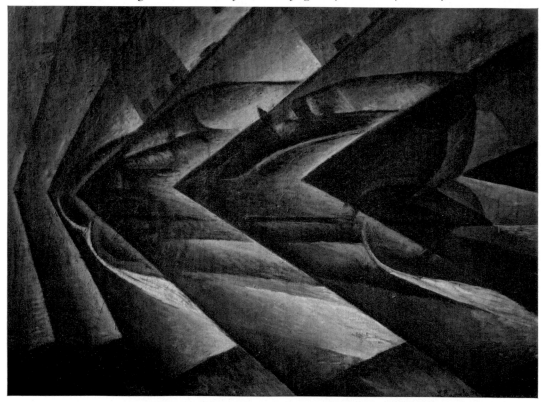

111 Luigi Russolo. *Automobile in corsa*. (1913). Oil on canvas, $41'' \times 55\frac{1}{2}''$

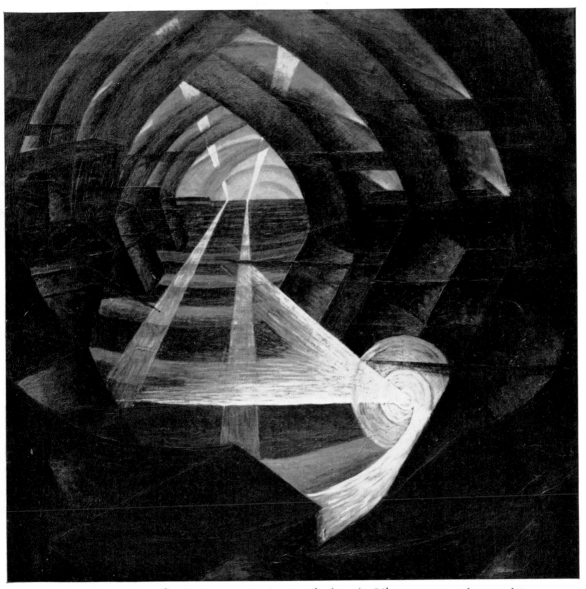

110　Luigi Russolo. *Le Case continuano in cielo*. (1913). Oil on canvas, 39½″ × 39½″

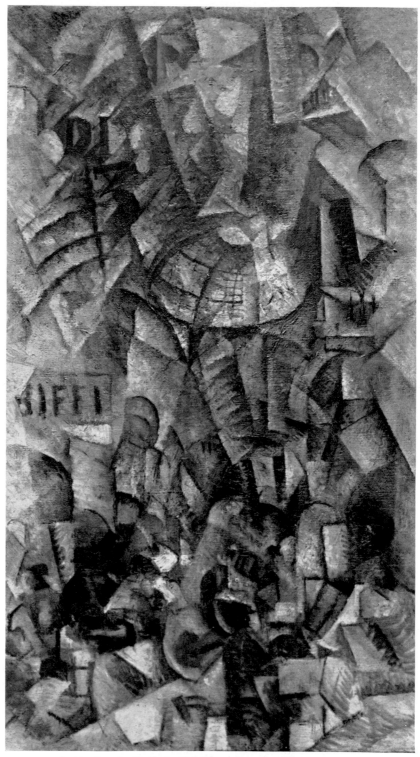

112 Carlo D. Carrà. *Galleria di Milano.* (1912). Oil on canvas, 36″ × 20″

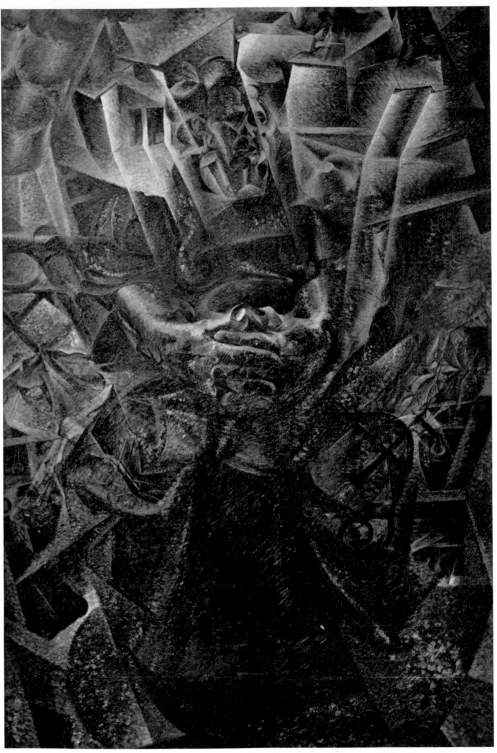

113 Umberto Boccioni. *Materia*. (1912). Oil on canvas, 7′ 4¾″ × 59¼″

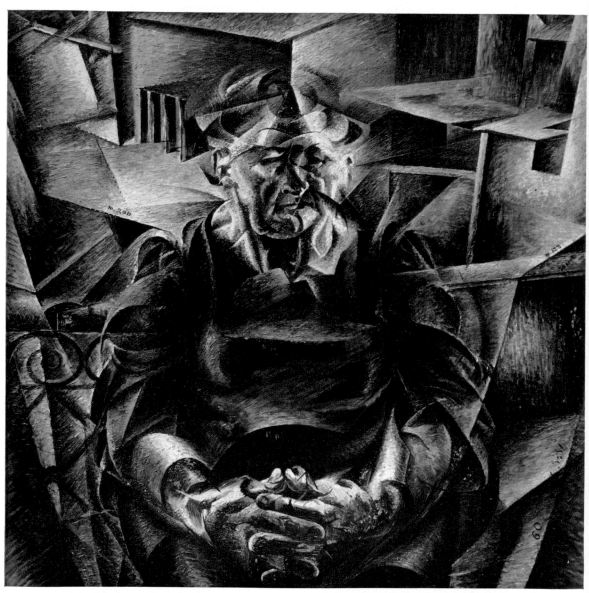

114 Umberto Boccioni. *Costruzione orizzontale* (1912). Oil on canvas, $37\frac{1}{2}'' \times 37\frac{1}{2}''$

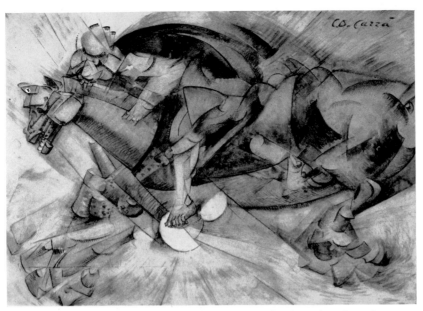

115 Carlo D. Carrà. *Velocità scompone il cavallo.* (1912). Ink and water-colour on paper, $10\frac{1}{4}'' \times 14\frac{1}{4}''$

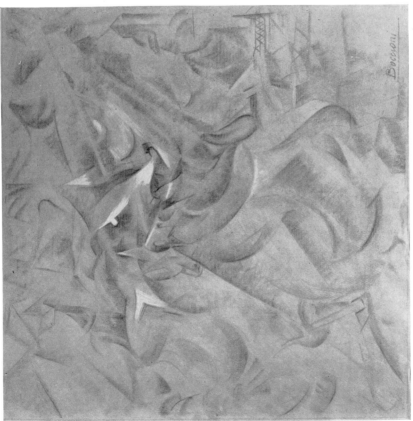

117 Umberto Boccioni. Study for *Elasticità.* (1912). Pencil with gouache on paper, $17\frac{1}{4}'' \times 17\frac{1}{4}''$

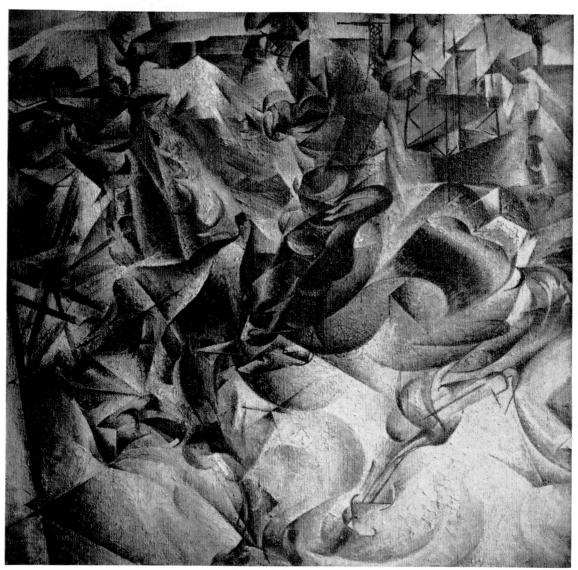

116 Umberto Boccioni. *Elasticità*. (1912). Oil on canvas, 39$\frac{3}{8}$″ × 39$\frac{3}{4}$″

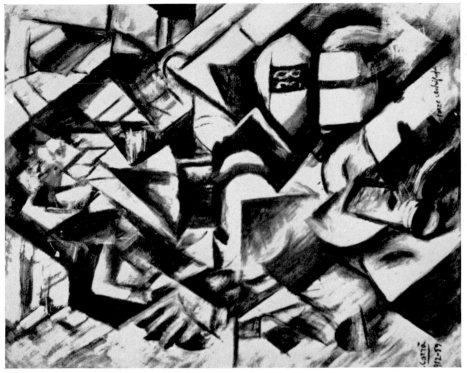

119 Carlo D. Carrà. *Forze centrifughe.* 1959 copy of Pl. 118.
Oil on canvas, $23\frac{5}{8}'' \times 19\frac{3}{4}''$

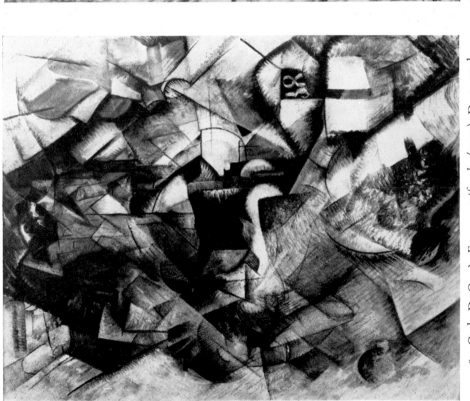

118 Carlo D. Carrà. *Forze centrifugale.* (1912). Destroyed

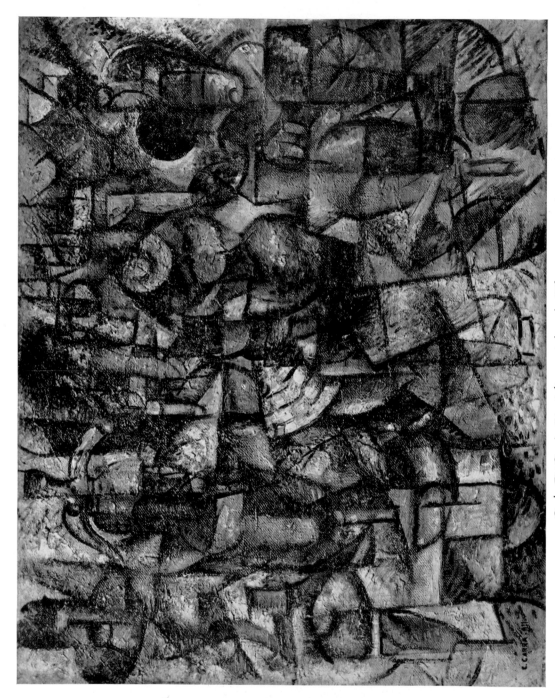

120 Carlo D. Carrà. *Ritmi di oggetti*. (1912). Oil on canvas, $20\frac{1}{8}'' \times 26''$

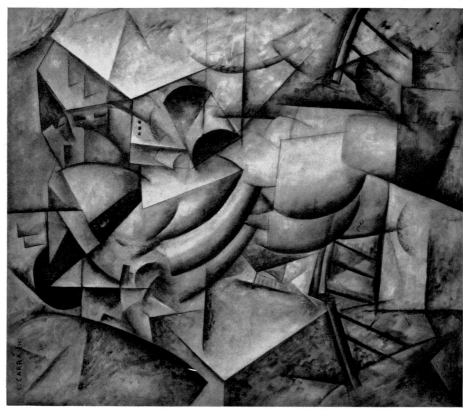

122 Carlo D. Carrà. *Simultaneità*. (1913). Oil on canvas, 57⅞″ × 52⅜″

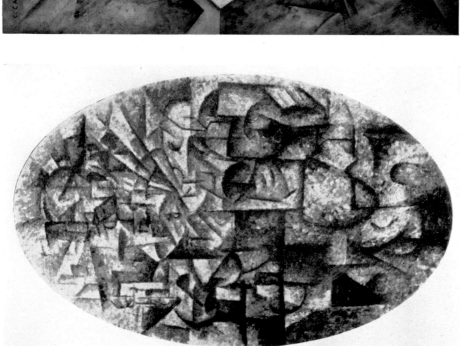

121 Carlo D. Carrà. *Donna + bottiglia + casa*
(*Espansione sferica nello spazio*). (1913). Destroyed

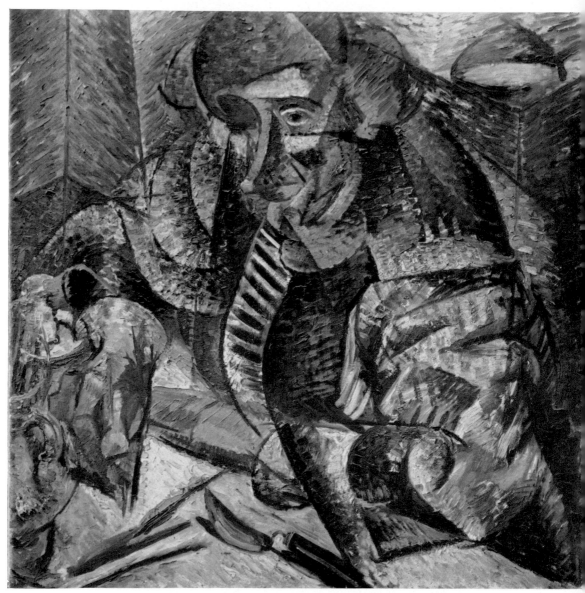

123 Umberto Boccioni. *Antigrazioso*. (1912–13). Oil on canvas, $31\frac{1}{2}''\times 31\frac{1}{2}''$

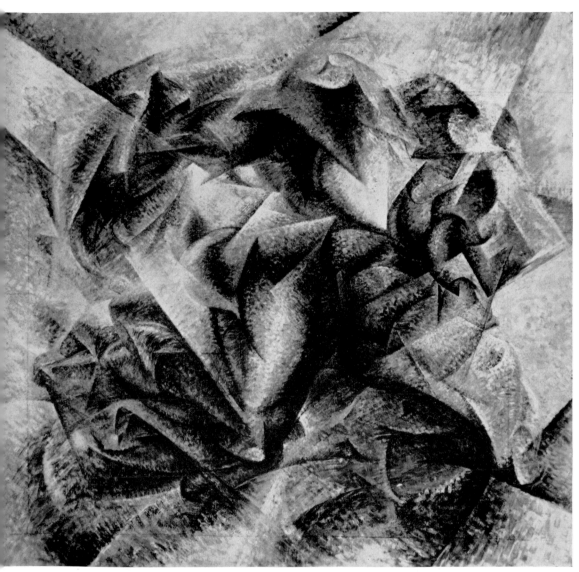

124 Umberto Boccioni. *Dinamismo di un footballer.* (1913). Oil on canvas, 6′ 5″ × 6′ 7″

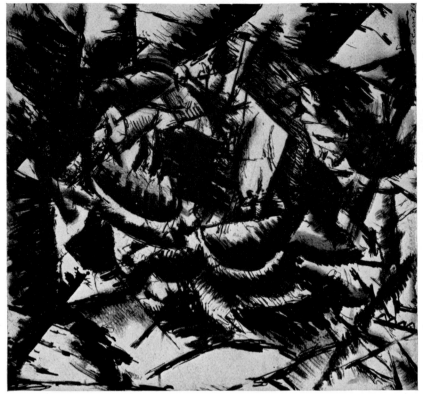

126 Carlo D. Carrà. *Boxeur I.* 1913. Ink and ink wash, $9\frac{5}{8}'' \times 9\frac{1}{8}''$

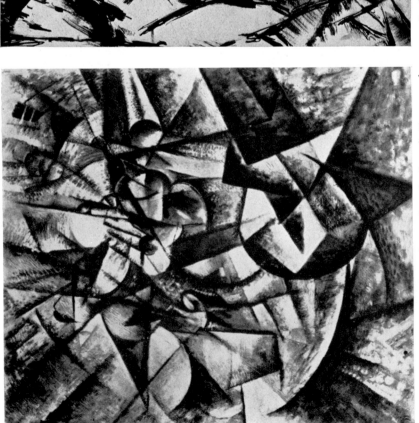

125 Carlo D. Carrà. *Trascendenze plastiche.* (1913). Destroyed

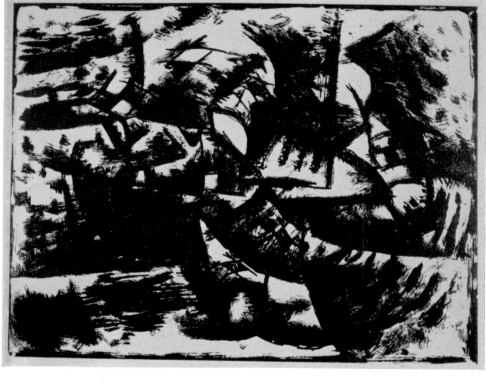

128 Carlo D. Carrà. 1° *Scarabocchio espressivo – Simultaneità d'un giocattolo.* (1913)

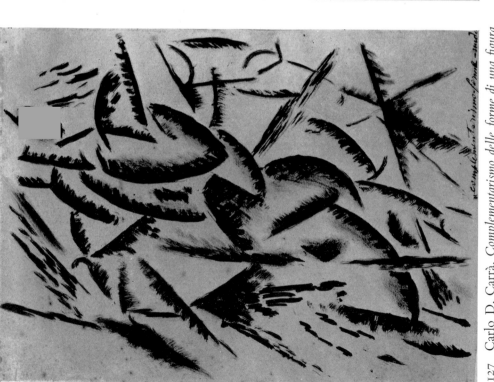

127 Carlo D. Carrà. *Complementarismo delle forme di una figura nuda.* (1913). Oil and gouache on paper, $16\frac{1}{2}'' \times 11\frac{1}{2}''$

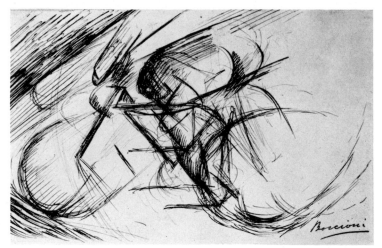

129 Umberto Boccioni. Study for *Dinamismo di un ciclista*. (1913). Pen and ink on paper, 6″ × 9½″

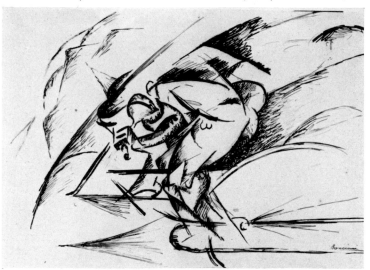

130 Umberto Boccioni. Study for *Dinamismo di un ciclista* (1913). Pen and brush and ink on paper, 8¾″ × 12¼″

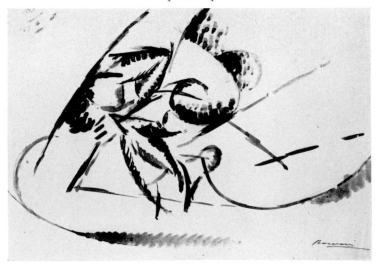

131 Umberto Boccioni. Study for *Dinamismo di un ciclista*. (1913). Brush and ink on paper, 8¼″ × 12¼″

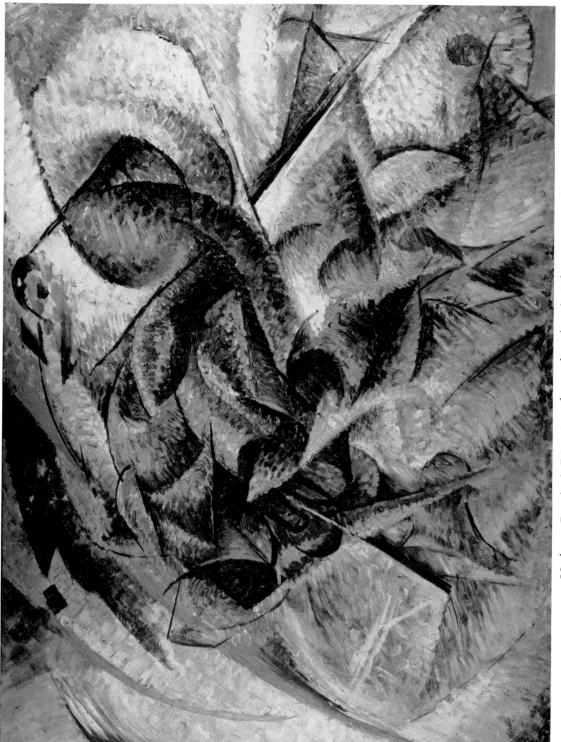

132 Umberto Boccioni. *Dinamismo di un ciclista.* (1913). Oil on canvas, $27\frac{1}{2}'' \times 37\frac{3}{8}''$

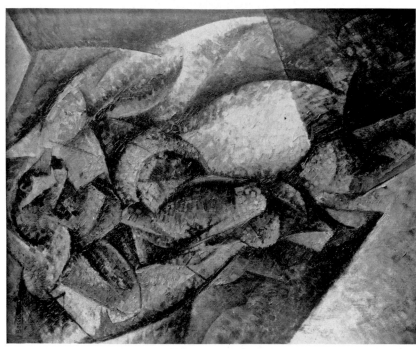

134 Umberto Boccioni. *Dinamismo di un corpo umano.* (1913).
Oil on canvas, $31\frac{1}{2}'' \times 25\frac{3}{4}''$.

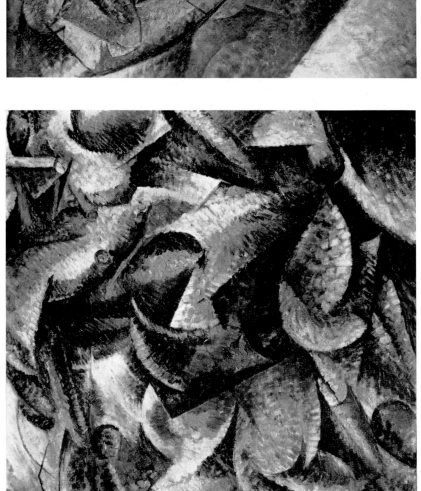

133 Umberto Boccioni. *Dinamismo di un corpo umano.* (1913). Oil on canvas,
$39\frac{1}{2}'' \times 39\frac{1}{2}''$.

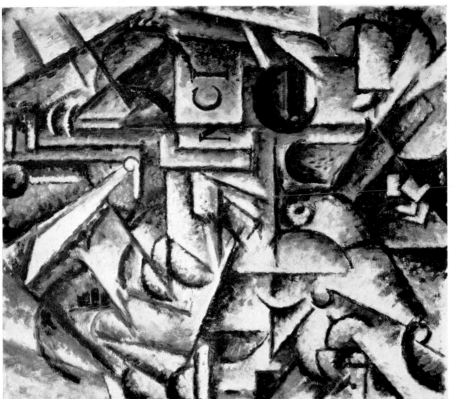

136 Ardengo Soffici. *Linee e volumi di una strada.* (1913). Oil on canvas, $20\frac{1}{2}'' \times 18\frac{1}{2}''$

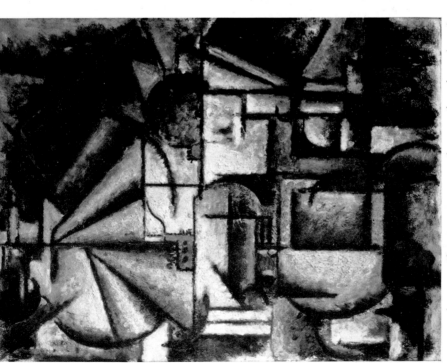

135 Ardengo Soffici. *Scomposizione dei piani di un lume.* (1912). Oil on canvas, $13\frac{3}{4}'' \times 11\frac{3}{4}''$

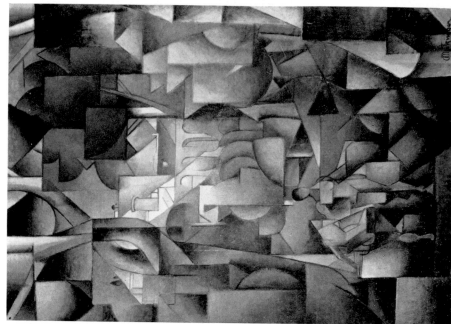

138 Jean Metzinger. *The Bathers.* 1913. Oil on canvas, 58¼″ × 41¾″

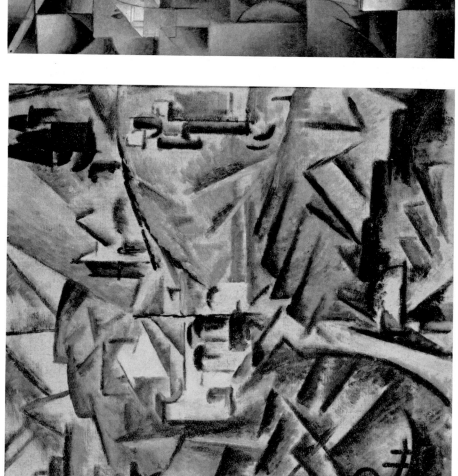

137 Ardengo Soffici. *Sintesi di un paesaggio autunnale.* (1913). Oil on canvas, 17⅞″ × 17″

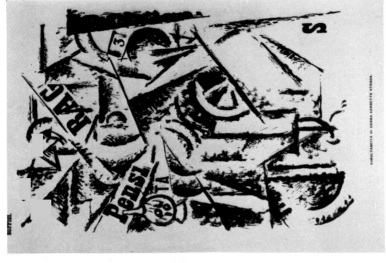

140 Ardengo Soffici. *Simultaneità di donna carretto strada.* (1913)

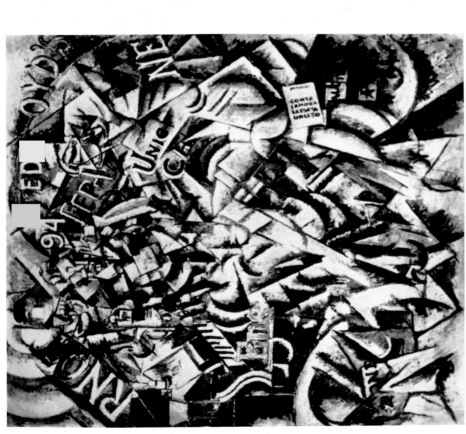

139 Ardengo Soffici. *Ballo dei pederasti (Dinamismo plastico).* (1913). Destroyed.

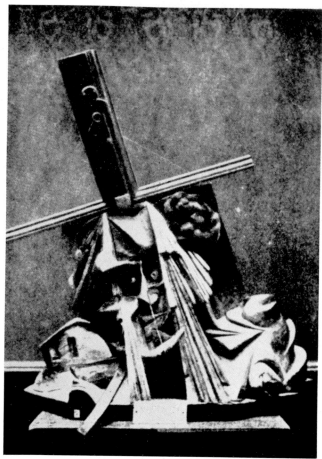

141 Umberto Boccioni. *Fusione di una testa e di una finestra*. (1912). Destroyed

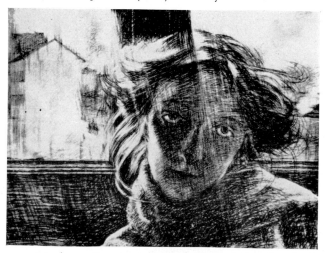

142 Umberto Boccioni. *Controluce*. 1910. Pencil and ink on paper, $14\frac{1}{2}'' \times 19\frac{1}{4}''$

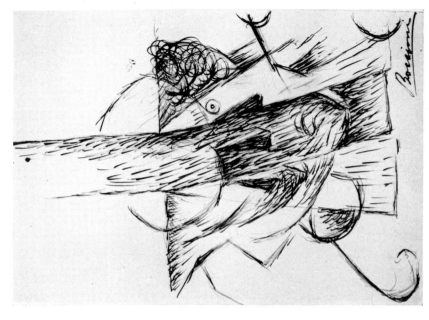

144 Umberto Boccioni. Study related to *Fusione di una testa e di una finestra.* (1912). Pen on white paper, $12\frac{1}{4}'' \times 8\frac{3}{8}''$

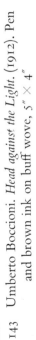

143 Umberto Boccioni. *Head against the Light.* (1912). Pen and brown ink on buff wove, $5'' \times 4''$

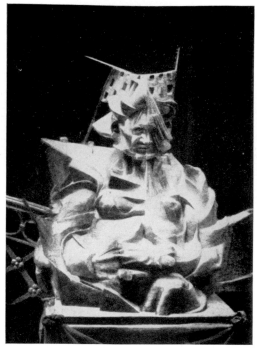

145 Umberto Boccioni. *Testa + casa + luce.*
(1912). Destroyed

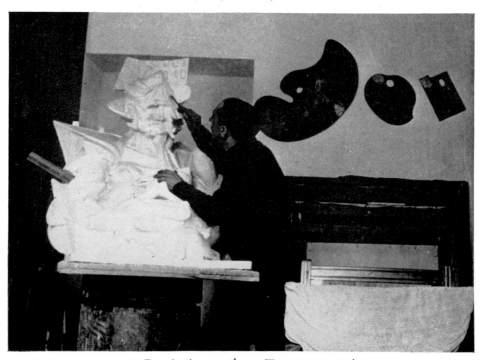

146 Boccioni at work on *Testa + casa + luce*

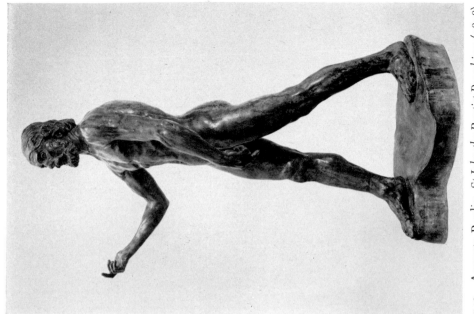

149 Auguste Rodin. *St John the Baptist Preaching.* (1878). Bronze, 6′ 6¾″ high

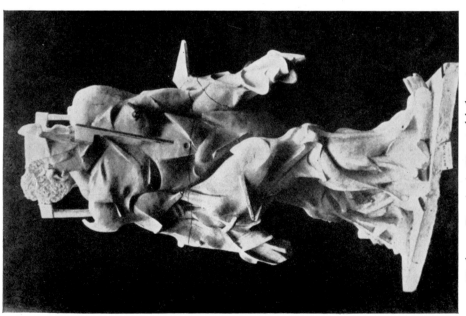

147 Umberto Boccioni. *Sintesi del dinamismo umano.* (1912). Destroyed

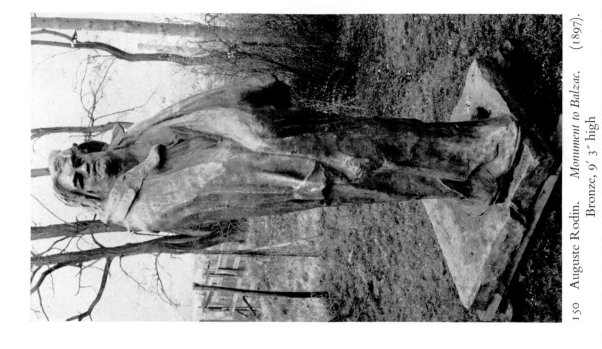

150 Auguste Rodin. *Monument to Balzac.* (1897).
Bronze, 9′ 3″ high

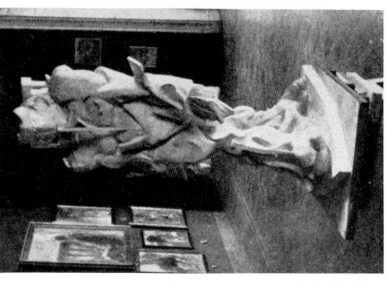

148 Umberto Boccioni. *Sintesi del dinamismo
umano.* Front view

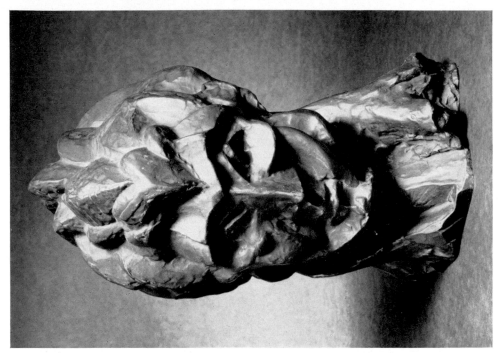

152 Pablo Picasso. *Woman's Head.* (1909). Bronze, 16¼" high

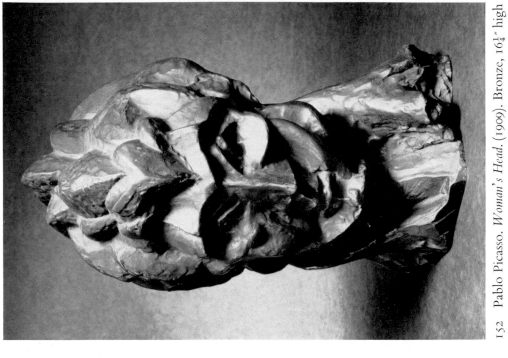

151 Umberto Boccioni. *Antigrazioso.* (1912). Bronze, 23" high

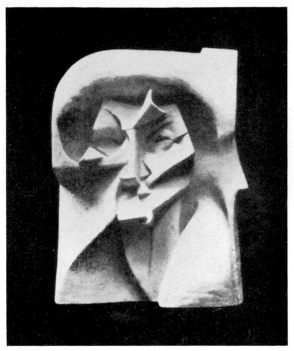

153 Umberto Boccioni. *Vuoti e pieni astratti di una testa*. (1912 or early 1913). Destroyed

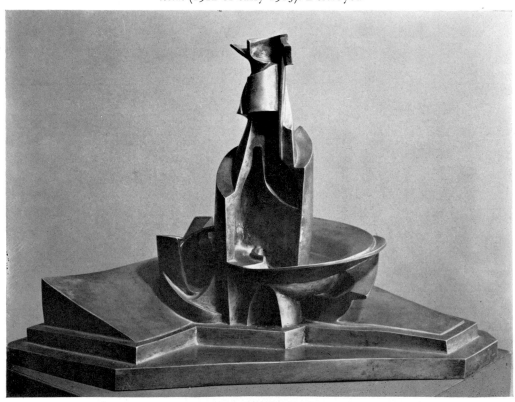

154 Umberto Boccioni. *Sviluppo di una bottiglia nello spazio* (*Natura morta*). (Late 1912 or early 1913). Bronze, 15″ high

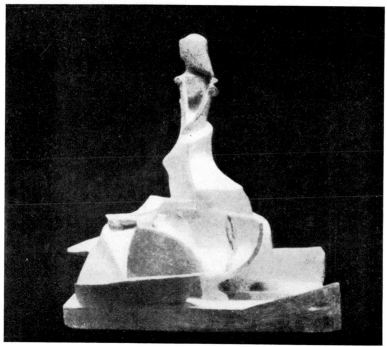

156 Umberto Boccioni. *Forme-forze di una bottiglia (Natura morta)*.
(1913). Destroyed

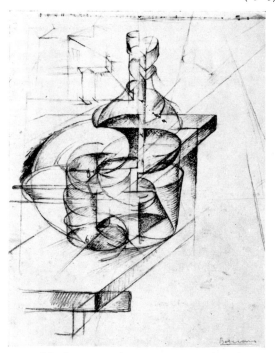

155 Umberto Boccioni. *Tavola + bottiglia +
caseggiato*. (1912). Pencil on white paper,
$13\frac{1}{8}'' \times 9\frac{1}{2}''$

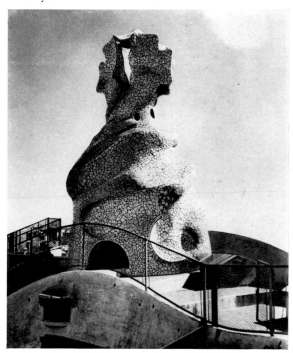

157 Antoni Gaudí. Ventilator on roof, Casa Milá,
92 Paseo de Gracia, Barcelona. (1905–10)

z*

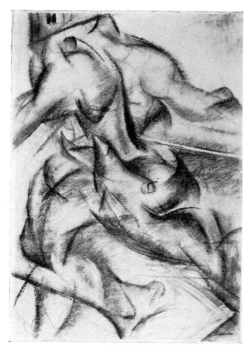

158 Umberto Boccioni. *Dinamismo muscolare*. (1913). Charcoal on white paper, 34″ × 23¼″

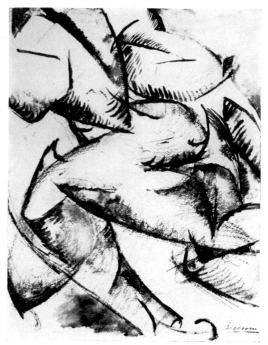

159 Umberto Boccioni. *Male Figure in Motion.* (1913). Charcoal, ink and touches of gouache on white paper, 12⅜″ × 9⅝″

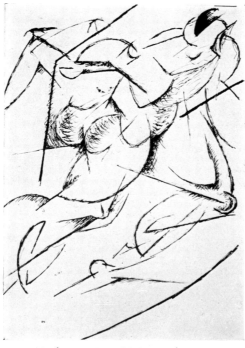

160 Umberto Boccioni. *Male Figure in Motion.* (1913). Pen and ink on white paper, 12¼″ × 8⅜″

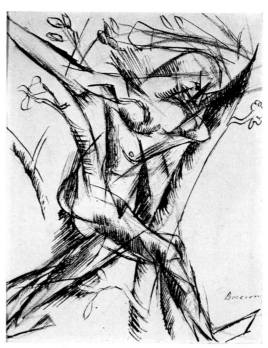

161 Umberto Boccioni. *Figure in Motion.* (1913). Pencil and ink on white paper, 11⅞″ × 9¼″

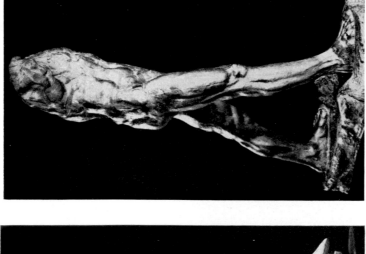

164 Auguste Rodin. *The Walking Man.* Enlarged version. (1905). Bronze, 6′ 11¾″ high

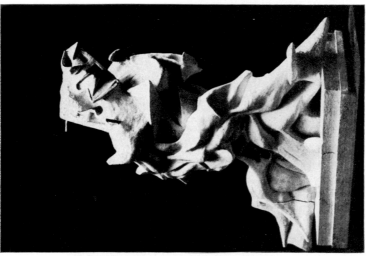

163 Umberto Boccioni. *Muscoli in velocità.* (1913). Destroyed

162 Umberto Boccioni. *Espansione spiralica di muscoli in movimento.* (1913). Destroyed

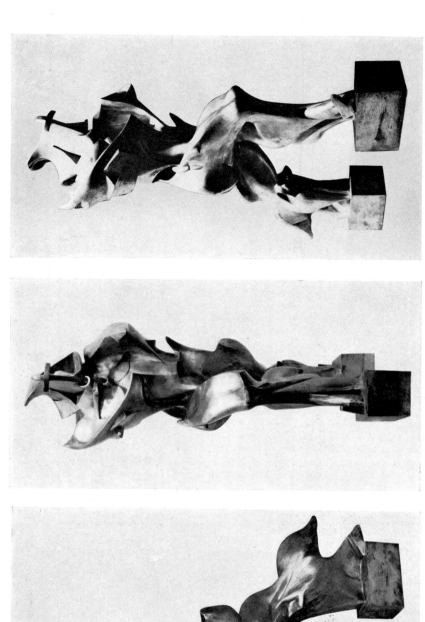

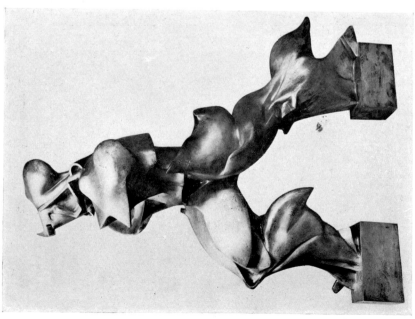

165–7 Umberto Boccioni. *Forme uniche della continuità nello spazio.* (1913). Bronze, 43½" high

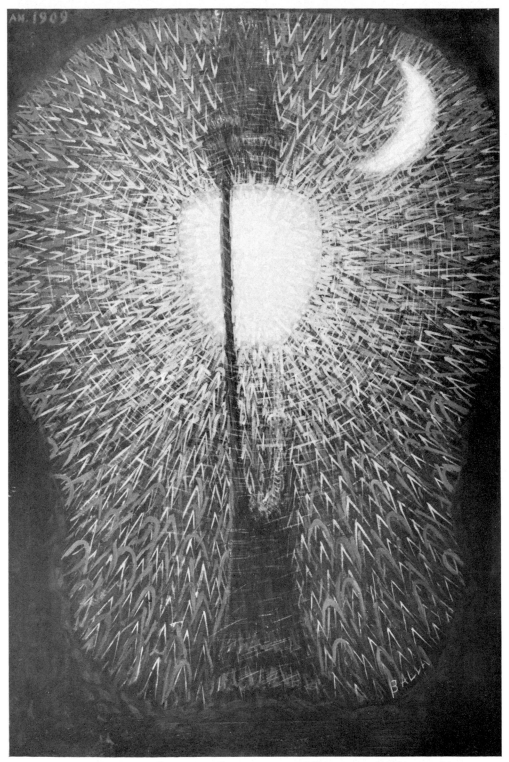

168 Giacomo Balla. *Lampe électrique*. 1909. Oil on canvas, $68\frac{3}{4}'' \times 45\frac{1}{4}''$

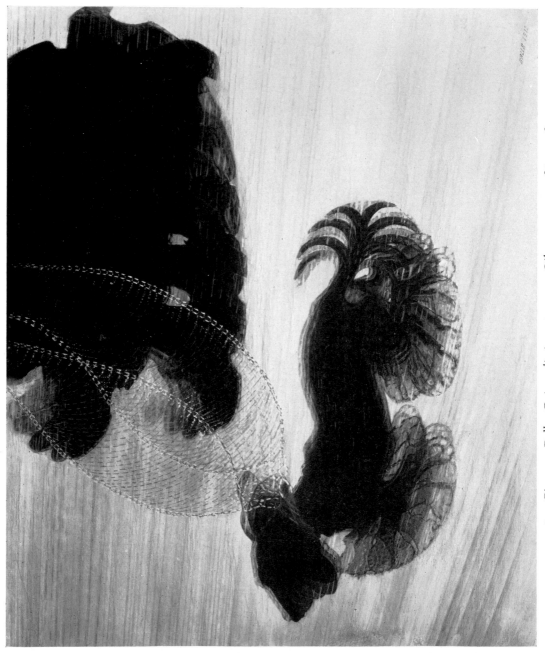

169 Giacomo Balla. *Guinzaglio in moto.* 1912. Oil on canvas, 35¾″ × 43⅜″

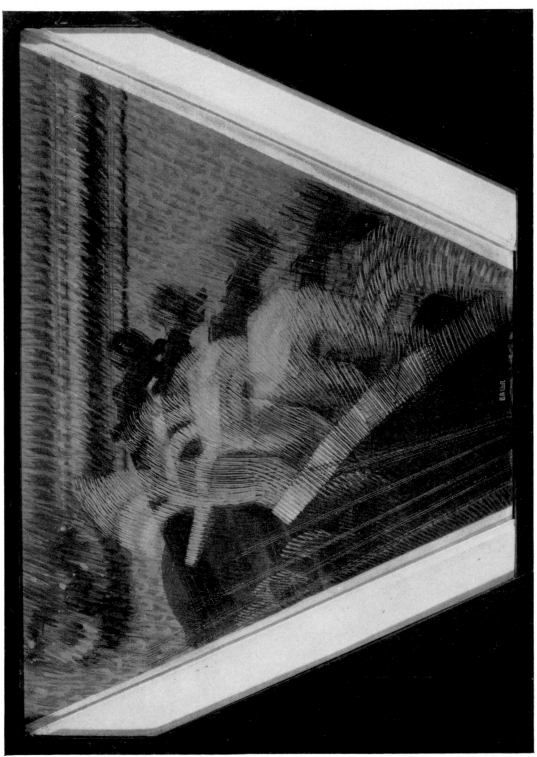

170 Giacomo Balla. *Ritmi dell'archetto.* (1912). Oil on canvas, $20\frac{1}{2}'' \times 29\frac{1}{2}''$

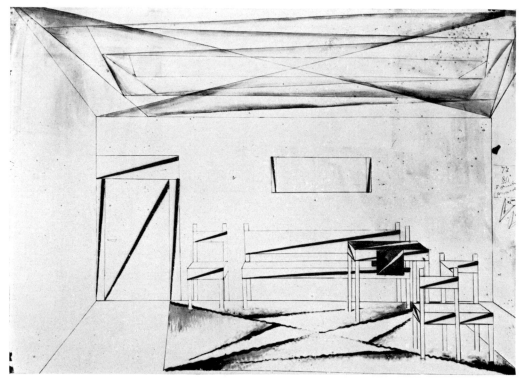

171 Giacomo Balla. Sketch for Interior with Furniture. (*c.* 1915). Ink, wash and pencil on white paper, $31\frac{1}{2}'' \times 47\frac{1}{2}''$

174 Giacomo Balla. Study for a *Compenetrazione iridescente*. (*c.* 1912). Watercolour and pencil, $8\frac{1}{2}'' \times 7''$

173 Giacomo Balla. *Compenetrazione iridescente, no. 2.* (*c.* 1912). Oil on
canvas, $30\frac{3}{8}'' \times 30\frac{3}{8}''$

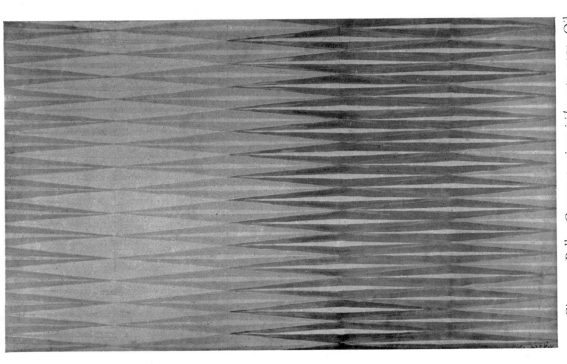

172 Giacomo Balla. *Compenetrazione iridescente.* 1912. Oil
on canvas, $39\frac{3}{8}'' \times 23\frac{5}{8}''$

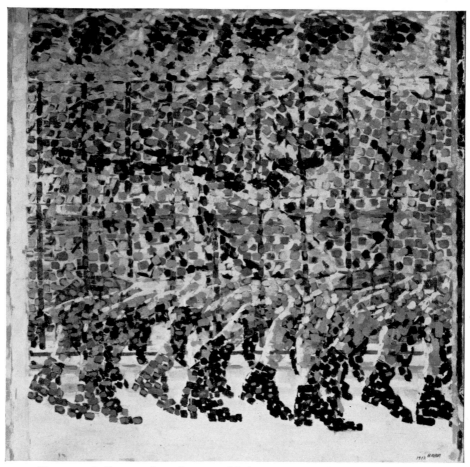

175 Giacomo Balla. *Bambina che corre al balcone*. 1912. Oil on canvas, 49¼″ × 49¼″

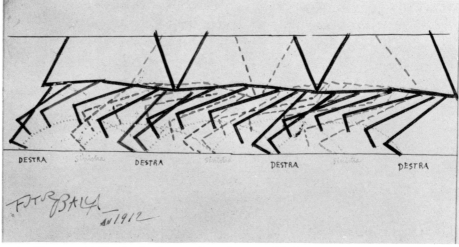

176 Giacomo Balla. Study for *Bambina che corre al balcone*. 1912. Black and red ink on paper, 6½″ × 9¼″

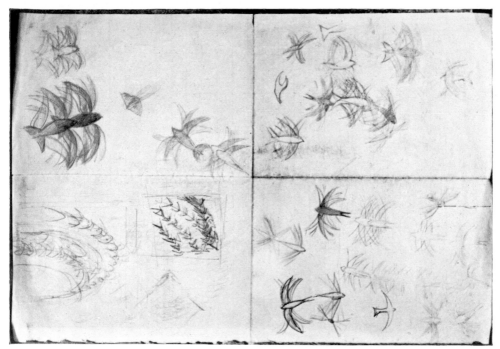

177 Giacomo Balla. *Studies of Flying Swifts*. 1913. Pencil on paper, 8¼″ × 12¼″

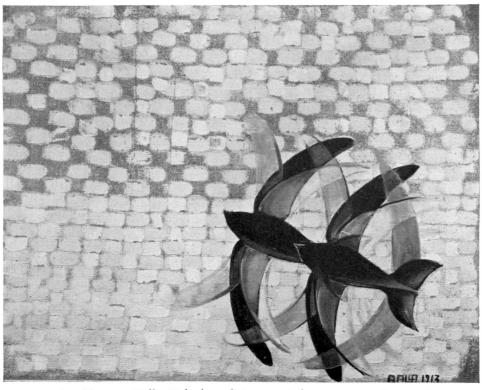

178 Giacomo Balla. *Volo di rondini*. 1913. Oil on canvas, 16½″ × 20⅞″

179 Giacomo Balla. *Linee andamentali + successioni dinamiche*. 1913. Oil on canvas, $38\frac{1}{8}'' \times 47\frac{1}{4}''$

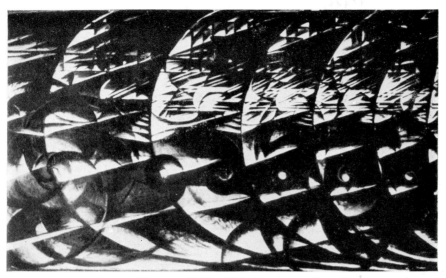

180 Giacomo Balla. *Velocità astratta*. (1913)

181 Giacomo Balla. *Plasticità di luci × velocità*. (1913)

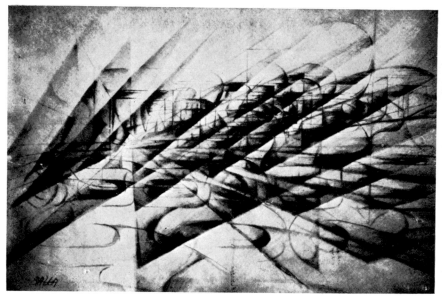

182 Giacomo Balla. *Penetrazioni dinamiche d'automobile.* (1913)

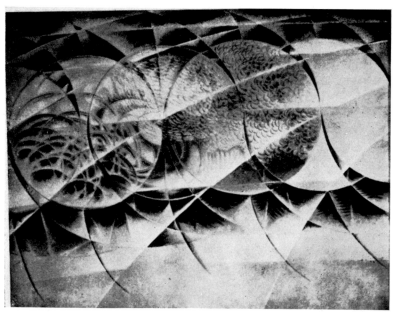

183 Giacomo Balla. *Spessori d'atmosfera.* (1913)

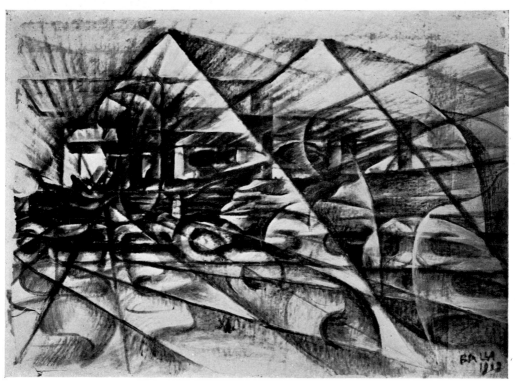

184 Giacomo Balla. *Auto in corsa.* 1913. Oil on paper, 26″ × 35½″

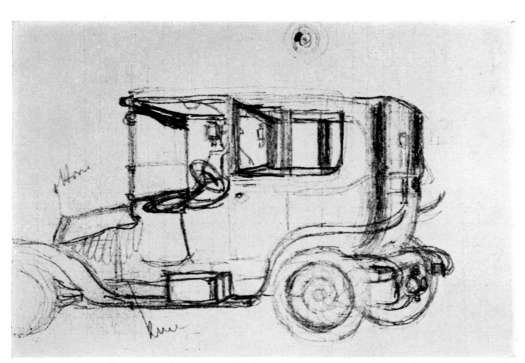

185 Giacomo Balla. *Study of an Automobile.* (*c.* 1912). Page from sketchbook. Pencil, 2⅞″ × 5⅛″

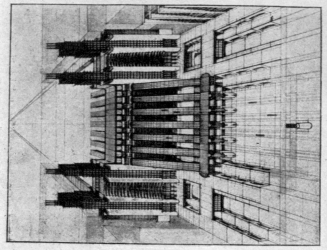

LA CITTÀ FUTURISTA. — Stazione d'aeroplani
e treni ferroviarî, con funicolari e ascensori, su
3 piani stradali.

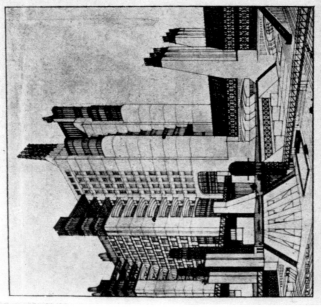

LA CITTÀ FUTURISTA. — Casamento, con ascensori esterni, gal-
leria, passaggio coperto, su 3 piani stradali (linea tramviaria,
strada per automobili, passerella metallica) fari e telegrafia
senza fili.

186–7 Antonio Sant'Elia. Two perspectives for *La Città Nuova.* (1914). (From his manifesto as printed in
Lacerba, II no. 15 (1 Agosto 1914), 230–1)

189 Antonio Sant'Elia. *Casamento con ascensori esterni su tre piani stradali.* (1914). Pen and Ink, $10\frac{1}{2}'' \times 8\frac{1}{4}''$

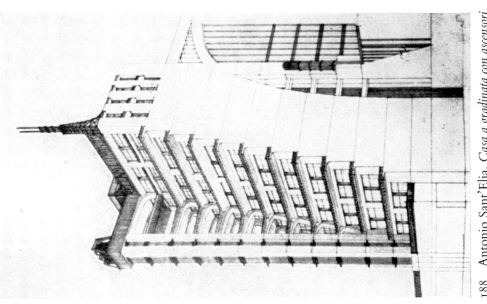

188 Antonio Sant'Elia. *Casa a gradinata con ascensori esterni.* (1914). Pen and ink, $15\frac{1}{4}'' \times 9\frac{1}{2}''$

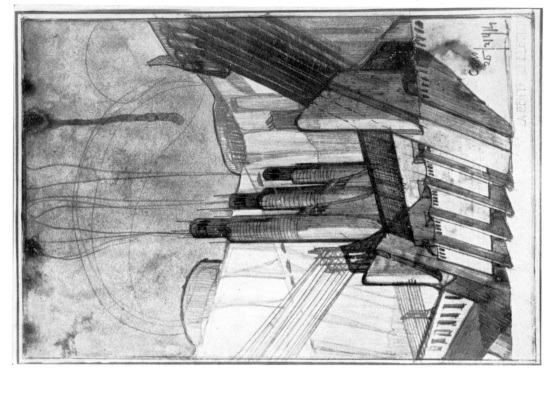

191 Antonio Sant'Elia. *La Centrale elettrica*. 1914. Ink, pencil and watercolour, $11\frac{3}{4}'' \times 7\frac{7}{8}''$

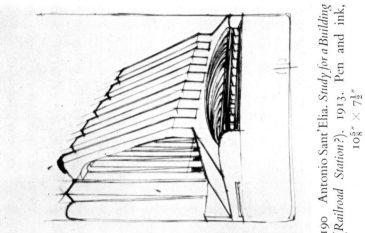

190 Antonio Sant'Elia. *Study for a Building (Railroad Station?)*. 1913. Pen and ink, $10\frac{5}{8}'' \times 7\frac{1}{2}''$

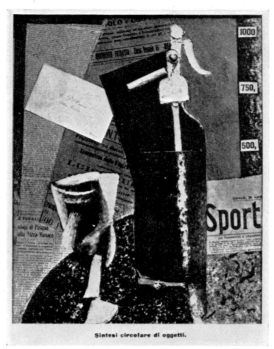

192 Carlo D. Carrà. *Sintesi circolare di oggetti.*
(1914)

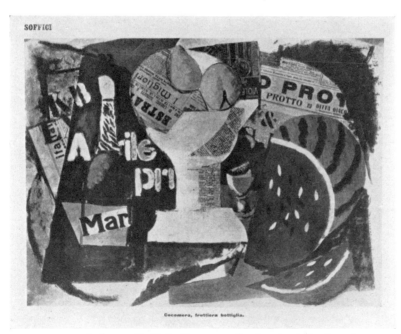

193 Ardengo Soffici. *Cocomero, fruttiera bottiglia.* (1914)

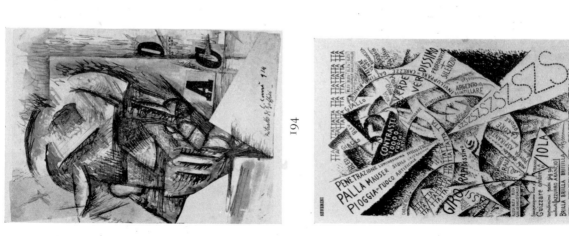

195

194 Carlo D. Carrà. *Ritratto di Soffici.* 1914. Papier collé, $8\frac{1}{4}'' \times 6\frac{1}{8}''$

195 Carlo D. Carrà. *Dipinto paroliberto – Festa patriottica.* (1914). Papier collé, $15\frac{1}{8}'' \times 11\frac{3}{4}''$

196 Gino Severini. *Danza serpentina* (1914)

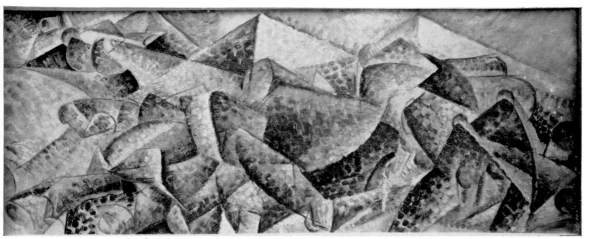

197 Umberto Boccioni. *Dinamismo plastico: cavallo + caseggiato.* (1914). Oil on canvas, $15\frac{5}{8}'' \times 43\frac{1}{2}''$

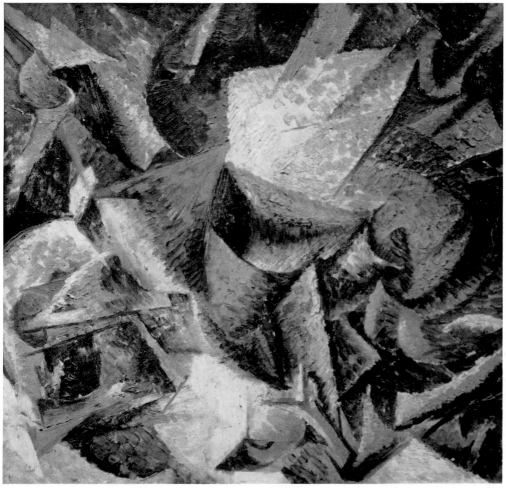

199 Umberto Boccioni. *Forme plastiche di un cavallo.* (1913–14). Oil on canvas, $15\frac{3}{4}'' \times 15\frac{3}{4}''$

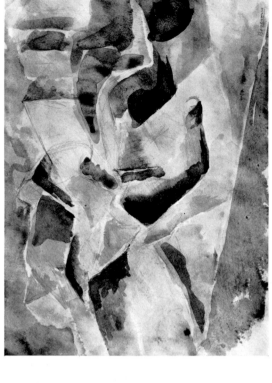

201

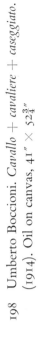

198 Umberto Boccioni. *Cavallo + cavaliere + caseggiato.* (1914). Oil on canvas, 41″ × 52¾″

200 Umberto Boccioni. *Allegoria macabra.* Study for *Beata Solitudo, Sola Beatitudo.* (1907). Pencil on white paper, 7½″ × 9⅝″

201 Umberto Boccioni. Study for *Cavallo + cavaliere + caseggiato.* (1914). Watercolour and pencil on paper, 9½″ × 13″

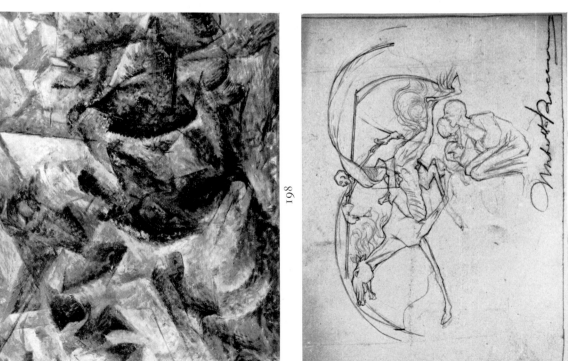

198

200

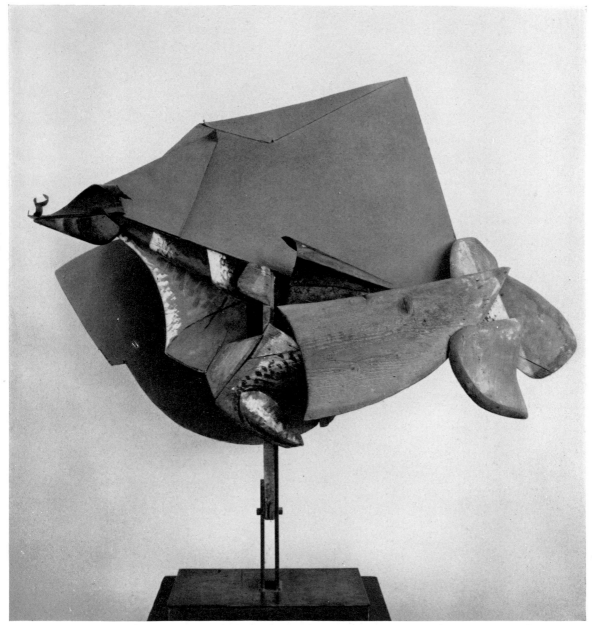

202 Umberto Boccioni. *Costruzione dinamica di un galoppo: cavallo + casa*. (1914). Wood, cardboard and metal, 26″ × 47¾″

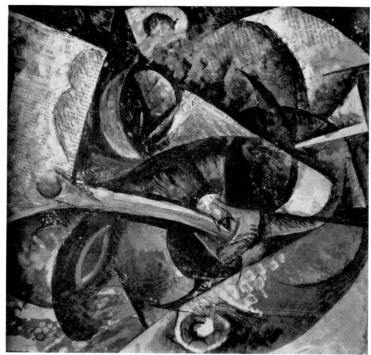

204 Umberto Boccioni. *Dinamismo di una testa di uomo.* (1914). Tempera and collage on canvas, $13\frac{3}{4}'' \times 13\frac{3}{4}''$

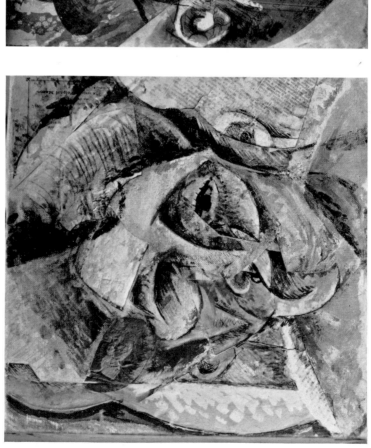

203 Umberto Boccioni. *Dinamismo di una testa di donna.* (1914). Tempera and collage on canvas, $13\frac{3}{4}'' \times 13\frac{3}{4}''$

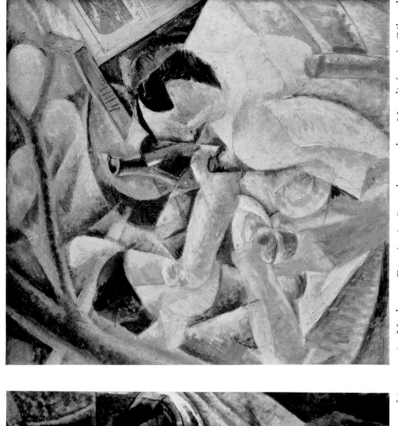

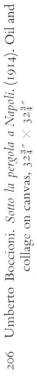

205　Umberto Boccioni. *Bevitore.* (1914). Oil on canvas, $34\frac{1}{4}'' \times 34\frac{1}{2}''$

206　Umberto Boccioni. *Sotto la pergola a Napoli.* (1914). Oil and collage on canvas, $32\frac{3}{4}'' \times 32\frac{3}{4}''$

208 Pablo Picasso. *Landscape with Figures.* (1908). Oil on canvas, $23\frac{5}{8}'' \times 28\frac{3}{4}''$

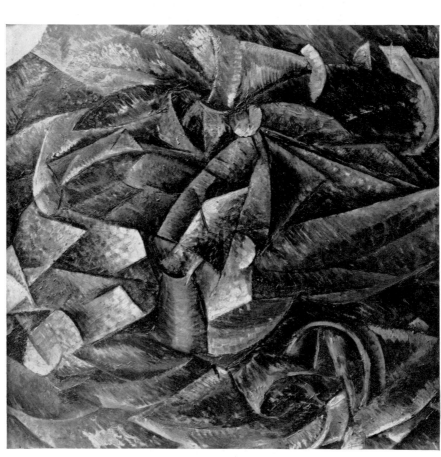

207 Umberto Boccioni. *Costruzione spiralica.* (1914). Oil on canvas, $37\frac{1}{2}'' \times 37\frac{1}{2}''$

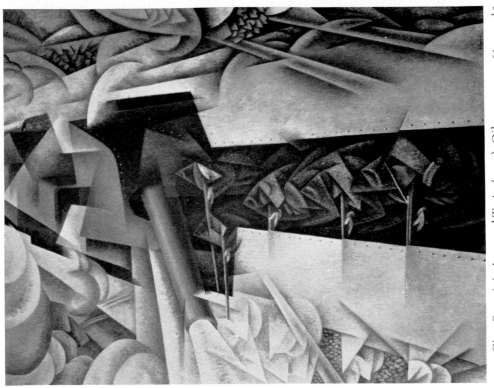

210　Gino Severini. *Armoured Train*. (1915). Oil on canvas, 46″ × 34½″

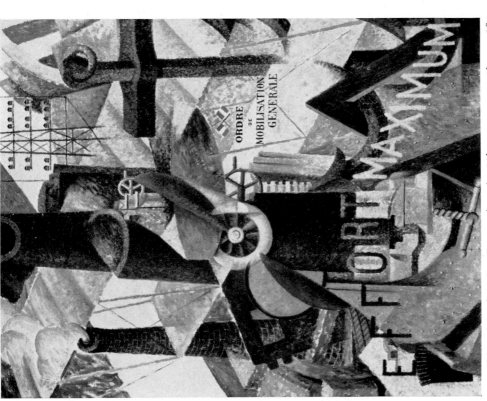

209　Gino Severini. *La Guerre*. (1915). Oil on canvas, 36¼″ × 28¾″

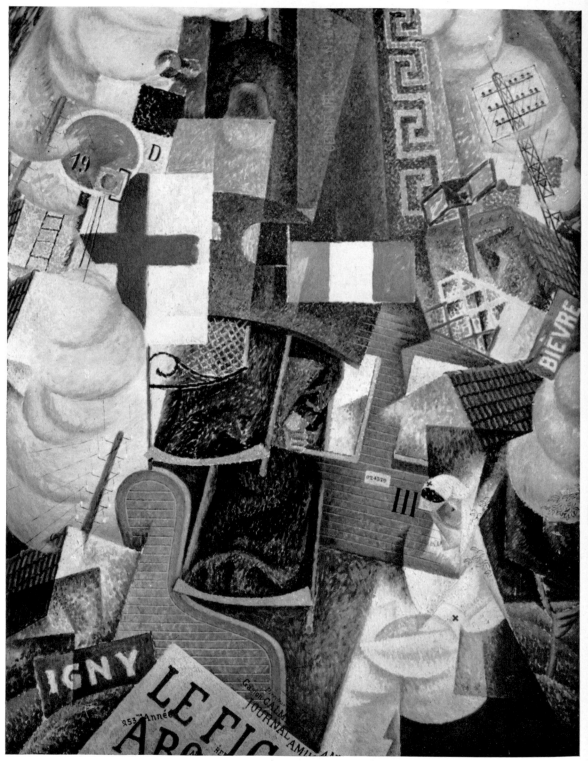

211 Gino Severini. *Red Cross Train*. (1915). Oil on canvas, $46\frac{1}{4}'' \times 35\frac{1}{4}''$

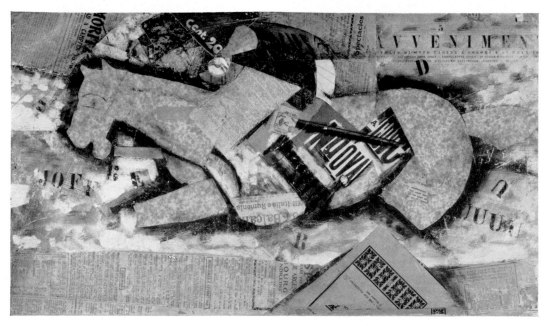

212 Carlo D. Carrà. *Inseguimento.* (1914). Collage and gouache on paper on canvas, $15\frac{1}{4}'' \times 26\frac{3}{4}''$

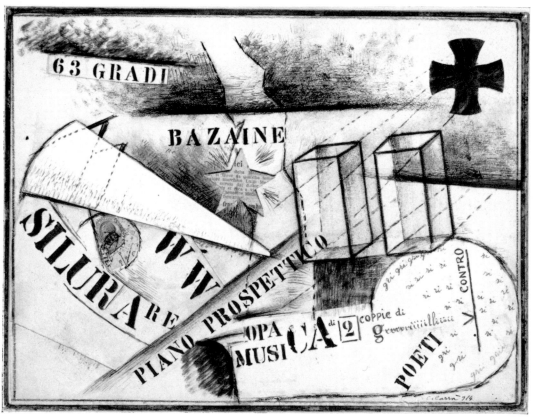

213 Carlo D. Carrà. *Angolo penetrante di Joffre sopra Marne contro 2 cubi Germanici.* (1915). Collage, gouache and ink, $10'' \times 13\frac{1}{2}''$

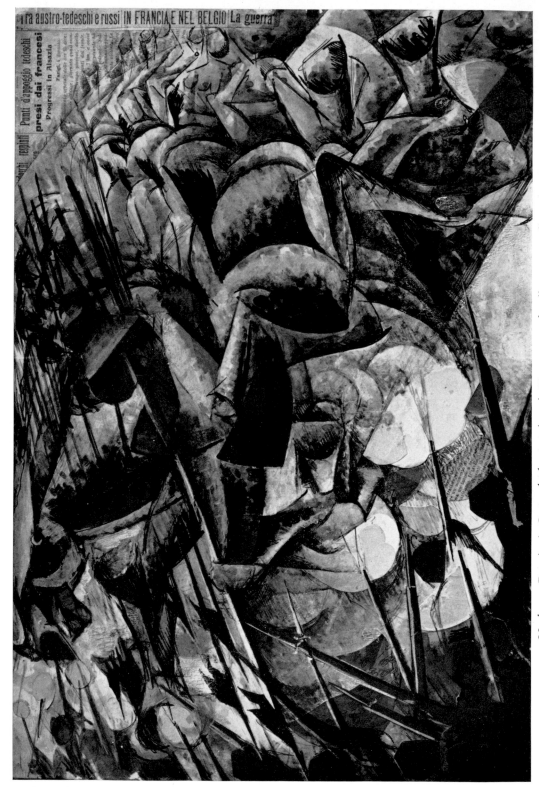

214 Umberto Boccioni. *Carica dei lancieri.* (1914). Tempera and collage on cardboard, $12\frac{7}{8}'' \times 19\frac{1}{2}''$

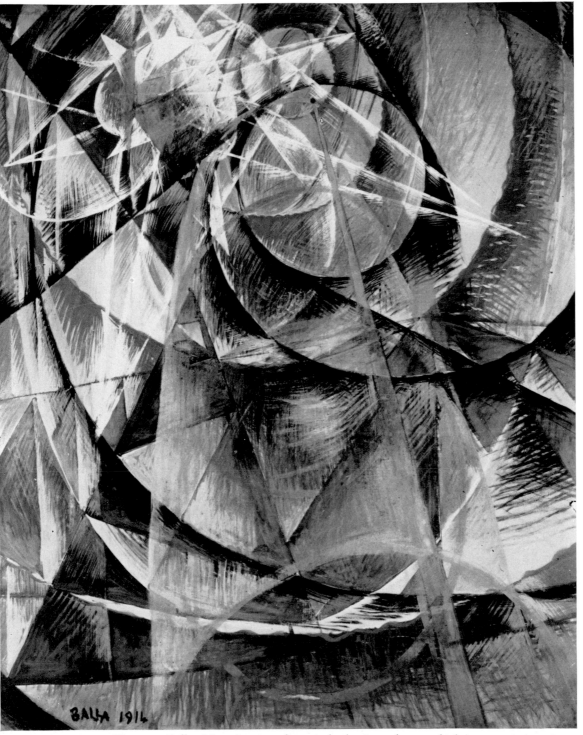

215 Giacomo Balla. *Mercurio passa davanti al sole visto col cannocchiale.* 1914.
Tempera on paper, $47\frac{1}{4}'' \times 39\frac{3}{8}''$

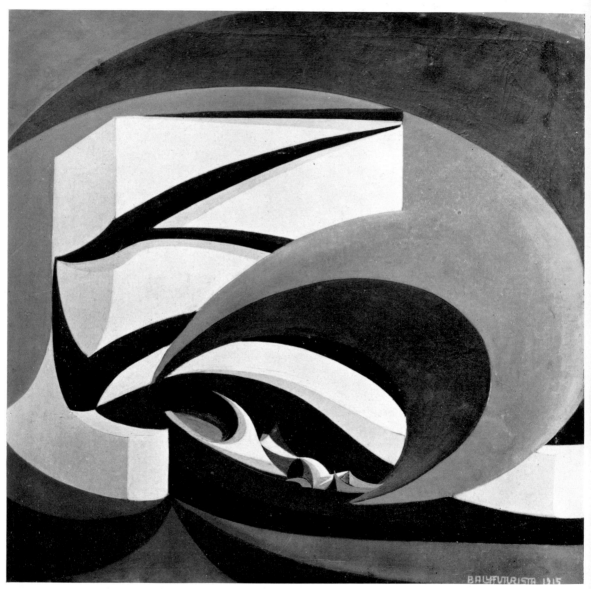

216 Giacomo Balla. *Bandiera sull'altare della patria*. 1915. Oil on canvas, $39\frac{1}{2}'' \times 39\frac{1}{2}''$

217

218

Giacomo Balla. Illustrations of *Complessi plastici*. (1914–15). Destroyed. (Balla-Depero, *Ricostruzione futurista dell'universo*, Il Marzo 1915.)

219 Umberto Boccioni. *Ritratto di Ferruccio Busoni*. 1916. Oil on canvas, $69\frac{1}{2}''\times47\frac{3}{4}''$